ROMAN
CRAFTS

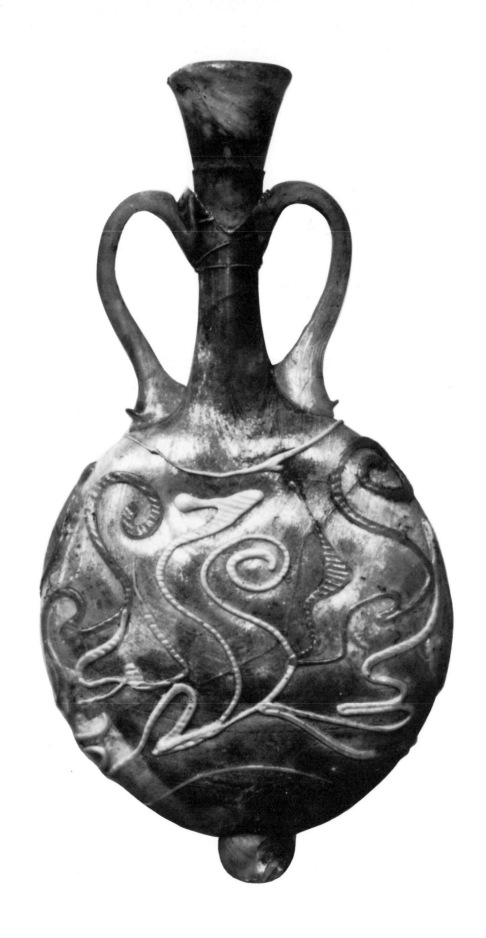

ROMAN CRAFTS

edited by

Donald Strong
& David Brown

New York New York University Press · 1976

© 1976 David Brown and the executors
of the estate of Donald Strong

First published in 1976 by
Gerald Duckworth & Co. Ltd,
The Old Piano Factory,
43 Gloucester Crescent, London NW1

Designed by Alphabet & Image, Sherborne, Dorset
with drawings by Michael Woods

Published in the U.S. by New York University Press

Library of Congress Catalog Card Number: 76-28589

ISBN 0-8147-7801-1

Filmset by Keyspools Ltd, Golborne, Lancs.
and printed by BAS Printers Ltd, Wallop, Hampshire.

*The illustration on page 2 shows a snake-thread glass flask,
about actual size*

Contents

List of Colour Illustrations

Introduction

How were Roman artefacts made? This was the question in the mind of each of the contributors to this book. In most cases their answers have come from a careful examination of the objects themselves rather than from any Roman textbook or craft manual. One single work, Vitruvius' *Architecture*, dominated the literature of building in the Roman world and this is an invaluable guide for the chapters on stucco, painting and mosaics. For the rest, odd scraps of information have to be gleaned from many authors; most come from Pliny's *Natural History* which is our richest source of craftsman's lore, but it is no textbook, as many people will have found.

In many senses this is a book about the backs of objects, and badly made or broken pieces. There is far more information about the making of an object to be learned from those parts which the craftsman didn't finish or which he finished badly than there is from a smooth and highly polished surface. The chisel marks on the back of a piece of sculpture, the hammer marks inside a metal jug, the joins visible inside a broken lamp or terracotta—these are the tell-tale pieces of evidence which explain how the objects were really made.

Other information comes from tools and workshops, though these are not as easy to identify as might be supposed. It seems probable that many crafts were practised in ordinary buildings with comparatively unspecialized tools, and that without some debris of the manufacturing process they would not be identified. Notable exceptions are the pottery industry for which there is the widespread evidence of kilns and workshops, and woodworking for which there is a wide range of readily recognizable tools; in this case it is the objects which have not survived.

Finally there is information to be derived from studying the ways in which objects are made today, or were being made in the recent past. In many cases it is through knowledge of these modern methods that we are able to say how the Roman craftsmen achieved their results; at other times certainty is not possible, and we can only suggest possible or probable ways of working.

It has not been our intention to discuss the craftsmen themselves. Their organization, their status, their conditions of work are topics very closely related to our theme; so too are questions of trade, trade routes, provincial markets, supply and demand—in fact the whole economic organization of the Empire.

Much has been and is being written about these subjects elsewhere; but it is necessary to say a little about the origins of the craftsmen, for they reflect the origins of the crafts.

The writing of a book which concentrates on Roman crafts does not mean that the craftsmen were necessarily Romans. The evidence of inscriptions, of makers' marks stamped on objects, of writers like Pliny, indicates quite clearly that the majority of craftsmen working in Italy in the early years of the Empire were freedmen and slaves, and most of them were of Greek origin. When Rome conquered the cities of the Hellenistic world in the second century BC scores of skilled craftsmen of all sorts flocked into Italy, and they brought their skills with them.

The early years of the Empire were a time of expanding markets, increased investment in industry and the rapid exploitation of new territory. These were the years in which massive demand from the army and the provinces transformed the Greek skills into thriving industries and dispersed their products to all parts of the Empire. Within the provinces the new products displaced many traditional ones, but here and there, as in the case of enamelling, or the spinning of wool and the firing of pottery, local practices were maintained and grew to become Roman ones. It is this mixture of techniques and methods current in the various parts of the Roman Empire that we describe in the chapters which follow.

Donald Strong died in 1973 when this book was no more than a collection of drafts and typescripts, and his wisdom and guidance have been much missed in putting the book together. This book is very much his book. He had first introduced the technological theme in a series of seminars which he organized at the Institute of Archaeology in London when he became professor there. When these seminars began to take shape as a book he was enthusiastic in seeking out additional contributions so that our coverage could be as comprehensive as possible. Often he would claim that he knew little of technical matters, and felt that he ought—we all ought—to know more, for how could we pretend to be specialists in art or archaeology and yet not know how our objects were made. His aim throughout was to stimulate discussion and investigation into these technical aspects of the subject. If this book achieves that aim it will have been successful.

David Brown

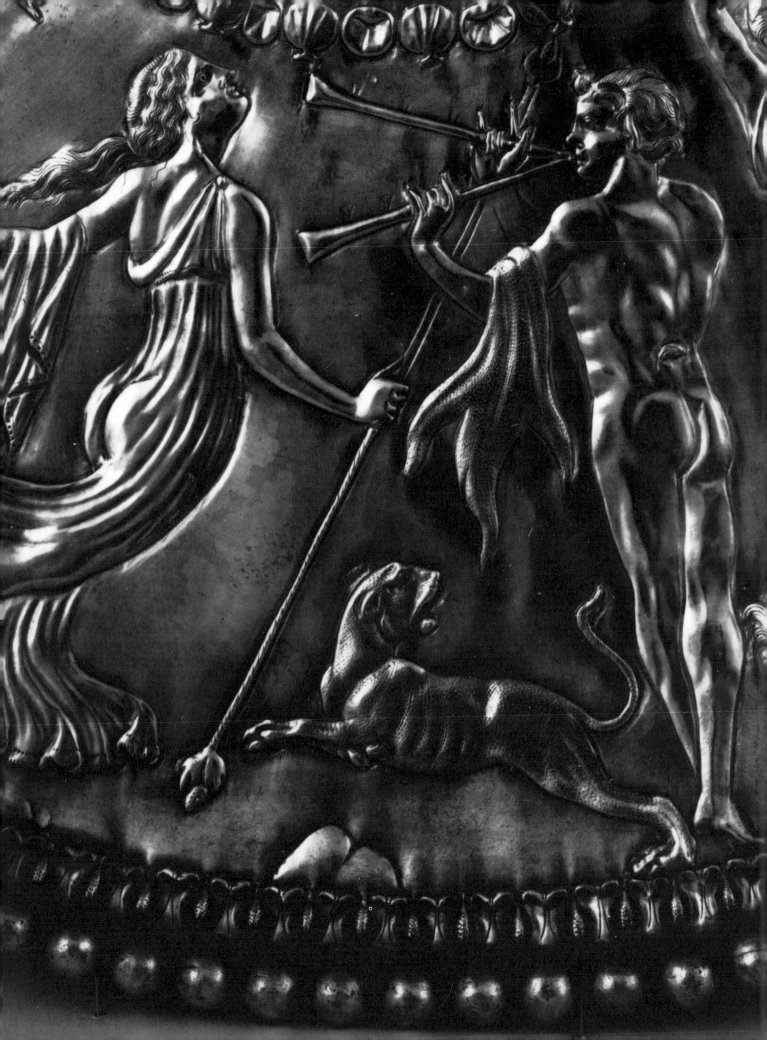

David Sherlock

1 Silver and Silversmithing

Silver was used throughout the Roman world for practically all those purposes for which it is used today. No doubt the production of silver coinage absorbed the greater quantity of metal, but the finest craftsmen were attracted to the making of high quality silverware. It was common practice for prosperous households to own large sets of eating and drinking vessels, *argentum escarium* and *argentum potorium*. Two hoards of such vessels buried by the eruption of Vesuvius contained over a hundred pieces each, 118 pieces in the Casa del Menandro at Pompeii and 109 pieces in a villa at Boscoreale. Other hoards, inventories of silver recorded on papyri, descriptions in literature and pictures of everyday life show that the same range and variety of vessels were common elsewhere. Some pieces were so large and elaborately decorated that they can only have been kept as show plate or given as special presents such as wedding presents or as rewards for public service. From the third century onwards there seems to have been a tendency for such pieces to get larger; a notable example, the Oceanus dish from the Mildenhall treasure, is very nearly two feet in diameter. The largest collections of silver plate must have been in the Imperial courts but these would have been exceptional. Temples and public bodies, like town councils, also had ceremonial plate, and when the Christian church became established, it adopted silver for both liturgical and domestic purposes.

There is no ancient treatise on the techniques of the Roman silversmith. Some detail is to be found in the writings of Pliny the Elder; but Pliny was not a craftsman, and his technical descriptions must be read with care before too great an emphasis is placed on their relevance and reliability. It is probable that the *De Diversis Artibus* of Theophilus (twelfth century) includes material from lost ancient treatises, and perhaps also the *De Re Metallica* of Agricola (sixteenth century). Both these works should be studied, not only for this reason, but also because it seems unlikely that the techniques themselves changed much between Roman and Medieval times.

Archaeology is a disappointing source for evidence of the techniques of silverworking. Tools such as hammers, punches and stakes are rarely found in a recognizable state, and it is unlikely that the silverworkers' tools would be distinguishable from those of other metalworkers, blacksmiths and jewellers; there is also the difficulty of knowing precisely what to look for. The excavations

1, Col. Plate I

1 Chased and pointillé decoration on the large Oceanus plate from the fourth century Mildenhall treasure. The rim is formed by beading. Diameter 23½ in.

11

at Silchester revealed cupellation furnaces and shops in which objects were being made and sold, but nothing in the way of tools or other indications of the way in which the actual craft was practised.

There remain the vessels themselves, and it is normally possible by comparison with medieval and later techniques to say how they *could* have been made. Certainty is seldom possible because the finishing and final polishing of the surfaces was probably intended to remove all traces of manufacture. Normally it is only in the case of enclosed vessels such as jugs and the backs of some objects where they were not meant to be seen that the tell-tale signs of file, hammer or lathe show without doubt how the vessel was made.

The principal sources of silver in the Greek and Hellenistic worlds (including the mines at Laurium in Attica where working conditions were notoriously hard) continued to be worked in the Roman period, but in the West, Spain became by far the richest silver-producing province. Britain herself was stated by ancient authors to be rich in gold, silver and other metals, and this seems to have been an important factor in the decision to invade. Tacitus describes them as *pretium victoriae*. Lead pigs (ingots) weighing 200 lb. or more and stamped with imperial marks show that the metals were being exploited within a few years of the Claudian invasion. The stamps include the phrase EX ARG. BRIT. which stands literally for 'from the silver mines of Britain'. Silver practically always occurs in a natural state in a lead ore called galena (lead sulphide) so *ex argentariis* might more properly be translated as 'from the galena mines'. Although they have an excellent lead content, British lead ores have a low silver content which nowadays would not be worth extracting. Nevertheless the Romans seem to have found it worthwhile, although it is not always clear from the analyses we have of surviving pigs whether the tiny quantities of silver remaining in them occurred naturally in those quantities in the ore, or are the residue after imperfect cupellations.

Cupellation is the process whereby silver (and gold) is extracted from lead and other base metals. The silver-bearing lead was melted in furnaces over a floor of bone ash. Once melted and heated to around 1000°C, the lead was oxidized to litharge with a blast of air from a bellows. This litharge was absorbed by the ash leaving the silver free on its surface. The litharge and ash mixture was subsequently resmelted to give lead.

The Romans could produce very pure silver by this method. But pure silver is very soft, and for practical purposes it was alloyed with some copper. Several pieces of Roman silverware have been analysed and with one exception the results show the silver to be between 92 and 98 per cent pure; in all cases the alloys include a small percentage of copper and often of gold and lead as well. This composition may be compared with Sterling silver which is 92.5 per cent pure. Small percentages of copper have little or no effect on the colour of the silver, and the resulting alloy is still soft enough to be cut easily and malleable enough to be shaped by hammering.

Shaping

The initial processes of shaping can best be understood by describing some pieces which I have made myself.

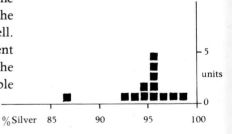

2 Diagram showing the purity of the silver used in making vessels during the Roman period.

The basic tools are few and simple though the master craftsman will use a great range of types and sizes which he makes himself to suit his own needs. A wooden workbench like a carpenter's is used for filing, polishing and other detailed work; a large tree stump, known as a steady block, for hammering directly on to, and also for fixing the iron stakes on which the silver is held during raising and planishing. The principal hammers are of iron and wood; horn and hide ones are also used. The surfaces of both stakes and hammers must be kept very smooth and clean so as not to spoil the silver or the tools.

From the start the metal is handled with care to avoid it being dropped or scratched, for even the smallest dents and scratches may mean hours of extra filing and polishing before an object is finished. My first object, a shallow silver bowl with a circular foot, began as a sheet of silver. A circle four inches in diameter was inscribed on the sheet with compasses and cut out with iron shears. The resulting disk of silver was held with the compass point on the underside over a depression in the top of the steady block. 'Sinking' the metal into the depression involved hammering the disk with hard blows of a rounded hammer; the work progressed from the outside towards the centre in concentric circles.

The chief property of silver is its malleability; but hammering the cold metal hardens it, and will eventually cause it to crack unless it is annealed. This process involves heating the object with a flame on a brick which can be rotated to produce even heat until it begins to glow with a pink colour, and then cooling it, generally by placing it for about a minute in a 'pickle vat' of dilute sulphuric acid which will clean it of impurities contracted during working and firing. The hardening is due to the distortion of the crystal structure of the metal; annealing allows it to reshape itself and restores softness and malleability to the metal. The need to anneal becomes apparent when the hammer rings dull or flat, like the sound of a cracked bell, and when the hammer blows no longer produce the same effect as before. 'Tired' metal transmits a stinging feeling to the hand holding it. The process of sinking followed by annealing was done two or three times to acquire the required depth.

After sinking, the bowl was turned over and placed on a round-headed iron stake for 'planishing'. This is a basic process in silversmithing and fundamental to the craft. The planishing hammer is smooth and is used with light taps to work round the bowl in spirals from the centre; each blow just touches the one before and fits between those in the previous row to produce the small quasi-hexagonal facets which give hammered silver its characteristic finish.

Just as a stone mason can produce a given number of chisel marks to the inch when dressing a block of stone, so a skilled silversmith can planish a surface into perfectly interlocking facet-blows of equal size. Planishing an average-sized piece of silver requires many thousands of blows and, for an apprentice, some concentration to avoid striking a false blow. One begins to appreciate the time and tedium that goes into a work of art after the technique has been learnt.

My bowl had to be annealed again during planishing. When hammering near the rim care was needed to prevent the rim from thinning out. Checks were made from time to time to ensure that the bowl remained circular and of even curvature. Finally the rim was filed to shape and the bowl polished.

The amount of polishing depends on the finish desired. The hammer marks

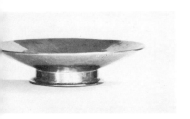

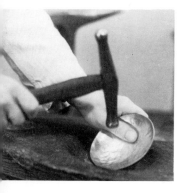

3 (top) A shallow bowl with soldered foot—made by the author. Diameter 4 in. **4** (above) A silversmith at work 'sinking' the metal into a depression in the top of a 'steady block'.

can be completely removed and a smooth shine produced so that it is indistinguishable from a piece of cast silver. Preliminary polishing is done nowadays with iron files of diminishing roughness, and then an abrasive stone, Ayr stone, lubricated with water, to remove the file marks and any accidental scratches. The stone can be cut to convenient sizes and shapes to fit any odd angles and corners that need polishing, but 'stoning' is still a fairly lengthy and laborious process. Further polishing is done with a bristle brush, pumice powder or Tripoli grease and oil, and finished off with chamois leather after washing in soap.

Soldering

The base of the bowl was made from a strip of metal cut out and hammered to shape around a cylindrical stake. The ends were soldered together before the base was soldered to the bowl, and as more than one stage of soldering was involved, solders with different melting points were used so that the solder of the first join should not melt when the silver was reheated to make the second join. The surfaces to be joined were filed and cleaned to form a close fit, and then tied together with iron binding wire. Solder and silver were then coated with borax which acts as a flux to prevent oxidization of the newly cleaned surfaces during heating. The solder and silver were heated together to a temperature at which the solder melted and flowed into the join. After cooling, superfluous solder was filed away. The base of the bowl was given an out-turned rim by soldering a second strip around its edge, and was then ready for final pickling and polishing.

A well-soldered join in silver is not visible, and in bronze and copper should appear as no more than a hair line. Modern solders are an alloy of silver, copper and tin. Theophilus recommended two parts of silver to one part of copper, and it is likely that the Romans used alloys of this sort, which have a melting point some way below those of the metals being worked. Softer solders were used by the Romans for joining handles on to cups and jugs in both silver and bronze. Samples of soft solder from the fourth century hoard of silverware discovered at Traprain Law in Scotland consisted of 85 per cent tin and 15 per cent lead. Such an alloy has a melting point around 300°C, well below that of silver. Two pieces of silver can also be welded together simply by hammering at a temperature of 500°C, or they can be rivetted: the Romans seem to have preferred this method for joining large pieces together.

Nowadays annealing and soldering are done in a gas flame whose temperature and direction can be carefully controlled. Heating must have been much harder for the Roman silversmith, and it presumably required great experience and skill for a piece of work not to be ruined. For annealing, charcoal fires could be controlled with skin bellows worked by slaves or apprentices; for soldering, heat could be applied directly where required with a pre-heated soldering iron, or directed with a blow pipe.

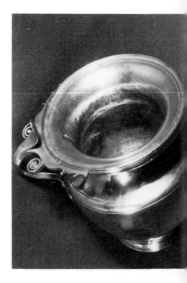

Raising

'Raising' is another of the silversmith's basic techniques. Vases, jugs, bowls and other deep vessels can be raised out of a flat sheet of metal to almost any desired shape merely by hammering. The raising hammer has a rectangular head set at

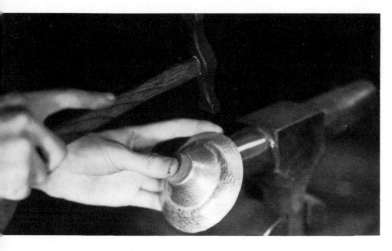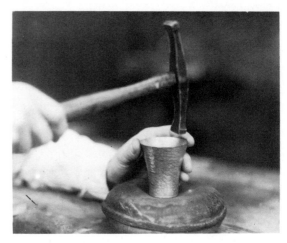

5 A silversmith 'raising' the walls of a beaker. **6** (right) Hammering the edge of a beaker to thicken the rim.

5

6

7 Overlapping hammer marks visible on the inside of a small jug from the Arcisate treasure. First century BC.

right angles to the handle, its edges just rounded to prevent their cutting the silver. My second object, a beaker 4 inches high, was raised from a disk of silver 6½ inches in diameter. The size of disk required was calculated by adding the average diameter of the beaker (2½ inches) and the height of the beaker (4 inches). The disk was first sunk in the block as far as possible, like the bowl, and annealed. Then, after the area reserved for the base had been marked off, it was turned over and held on an iron stake at an angle so that the edge of the stake touched it just above the area marked for the base. The silver was then hammered on to the stake just above the point of contact; between each blow the metal was rotated slightly and so gradually driven, or raised, into the shape required. The work continued outwards from the centre, and when the hammering reached the edge, the metal was annealed and the whole process repeated starting from a point just above where the previous hammering started. The beaker was finally raised after this process had been repeated thirty times, though a practised silversmith would expect to have done it in about twelve.

The skill comes in being able to hold the metal at exactly the right angle, and in knowing just how wide a band of silver can be effectively hammered in each course round. The greater the curvature of the metal, the trickier the work becomes. With large bowls raising can produce waves in the metal which are not only difficult to condense into an even surface, but also detract from the strength of the object. When hammering near the edge of the object care must be taken not to thin or split the metal. If this happens the rim can be thickened again by hammering the edge downwards, holding the object on a leather sandbag. The beaker was finished by further annealing, planishing and polishing as described for my first piece.

The basic processes involved in the making of these two pieces are not likely to differ much from those used by Roman silversmiths, yet certain evidence for sinking and raising comes only from a few sorts of vessel. These are enclosed vessels, such as jugs and flagons, in which the insides could never be fully polished. The inside of a small jug from the Arcisate treasure shows clearly the unpolished facets of the overlapping hammer blows; yet polishing on the outside of the same vessel and around the mouth and rim has removed all trace of the hammer marks which must once have covered these areas. It seems to have been

15

normal practice for Roman silversmiths to remove traces of raising from the visible parts of their vessels, and open vessels like bowls and cups are normally polished on both sides.

The visible parts of vessels, when well polished, reveal little sign of the method of polishing, but bases and the backs of plates in particular are often less well polished and lathe marks show distinctly. It appears to have been normal throughout the Roman period to finish and polish all regularly-shaped silver vessels on the lathe; the same was true for bronze vessels and the process is described more fully in the next chapter. Similarly, casting processes are the same for silver as for bronze, and these will be described with reference to bronze. Normally cast pieces are thicker and heavier in proportion to their size than raised pieces. Bases and handles and other elaborately decorated pieces were generally cast and soldered onto the body of the vessel after the shaping and polishing had been finished.

Finally, to illustrate the way in which more intricate objects can be made by assembling small pieces, I describe the making of a spoon, an imitation of a fourth century type called a *cochleare*. The piece for the bowl was cut out of a sheet of silver, blocked to about half the required depth and then shaped by hammering into a leaden mould with a punch matching the shape of the mould. For the join a strip of metal was hammered and bent with pincers into an open scroll with a projecting piece to give a 'rat-tail' down the back of the bowl. The handle was made from a piece of silver wire, rectangular in cross-section and $4\frac{1}{2}$ inches long. It was made to taper to a rounded point by hammering towards one end; this had the effect of lengthening the handle to $6\frac{1}{2}$ inches and also hardening and strengthening the metal. All traces of the hammer were removed by stoning. Finally the spoon was assembled by two separate solderings, and its shape refined by filing and polishing. The final result was similar to the spoons from the Mildenhall treasure.

It is certain that Roman silversmiths knew of the shaping methods which have been described; there remains one technique, much used today, about which we cannot be certain. This is the technique of shaping metal by spinning it on a lathe. A disk of silver is mounted on a lathe next to a shaped wooden pattern

8

Col. Plate I

8 A spoon made by the author in imitation of the fourth century type called a *cochleare*. Length $7\frac{3}{4}$ in.

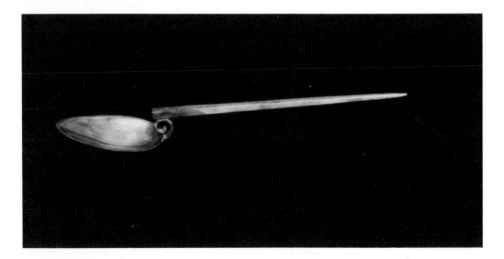

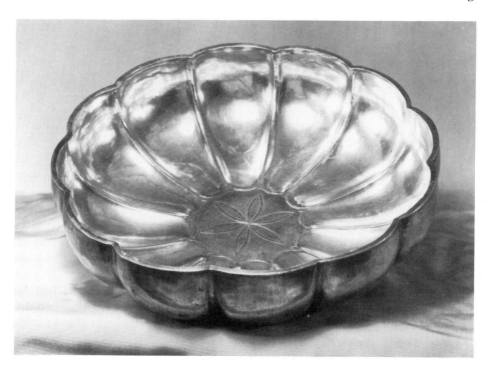

9 A fluted bowl from the third century Chaourse treasure with 10 (below) a detailed view showing the engraved decoration in the centre, and marks of polishing around the centre and to and fro along the fluting. Overall diameter $9\frac{1}{2}$ in.

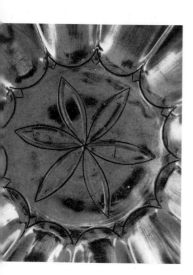

piece, say a curved bowl shape. As the lathe spins a metal tool is pressed against the silver and strokes or burnishes it over the wooden pattern until it takes up the shape of a bowl. This method has the obvious advantage of speed though the piece will have to be removed from time to time for annealing in just the same way as if it was being hammered into shape. So notable an authority as Herbert Maryon thought he could see signs of this technique on some pieces of late Roman silverware, but it is possible that these were simply the signs of turning and polishing and not of actual spinning, and it remains uncertain whether the Roman lathes were fast and powerful enough to use the technique.

Decoration of silverware

Objects being raised can only be kept round if the work progresses evenly on all sides and is carefully checked from time to time. Unwanted irregularities may be difficult to remove, and the larger the vessel the more difficult this is. However, irregularities can be hammered into the walls of the vessel deliberately as a form of decoration, of which the commonest varieties are fluting and scallops. This sort of decoration is characteristic of late Roman silverware and is well illustrated by a bowl from the Chaourse treasure. It is probable that the lines of the fluting and the pattern inscribed in the centre of the bowl were carefully marked out on the surface of the vessel before the final shaping began. Obviously a vessel like this could not be polished on a lathe: polishing was done with a to-and-fro motion along the line of the flutes.

Repoussé work

The main method of producing decoration in relief is called *repoussé* (literally 'pushed out'). The work is done by gently hammering the back of the silver

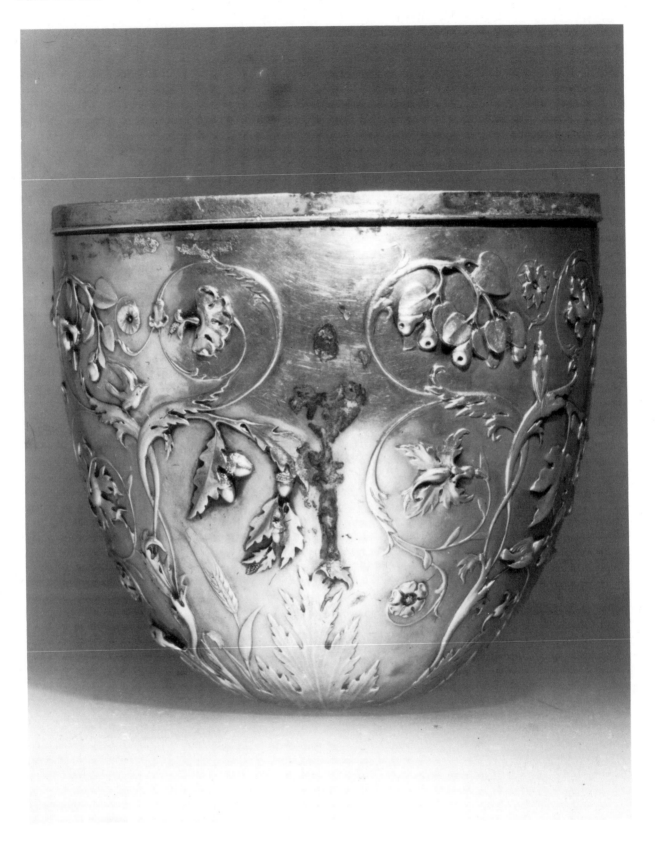

11 Repoussé decoration on the bowl of a cup of the Augustan period. The central scar shows where a handle was once attached.

with a small-headed hammer, or a hammer and punch, so that the metal stands out, embossed, on the front. The object is placed face down on a bed of soft pitch which supports the silver and yet yields as the design is beaten into it. If the metal wears so thin that the embossing is unsuitable for normal use, it can be supported from behind with a lead filling (called by the Romans *plumbatum*); if the metal wears right through it will have to be repaired with solder. As with all cold working the metal will have to be annealed from time to time to keep it workable. Nowadays a snarling iron would be used to boss up the inside of a narrow vessel at points that are outside the reach of normal tools, but it is not certain that Roman silversmiths knew of this tool. The *repoussé* technique was especially popular for decorating drinking cups with floral and figured scenes, but it left an uneven surface on the inside of the cup and it was normal practice to fit a smooth inner lining inside, the two parts being soldered together at the rim.

12
13

Engraving and chasing

Light decoration can be done simply by drawing or scratching a surface with a pointed tool, but the actual engraving involves the removal of a strip of metal by cutting the surface with a graver which has a sharp V-shaped blade. It would depend on the confidence and skill of the silversmith whether or not he chose to sketch his design lightly on the surface beforehand. An apparent imbalance of incising and engraving could mean that the decoration was never finished.

Chasing involves hammering the front surface of the silver with punches, some of which the modern silversmith makes himself to suit his own technique. For example, a beader produces small dots (sometimes called *pointillé*) while a hollow beader with a point like a biro without the ball tip produces a small raised bead by driving the surrounding metal downwards. A series of oblique indentations with a punch produces a continuous line. The commonest use of

12 The maker's view—the uneven surface on the inside of a cup with repoussé decoration—and the normal view **13** (right) with a smooth inner lining in position.

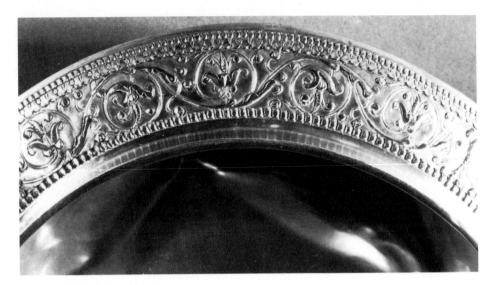

14 Chased and beaded decoration on the flange of a bowl from the third century Chaourse treasure.

1, Col. Plate I

chasing is for low-relief decoration, seen at its best on the Oceanus dish from the Mildenhall treasure. Here the whole of the detail of the figures and the background has been achieved by progressively hammering down the points of lower relief before final polishing and adding details with the graver and beader. Some figures stand out one sixteenth of an inch from the background. Herbert Maryon has suggested that the work involved could have been reduced by first casting the figures in outline; but there is no way of checking this.

Gilding, niello and inlay

The Romans used two methods of gilding. In the first, gold foil was cut to shape and glued onto the silver with a suitable adhesive. This method could of course be used for objects in other metals and other materials. The second method was mercury gilding. Gold and mercury were mixed to form an amalgam which was applied to the surface of the object; this was then heated causing the mercury to evaporate and leaving the area gilded. Gilding was seldom used to cover an entire object; in the case of silver objects gilding was normally restricted to one or two bands embellishing the rim of a cup or the neck of a flagon, or to picking out details of a figured scene.

Niello is a powder compound of silver sulphide; it hardens on heating and can then be polished to a smooth and shiny black finish. The contrast in colours when niello is inlaid in silver is very pleasing, and niello work (*opus nigellum*) was much used to fill inscriptions and decorative patterns such as the swastika in the centre of the Augustan silver dish.

Silver was also much used for inlays in other materials such as the woodwork of furniture, ivory and bronze fittings and statuettes. In particular, in the first century, it was common for bronze statuettes to be embellished with small pieces of inlay; the eyes and the lips were favourite spots, also details of the clothing such as buttons and sandal straps. Inlays of this sort were held in place by being hammered into undercut grooves. A tour de force of inlaying is the pattern, part in silver, part in niello, which decorates the cuirass of a bronze statuette of the Emperor Nero.

15 Niello inlay in the centre of a first century silver plate. About actual size.

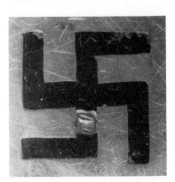

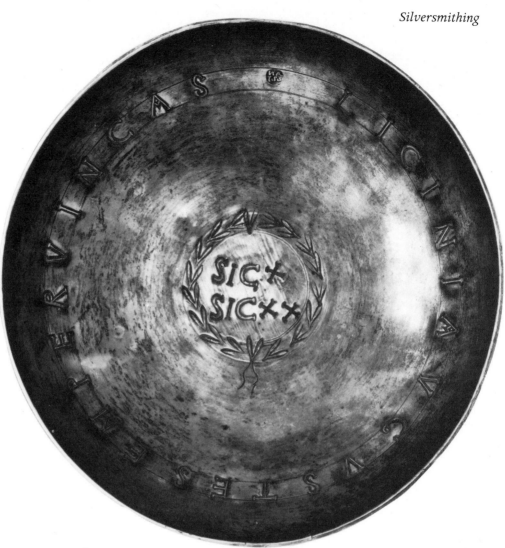

Stamped inscription

The inscription on the *largitio* bowl of the Emperor Licinius has been stamped into the silver. Each letter is a complete punch, and one must assume that the silversmith who made this bowl had a complete set of letter punches and could produce whatever dedication he was asked for.

16 (right) Stamped lettering and decoration on a *largitio* bowl of Licinius, 317 AD. **17** (below) control stamps of Heraclius (613–629/30 AD) on the base of a bowl from the Lampsacus treasure.

Hallmarks

Multiple hallmarks of the sort used today were not known to the Romans. It is quite common to find that the weight of a vessel has been scratched on its base. In the fifth and sixth centuries some pieces of silver were stamped with an Imperial mark as a sort of guarantee of quality. This was often done between manufacture and decoration and so is valuable evidence of when and where the latter took place.

Cleaning and repairing silver

Silver tarnishes easily and must be regularly cleaned to keep it in good condition. Rich households employed *servi ad argentum* solely for this task. Acid and soap

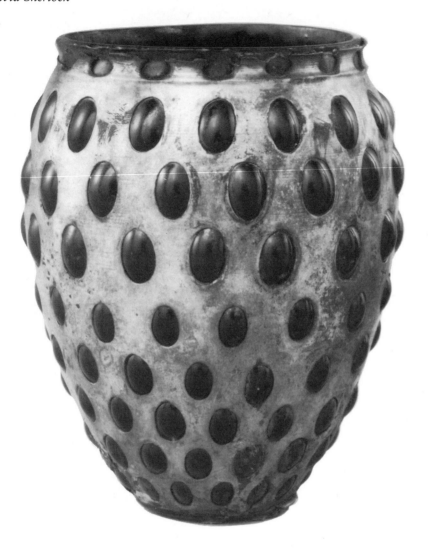

18 An openwork effect achieved by blowing a blue glass vase inside a silver vase with oval cut-outs. Height $3\frac{1}{2}$ in.

19 Soldered repairs on the back of a plate from the Hildesheim treasure. 50 BC–50 AD.

solutions were used for the cleaning; chalk and leather for the polishing. Damaged silver was repaired by rivetting or soldering, and pieces worn thin with age were patched with extra metal.

Silver and other materials

Some examples of how silver was used with other materials have already been noted. Silver jewellery is rare, but silver vessels could be set with glass or, very occasionally, semi-precious stones. Some silver openwork was evidently intended to hold glass cups or bowls. When silver became scarce or unobtainable, silver objects were imitated in other metals such as pewter and bronze, and bronze objects were coated with thin silver sheet.

The accomplished silversmith must be conversant with all the various techniques described above and, by analogy, the Roman silversmith too. An elaborate jug or bowl may have been raised, planished and polished on a lathe; its decoration may have been done by engraving, chasing and *repoussé*; its handle may have been cast first and then rivetted on; and its base soldered on.

Where characteristic native elements such as Celtic or Oriental motifs are absent from the designs on Roman plate, little attempt has so far been made by scholars to distinguish different workshops and styles. Actually, there seems to be a remarkable similarity about Roman plate throughout the Empire, both in time and place. For the first four hundred years hardly any of the early styles or decorations can definitely be said to die out. The old vase and dish forms continue, but with perhaps an increase in fluted shapes and later a fashion for rectangular, hexagonal and octagonal dishes and trays. After Constantine, Christian imagery begins to come into decoration, but it is in a traditional classical style and there is no sign of the old familiar mythological scenes becoming obsolete. The opportunities the Empire gave for trade and travel must have quickly disseminated the products of silversmiths, who seem from epigraphic and literary evidence to have themselves been free to move from one centre of civilization to another, working sometimes on a piece specially commissioned by a rich customer or simply setting up bench and shop, near production centres or in towns and cities, like the craftsmen of any age. They also worked outside the Roman empire and their products were an important export. Rome itself had guilds of silversmiths and gilders, and a special silver market (*basilica argentaria*). The *clivus argentarius* beneath the Capitol appears to have been a kind of 'Chancery Lane'.

Bibliography

General

Aitchison, L., *A History of Metals*, London, 1960

Strong, D. E., *Greek and Roman Gold and Silver Plate*, London, 1966

Walters, H. B., *Catalogue of the Silver Plate, Greek, Etruscan and Roman, in the British Museum*, London, 1921

Modern manuals

Cuzner, B., *The Silversmith's Manual*, London, 1962

Holden, G., *The Craft of the Silversmith*, London, 1954

Metallurgy and mining

Davies, O., *Roman Mines in Europe*, Oxford, 1935

Tylecote, R. F., *Metallurgy in Archaeology*, London, 1962

Technical details

Maryon, H., 'The Mildenhall Treasure: some technical problems', in *Man*, 1948, nos 25 and 43

Moss, A. A., 'Niello', in *Studies in Conservation*, 1, 1953

Thouvenin, A., 'La soudure dans la construction des oeuvres . . .', in *Revue Archéologique de l'Est et du Centre-Est*, 24, 1973

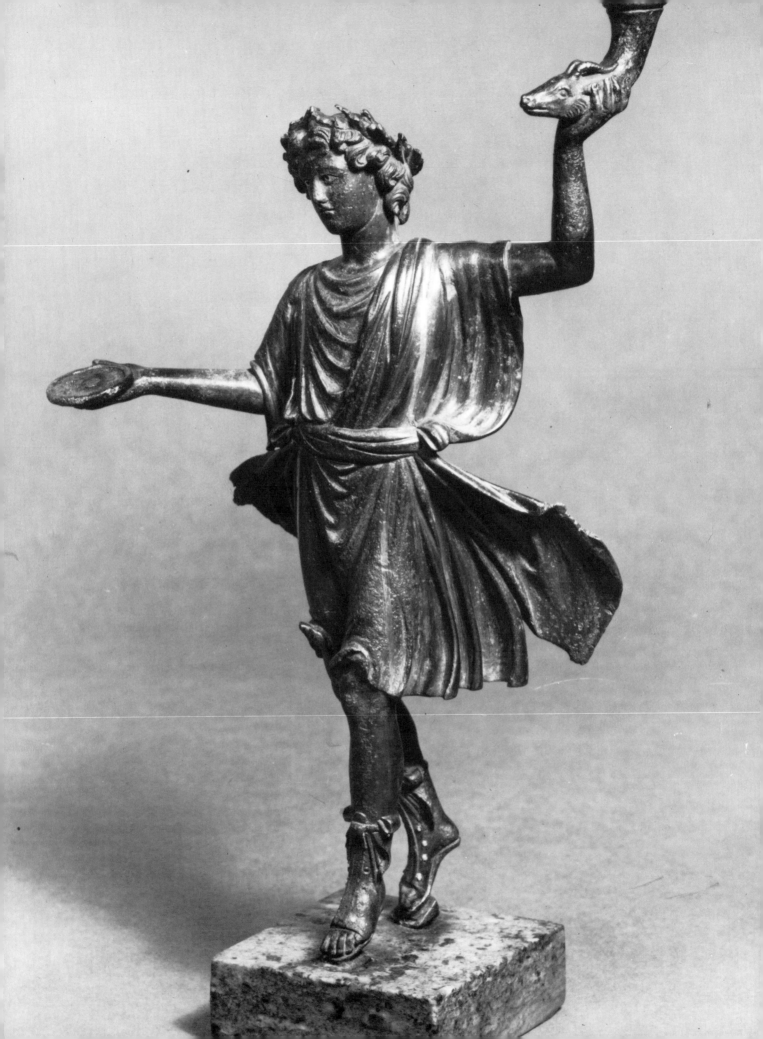

David Brown

2 Bronze and Pewter

The importance of bronze in the Roman world is indicated by the numerous uses to which it was put: pots and pans and various bronze fittings for everyday life in the home; belts, belt equipment, armour and harness for the army; brooches for fastening clothes; bronze figurines and statuary for official and religious purposes. There must have been thousands of bronzesmiths throughout the Empire, and the knowledge of the ways of working bronze must have been widespread.

None of these bronzesmiths has left a treatise on his craft, so, as in the case of silver, it is the objects themselves which are the best guide to the techniques of manufacture. But before turning to the objects it will be useful to survey the properties of the metals and the alloys which the Roman craftsman used; these properties must have been an established part of the bronzeworker's tradition, and though he may not have understood the reasons for them, the craftsman must have known of them and worked within the limits which they imposed.

Bronze

The major constituent of bronze is copper which, when pure, is an extremely soft and ductile metal. The addition of tin hardens and toughens the metal. These mechanical properties increase as the proportion of tin is increased up to 13.2 per cent. Above this proportion of tin, an intermetallic compound is formed on cooling and the resultant alloy, though hard, is brittle and unsuitable for any use which requires subsequent cold working such as hammering or stamping. Thus Roman bronzes which are to be cold worked may be expected to have a proportion of tin up to 13.2 per cent.

Bronze of copper and tin alone is suitable for cold working, but it is not particularly suitable for casting. Good casting properties depend on the ability of the molten metal to flow well and to fill the moulds. The casting properties of bronze are greatly increased by the inclusion of lead in the alloy; this has the additional advantage of lowering the melting point of the metal. But the lead affects the mechanical properties required for cold working, so the craftsman had to strike a balance between lead and tin depending on what he was going to use the bronze for. Adding lead up to 2 per cent varies the mechanical properties very little; from 3 per cent upwards they change sharply and the malleability is

20 Cast bronze statuette of a dancing Lar—the household god. The legs were made separately and cast on. Details such as the eyes, lips and buttons are inlaid in silver. First century AD. Height 8½ in.

25

rapidly affected; when the percentage of lead rises as high as 30 per cent it becomes difficult to keep the elements alloyed and to prevent the lead from separating from the copper and tin. For all practical purposes this percentage is the limit for bronze. Thus for Roman cast bronzes some lead is to be expected, though for those which are subsequently to be cold-worked in some way the percentage will be expected to be low; for those bronzes which merely need finishing with an engraving tool or a chisel, and then polishing in some way, and in which softness is permitted, higher percentages of lead, above 10 per cent and even above 20 per cent, may be expected.

Brass

Brass is an alloy of copper and zinc, and is readily distinguished from bronze by its golden-yellow colour. Its properties make it suitable for casting, cutting and stamping, though not particularly suitable for cold working. Whereas copper, lead and tin could all be extracted from their ores to give a pure metal, this could not be done for zinc during the Roman period, nor even until after the Middle Ages. But the ore containing the zinc oxides was known and is described by Pliny. The method of creating brass was to smelt the zinc ore together with pure copper or with copper ore. When smelted by itself the zinc volatizes and is lost; when smelted with the copper, the zinc is incorporated with the copper and the resultant alloy is brass. Alloys with as much as 30–35 per cent of zinc are used today, but in view of the method of manufacture it is unlikely that the Romans had much control of the proportions of the two metals. Brass was used notably for coins, which were struck, and for the cast and chased vessels known as Hemmoor buckets made in northern Gaul and dependent, no doubt, on the zinc deposits near Aachen.

Pewter

Pewter is an alloy of lead and tin. It is a soft metal with a low melting point, around 300°C; it is easy to cast but does not respond well to cold working. It was used throughout the Roman world as a solder, and in this respect is described later; but beyond that its use as a metal for making plates and other vessels seems to be confined to Britain, where evidence of manufacture and examples of vessels are widespread. Although it is a totally different sort of metal from bronze and brass, and is worked at a very much lower temperature, the evidence for its manufacture gives useful information about the tools and methods of the metalworker in general and it seems appropriate to consider all three metals together.

Casting processes

The normal way of making small bronze objects such as figurines, fittings for furniture and harness and handles of all sorts was to cast them. In this way the object could be formed as nearly as possible to the required shape and the amount of cold working, cutting down and polishing was kept to a minimum. Small pieces, up to six or nine inches across, were cast solid using the lost wax method.

21 Stages in lost-wax casting: a wax model is prepared and covered with a clay mantle. The wax is then melted out and the bronze is poured in. Lastly, the mantle is broken open to reveal the figure.

Lost wax casting

The first process was to make a wax model of the finished object. This wax model was then coated with a mantle of clay or clay and sand. The assemblage was heated, and the wax melted and ran out through a suitable hole. The mantle was heated further until it was at least partially fired and would be able to withstand the shock from the heat of the molten bronze. The liquid metal was poured in until the space left by the wax was filled with bronze. The metal cooled and solidified, the mantle was broken open and the casting released. The unwanted metal filling the pouring hole was removed and the object was polished up to the required finish. The broken mantle was of no further use and was thrown away. This principle of lost wax casting must have been extremely common throughout the Empire.

In the case of casting anything but the most simple shape, it is likely that there would be several channels made in the mantle from the pouring hole to the various parts of the object; these would ensure that the molten metal was distributed as quickly as possible throughout the mould. Similarly it is probable that there were other channels to allow the air to escape as the molten metal was poured in. As the metal flowed into the mould it would expel the air through these holes and would then rise up to fill the holes too. This would be a sign to the craftsman that the mould was full. These jets of bronze from the pouring and air holes would all be cleaned off the finished casting. Fragments of casting jets of this sort are one of the commonest sorts of evidence of bronze casting although, in most cases, scrap metal and failed castings would have been collected and put back into the melting pot. The fragments of the mantle which were discarded were usually so poorly fired that they have now disintegrated and are unrecognizable. Other evidence of casting workshops comes from small earthenware crucibles no more than two or three inches across. These are comparatively common finds from Roman sites and indicate that small scale bronze casting was widely practised. However pieces of this size could not have held enough metal to cast more than pins and brooches. It goes without saying that once the molten metal has begun to be poured there can be no stopping. Workshops involved in large scale production of a wide range of products must have had larger and more durable crucibles.

Hollow casts

Bronze objects larger than six to nine inches, or of particularly bulky shape, would be heavy and expensive in metal if cast solid, and it is usual to find that pieces of this size are hollow or have a clay core. Although the outer surfaces of these bronzes have been finished in the same way as the solid cast bronzes so that evidence of the method of manufacture is removed, the backs and the insides of hollow cast pieces and the nature of their cores frequently reveal details of the methods of casting. Let us take as an example a statuette some twelve inches high. The shape of the figure was built up in clay, taking up the general form of the figure to within about one eighth of an inch of the eventual surface. Over this core the figure itself was modelled in wax with all the final details put in. Some of these details would be built up totally in wax, for instance

the extremities such as the ears, fingers, and locks of hair. Finally the wax figure was covered with clay in exactly the same way as with solid cast figures. The complete assemblage was then heated and the wax melted out leaving a space into which the molten bronze could be poured. After cooling the outer mantle was broken open to reveal a complete figure composed of a thin layer of bronze over a clay core.

If the statuette was complete there was no need to remove the clay core, and no attempt was made to do so, as can be seen from the inside of a broken statuette of Horus Imperator from Egypt. The core is dark grey and of a coarse sandy material chosen no doubt because it would withstand heating to a high temperature, without great expansion. The thinness of the bronze shows how thin the wax covering of the core was. As in the case of solid castings the outer clay mantle was used only once and was then discarded.

Fragments of such a mantle used to cast a naked figure some fifteen inches high have been found at Gestingthorpe, Essex, and they show how the outer covering was applied. The clay was built up in two layers. The inner layer, next to the wax, is of fine grained clay so that it would faithfully reproduce the details of the wax model; the outer layer is thicker and of coarser clay, giving the composite mantle strength and the ability to withstand the heat shock. Even so the total thickness of the mantle is remarkably thin, no more than three eighths of an inch, and it is probable that for support at the moment of casting the whole thing would have been packed around with sand or earth. A part of the pouring cup with vents for the flow of the molten metal survives from this mould. The cup itself is hollow, about an inch across, and four channels flow downwards from it.

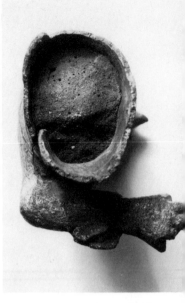

22 Clay core filling the inside of a bronze statuette of Horus Imperator from Roman Egypt. Second century AD. Breadth about 2 in.

23 Fragments of an outer clay mantle and pouring cup used in casting a statuette of a naked figure, from Gestingthorpe, Essex. The two layers of clay in the mantle are visible around the edges of the larger pieces.

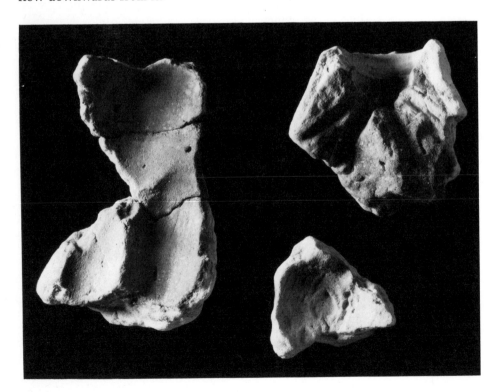

At one point in the left thigh of the figure there is a hole in the mantle which may have been a point for support of the clay core inside the statuette. Support for the core was vital for when the wax was melted out the core would be loose within the surrounding mantle and would fall sideways, the even gap into which the bronze was poured would be closed and the casting would be a failure. It was normal to support the core with metal rods of the same composition as the casting itself. These rods were pushed through the wax layer and into the core inside; the part which projected on the outside would be covered in the process of applying the mantle. A number of these rods sufficient to hold the core in place—perhaps half a dozen in the case of this statuette—were built in as the work progressed. When the wax was melted out, the rods formed a bridge between the core and the mantle keeping them in their correct relative positions and the gap between them open. When the molten metal was poured in, if it was hot enough, it fused on to the edges of these rods so that they became a part of the walls of the statue. After removal from the mantle the part of the rod which projected on the outside was cut off, and the only trace was that left buried in the core on the inside of the figure.

The limiting factors in the case of castings of this sort are concerned with the amount of molten metal that can be handled at one time. The larger the casting the more metal required at a high temperature, and the further the molten metal had to run before it could be allowed to cool; consequently the hotter the metal had to be. These two factors combine to limit the size of most thin-walled castings to a maximum dimension of about three feet. Even then the practical difficulties of handling a sufficient quantity of molten metal could not be settled by merely having larger crucibles. The metal had to be melted in a furnace which was situated near to, but at a higher level than, the mould into which it was to be poured. In this way the molten metal could flow through channels into the waiting mould under the action of gravity and without the need for transport in crucibles. The American excavations on the Agora at Athens have shown the ways in which this was done.

At a number of places on the Agora bronze casting pits have been discovered. They range in date from the sixth century BC to the fifth century AD, and show that the same technique was being used throughout this period. One of the best preserved pits, on the west slope of the Areopagus, is dated to the second century BC. It was key-hole shaped and was reached by a flight of steps at the narrow end. It was cut some three to four feet into the subsoil and was lined with rubble and mud brick walling. There were slots in the sides of the pit showing where the area of the steps had been partitioned off. In the centre of the floor was a plinth on which had been erected the clay mantle surrounding the statue. The lower part of this mantle remained still attached to the top of the plinth. The walls of the pit were heavily stained by fire.

The following sequence of events can be inferred. After building the wax model over the clay core the mantle was applied and the whole assemblage was lowered into the pit to be luted in place on the plinth. If the object was large and elaborate it seems possible that the whole process, including the art work of building the wax model, could have been done at the bottom of the pit. Once the assemblage was in position on the plinth, the pit was fired, melting the

24 Cross-section and plan views of a casting pit found on the Athenian Agora. The statue was mounted on the central plinth and during casting that part of the pit was partitioned off from the steps. Second century BC. Depth about 4 feet.

wax and partially baking the mantle. It may have been possible to collect the molten wax, or this may have caught fire and added to the baking process. After firing the mantle was surrounded with a packing of earth and sand, the partition being erected to avoid unnecessary filling of the pit. The furnace for melting the bronze was built on the edge of the pit, and once molten the liquid metal could be run off in channels straight into the mould. After cooling the whole pit would have to be emptied out, the mantle broken open and the casting hauled out for finishing and erection. The pit could no doubt be reused if required.

It seems likely from the way casting pits were dotted about among the buildings on the Agora that it was the custom for the craftsmen to work as close as possible to the site where the finished statue was required, rather than carrying out their commissions in the workshop and transporting the finished object to the site.

Several of the Athenian casting pits contained fragments of clay mantles; the best preserved of these came from a small pit used in the sixth century BC for casting a statue of Apollo type. The remains of this mantle were exactly like those described from Gestingthorpe: an inner layer of fine clay and an outer layer of coarse clay, and the double layer was no more than an inch thick.

The statuette of Apollo was three feet high and was cast in one piece. Larger statuettes were invariably cast in a number of pieces and welded or rivetted together afterwards. One of the Athenian casting pits contained, on its central plinth, the stubs of moulds for three separate limbs of a life size statue. Clearly these were all prepared for casting at the same time, though perhaps not all from the same batch of molten metal.

A good example of a statue cast in pieces is a late Etruscan/early Roman figure of a priestess from Nemi. The ancient joints have failed and the figure can be separated into its component parts. There are eight pieces; the draped body and head take up three, the arms two, the feet two and the top of the head the eighth.

The preparation of a mould for casting a statue in pieces like this is rather more complicated than the processes described so far. It would not be practical merely to make a wax-covered clay model and then try to cut it up. It would be impossible to cut along the lines and folds of the drapery as carefully as has been done in the case of the priestess, and anyway a statue of this size must have had some sort of internal framework to act as a support for the unfired clay core.

Ancient bronze casters must have used a method which allowed for separate moulds to be made of the various parts of the original model. This could be done in a number of ways, and there is no justification in claiming that the method I describe was the only method used, though it is both simple and adaptable.

First the artist prepared the model. This could be in wax, clay or plaster, or it could even be another bronze figure which it was desired to copy. The bronze caster then decided how he was going to make his casts, where the dividing lines would be and so on. He then made moulds of the outside of each part. The moulds are likely to have been of plaster because it sets quickly. The mould for each part was made in several pieces so that the mould could be removed from the model and reassembled with a hollow inside.

Once arranged, the inside of this mould was coated with wax; either warm and pliable slabs of wax were pressed into the mould with suitable tools, or

25 Bronze statue of a priestess from Nemi laid out to show the eight separate pieces in which it was made. Late Etruscan/early Roman. About half life size.

molten wax was poured in and run round the inside until the layer built up was as thick as the bronze would be. Then the whole of the inside of the assemblage was filled with a clay and sand filling equivalent to the core of a normal statuette. The outer plaster mould was then dismantled and removed, and the wax model coated in its own clay mantle. This part of the statue was then ready for melting out the wax and casting in the usual way.

One of the side effects of this method of preparing a mould and casting stems from the fact that the wax was built up on the inside of the plaster mould. If the hot wax was overheated at this stage drips of wax could run down the inside. If these drips were not removed their shape was preserved by the clay core and they come out of the final casting looking like solid bronze drips. The bronze itself was never free to run in this way for it was only filling the space occupied by the wax. Wax drips of this sort are occasionally to be seen on the insides of pieces of bronze statuary and are proof of this method of casting.

An alternative method, involving less stages, was to make a piece mould of the outside of the parts of the model working directly in clay or in a mixture of clay and sand suitable for the mantle. This mould was then assembled around a core which had been roughly fashioned to shape by hand. In this way no wax was involved; but the core, being modelled by hand rather than being cast to fill the hollow, was invariably a less good fit within the outer mantle. The result is that the final casting was much thicker than one in which wax was used. This process seems to come nearest to what is now called sand casting. Casting in a mould prepared in a sand box does not appear to have been known in antiquity.

The advantages of being able to make a statue in pieces were in part offset by the need to join the pieces together. Rivets through overlapping sections of metal were one way, though whenever possible the pieces seem to have been welded together. The normal process, fusion welding or casting on, involved placing the two sections to be joined together in the required position and building up around the join, both inside and outside, a mould of clay through which molten metal could be poured. The molten metal was poured *through* the mould, heating up the two edges which were to be joined. If the edges were not pre-heated the molten metal would solidify without fusing them together and the resulting join would be unsatisfactory. When the two edges had been heated almost to melting point the exit was stopped and the mould filled full. As the metal cooled it fused the two edges joining them solidly together. This method left a some-what untidy and irregular surface on both sides. The outside scars were removed during the finishing process; the scar on the inside remained concealed. It seems unlikely that a very large join could have been made in one stage by the fusion welding process, and to make a join around the waist of a life size statue would probably have needed three or four separate welds all of which would overlap to make the finished join a complete circuit of the body. Normally such joins, when properly finished off, would not have been visible on the outside of a statue in ancient times. Today they are sometimes visible as patination and corrosion develop in different ways on the ordinary cast metal and the weld metal.

It is normal to expect that the entire surface of an ancient casting would have been worked over after removal from the mould; chisel and graver, abrasive and polish were certainly used, and probably files as well. Frequently details

26

26 Drips of bronze on the inside surface of a fragment of a statue. 4 in. long.

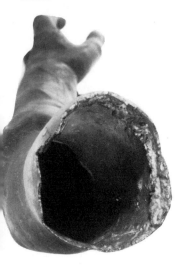

27 An ancient joint showing up as a rough fringe of metal on the inside of an arm from a life size statue.

such as the curls of the hair and the eyebrows were left to be cut out in the cold metal. Casting flaws had to be removed and patched. The commonest type of flaw was the blow hole in the surface of the bronze, due either to an inclusion of some foreign body in the melt, or to trapping of air in the casting, and so leaving a bubble on the surface of the piece. Such flaws, when only on the surface of the metal, were replaced with a patch: the bad part was cut away to a rectangular shape, and the edges were slightly undercut. Then a patch of metal of the same size was inserted and the edges were hammered shut against it. After final polishing such repairs would only be visible to a careful searcher, though few large pieces are without them. When the flaw penetrated the full thickness of the casting, the hole was filled with a cast-on patch as described for joins. Such a flaw occurred on the back of the Nemi priestess where an oval patch of paler patination reveals where a hole was filled by pouring in additional metal. It was common, for the sake of emphasis, for eyes and lips and other details to be set with some contrasting metal, silver or perhaps pure copper which is pink compared to the golden brown of the bronze; these pieces were inserted in the same way as patches and held in place by being hammered into undercuts. The small statue of Nero from Suffolk has silver, copper and niello combined in a tour-de-force of this sort of inlaid decoration.

28

29

20

Col. Plate II

Mass-production

The production of life size bronze statues can hardly be described as mass production, and most will have been in the nature of a 'one-off' job. Yet even

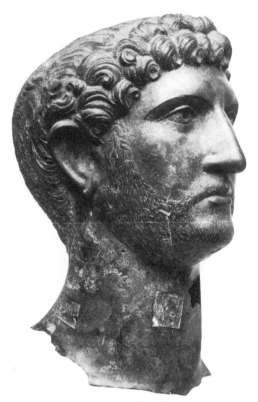

28 (left) Casting faults repaired with patches — now lost — on a head of Hadrian from the Thames.
29 (right) Cast-on oval patches on the back of the Nemi priestess.

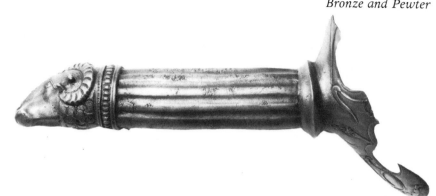

30, 31 Ram-headed pan handle with a cross-section to show how the handle was cast in a two-piece mould, the core being held in place by a bronze pin. Length 6¼ in.

with bronze statuary there must have been cases when several copies of the same figure were required, for example, official bronze portraits of the Emperor and members of the Imperial family, and of various deities. In these cases the model would have remained intact to serve as a source for piece moulds for new castings. This was the beginning of a production line. Even so, and despite the sheer size of the statues and the quantities of metal being used, the bulk of production must have been concentrated in purely utilitarian articles such as bronze vessels and fittings for carts, harness, furniture and so on. These were the basic products of the bronze casting workshops.

Knowing that Roman technology included a knowledge of piece moulding, it makes no sense to suggest that all small bronze castings were made by the direct lost wax process. This method was in no way conducive to mass production, and must have been the exception rather than the rule. The making of a typical cast bronze handle shows how piece moulding was geared to mass production. The handle is one of a sort that must have been being made in thousands. The bronze was cast around a sandy clay core roughly shaped to the tubular profile of the interior of the handle. It looks as though this is the sort of core put into a piece mould in which there was no need of wax. The core was held in place by a single bronze pin running across the mould, and in this case the temperature of the bronze was not sufficient to fuse with the pin, so it is visible, like a rivet, on the outside of the handle. The mould was presumably a two-piece clay mould of a sort which could have been formed from an archetype in the same way as is described for the production of lamp moulds.

There is a remarkable lack of mould debris from bronzecasting workshops, and the few fragments of moulds of this sort which have been found in various parts of the Empire come from the sites of potters' workshops, and were probably being used for making pottery imitations of metal objects rather than the objects themselves.

Casting of vessels

Metal vessels, whether of silver or bronze, could be cast or beaten into shape by raising. The process of raising has been described for silver; it was basically the same for bronze and the description will not be repeated here. Cast vessels were of two sorts: open vessels, including such pieces as flat plates, dishes, and casseroles, and closed vessels, such as jugs and bottles with narrow necks, and lamps.

Fragments of stone moulds for casting open vessels have been found at Lyon

and Vichy in France, and along with the surrounding debris of bronze waste they leave no doubt that these pieces were for casting *bronze* vessels. These moulds work in exactly the same way as those used for casting pewter, and since these survive in far better condition, perhaps because of the lower temperature involved, they will serve as examples. Pewter was always cast, and moulds have been found at several places in Britain. The moulds, both those for bronze and pewter, are all of stone, typically fine-grained limestones and lias. The stones were hollowed out and lathe-turned to the required size and finish, one shaped to match the outside of the vessel, the other shaped to fit the inside. When placed together the gap between them was the space for casting. A pouring hole cut in the lip of the mould allowed for the inflow of molten metal; the escaping air was presumably forced out through the join in the stones. There seems to be no difference between the practice of bronze workers and pewterers in this technique, though the temperatures of operation of the two metals differed widely. Pewterers were operating at about 300°C while bronze workers were operating at 1000–1100°C. No doubt the wastage on the moulds used by bronze workers was greater due to breakage from heat shock. But the moulds themselves would be fairly easy to make and, having precisely turned interiors, they were a most reliable way of getting an accurately shaped vessel.

Once the initial casting had been made it was the normal practice to turn the vessel to its final shape and polish it on a lathe. Roman writers give no hints at all of the sorts of lathes that were in operation, and it is frequently assumed that they had no more than a simple pole lathe which could spin half a dozen times in one direction and then had to be allowed to spin back half a dozen times in the other direction. An examination of lathe-turned work shows conclusively that this was not so and that the Romans had lathes which rotated continuously, and which were capable of fine and skilled work.

Alfred Mutz has made a detailed study of the products of Roman lathes, products which include metal vessels of all sorts, glass and even stone objects, and he has constructed a lathe built of wood, incorporating all the features which can be inferred from the vessels themselves. This lathe requires two operators, one to turn the crank to drive it, and the second to hold the cutting tool and guide the work.

The wheel which is cranked is geared to give up to six or seven revolutions of the lathe spindle for each turn of the crank. The frame of the lathe is built of solid wood which gives it sufficient weight and rigidity to be stable. The face plate of the lathe is adaptable to suit the object being turned. As set up, the face plate is mounted with a plane disk inscribed with concentric circles to act as a guide to centering the object. This face plate is set on to the end of the mandrel, and is gripped by the three projecting spikes provided; for alternative sorts of fixing there are three small sockets, or a central recess. The other side of the object is supported by the spindle, which is adjustable, and which tapers to a point, so that at the point of contact where it presses on the base of the object the area covered is small, and the maximum area of the object is free for turning. A wooden block beside the work acts as a tool rest.

The lathe was used for finishing, or for final cutting to shape and finishing. Vessels had to be mounted up twice, for inside and outside could not be turned

32 (above) The two stones of a mould for casting a pewter bowl, from Leswyn St. Just, Cornwall. Diameter 5 in.

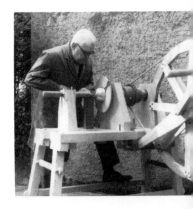

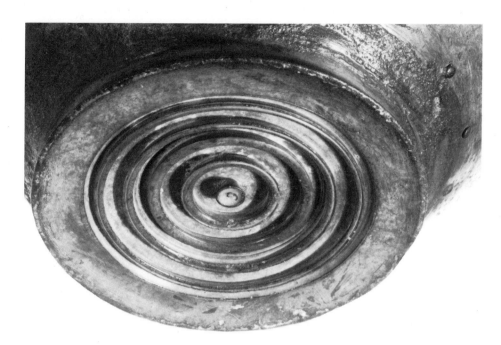

36 Deeply-turned grooves on the base of a bronze saucepan. First/second century AD. Diameter 4¾ in.

36

33, 34 Alfred Mutz's reconstruction lathe set up to turn a saucepan and a small bottle. The three spikes on the faceplate (**35** above) correspond with the marks found on the backs of pewter plates.

at the same time. If the second mounting was not exactly co-axial with the first, the vessel would come out thicker than intended around one side, and thinner around the other; this sort of error was quite common. In some cases where there were overhanging rims and mouldings, a great deal of metal had to be turned off on the lathe. A feature of many cast bronze casseroles is the very deep and apparently decorative cutting into the thick base of the pan. It shows the degree to which the craftsmen were to give themselves additional work to produce vessels of high quality.

Examples of extensive lathe work of this sort, involving decorative cutting and the removal of large quantities of metal are typical of the early years of the Empire up to the middle or end of the second century; in the third and fourth centuries the vessels were made in exactly the same way, but the shapes were designed to be more economical of labour, and the amount of cutting on the lathe is reduced to a minimum. One feature of this economy was that large plates were not turned round on the lathe to have both sides fully polished; most of the back could be reached at the same time as the front, but the area covered by the face plate of the lathe remained unpolished. The backs of some of the large silver plates from the Kaiseraugst treasure have unpolished areas in the centre of the back. The same unpolished areas are visible on many of the large pewter plates found in Britain. In addition, because pewter is so soft and easily scratched, there are often traces of the marks used to set the piece up on the lathe and the scars where it was attached.

For example, the back of a pewter plate from a hoard at Appleford, Berkshire, shows a number of compass drawn arcs and circles as well as patches where holes have been filled. These marks are so regular a feature of the backs of plates that they cannot be described as decoration as has often been done in the past. The explanation is as follows: having made a casting which left only the slightly raised footstand on the base, the craftsman had to find the centre of the plate

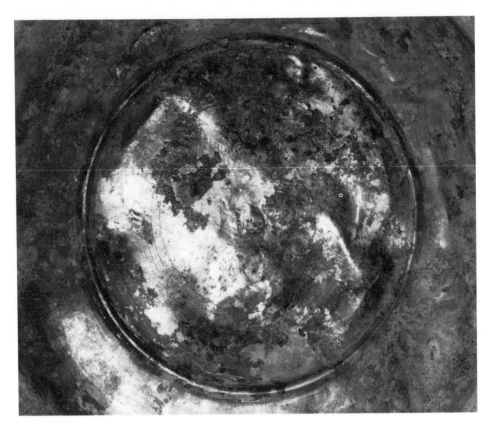

37 Compass drawn arcs and circles on the back of a pewter plate from the fourth-century Appleford hoard.

so that he could set it up on the lathe. This was done with compasses: with one arm centred on the footstand, the other struck an arc roughly across the centre of the plate. This was done four times, as it were from the four cardinal points of the compass; and four intersecting arcs resulted. If the arcs were exactly equal to the radius of the footstand, they would all intersect at one point in the centre of the plate; if too large or too small they would intersect to leave a square surrounding the centre of the plate, and from this it was possible to estimate the centre point accurately. Exactly the same method is used by silversmiths today.

Following this the compasses were used to inscribe a series of circles centred on the centre of the plate and approximately equal in size to the face plate of the lathe. These circles aid the positioning of the plate in the centre of the lathe, and correspond to the circles on the face plate of Alfred Mutz's lathe. Pewter is soft and can be gripped directly by the three projecting spikes, so an additional mounting disk was not necessary. The plate was set up on the lathe and polished all over the front and over as much of the back as could be reached. A small area, usually about a quarter of an inch in diameter in the centre of the plate was left unpolished. This was the point where the spindle was attached. After removal from the lathe, the centre of the plate as marked by the spindle, and the three spike holes on the back were filled up with plugs of pewter.

These marks on the backs of the pewter plates were not known to Alfred Mutz when he designed his reconstruction lathe, yet the two correspond so completely —even to the number of gripping spikes—that there can be no doubt of the correctness of the reconstruction.

Cast vessels with cores

There is a further class of cast vessels that cannot have been made in two-piece moulds in the way that open bowls and plates were. Jugs, bottles and lamps were all being mass produced and it seems likely that their outside surfaces were being formed by permanent two-piece moulds of stone or clay while the inside was being shaped by a core which was suspended inside. A sectional drawing of a small vessel shows the way this could be done. After the metal had been cast and had cooled the core would have to be broken up and raked out; then as usual the outside of the vessel would be finished on the lathe.

Some small bottles and jugs made in this way had narrow necks which were too small to allow the core to be extracted. In these cases the vessel was made without a base; after casting the core was extracted through the bottom and a separate base was soldered into place before the vessel was finished on the wheel. Bronze lamps were cast in one piece, and the core was raked out through the oil and wick holes. A part of the outside surface, the base and mouth and frequently a part of the inside as well, were turned on the lathe but the remainder had to be finished by hand.

Raised vessels and composite vessels

Many types of bronze vessels were raised from sheet metal in the way described for silver. The difference between raised and cast vessels is not always obvious at first sight; normally raised vessels are thinner and lighter in proportion to their size than cast vessels, and if the inside is visible it will have the tell-tale traces of hammer blows rather than the rough cast surface.

There are many sorts of composite vessels made of two or more pieces which have been raised or cast separately, or even of two pieces one of which has been cast and one raised. Jugs with a sharply angled carination in the body would have been difficult to make in one piece; body and neck were raised separately and jointed together either with solder, or mechanically by overlapping one edge into a groove in the other. Other varieties of jug, raised from sheet metal, were soldered on to a solid cast base which could be elaborately turned.

Joints such as these between various parts of the body of a vessel were made with hard solders in the same way as described for silver though, of course, a bronze alloy was used. The jointing of handles to the body of the vessel was normally done with a soft tin/lead solder with a melting point very much less than either of the pieces being joined. There was thus no danger of damaging the vessel which by this stage had already been polished on the lathe and was to all intents and purposes finished. Bronze could be embossed in the same way as silver but it was not a very functional sort of decoration and few bronze objects were decorated in this way; military parade helmets are the outstanding examples.

An alternative variety of repoussé was much used in making decorative bronze sheet such as was used to cover belts, wooden boxes and the scabbards of swords. A spectacular example of this is the 'Tiberius' sword scabbard from Mainz. Pieces like this were not individual works of art; they were standard items of military equipment and were no doubt made in their tens if not in their hundreds. The repoussé decoration was created by hammering the sheet metal into a die in which the decorative scene had been cut in reverse. A die of this

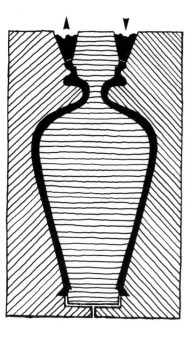

38 Casting a narrow-necked vessel in a two-piece mould. The core, suspended inside, was broken up and removed through the base which was added afterwards.

39 The join between neck and body clearly visible on a jug from Lesmahagow, Lanarkshire. Height 10½ in.

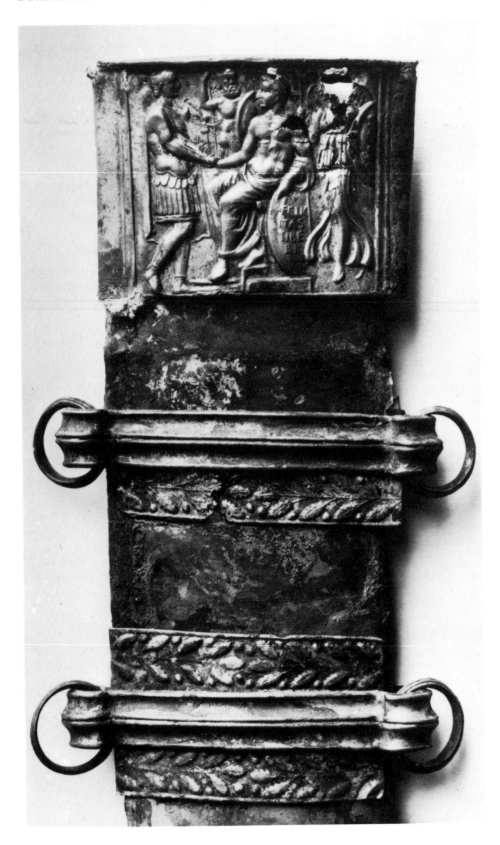

40 A sword scabbard from Mainz decorated with an embossed plaque and strips made by hammering sheet metal into a die.

type was found at Wroxeter; it is of iron and has a strip of pattern cut into each side. The pattern is based on local Celtic patterns being copied in Britain in the second half of the first century AD. A similar use of dies for making gold strip is described in the chapter on jewellery.

Tinning

Brooches and military bronzes of all sorts were very often tinned; but perhaps more important was the tinning of the insides of bronze vessels used for cooking. Pliny recommends it: 'the tinning of bronze vessels prevents the formation of destructive verdigris and gives the contents a very much pleasanter taste'. The process was simply that of flushing the cleaned bronze surface with molten tin. The melting point of tin is so much lower than that of bronze that there was no risk of damage to the finished bronze vessel.

The composition of bronze alloys

The most intriguing part of the elder Pliny's chapter on bronze is the section where he gives a series of recipes for alloys for making different sorts of objects. Unfortunately the recipes are not totally clear; the difficulty we have in understanding them comes from Pliny's terminology which perhaps in turn illustrates some of the difficulties that the Roman craftsmen themselves had in describing metals and alloys. The recipes can be stated briefly:

The best bronze for making vessels is Campanian,

At Capua the recipe is .100 lb. copper
 10 lb. Spanish silver lead

At other workshops .100 lb. copper
 8 lb. Spanish silver lead

Bronze for making statues and for tablets 75 lb. copper
 25 lb. scrap bronze
 $12\frac{1}{2}$ lb. Spanish silver lead

Bronze for casting .100 lb. copper
 10 lb. lead
 5 lb. Spanish silver lead

Bronze for making large jars100 lb. copper
 3–4 lb. Spanish silver lead

These recipes are bedevilled by the uncertainty as to what Pliny means by Spanish silver lead, *plumbum argentarum Hispaniensis*. Elsewhere he speaks of it as being a mixture of equal proportions of tin and lead, i.e. a sort of pewter; but he then goes on to talk of imitations of Spanish silver lead which have different proportions. Various attempts have been made to interpret the recipes making various assumptions, for example by accepting that it is an equal-parts alloy of lead and tin, or that Pliny really meant just tin. Unfortunately, none of these explanations is really satisfactory. There is no evidence from archaeology to suggest that the Romans prepared any such ready-made alloy. Rather, the evidence points the other way. The ingots of copper, lead and tin, which have

41 An iron die used for embossing bronze sheet, from Wroxeter. First century AD. Length 11 in.

been found from time to time, and in all in some quantity, are normally of very pure metal, and this seems to have been the way in which the metal was transported about. Also, it seems unlikely that, once a lead/tin alloy had been prepared, Roman craftsmen would have had the technical ability to separate the two metals, or even to tell what the proportions were, save perhaps in the very broadest terms. If *plumbum argentarum* was really an alloy as Pliny says, it seems unlikely that it would have been made up in a fixed proportion between lead and tin; it is more likely to have been some unspecified alloy of the two, and perhaps a term that was used only in the bronze workshops from which he got his information.

Despite this serious query, the way in which the recipes are laid out with their specific proportions for specific tasks shows that the Roman craftsmen knew what their materials were capable of; it was never a question of just making use of any bronze that happened to be available. In fact scrap metal was a quite clearly recognized item to be dealt with as is indicated by its inclusion in the recipe for bronze for statues and tablets; this sounds like a category which might have been labelled 'general bronze castings' and in which scrap could safely be incorporated. Obviously there was no certainty about the composition of much of the scrap and something between a quarter and a fifth was the rate at which it could safely be included without spoiling the melt.

These recipes should be compared with the results of recent analyses of Roman bronzes. The best series of analyses is that of all the bronze vessels found at Nijmegen in Holland. I have made a selection from these results to show the contents of the alloys used for making thin bronze vessels such as were raised from a sheet of metal, and also for small cast bronze fittings such as handles and escutcheon plates. It is not possible to include all the figures from Nijmegen, for it is not always clear from the published descriptions whether the vessels were cast or raised.

The graphs show two points very clearly. Lead was excluded from the alloys to be used for raised vessels, but was included in castings in varying qualities up to about 30 per cent; and the brittleness of the alloy with more than 14 per cent of tin made this figure the maximum to be included in a workable metal. Both these points are fully in agreement with the known mechanical properties of bronze and bronze alloys.

A third graph, of analyses of Roman statuary bronzes from Lyon and elsewhere, is very similar to the one for small cast fittings from Nijmegen. Obviously there was no difference between the alloys used for small and large pieces. A rather more subtle difference may be noticed between the tin contents of the two graphs of cast metal and that of beaten metal. The castings have a uniformly high tin content, averaging out at about 8 per cent; the tin contents of the beaten metal are rather more evenly spread between 2 or 3 and 13 per cent. Hardness was not always a requirement for beaten vessels, and it is clear that many were made with an alloy that had the ductility and malleability of almost pure copper.

Pliny was not a craftsman; it is unlikely that he fully understood what he was trying to describe, and it is not surprising that his account is confusing. But these analyses show that the Roman bronzeworker knew exactly what the properties of his material were, and how he could exploit them to the utmost.

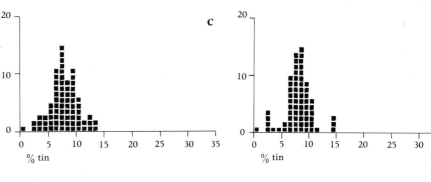

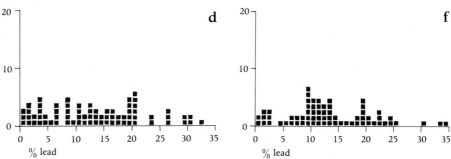

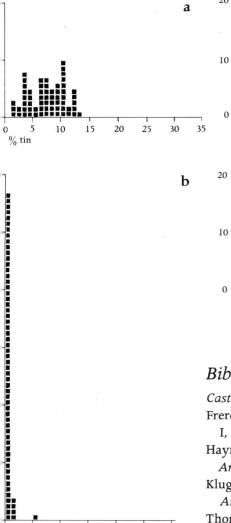

42 The relative proportions of tin and lead in thin walled, i.e. 'raised', bronze vessels from Nijmegen (**a** and **b**), small cast bronze fittings from Nijmegen (**c** and **d**), and Roman bronze statues from Nijmegen, Lyon and elsewhere (**e** and **f**).

Bibliography

Casting

Frere, S. S., 'A mould for a bronze statuette from Gestingthorpe', in *Britannia*, I, 1970

Haynes, D. E. L., 'The Bronze Priestess from Nemi', in *Mitteilungen des Deutschen Archäologischen Instituts, Römische Abteilung*, 67, 1960

Kluge, K., *Die Antiken Erzgestaltung und ihre Technischen Grundlagen (Die Antiken Grossbronzen, I)*, Berlin, 1927

Thompson, H. A., and Wycherley, R. E., *The Agora of Athens (The Athenian Agora, XIV)*, Princeton, 1972

Fusion welding

Lechtman, H., and Steinberg, A., 'Bronze Joining', in S. Doeringer (ed.), *Art and Technology*, Cambridge, Mass., 1970

Lathes

Mutz, A., *Die Kunst des Metalldrehens bei den Römern*, Basle, 1972

Analyses

den Boesterd, M. H. P., and Hoekstra, E., 'Spectrochemical Analyses of Roman Bronze Vessels', in *Oudheidkundige Mededelingen*, 46, 1965

Caley, E. R., 'Chemical Composition of Greek and Roman Statuary Bronzes', in S. Doeringer (ed.), *Art and Technology*, Cambridge, Mass., 1970

Picon, M. et al., 'Recherches techniques sur des bronzes de Gaule romaine', *Gallia*, 24, 1966

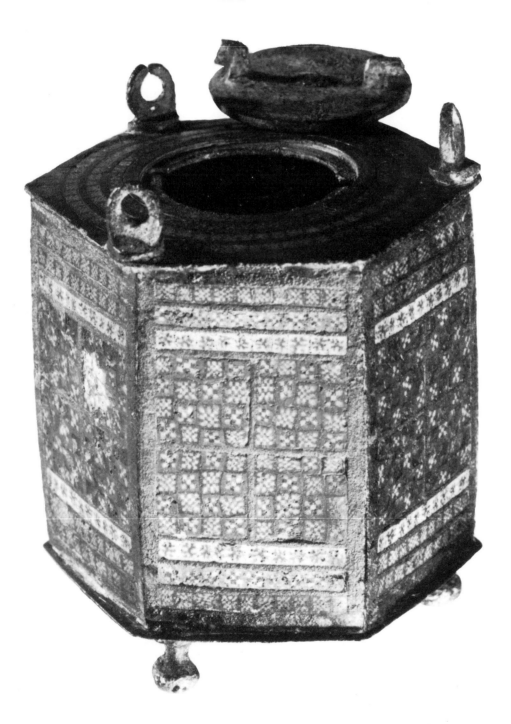

43 Hexagonal bronze box decorated with panels of millefiori enamel, from Cologne. About twice actual size.

Sarnia A. Butcher

3 Enamelling

Enamel was used in Roman times to produce brightly coloured decoration on small bronze objects. Its somewhat gaudy effect appealed to barbarian taste, and it was amongst the tribes on the edge of the Roman world that it seems to have been developed and amongst their conquered descendants that it was most popular. There is only one reference to the process in the literature of the period and that is not a technical description; nor has a contemporary workshop been found. It is therefore mainly from the surviving objects that deductions about the craft must be made.

The predecessor of Roman enamelling is seen in Celtic contexts. In the period beginning *c*. 400 BC inlays of glassy material were used, apparently at first as a substitute for coral, in decorative studs on the terminals of torques, on shield bosses and on other display pieces. At first red was the only colour used but by the first century AD blue and yellow appear with red on such British pieces as the Santon Downham, Westhall and Polden harness ornaments.

In the last quarter of the first century AD enamelled brooches were being made in abundance. There are some Celtic motifs amongst the British examples, but on the whole they are Roman-provincial in style and mark the beginning of the main period of enamel production in the western Roman Empire. This reached its height in the second century and continued into the third. During these years large numbers of enamelled trinkets, brooches, rings, studs etc., were produced in Britain and Gaul and were carried to Pannonia, Sarmatia and even to Dura-Europos in Syria, and northwards across the frontier into Free Germany.

Enamel has been defined by both Herbert Maryon and Henry Hodges as a vitreous substance fused to a metallic base. Although very little technical investigation has been done a few individual pieces have been studied and it seems clear that the method used in the Roman period was basically the same as that employed by studio enamellers of today. The craftsman obtains his material in the form of a slab which has been made by melting together a soft glass (a compound of flint or sand, red lead and soda or potash) with metallic oxides for colouring and opacity. Pieces of this are ground to a powder, the 'frit', mixed

44 Millefiori enamel on a brooch and a stud from Nornour, Isles of Scilly. Actual size.

with water, and applied to the metal to be decorated. The whole object is then heated to the point at which the frit melts. The surface of the metal should also melt slightly to allow complete fusion, but this does not always seem to have been achieved with early enamels. The metal used was almost always bronze; a very few enamelled iron objects have been found but silver does not seem to have been decorated in this way.

The method known as *champlevé* was usually employed; in this the enamel is placed in cells which are cut or cast in the metal. The limitations of the method have an effect on the designs produced; each colour is usually placed in a separate cell so that the raised metal between them forms the pattern. On some objects several colours are laid together without metal divisions. Presumably this would require accurate control of temperature so that those first applied were not discoloured by subsequent firings. The enamel begins to harden as soon as it leaves the furnace and the only way of modifying the result is by re-heating, applying more frit and polishing with an abrasive when cold.

Few analyses of Roman enamels have been published, and it seems that they may be difficult to obtain. During a recent examination of some pieces in the British Museum it was discovered that most of the enamels were severely weathered and heavily contaminated with bronze corrosion products and elements derived from the soil, to such an extent that the original composition of the enamels could not be determined.

More information is available about the Iron Age material from the nineteenth century excavations at Bibracte and recent work carried out by M. J. Hughes at the British Museum laboratory. The analysis of more than thirty specimens of 'opaque red glass' has shown that they have a remarkably consistent content of cuprous oxide and lead oxide (an average of 7 per cent and 25 per cent respectively). Hughes gives technical reasons for suggesting that this material could not have been used in the form of powdered frit, but was applied to the metal as small pieces of glass only slightly softened by heating, and visual examination of many Iron Age pieces leads to the same conclusion. However,

Col. Plate III below

the use of melted enamel seems to have been known in the Iron Age, for the type of enamelling practised at Bibracte requires it; and it was certainly being used for the red enamels of the Roman period, for they can be seen to have a much smoother surface than those of the Iron Age, and to fill every crevice of their recesses in a way which could not have been possible if lumps of glass had been used.

A development of the use of 'solid' glass can be seen in the *millefiori* and glass paste inlays of the Roman period. From the appearance of some specimens it seems that these were fired directly to the metal in the presence of heat; in other cases they were inserted into a bed of enamel which, having a lower melting point, acted as a sort of glue. The latter method has been detected in some Celtic pieces and is described in detail by E. M. Jope in his study of the Carlungie brooch, an object dating from the second or early third century AD.

The millefiori technique originated in Egypt where it was used for making decorative plaques for inlay, and subsequently for mould pressed glass bowls. It involves the arrangement of coloured glass rods into a pattern so that they can be fused together to make a composite rod. Transverse slices cut from the composite rod each reproduce the original pattern. The very small pieces required by enamelworkers were produced by heating the patterned rod, and drawing it out until the diameter was reduced to the required size. The type of

44 left

Col. Plate III below
44 right

pattern produced can be illustrated by the Nornour brooch on which the individual plaques are set directly into a ring recessed in the surface of the brooch. Here the tiny florets from which the process takes its name alternate with chequers of blue and white rods encased in red. A stud found at the same site has an outer band of two rows of pale blue and white chequers surrounding a ring of florets on white alternating with plain red. The description of the process can be supported by the finding of the actual rods, and by the evidence of modern glass-makers who use it in the manufacture, for instance, of paper weights containing clusters of small flowers. All the known examples of rods are from Early Christian sites but there can be little doubt that enamellers of the Roman period used very similar pieces.

Simpler glass inlays were very commonly used: spots of contrasting colour are found embedded in a field of plain enamel. On several of the Nornour brooches rounded hollows can be seen where such spots have fallen out, proving that the main enamel field was continuous, and the spots inserted. On the brooch

45

illustrated the spots are bi-coloured: red is cased in white, and they are set in a dark blue field.

45 Enamelled plate brooches from Nornour, Isles of Scilly. Actual size.

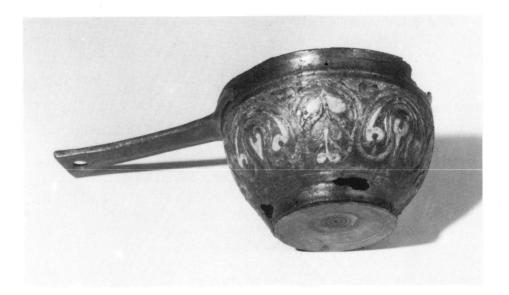

46 Enamelled bronze skillet from Brougham. Diameter 3½ in. 47 (below) Enamelled brooches from Nornour. Actual size.

46

48

Two other Nornour brooches seem to contain random scraps of coloured glass, used to give an effect of rich colouring. In the upper part of the disk of the lower brooch in fig. 47 the group of red and white stripes suggests a partly-melted fragment of millefiori.

Ancient enamel is confined to small objects, no doubt because of the difficulty of firing large pieces. To obtain the necessary control of temperature either a very small furnace or a small muffle within a larger hearth would be employed. Where enamel decoration appears on something large, like a scabbard or shield, it is on separate studs or other applied plates. The largest objects on which enamel was applied directly were bronze bowls, and even they are small, usually about 3½ inches in diameter. Nevertheless they offer scope for far more elaborate patterns than are possible on the small surfaces of the brooches. A number of these bowls, some with enamelled handles, have been found in Britain and elsewhere in Europe; they seem to be products of three or four separate workshops.

One group of vessels is probably British: red and blue are the commonest colours, often with a turquoise-green as well, as on a bowl from Brougham. These are also the colours seen most often on a distinctively British group of brooches, known as the head-stud type, and the dragonesque and umbo-shaped disk brooches. Such dating evidence as there is suggests that all these objects were being made in the late first and early second centuries AD. Another group of bowls, whose distribution is mainly continental is associated with somewhat later finds (*c.* AD 200) and employs a wider range of colours, including orange, dark and light blue, and yellowish green. In both these groups the patterns are formed by the metal outlining the cells, and each cell contains enamel of only one colour. Often the edges of the enamelled area are toothed to give better adhesion between enamel and bronze as can be seen in the handle from Kirkby Lathorpe. This piece also shows the use of a bedding matrix of some sort. The areas which appear white were originally covered with blue, but most of this has now fallen out.

A third group of vessels includes elegantly shaped vases and candle sticks made up of separate pieces of metal soldered together. None of the finds is well documented, but one from Angoulême was associated with coins of the late third century. Finally, there is a group of vessels made up of flat panels covered with millefiori enamel, and soldered together to make square or polygonal vases. The small hexagonal box from Cologne is a typical example of this work. Finds of both these last two groups are extremely rare and none is certainly known from Britain.

These elaborate vessels represent the height of the Roman enameller's achievement. The everyday products, made in great quantity, were small bronze objects, brooches, studs and the like. The typical bow brooch—like a safety pin—has one side buried in the cloth, the other exposed, and it was the exposed surface which was elaborated and decorated in various ways. The

43

48 Enamelled skillet handle from Kirkby Lathorpe. Actual size.

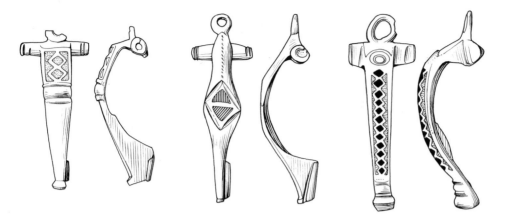

49 Enamelled bow brooches from Nornour, Isles of Scilly. Actual size.

examples of bow brooches from Nornour show how small cells were filled with enamel. In the centre brooch there are only two triangles of enamel, giving a spot of colour to the middle of the brooch; the brooches on either side show the common pattern of alternate lozenge-shaped and triangular cells with contrasting colours.

A typical plate brooch is more like decorative brooches worn today, the exposed surface is a broad flat area, often a disk. Here the shapes naturally dictate the patterns—wheel shapes and concentric circles. Concentric bands of contrasting colours are common, as are inlaid spots like eyes in a field of plain colour. The effect is decorative, and the objects were probably worn as much for ornament as for fastening clothes.

50, Col. Plate III below

45

The number and variety of objects which have been mentioned show that enamelling must have been practised on quite a large scale in the Roman period. It is sometimes thought that this large production was centred in the Rhineland, where other decorative crafts, in pottery, glass, jet and metal working are known to have flourished. But it becomes clear from the distribution of the different type of objects that many workshops were in operation. For example there are several classes of enamelled objects found almost exclusively in Britain, the dragonesque, trumpet and head-stud brooches, and the bowls of Braughing style. Even within Britain itself some of these objects display regional distributions and there are likely to have been several workshops. Apart from the skilled craftsmen who must have produced the vessels and elaborate brooches, it seems likely that many bronzeworkers could also have turned their hands to simple enamelling; some of the commoner forms of brooch bear the odd spot or square of enamel whilst others have the same pattern without enamel.

50 Enamelled plate brooches from Kidlington and Woodeaton, Oxfordshire. Actual size.

With a small scale of production, an enameller's workshop cannot have been of a very sophisticated kind and was probably operated by a small group of people, perhaps a family unit. The main items of equipment would be a charcoal hearth, bellows, tongs, crucibles, material for moulding and bronze scrap as 'raw material'. Decoration would be cut either on a die or on the casting, and for this various engraving tools would be needed. The same tools would serve to cut cells to receive enamel and little else would be needed for enamelling on a small scale. At present it is not certain in what form the craftsman obtained or used his raw material. It is possible that scrap glass could provide the basis,

already coloured and perhaps only needing the addition of an opacifying agent. On the other hand it may be that lumps of the material were traded by the specialist workshops to the more general metal worker: pieces of unused enamel have been found on early Christian sites, and a trade in lumps of coloured glass has been suggested for the Iron Age.

The equipment needed has been suggested partly by analogy with the modern craftsman's methods and partly from what little is known of ancient workshops and scattered finds. Although no enameller's shop has been found within the boundaries of the Roman Empire two are known which lie close to it geographically and historically.

One of these was at Mont Beuvray, the hilltop capital of the Gaulish tribe of the Aedui, near Autun in central France. It was excavated at the end of the nineteenth century. Here in what seems to have been an industrial quarter the sheds of metal workers were found, with many traces of enamelling scattered amongst the slag and debris of bronze and iron working. The coins indicate that this activity could be dated to the mid-first century BC, about the time of Caesar's conquest. The technique of enamelling was different from that described; the heads of decorative studs and bosses were grooved and then covered in a shell of red enamel. Scraps of the material were found together with partly made and discarded objects. Because other processes were going on in the same workshops it is impossible to be certain whether any of the equipment found was exclusively used for enamelling. Circular hearths, 25 inches to 40 inches in diameter, were set into the ground and lined with clay. One contained the debris of a clay dome; another, set into an earthen bench, had broken clay *tuyeres* (bellows nozzles) an iron poker and residues of iron, bronze, lead and coloured glass, as well as scraps of enamel and enamelled bronze nails. The surrounding ground surface was covered with scraps of red enamel, filings, broken shells which had failed to adhere to the studs and small cubes of raw material.

Experiments were made with some of this raw material. It was ground to a powder, moistened and added to a 'Gaulish bronze', which was put in a muffle oven. After a few minutes the bronze was found to be covered with transparent green glaze—the result of an oxidizing atmosphere. Red enamel similar to the original objects could only be produced in a reducing atmosphere, obtained by closing the air intake and throwing wood on to the charcoal. The object came out with surplus vitreous material which was removed by polishing with hollowed sandstones found in the workshop.

The other workshop was found at Garranes, Co. Cork, in Ireland and dates from the early Christian period (*c.* fifth to sixth centuries AD). The site is an earthen ring fort, and was excavated about thirty years ago. Here in a thick black deposit in the shelter of the ramparts were found many traces of metal working and enamelling. There were numerous fragments of crucibles, and moulds made of stone and clay, part of a *tuyere*, scraps of bronze, iron tongs, shears and engraving tools and material that was interpreted as enamel waste: 'certain fragments of glass . . . all without shape and such as might have broken off larger pieces, or, having been molten, cooled in a formless shape.' Some were green, others red, and yellow. Two red fragments were fused to the clay of a crucible. The most interesting find was that of pieces of rods for making

millefiori or mosaic patterns. One showed a six-pointed star, nearly $\frac{1}{4}$ inch across; others had a chequer within a cross cased in red, and four-pointed stars in each arm of a cross surrounding a group of four stars. The excavator thought it possible that they had been made on the site rather than imported since single colour rods were also found, interpreted as a stage in the manufacture of the composite patterns. Millefiori rods have since been found at other early Christian sites, Lagore, Dinas Powys and Monkwearmouth.

Some of the crucibles at Garranes are of stone, and it was suggested that these were heated by a blow-pipe since they are too thick for heat to have penetrated the sides. Although a few postholes and an arc of stones were found associated with the black deposit no buildings could be identified and it is thought that there may have been nothing more than light shelters in the lee of the rampart, and that in times of peace the ring-work was occupied only by craftsmen.

There are no comparable finds from the first to third centuries AD, the height of the Roman enamelling period. At one time it was thought that the industrial complex attached to the large villa at Anthée in Belgium included an enameller's workshop which was the source of the many enamelled brooches found in the cemeteries in the neighbourhood of Namur; but a recent study by Paule Spitaels has refuted this claim. At Nornour in the Isles of Scilly about 300 bronze brooches have been found and a large proportion of them were enamelled. The homogeneity of style shown by many of the objects and some features of the site have prompted the suggestion that there was a workshop here. At present this must remain no more than a possibility for further excavation has failed to find the expected scraps or debris of metal or enamel, tools, pieces of crucible or mould, or any partly finished objects. It is however difficult to account for the presence of groups of similar objects except by supposing that they were manufactured somewhere close at hand.

It is too far-fetched to identify Nornour with the site given in the only classical reference to what seems to be enamelling. Philostratus, writing in the early third century describes, in *Imagines* I 28, a picture showing a hunting party whose horses had 'silver bridles and many-coloured and golden disks. These colours the barbarians who live by the Ocean cast of glowing ore. The colours run and become as hard as stone and preserve what is painted with them.' The craftsmen of Gaul or mainland Britain would appear to a Mediterranean intellectual as barbarians and their province be thought of as bordering the ocean. It is also far more likely that Philostratus had come across enamellers in Gaul or Britain than in the remote south-western archipelago.

The technology of enamelling elsewhere within the Roman Empire seems unlikely to differ greatly from the examples which have been described and it is therefore to be expected that when workshops are eventually found they will be relatively simple, and will demonstrate that this, like some other crafts of the time, depended not on elaborate equipment but on the skill of individual craftsmen.

51 Enlarged cross-sections of fragments of millefiori from Garranes, Co. Cork, Ireland, and a bronze tube in which one of the fragments was held.

Bibliography

Bulliot, J. G., *Fouilles de Mont Beuvray 1867–1895*, II, Autun, 1899

Butcher, S. A., 'Enamelling in Roman Britain', in *Studies presented to A. J. Taylor*, London, 1974

Dudley, D., and Hull, M. R., 'Excavations at Nornour in the Isles of Scilly', in *Archaeological Journal*, 124, 1968

Exner, K., 'Die provinzialrömischen Emailfibeln der Rheinlande', in *29 Bericht der Römisch-Germanischen Kommission*, 1939

Forsyth, W. H., 'Provincial Roman Enamels recently acquired by the Metropolitan Museum', in *Art Bulletin*, 32, 1950

Henry, F., 'Emailleurs d'Occident', in *Préhistoire*, 2, 1933

Hodges, H., *Artifacts*, London, 1964

Hughes, M. J., 'A technical study of opaque red glass', in *Proceedings of the Prehistoric Society*, 38, 1972

Jope, E. M., 'The Carlungie Brooch', in F. W. Wainwright, *Antiquaries Journal*, 33, 1953

Maryon, H., *Metal-work and Enamelling*, London, 1954

Newton, R. G., 'Coloured Glass as an Item of Trade: a preliminary examination', in *Archaeometry*, 13, 1971

O'Riordain, S. P., 'The excavation . . . at Garranes', in *Proceedings of the Royal Irish Academy*, 47, 1942

Painter, K. S., and Sax, M., 'The British Museum Collection of Roman head-stud brooches', in *British Museum Quarterly*, 34, 1970

Sellye, I. G., *Les Bronzes Emaillés de la Pannonie Romaine*, 1939

Spitaels, P., 'La villa gallo-romaine d'Anthée: centre d'émaillerie légendaire', in *Helinium*, 10, 1970

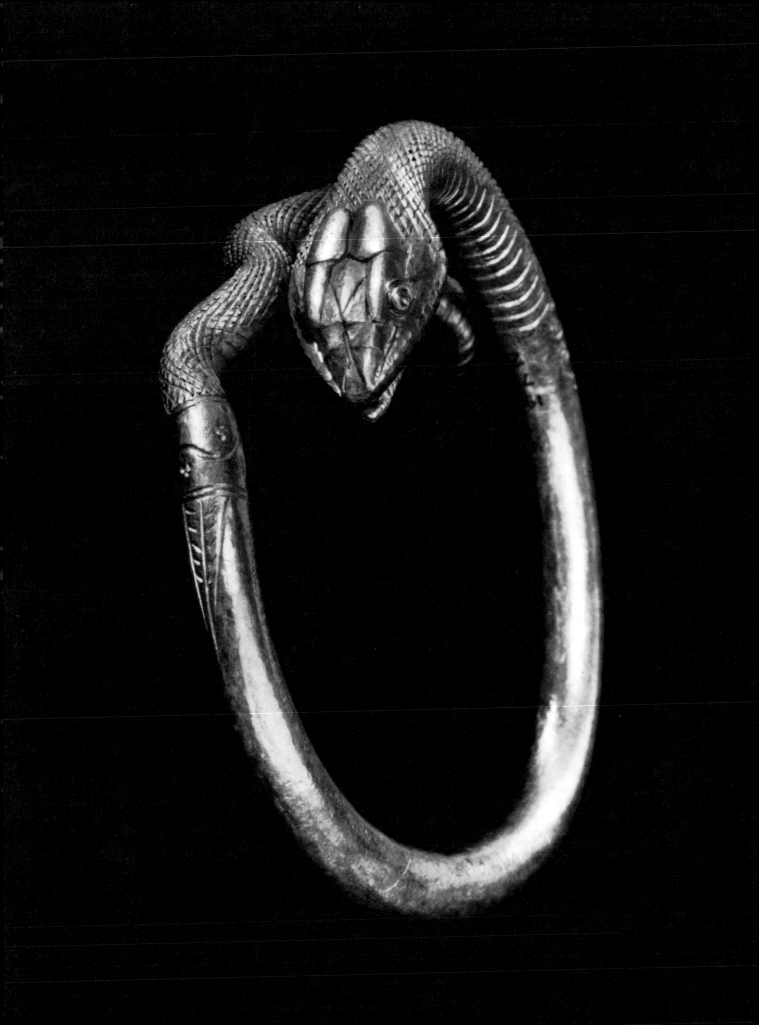

Reynold Higgins

4 Jewellery

The Roman goldsmith was heir to a rich tradition rooted in Greece and the Middle East. Formally and technically he carried on where the Hellenistic craftsmen left off, but in some three centuries he had utterly transformed this ancient and generally ultra-conservative craft; so much so that late-Roman jewellery has less in common with Hellenistic than with the Byzantine style which was to follow and to predominate throughout the Middle Ages.

On the other hand, inventive as he was, the Roman goldsmith failed to uphold the high technical standards inherited from his Greek forebears. Roman jewellery, in comparison with Greek, is often coarse in execution and meretricious in style. The old processes were still employed, but in a simplified and labour-saving form.

What exactly, in detail, were these processes? The evidence takes several forms: written sources, which are however seldom comprehensible; representations in sculptures and paintings of goldsmiths at work; surviving tools; similar evidence from related civilizations, such as the Minoan, Mycenaean and Greek; and comparative technology. This last source has proved by far the most productive, especially of recent years with the experiments carried out by Mrs Patricia Davidson.

The chief centres of production under the Roman Empire were Alexandria, Antioch, and above all Rome, where we have evidence for the existence of goldsmiths' guilds.

The workshop

The Roman goldsmith received his raw material in the form of bars (or ingots) of gold originating in all probability in the Balkans, Gaul, Spain or Britain. It was much purer, and consequently much softer than the gold used today. Apart from small quantities of a few base metals, the only impurity present in ancient gold jewellery is silver, which seldom amounts to less than 5 per cent, and can amount to 50 per cent of the whole. As these are the proportions found in gold as it occurs in nature (natural gold is never without silver), it would appear that in Roman times jewellery was often made of unrefined gold. Where there is more than 20 per cent of silver, the metal is so different in appearance as to deserve a different name; in antiquity it was known as *white gold* or *electrum*.

The goldsmith's workshop, although perfectly adequate for his needs, was

52 Solid cast gold snake bracelet with carved surface decoration. First century AD.

53 Erotes as goldsmiths on a fresco from the House of the Vettii at Pompeii.

poor in equipment when compared with its modern counterpart. The source of heat was an open charcoal fire which could be blown up with a blowpipe or bellows. The work to be heated was placed over this fire in a terracotta crucible or held in tongs.

The principal tools were an anvil; hammers of various kinds; stamps, dies and models; punches; tracers; chisels and engraving tools; moulds; tongs, scales and burnishing-stones; abrasives; crucibles of terracotta, and a bowl of pitch. No files were used, no piercing-saws, no blowlamps, no acid for 'pickling' and no proper draw-plates. The use of lenses is still a disputed question.

Basic processes

The basic elements from which ancient jewellery is composed are sheet-metal, wire and cast metal. Most articles consist of a number of separately made parts soldered together and frequently embellished by secondary decorative processes.

Sheet gold

54 Bronze stamp for making a gold pendant. Third/second centuries BC. Length $1\frac{1}{4}$ in.

Sheet gold is made by hammering an ingot on an anvil. Whenever the work becomes hard and brittle, it is annealed in the same way as silver and bronze. When it reaches a thickness of between 10 and 25 thousandths of an inch (0.2 and 0.5 mm.) the gold is thin enough to be worked easily but stout enough to stand up to reasonable wear and tear. In this state, it is called sheet gold. There are several different ways in which sheet gold was shaped. *Repoussé* and *chasing* techniques are both much used in the decoration of sheet gold. The metal rests on a bed of some yielding material, wood or lead, or, most commonly, a bowl of warm pitch. In general, outlines are done from the front with a tracer, a punch

56 Part of a gold diadem with embossed decoration worked in a die. Romano Egyptian, from Naucratis; first century AD.

shaped like a blunt chisel, and the embossing within the outline from the back with a round-faced punch. Punches and tracers have survived in a goldsmith's hoard of about the second century BC from Galjub in Egypt.

54

Stamping is a variant of repoussé frequently employed in a form of mass-production. Punch-faces are shaped with one entire unit of design in relief and are driven into the back of the sheet. *Striking* is a similar process but the design is cut in intaglio and the punch is in consequence driven in from the front, as in striking a coin. This process was seldom employed as it needed very thick gold. Nor is its use easy to detect since, once the outline is cut away, the result is indistinguishable from cast work.

57

Shapes were sometimes formed over a model of wood or bronze in a third form of mass-production. A number of such models have survived in the Galjub hoard. Working into a die is a further method of mass-production. In making a globular bead, a hemisphere is made by driving a piece of sheet-gold into a hollow die, which is pierced through the centre and soldered to a similar hemisphere, similarly pierced. More elaborate patterns could be made in this way, provided the gold was thin enough to be rubbed into the die. Such a die, for making diadems, was made in the seventh century BC in Corinth and was exported to Corcyra (the modern Corfu), where it was discovered. Similar dies must have been in use amongst Roman craftsmen.

57 Bronze model of a female head from the Galjub hoard.

Wire

Col. Plate IV top left

Wire was normally made by twisting a strip of metal and then rolling it between plates of stone or bronze. An alternative method, related to the medieval *draw-plate*, is believed to have been used occasionally in Hellenistic and Roman times.

55 (left) One face of a four-sided bronze die for embossing gold diadems, and a modern impression **58** (right) from it. Greek, from Corfu; seventh century BC. Actual size.

A roughly-shaped wire is pulled through holes of decreasing thickness in a plate of bronze or stone.

For ornamental work, wire was frequently given a more interesting form by twisting two or more strands together or by spiralling a thin wire to form a thicker one. Beaded wire was always popular. Its method of manufacture has not been definitely established, but it was probably made by soldering the individual elements together. The Roman goldsmith used wire for earrings, occasionally for finger-rings, for filigree (described below), but above all for ornamental chains.

The *simple* chain, made by inserting a section of wire in a previous link, bending it round and soldering the ends together, was not used in Roman jewellery. What was used was the so-called *loop-in-loop*, *square*, or *upset* chain, an elaborate and very decorative form which was known in Crete as early as 2500 BC, and in Western Asia earlier still. It is made from previously prepared links and is found in varying degrees of complexity.

In the simplest form the first link is made oval in shape and bent in half; the next link, of the same shape, is threaded through the looped ends of the first, and bent in half. This process is continued until the chain is complete. Such a chain has a square section. A similar but more compact chain is made by threading each successive link through the ends of the two preceding.

A so-called *cord* is made by cross-linking a double loop-in-loop chain so that instead of two it has four, six, or even eight principal faces. Such cords are often quite erroneously described as being plaited. *Straps*, also frequently miscalled plaits or braids, are made from several lengths of loop-in-loop chain, interlinked side-by-side.

59 Gold earring enlarged to show the method of making the wire. First/second centuries AD.

68, 69

64

60 Inlaid stones on a necklace made of a double loop-in-loop chain. From Rome; first/second centuries AD. 61 (above) Detail of a double loop-in-loop chain.

56

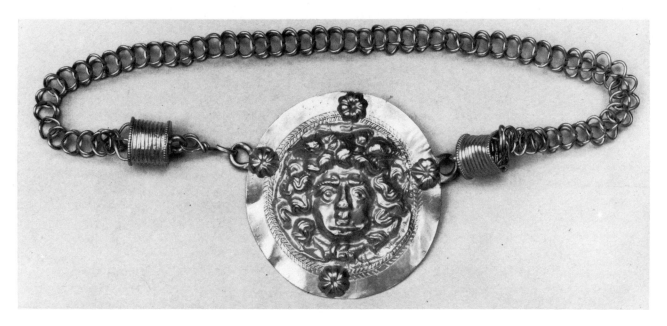

62 (above) Gold necklace with simple loop-in-loop chain. Third century AD. 63 (left) Detail of a simple loop-in-loop chain. 64 (below) Necklace made of a composite gold wire strap. First/second centuries AD.

Casting

From motives of economy, gold jewellery was not regularly cast, for sheet-metal in general gave comparable results using less gold, so the cost was less. There

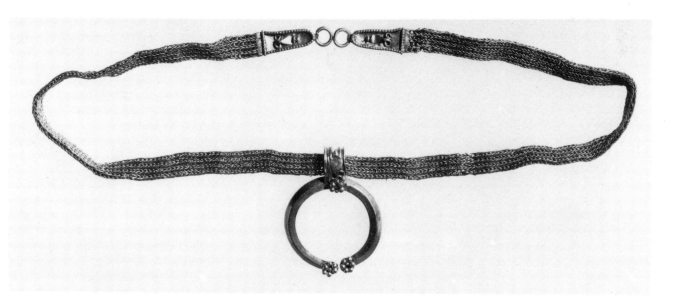

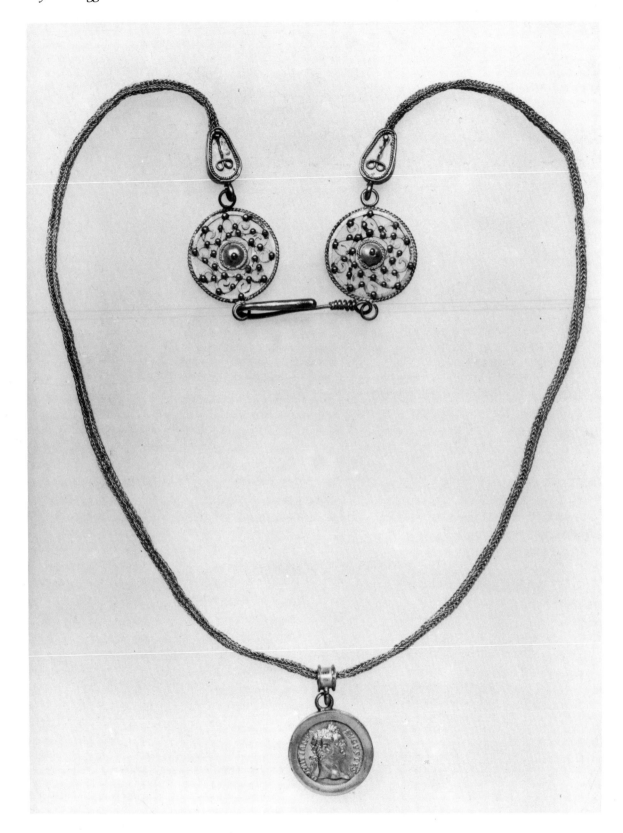

65 (left) Necklace made of a gold wire cord. From Egypt; first/second centuries AD. 66 (above) Cast gold pin. Third century AD. 67 (right) Stone mould, made of chlorite, for casting jewellery. First/second centuries AD.

68, 69 Details of a six-ply cord or rope seen from the side when completed and, below, from the end in process of manufacture.

were, however, exceptions and in Roman jewellery finger-rings, pins and fibulae were sometimes made in this way. A number of Roman moulds of steatite and chlorite appear to have served for casting parts of silver vessels and, less commonly, articles of jewellery. It has often been suggested that they were not used for direct casting but for the making of wax models for lost-wax casting. A suggestion by Henry Hodges that direct casting was more probable led to an examination of a number of such moulds in the British Museum's Research Laboratory. Particles of silver were found adhering to the pour-channel of one example. While not absolutely conclusive, for workshop contamination cannot be ruled out, this evidence strongly suggests that the moulds were used for direct casting. It was, moreover, pointed out that it would be difficult to make the wax flow down the fine pour-channels, and equally difficult to remove a wax cast from such moulds without damage.

Soldering

Usually a piece of jewellery was made up of a number of separate elements soldered together. In Minoan jewellery hard-soldering (or brazing) as practised today was employed, but experiments by Mrs Davidson have shown that by Roman times (and well before) major joins were effected by the same method which had been established in 1933 by H. A. P. Littledale for filigree and granulation: *colloid hard-soldering.*

To do this a copper salt (they probably used verdigris in antiquity) is ground up and mixed with an equal quantity of gum, and the mixture is diluted with water to the consistency of a thin paste. The surfaces to be joined are coated with the paste and brought together so that they adhere to each other. The work is then heated. At 100°C the verdigris changes to copper oxide; at 600° the gum turns to carbon; at 850° the carbon absorbs the oxygen from the copper oxide and goes off as carbon dioxide, leaving a layer of pure copper between the parts to be joined; at 890°C the copper and the gold melt and the join is made.

Although this process had died out in the West by AD 1000, Henry Hodges

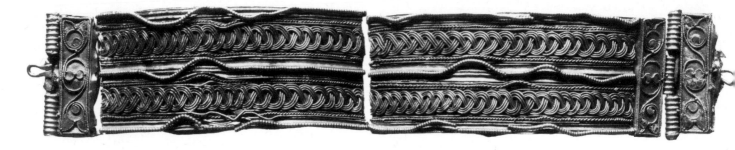

records that it has apparently been practised continuously in the Nilgiri Hills in South India, a fact unknown to Littledale.

Decorative processes

Filigree and granulation. The heyday of granulation had been in the eighth and seventh centuries BC, and of filigree in the fifth and fourth centuries BC. Neither of these processes is common in Roman jewellery, but both were still practised to a limited extent.

The commonest form of filigree, and the only form practised by the Romans, consists of wires soldered in patterns on a background. From the nature of the material the most popular patterns are circles, spirals, and straight lines.

Granulation is a refinement of filigree in which the wires are replaced by minute balls of gold. It is not known for certain how the balls, or grains, of gold were prepared, but the most likely method is as follows: small pieces of gold of roughly the same size are laid separately in a clay crucible on a bed of powdered charcoal, and alternate layers of gold and charcoal are built up until the crucible is full. It is then brought to a bright red heat, which melts the gold into minute balls, separated from each other by the charcoal. When the work has cooled the charcoal is washed away and the gold balls remain. They are graded for size by sifting in meshes of varying gauges and are then ready for use.

Enamel and niello. Although enamel is frequently found in Hellenistic jewellery, it is rare in Roman. Occasionally in the West, where there were strong traditions of enamelling on bronze, small touches of enamel are set in areas bounded by filigree. Niello, too, is occasionally used on gold, and is applied in the same way as on silver plate.

70 Parts of gold bracelets with decoration in filigree and touches of enamel at the ends. From Rhayader; second/third centuries AD.

70

71

71 (left) A pair of gold earrings with granulated decoration. From Samsun, Turkey; third century AD. **72** (right) A gold finger-ring with inset bezel and niello lettering. From Beauvais; second/third centuries AD.

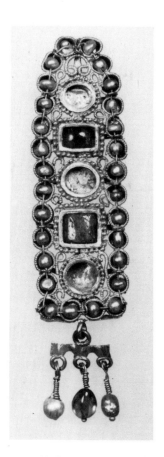

Inlay. Inlaying with coloured stones and glass was the most popular method of decorating jewellery in Roman times. The inlays are cut to shape and cemented in cells formed by strips of metal soldered to the surface. Hellenistic goldsmiths had used fairly hard stones such as the quartzes, and garnets. The Romans in addition used even harder stones, such as sapphires, aquamarines, and emeralds from the newly-discovered mines in Egypt. Even diamonds, though uncut, are occasionally found in finger-rings.

Beads. Sometimes beads were attached by wires to jewellery, especially to earrings and to openwork objects like a hair-ornament from Tunis; and they were strung together to form necklaces. Favourite materials were pearls and emerald crystals, which were used in their natural hexagonal form.

Carving. Massive cast objects, such as the snake-bracelet shown on page 52 were sometimes worked over with a chisel in a technique more familiar to stone-carvers.

Piercing. Towards the end of the Roman period we find sheet gold pierced with a chisel to make lace-like patterns. This technique, known as *opus interrasile*, was particularly popular for necklaces and bracelets.

Finishing

As his work progressed, the Roman goldsmith removed scratches and blemishes with mild abrasives and burnishing-stones. No file-marks have been detected on ancient jewellery and it seems that this somewhat severe instrument was not used.

73 Gold hair ornament inlaid with sapphire, emerald and pearls. From Tunis; third century AD. **74** (right) Fragment of a gold bracelet with openwork, *opus interrasile*, decoration. Fourth century AD.

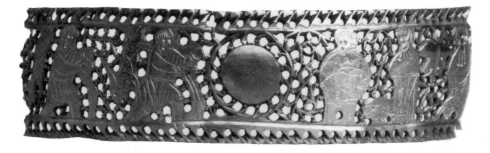

Bibliography

Higgins, R. A., *Greek and Roman Jewellery*, London, 1961
Hoffmann, Herbert, and Davidson, Patricia F., *Greek Gold*, Mainz, 1965
Ippel, A., *Der Bronzefund von Galjub*, Berlin, 1922

75, 76 (top) Silver denarius of Rome, 45 BC. On the obverse, Juno Moneta; the 'pellets' at the extremities of the letters are made by a bow drill. On the reverse, coining implements. 77 (centre) Reverse of a bronze follis of Alexandria (300 AD) showing a standing Genius with many details of the figure inserted by bow drill. 78, 79 (bottom) Billon antoninianus of Rome, 250 AD. On the obverse, Decius; the lettering is scorper cut with prominent serifs. On the reverse, Dacia; the reverse die was considerably more worn than the obverse one.

David Sellwood

5 Minting

The Greeks were chiefly responsible for the very concept of a coin, with its standard shape and design and an accepted trading value, as opposed to relatively formless bullion which had to be weighed out at every transaction. Most of our present minting technology stems ultimately from the same source. Nevertheless, as we shall see, the Romans did initiate several processes characteristic of their respect for efficiency.

Fundamental to any investigation of the moneyers' methods must be an awareness of the contemporary state of metallurgy. Copper and bronze had been worked with increasing sophistication for three millennia before the Republic became prominent, and although the Iron Age was by then well under way, this new metal—especially in the guise of steel—can merely be said to have supplemented, not supplanted, copper and its alloys for everyday purposes. Accordingly, most of the basic techniques to be described were developed in Mesopotamia, refined in Greece and then adapted to mass production in Rome.

The usual method of coining at this time was to lay a blank on a fixed lower die, hold an upper die above it and then impress both designs by hitting the upper die with a hammer. We shall deal first with the preparation of the flans or blanks, then with the manufacture of the dies and finally with the striking process.

The flans

In antiquity, the metals used for currency were gold, silver, copper, tin, zinc and lead, either as more or less pure metals or as alloys. Antimony and nickel appear occasionally, perhaps because they were confused with tin; iron, intrinsically unsuitable both because of difficulties in working it and because it corrodes so easily, is only present as a trace element in analyses of the relevant coins.

Because gold is rarer than silver or indeed the other base metals, its use will depend on whether the mint authorities are aiming at the convenience of transferring large sums with a small number of coins or alternatively whether they are trying to cater for the needs of minor transactions in the market place. However the presence in gold or silver of less costly alloying elements may not necessarily be due to the desire to defraud the public but is perhaps indicative

of attempts to improve the castability or machinability of the flans, a point discussed below. It happens also that alloys have a melting point lower than that of the constituent pure metals and this leads to economies of smelting fuels. Finally, alloys are, in general, harder and more resistant to wear. It must be admitted that this fact, important as it may be to us, was probably never considered seriously, if at all, by the Greeks and Romans; loss of weight through circulation was regarded, with the habitual callousness of state-controlled organizations, as an expense to be borne by the individual.

The very earliest coins were struck in Ionia from a naturally occurring amalgam of gold and silver, though even at this date, *c.* 625 BC, both the cupellation process of separating gold and silver from other metals and also the salt or sulphur processes of 'parting' gold from silver seem to have been known. Such methods were very efficient, and analyses of Roman gold, from the Republican era through to Constantine's issues, show more than 98 per cent and often as high as 99.8 per cent gold. Silver, too, after being 'cupelled' from lead (leaving as little as 0.01 per cent behind) was usually intended to be absolutely pure (95 per cent to 99 per cent) in the Republic and early Empire. Subsequent alloying (down to 80 per cent silver for Nero, to 50 per cent in the reign of Septimius and to 2 per cent under Gallienus) was done with copper, but with economic rather than technical advantage in mind. From the start, base metal issues tended to contain lead, a typical analysis for a third century BC issue being 70 per cent copper, 8 per cent tin and 22 per cent lead. An alloy of this nature is very easy to cast, an important factor for mint craftsmen. Under Augustus a new alloy, brass (averaging 80 per cent copper and 20 per cent zinc), was introduced. Its yellow colour gave it the name *orichalcum* and permitted the circulation of different denominations having the same weight, one made from brass, the other from red copper; again, however, no particular technical gain accrued. The practical improvements ensuing from 'leading' were still recognized; for example a sestertius of Severus Alexander contained 71 per cent copper, 7 per cent zinc, 6 per cent tin and 16 per cent lead, while a standard Tetrarchic bronze would have been 84 per cent copper, 8 per cent tin and 8 per cent lead. So much for the types of alloys.

Before the Greeks came to Italy, barter in the peninsula was supplemented by the exchange of lumps of bronze often cast in a rectangular form with the effigy of exotic animals such as elephants upon them. The cities of Magna Graecia had, of course, a silver currency and this drifted northwards to Latium by way of trade. Here the mint directors, Roman aristocrats who were notorious for their partiality to foreign innovation, pressed ahead with an answer to the influx of small and convenient precious metal coins. Cato the Censor would have applauded their massive bronze 'librae' and scarcely less cumbersome fractions—no concession here to imported trumpery with its threat to traditional 'gravitas'. Such pieces, literally weighing a pound, were cast upright in a two-part mould, probably made of steatite or baked clay faced with some form of carbon to produce a smooth surface, if not a very detailed design. Inadequate 'risers' or escape vents caused air to be trapped and resulted in the pit on the 'wheel' side of the specimen illustrated. Whether by chance or intention, this blemish occurs in such a way as to conceal the presence or absence of a fourth pellet, denoting

Top to bottom: Bronze Aes grave. **80** Obverse, **81** edge and **82** reverse views of a quadrans of Rome, 241–222 BC. The edge view shows a cavity caused by contraction during cooling; the reverse a cavity caused by air trapped in the mould. **83** Two halves of a stone mould for casting this type of coin.

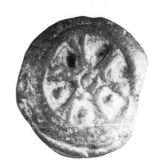

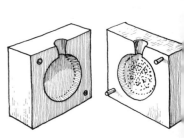

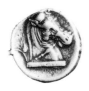

84 (above) Remains of a casting flash on the edge of a silver didrachm of Rome.

86 Iron age clay mould fragment (above) and **85** (top) modern test copper plugs cast in a similar mould.

either 3/12 or 4/12 of the As, the substantive denomination. At the same time, differential rates of cooling have produced a central porosity and 'pipe', of which the large hole in the edge view is only the most obvious evidence.

In spite of their pious conservatism, the mint triumvirs—*tresviri aere argento auro flando feriundo*—were eventually obliged to authorize a silver currency. No Roman craftsmen having appropriate experience, Greek workers from the South Italian mints were engaged. These naturally brought with them the techniques associated with their own magnificent coinages. As far as the flans are concerned, we find a feature immediately linking early Romano-Campanian didrachms, struck in the third century BC and, say, those of Neapolis. Two small protrusions will be seen at diametrically opposite points on the edge of the flan. These are the remnants of an equatorial ridge on a more or less spherical blank cast between two mould halves. Complete enclosure of the molten silver in this way reduces the oxidation which can occur in single-sided moulds with the upper face exposed to the atmosphere; heat loss from such a shape is the minimum possible.

It is often suggested that blanks were cast in baked clay moulds of the type recovered from Iron Age sites both in Britain and elsewhere on the Continent. To produce the very smooth edges typical of most coins of the period, a special mould lining would have been required and of this no traces are visible on the examples I have inspected. Attempts to cast specimen blanks by pouring molten copper into one of these depressions produced pieces with a cylindrical 'dump' of a section unsuited for the thin flan characteristics of the coins; the 'mushroom' top which the illustration shows arose from overfilling by my inexperienced and unsteady hand and is, of course, absent in the intended product. At the same time, the very rough edge surface of these experimental pieces is only met with on a few series within the Roman period; Alexandrian tetradrachms are perhaps the most common of these. Experiments in melting granular metal placed in the depression of the mould which is then itself put in the furnace yield blanks of a better finish; however their length is still too great compared with their diameter to make satisfactory blanks.

Flans for the Imperial bronze coinage in Egypt were cast in open moulds, with interconnecting channels running between a series of depressions. Remnants of the broken-off tongues can frequently be made out on the coin edges, which are always chamfered in one direction only. Sometimes the same principle was

87, 88 (left, above) Edge and obverse views of a large bronze unit from Alexandria (114 AD) showing chamfered edges and the 'throat' of a casting channel. **89, 90** (left, below) Edge and obverse views of a billon tetradrachm from Alexandria (65 AD) showing a rough cast surface.

91 (right) Diagram of an open mould for casting blanks 'en chapelet'.

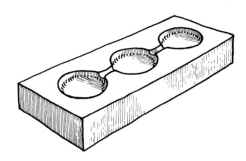

 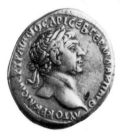

applied to two-part moulds, and blanks so manufactured come from mints both inside and outside the frontiers of the Empire. The specimen above left has not had both ends of the channel 'throated' to permit the tongue to be snapped off easily. The relatively smooth surface on the unstruck parts of the last two coins points to permanent moulds cut from a stone such as steatite.

The craftsmen of antiquity would undoubtedly have observed the phenomenon in fluids which we now call 'surface tension'. Molten metals poured on to a smooth flat surface coalesce into thin disks. Their section accords well enough with the round edge profile of many ancient coins, and this seems a likely method of producing blanks. It might be objected that control of the weight would be inadequate by such a method; however, I have found by experiment that very little practice is needed to attain a reasonable accuracy. In an attempt to cast blanks suitable for a tetradrachm of 17.5 grammes, my first run of ten was widely scattered, but by the eighth run I had attained a more or less acceptable accuracy. If thinner flans were necessary, these blanks could be beaten out to the new dimensions with no great difficulty, although insufficiently annealed metals would tend to split along radial lines, a fault only too frequently found in extant specimens.

Larger crucibles carrying, say, two or three kilogrammes of melt naturally present problems in handling. In this instance, the intermittent nature of the operation of pouring could be avoided by emptying in one movement to form a single continuous sheet, which could subsequently be chopped up by chisel or shears to appropriate flan sizes. Many sestertii from the third century AD are basically square in outline, a shape consonant with a production sequence such as that just postulated. Indeed, for the coin illustrated, the 'corners' as seen in the edge view are thicker than the middle of the side as though they had been hammered in to make the flan approximately circular prior to striking. Similar facets, caused by some initial rounding-off process, are found in other issues as well.

Exposure to the atmosphere gives rise to oxidation of a cooling metal and, in addition, slag or other impurities float to the upper surface because of their lower density. It is probable, therefore, that many blanks cast by the methods outlined above had at least one side requiring further treatment before striking was possible. Dipping in some organic acid such as that obtained from crushed quinces would have been at least partially effective, but more drastic mechanical means were also tried. An instrument resembling a facing bit and clamped in a hand brace was located in a central depression in the flan surface and then rotated so that the tool edge actually cut away the rough surface, as shown in the

Left to right: **92, 93** A Parthian coin showing a large spur from the casting channel and a central parting line from a two-piece mould. **94, 95** A brass sestertius with a basically square flan which is thicker at the edges than in the centre. **96, 97** A billon tetradrachm with edge facets caused by hammering to shape before striking.

98 Experimental copper blank cast on to a flat metal plate.

	1st run	8th run
Weights of blanks in gms.	17·0	15·2
	18·6	18·0
	25·8	16·3
	23·6	17·1
	27·1	18·0
	17·3	16·0
	22·9	17·6
	19·5	15·2
	20·7	17·1
	19·9	20·5
Standard deviation from tetradrachm weight (17·5 gms.)	5·00 gms.	1·52 gms.

99 Table showing the improvement in weight accuracy when casting blanks on to a flat plate.

100

Left to right: **100** A possible cutter for 'facing' blanks. **101** Bronze unit from Samos (about 250 AD). On the obverse a large central punch hole and turning marks across the face. The oblique view **102** shows the depth of turning. The reverse **103** is unaffected showing that this cutting was done before striking.

diagram. This technique first appears on large Ptolemaic bronzes of about 220 BC and it soon spread to Asia Minor and elsewhere in the Hellenistic world. The depth of cut would be governed by the relationship of the depth of the central tang of the tool and that of the punched hole which was itself regulated by a shoulder on the punch. Unfortunately, this hole is never obliterated and unsightly turning marks often remain on the coin too, even after striking. The addition of lead, mentioned above in relationship to alloying procedures, has two advantages in this context. Firstly, it increases the fluidity of the molten metal, thus facilitating pouring and reducing the tendency to porosity and blowholes. Secondly, it weakens the grain boundaries in the structure of the metal, inducing what is termed technically a 'free-cutting' effect, making for ease of filing or turning. This is important in that mere friction between the under surface of the blank and the workbench would suffice to hold the blank in position whilst being turned, and no vice would be required.

The notorious debasement of the silver coinage during the Severan period and again prior to Diocletian forced the mints into metallurgical trickery. The coppery appearance of the coins naturally caused the public to resist their circulation, and hence their surface had, in some way, to be 'silvered'. Monuments to the financial naiveté of the third century Emperors, such 'whited sepulchres' could be produced by several methods, which were consistent in general with mass-production requirements. The most simple way has already been indicated: this was to immerse the blanks in some acid which leached away not just surface impurities but the copper too, leaving only the silver. Under the impact of the dies this was deformed to a continuous layer, which would withstand a fair amount of circulation before the true nature of the metal became apparent. Another process involved dipping and this would be more appropriate where the initial silver content was very low. The flan was grasped on the edge by tongs and held for a short period below the surface of a bath of molten silver or silver chloride, a by-product of the cupellation of gold. Finally, silver grains with some flux such as borax might be sprinkled on the face of the flan, which was then placed in a furnace and heated until the silver melted and ran into a continuous coating; a second operation would be necessary for the underside and even then the edges would escape. Examination of specimens retaining their frail 'wash' on the flat faces rarely reveals any silver on the edges, so that the method just described is not ruled out by the last objection. Furthermore, although the dipping process appears less time-consuming to us, the laboriousness of the granular method would be no impediment to its adoption by a slave-powered society.

Such an economic factor may have been of little concern to a financially irresponsible officialdom, but it had to be taken into account by forgers whose standard of living depended on their efficiency. Because of the ingenuity displayed by these unlicensed moneyers, their processes are well worth our attention and, indeed, form part of the technological background of the age. This, then, is the right point to consider the question of plated coins. The most obvious difference between the latter and the debased coinage of the third century is that their plating is very much thicker. Metallurgical investigations have revealed that for the most part these specimens consist of a copper core, to which a silver sheet has been fixed by a eutectic silver-copper solder; the edges are carefully doubled over to prevent exposure of the core and the application of a flux contributed to the efficiency of the soldering action. The thickness of the silver plate was normally quite sufficient to ensure that there was no breakthrough to the core when the flan was distorted under the pressure of the dies.

We have a compelling demonstration of the tenacity of the plate. Many of the denarii of the Republican period went beyond the boundaries of the Roman state to pay for luxury imports such as furs and amber. In these regions the fiduciary nature of coinage was irrelevant; only the actual precious metal content was important, because in many cases it was melted down for jewellery or utensils. When plated coins started to form an unacceptable proportion of the currency, not merely was there unrest at home but, more alarmingly, the barbarians refused to trade. In an effort to convince all users of the genuineness of any coin, chisel cuts were sometimes made on the face of the flan and then the mint co-operated by putting a series of radial cuts around the whole edge before striking, as shown in figs. 105–110. Even this elaborate safeguard offered no security against fraud. Inspection of the illustration reveals that a coin with both chisel cuts and serrated edge is of plated manufacture. While the plating has corroded through at other points on the flan, the silver is continuous under the chisel impression and on the edge itself chemical action rather than mechanical disruption is responsible for laying bare the centre. No wonder the 'serrati' eventually dropped out of production.

It is still not clear whether such plated coins are wholly the work of counterfeiters. Although no die links (two coins with at least one die in common) occur in the Roman series between solid silver and plated specimens, they may be found among Greek issues. Perhaps the official mints, dissatisfied with their other profits, resorted to plating for further financial gain.

Less equipment, but hardly less expertise was necessary to make cast forgeries. A regular struck specimen taken from currency was the pattern from which a

104 Diagram showing the method of plating coins with silver.

104

105–110

105–110 Obverse, edge and reverse views of two silver serrate denarii of Rome (79 BC). The coin on the right is plated, but this is not evident from the edge notches and the plating is continuous even under the chisel cuts. Corrosion has broken through to the core above the eagle and over the length of the fasces on the reverse.

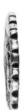

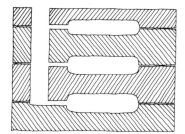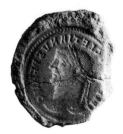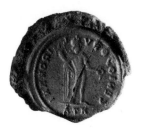

Left to right: **111** Tiered assembly of a four-part forger's mould of clay. **112–14** Fragment of a forger's mould from Alexandria made from a follis struck at Trier about 300 AD; obverse, edge and reverse views.

series of impressions in clay were taken and assembled into a mould. Of course, the surface of cast, as compared with struck, specimens is pitted and detail is lost; furthermore, flaws on the original are only too faithfully reproduced in the copies. However, when such enormous issues circulated, the aberrant example must usually have escaped question.

The dies

The lore of working in copper and bronze had, as mentioned above, been accumulating for upwards of three thousand years when the first coin dies stamped their designs on a blank. On the other hand iron, successfully 'steeled' in any quantity about 1000 BC, had barely entered into the economy of many parts of the Mediterranean periphery by five hundred years after this. Thus, although the rise to greatness of the Roman empire is usually reckoned to coincide with the advent of the Iron Age, yet we should not be surprised that craftsmen, where they had a choice, were loth to abandon the metals with whose quirks they had long been familiar.

The majority of dies from the Roman period now extant were fashioned from a high tin bronze; a typical example dating from the reign of Augustus has the following analysis: 75.1 per cent copper, 23.1 per cent tin, 0.9 per cent antimony, 0.3 per cent bismuth, 0.2 per cent iron. It must be admitted that our present dearth of iron dies from archaeological contexts may be due to rust, which has either destroyed them completely or left them as lumps of metal of unrecognized significance. However, we do have additional evidence from the coins themselves that iron or steel were only occasionally employed. A few ancient issues, such as those from Syracuse, were struck from rusty—and therefore ferrous—dies. The excrescences on the coin surfaces are quite characteristic and yet we do not often find them. If Syracuse, once the largest, most opulent and efficiently organized city of the ancient world could not prevent its dies from corroding, is it likely that any iron dies used in mints elsewhere would have been better preserved?

We shall discuss below the temperature of striking, but for hot-struck coining bronze does have an additional advantage. Steel is hardened by quenching and tempering, but can be de-tempered by slow cooling from a sufficiently high temperature again. With high tin bronzes, on the contrary, quenching produces the soft state, whereas slow cooling (a result of intermittent contact with hot blanks) increases the hardness and toughness.

The face of the die carries some design which is to appear on the eventual coin. In almost all cases, the designs were in relief on the coin and, accordingly, in intaglio on the die, which thus resembles the stamp-seal in its function. It is

natural to find that methods used for producing seal stones should have been adapted to engrave metal dies. The fundamental problem solved by these craftsmen of antiquity was that of cutting a hard material with a soft tool. To do this, they invented the process we now call lapping. Abrasives such as corundum occur naturally in a sharp-edged crystalline form; if corundum particles are pressed between a hard and a soft surface, they are forced into the latter from which they now protrude like teeth. Rubbing of the two surfaces then produces abrasion of the harder material. Such a technique was combined with the use of a bow-drill to 'excavate' the intaglio areas of the design on the die. In particular, lettering was 'marked out' by initial holes, which were then connected by running the cutter between them. Details of portraiture, eyes, lips, muscles, etc., are especially amenable to treatment in this way.

Steel tools such as scorpers were available to the engravers. The actual shape of many letters on coins indicates that they were cut by a sharp implement of this nature. The exaggerated serifs where the tool stroke has run out could not have been inserted by the bow-drill. Other features, for example hair, are very easily cut on the die by scorpers so that they will stand out in relief on the coin.

Finally, we come to a method of producing die designs based on the very concept of striking a coin—this is 'hubbing', a process currently employed at modern mints. The hub, a master punch in relief like the coin, is hammered into the die face to reproduce the necessary intaglio. In some experiments to test the feasibility of hubbing, I made a helmet punch (below right) from a 20 per cent tin bronze. With a couple of blows from a two-pound hammer I then 'hubbed' a pair of serviceable dies from the same alloy. There is no proof that the Romans actually used this technique, though we have indications that the Greeks did. However, once it had made an appearance, hubbing is in so many ways superior to other methods that it is hard to believe it would have been discontinued. Obviously it saves time as compared with engraving but it also consolidates the central part of the die which suffers the worst stressing when deforming the blank. For details such as lettering and hair it is necessary to cut away metal leaving them *in relief* on the hub and this presents some difficulty. Accordingly, I think that in general, a combination of hubbing and engraving would have been employed.

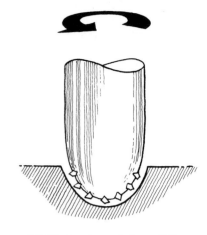

115 The lapping technique of die engraving: hard corundum particles embedded in the tip of a soft copper drill make a bit hard enough to engrave a bronze die.

116 An experimental scorper made of quenched and tempered steel.

117 (left) Experimental bronze dies made by hubbing, and **118** (below) an experimental bronze hub.

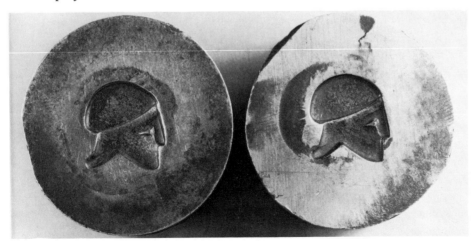

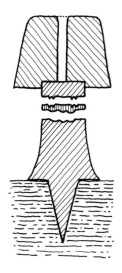

119, 120 The upper and lower dies in position for striking a coin. The upper die is of bronze mounted in a protective iron cap with an extrusion hole that allows the die to be poked out when it is worn and needs replacing. The lower die is tanged and mounted in a balk of timber.

76

121, 122 A silver denarius of Rome, about 110 BC. The obverse shows a Janus head; the reverse shows a brockage of the obverse.

The upper die, or trussel, usually differed considerably in shape from the lower die or pile. The trussel had to be easily portable, capable of being held in the hand, or at least with a pair of tongs. Since it was in immediate contact with the hammer it had to be sufficiently massive to withstand the resulting high stresses; alternatively it required protection by an iron cap—a number of these were found in association with dies in Spain. The lower die was more often set in an anvil, but at some primitive workshops it was probably tanged and mounted in a balk of timber, a method common in medieval times. Even where dies seem to be aligned there is enough variation between the obverse and reverse axes to show that the trussel was detached and positioned by eye, and not hinged as is often suggested.

The striking

Until now we have been discussing the work of men with vast if empirical scientific knowledge, who could rise, at times, to artistic levels hardly equalled since. With the actual striking of the coins we meet the mere journeymen of the craft. One of the great surprises in Greek numismatics is to find dies, engraved with exquisite care, afterwards subjected to such cavalier treatment that they became corroded or fractured; the resultant coins are themselves frequently off-centre or flawed in some other respect. Many Roman mints had a work force which was no better.

The implements used, tongs, hammer and anvil, are depicted on a famous denarius of T. Carisius illustrated here. They could be handled by one man and at provincial mints no doubt often were. In my own experiments in striking, I used the tongs to transfer heated blanks from a furnace to a lower die, set on an anvil; having laid aside the tongs, I positioned the upper die with my left hand above the blank and hit it with a two-pound hammer. After a little practice, I found that, including melting and pouring the blanks, I could manufacture a hundred coins per hour. Such a rate must have more than sufficed for those establishments where prestige rather than economics was the reason for striking at all.

Obviously, matters were differently organized in Rome, Antioch, Lyons or Alexandria. At these mints, output was reckoned by the million and, in spite of the availability of cheap slave-labour, separation of the various functions took place, a team of four being normal. The first operator transferred a blank from the furnace (for hot-striking) or some receptacle (for cold) to the lower die. The second now held the upper die in position so that the third could bring the hammer down upon it. The fourth removed the now completed coin and the cycle started afresh. Things were apt to go wrong and the greater the speed, the more the liability to error. For example, if the newly struck blank adhered to the upper die, the rhythm developed by the team did not permit an immediate halt to clear the obstruction. A 'brockage' resulted, the next blank receiving upon its reverse an incuse impression from the obverse of the last one instead of from the die. The far greater percentage of brockages present in the Roman series as compared with the Greek bears witness to the corresponding rise in production rate. At other times, the fourth man did not move fast enough—a new blank was put down partially covering the old flan and we get a segment of the die on each.

123 Bronze units from Antioch with busts of Licinius or Constantine, about 310 AD. Incomplete withdrawal of struck coins has resulted in a second off-centre impression from the die.

An unpublished hoard containing a high proportion of mis-strikes produced four of the type just described, belonging to one issue of Licinius and Constantine. In each case, the second off-centre die impression shows that the interrupted withdrawal was taking place in the same direction. The implication is of standardized positions not just for the dies but also for the craftsmen around the anvil, an early exercise in ergonomics applied to mass-production.

123

The temperature of the flans at striking can often be deduced by metallographic examination of the crystal structure. From such studies we know that Athenian tetradrachms were regularly hot-struck from above a recrystallization temperature, whose level depends upon the alloying present. Recent work by Cope inclines him to believe that all Roman coins were similarly hot-struck. The radial cracks on the denarius of Caesar may indicate cold striking, though insufficient preliminary annealing of the blank could also be responsible for such flaws. Now gold and silver are nowhere near so hard as properly heat-treated bronze; hence for the low relief characteristic of later Roman issues in these metals, hot-striking would not have meant a startling extension of die life. For bronze flans, though, it would have been advantageous, and except for ephemeral or peripheral workshops, Cope is no doubt correct. The very great detail obtained on brockage surfaces (fig. 122, page 71) proves that silver can be used to strike silver and so we may continue to postulate bronze dies for a bronze coinage. No documentary evidence survives from this period to tell us how many coins it was usual to expect from a pair of dies. The trussels were generally consumed faster than the piles, but, as a result of experiments, it seems that ten thousand is about the right order of answer. This figure is a far cry from the estimate of eighteenth century antiquarians who thought the dies were 'finished' after producing a single coin.

Col. Plate IV top right

122

The sheer volume of currency circulating throughout the Empire was not paralleled again until recent times. In consequence, the organizational problems within the Roman mints must have been as difficult to surmount as the technical ones. At the major establishments, a number of *officinae* operated together; during the first century BC we have the Triumvirs responsible for gold, silver and bronze, each presumably with his own corps of workers. Two centuries later, division of executive power was not explicitly referred to on the coins,

124 A bronze coin (337–346 AD) with an inscription in the exergue showing that it was struck in the fourteenth officina at Antioch.

but within any one issue, different types served to distinguish the products of the half-dozen officinae at Rome. In the Constantinian period, when the precious metals formed an almost insignificant part of the money in use, regimentation of society at large was reflected at the mints; here the die designs were often simplified to a mere inscription that could be entrusted to any apprentice, and each carried not just the name of the mint but the officina number too.

The formidable position of the mint in Roman society was vividly brought home in the reign of Aurelian. The moneyers, fearing discovery of their peculations under the preceding emperors, sprang to arms and, according to Aurelian himself, killed seven thousand of his soldiers before the revolt was quelled. Perhaps the sight of so much wealth literally slipping through their fingers caused these furnace stokers, foundry workers, die engravers and hammermen to be the most militant of the ancient craftsmen.

Bibliography

Barb, A., 'Zur antiken Münztechnik', in *Numismatische Zeitschrift*, 1930

Campbell, W., *Greek and Roman Plated Coins*, New York, 1933

Cope, L., 'The Metallurgical Analysis of Roman Coinage', in E. T. Hall and D. M. Metcalf (ed.), *Methods of Chemical and Metallurgical Investigation of Ancient Coinage*, London, 1972

Crawford, M., 'Plated Coins—False Coins', in *Numismatic Chronicle*, 1968

Durán, R., 'Breves consideraciones sobre los troqueles romanos', in *Numisma*, 2, 1952

Elam, C., 'An investigation of the microstructure of 15 silver Greek coins and some forgeries', in *Journal of the Institute of Metals*, 1931

Hammer, J., 'Der Feingehalt der greichischen und römischen Münzen', in *Zeitschrift für Numismatik*, 1908

Hill, G. F., 'Ancient Methods of Coining', in *Numismatic Chronicle*, 1924

Le Gentilhomme, P., 'Coin monétaire d'Auguste', in *Revue Numismatique*, 1946

Picon, M., Guey, J., 'Monnaies d'argent fourrées fabriquées par trempage', in *Bulletin de la Société Française de Numismatique*, 1968

Schwabacher, W., 'The Production of Hubs Reconsidered', in *Numismatic Chronicle*, 1965

Sellwood, D., 'Some Experiments in Greek Minting Techniques', in *Numismatic Chronicle*, 1963

Vermeule, C., *Ancient Dies and Coining Methods*, London, 1954

Vicajee, A., *Notes on The Hand Minting of Coins of India*, Hyderabad, 1908

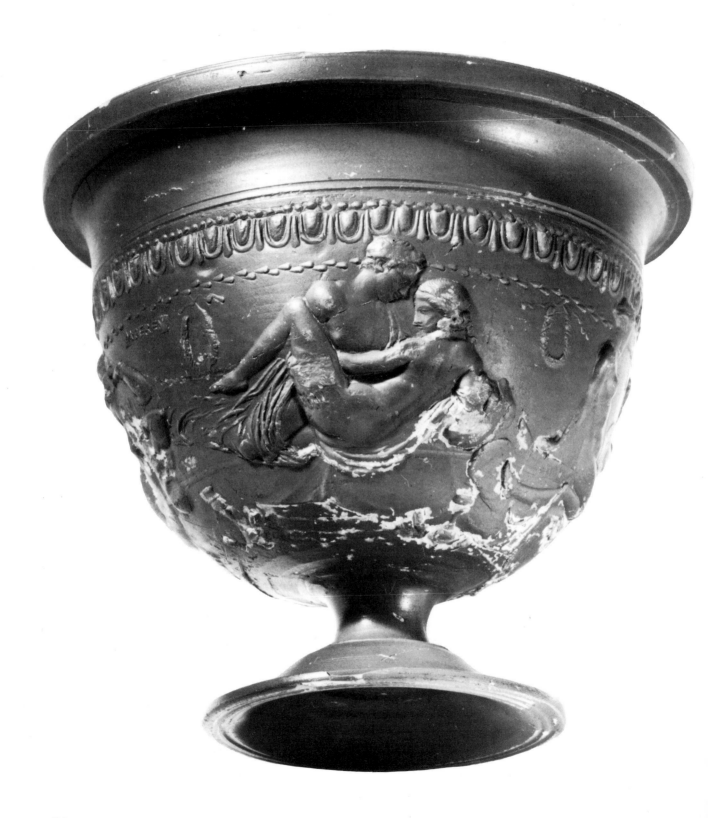

74

David Brown

6 Pottery

The finest Roman pottery was made at Arezzo in central Italy during the principate of Augustus, yet the signatures and stamps on the pots show that the potters themselves were Greeks and Asians, freedmen and slaves. This is easily explained: the techniques, shapes and styles of decoration of Arretine pottery all had their origins in the art and technology of the Hellenistic world. The Greek fashion for painted vases had given way to one for pots with decoration moulded in relief; the basic black background colour common throughout the Greek world between the sixth and first centuries BC had given way to red; and the styles of decoration had changed with the times. These changes can be seen taking place during the second and first centuries BC; they culminate in the products of Arezzo.

Pottery was made throughout the Empire and in a whole range of varieties from table wares to coarse cooking vessels and storage jars; shapes, decoration and even the types of vessel differ from province to province, yet it was normal for the best table ware to be red. Megarian bowls, Pergamene ware, Arretine, samian and other terra sigillata wares, North African red slip ware and the late Gaulish and British imitations all have the characteristic red surface. A description of the making of some typical examples of these wares will explain many of the techniques used by Roman potters.

125

The red table wares have a surface coating which is not a glaze in the sense that glaze implies a vitrified, glassy surface; nor is it a slip, for to potters this implies merely a coating of liquid clay, sometimes coloured. The red surface coating was made from a special preparation derived from clay, and to distinguish it from glaze and slip the word 'gloss' is used nowadays. This gloss surface was applied to the pot before firing, but after all the other processes of making and shaping—all of which took place on a wheel.

The potter's wheel

There are neither descriptions, nor illustrations of Roman potters' wheels, nor do examples survive to show what they were like. Illustrations of potters on Greek vases show that they worked on a wheel set low on the ground; either they squatted on their heels, or sat with their feet spread wide. The wheel was broad and flat, and was driven round either by occasional thrusts from the potter

125 Arretine crater with moulded decoration and a pedestal foot, made by the potter M. Perennius Tigranus, 10 BC–10 AD. Height 6 in.

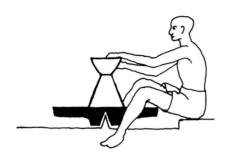

127

126, 127 Two sorts of potter's wheel, both probably used by Roman potters. (After Adam Winter)

himself, or from a second worker sitting opposite him. There is little doubt that Roman potters were using wheels like this in which the working surface and the flywheel were combined in one. But it also seems probable, though there is no direct evidence for it, that they had a wheel set up more like modern ones with a small wheel head for working on set at waist height and connected to a fly-wheel below. In this way the wheel would be propelled by direct thrusts from the potter's feet. A wheel like this gives the potter greater control of the work; it is also more convenient for making small or finely-turned vessels such as were popular in the first century AD. There is no evidence for the crankshaft as used in present day kick-wheels.

The wheel and its structure could both have been of wood, so it is not surprising that neither has been found. Large rings of baked clay with a large central hole and one flat side are found in a number of potters' workshops, particularly the samian ware workshops in Gaul and Germany; they are often described as wheels, but their central hole and their unevenness really preclude this, and they are too small to have been flywheels. It seems more likely that they were a part of the structure of the kilns which will be described later.

One detail about the wheels comes from the pots themselves; the grooves left by fingers running up the surface of the clay as it rotated, and the ripples which often occur on the inside of a pot when trying to draw in the neck of a narrow-mouthed vessel both show that it was normal for the wheel to rotate in an anti-clockwise direction, as it is today.

128 Ripples on the inside of a small slip-coated pot.

Clays

There is no detailed knowledge of what Roman practice was with regard to clay. In some extreme cases it is obvious that additions such as pieces of crushed shell and flint, or pieces of crushed pot were made to a basic clay; but it may be assumed that clays were usually used in much the same state as when dug. It is reasonable to assume that Roman potters would have known that a clay is more easily worked if left to weather in the open for a while, and also that it had to be kneaded by hand to free it of air bubbles and get it to an even consistency. If the clay was full of unwanted impurities, sand or grit and stones, it could be cleaned by mixing with water until it dissolved into a slurry; when left to stand the heavy impurities would settle to the bottom first and any lighter, organic debris would float to the surface, so allowing the clean clay to be separated and dried ready for use. This process seems laborious and unnecessary for large

quantities of newly-dug clay, but may nevertheless have been normal for recycling clay which had become too dry. At least it can be said confidently that both processes, the refinement of coarse clay and the addition of coarse particles to fine clay, must have been within the ability of Roman potters.

Throwing pots

The process of throwing pots on a wheel, centering the clay, hollowing out the inside, drawing the clay up into a cylinder and finally shaping it, is too basic to need detailed description. It seems incredibly difficult to anyone who cannot or has not done it, and is second nature to everyone who can.

Most vessels could be thrown to their final shape though they would need tidying up at the base where they were in contact with the head of the wheel. After shaping, the surface was usually smoothed over on the outside with the aid of a damp sponge or a piece of stick to eliminate finger marks. The pot was then cut off the wheel with a string which left a characteristic swirling curve on the base. The tidying up of the base and the shaping of the foot were done when the pot had hardened sufficiently to withstand handling. It was set up on the wheel, upside down and resting on its rim, so that the base was free to be turned. As the pot rotated a sharp tool was used to turn the base to the shape required. Turning could vary from merely trimming off the rough edges and flattening the base to elaborate cutting out of a foot and shaping the lower parts to complement the lines of the rest of the pot. The simplest trimming of the foot was done by paring off the rough edges with a knife, and this avoided having to set the pot up on the wheel again.

In the case of Arretine and other red gloss pots, the smoothness of the surfaces and the way in which precise mouldings were formed show that both the insides and the outsides were finished off with a turning tool. It is often stated that the mass production of identical vessels means that the potters used a template to determine size, shape and details of the mouldings. But it is more likely that they used a variety of turning tools, wooden spatulae with variously shaped ends, some curved, some angled. These could have been extremely adaptable and could have been used as partial templates to shape the curves and angles and detailed mouldings; it is noticeable that the most complicated of these occurred on the outsides of the pots and on the inside edges of the rims where they could be reached most easily. The use of a one-piece template would have been impracticable for it would have tended to tear the pot off the wheel.

129 The marks of throwing on a drainpipe from Jericho.

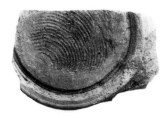

130 (above) Curved lines made by cutting the pot off the wheel with a string. **131** (below) A deeply-turned foot on the underside of a cup from Cyprus. The uneven covering of gloss is due to double dipping. **132** (below, right) Profiles of Arretine and Gaulish plates with elaborate mouldings.

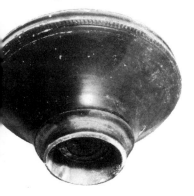

David Brown

Size was no more of a problem than shape. It was basically controlled by the size of the lump of clay. If it was required to throw a hundred bowls all of the same size, a hundred equal balls of clay were prepared. In throwing the first half dozen of the day the potter would check the height and diameter of each. Thereafter he would probably do no more than check an occasional measurement in every three or four bowls. It would not have been feasible to measure each dimension of each moulding of each object.

Pots with moulded decoration

The idea for vessels with moulded relief decoration seems to come from repoussé decoration of silver vessels. It is certain that the designs of the two were often very similar, particularly where Arretine pottery was concerned, and it is interesting to note Pliny's reference to the copying of designs and the means of copying. Plaster casts were made of the surface decoration of silver vessels and these, so Pliny says, were used as portable patterns of Greek art. If these pattern pieces were available to silversmiths then it must be possible that they were used by potters too.

The mould was made in the following way. A thick clay bowl was thrown on the wheel and the inside smoothed to the required shape of the pot to be moulded. The decoration was then impressed into the inside surface of the mould with punches, or poinçons, bearing the appropriate ornament, figure scenes, decorative details, repetitive border patterns and so on.

Punches have been found at most workshops where moulded pots were made. They were made of clay, and had the ornamental design on one side with a convenient handle hold behind; sometimes they were inscribed or stamped with the names of the potters. Punches could have been made by direct modelling,

133 A fragment of a plaster cast moulded from a silver bowl of the second century BC. From Egypt. 4¼ in. wide.

134, 135

134, 135 Two views of a poinçon showing a woman with a basket of fruit. The lack of curvature shows that this piece was for use in a straight-sided mould. From Arezzo.

78

or by taking an impression from a master mould, or even by copying another piece of pottery or a design on silver.

To set out a design in a mould, a number of guide lines were normally inscribed first along the lines of the borders. Once these were located, the figure scenes could be impressed, then the decorative details and finally the borders themselves. Details of swags and garlands were often inscribed freehand in the surface.

In order to get an even depth of relief for the decoration, the punches had to be shaped to fit the curvature of the mould, and punches for straight-sided and curved vessels were not interchangeable. Duplicate straight and curved punches do not appear to have been common, with the result that particular scenes were restricted to particular shapes. Some scenes of two or three figures in a group were made up of two or three different punches. This allowed for the figures to be changed or placed in slightly different positions so that the scene could be varied from mould to mould. Figures from groups were often used alone and out of context, as on a fragment of a mould in the style of the potter P. Cornelius. Here the figure of Eros is shown with outstretched arms; the figure belonged to a group in which Eros rode in a chariot drawn by Pegasus, and the outstretched arms held the reins. Badly-impressed punches caused the clay to well up around the impression, and the resulting irregularity was transferred from the mould to the finished pot. Also, of course, the punches must not be impressed into the mould too deeply or the high points of the relief would be defaced when the pot was lifted out of the mould.

The action of pushing the punch into the inside of the mould distorted the outside and the final process in making a mould was to place it upside down on the wheel and turn the outside smooth. The walls were normally left quite thick, a centimetre or so, and the mould was fired in the kiln before being used.

138

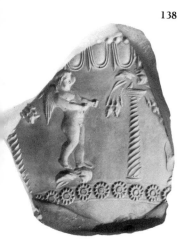

136 A fragment of a pottery mould with decoration in the style of the potter P. Cornelius.

137

137, 138 A view of the outside and of the inside of a mould showing the impressed figures, the potter's stamp here back to front, fine layout lines cutting across the necks of the figures and free-hand drawing of details like the stems of the flowers. From Arezzo. Diameter 8¾ in.

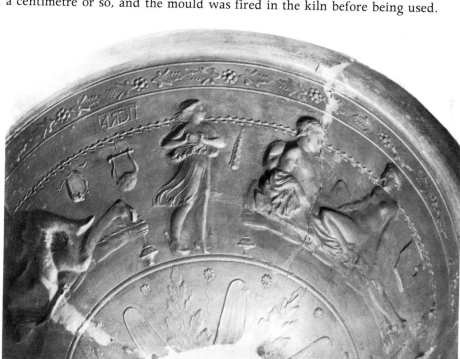

The actual process of getting the clay into the mould presents something of a problem. It is possible to throw the clay in the centre of a mould and stretch it out until it covers the whole of the inside surface, but in doing this air bubbles are inevitably trapped in the hollows of the relief decoration and there seems to be no way of getting rid of them. This difficulty would be overcome nowadays by means of slip casting, but there is no evidence to suggest that this method was used in antiquity. Lamp makers and the makers of terracotta figurines had the same problem and got round it by forcing the clay into the mould with their fingers. It seems possible that the same method could have been used to make moulded pottery, the clay being worked into the mould with the fingers *before* the mould was spun on the wheel. Turning and shaping tools would then have been used to cut the inside of the pot down to its final smooth finish.

The mould only accounted for the decorated part of the vessel, and in all cases there were the rim and the foot to be finished as well. There is never any sign of a join between the moulded part of the vessel and the rim, and it is clear that they were made of the same piece of clay. When the clay was forced into the mould with the fingers, a generous amount must have been left as a thick edge around the top; once the mould was on the wheel, this edge could be drawn up and thrown to the shape required.

The mould was then set aside to allow the pot to dry. Much of the moisture was absorbed by the thick walls of the mould. As the clay dried it shrank, the pot became loose inside the mould and could be lifted out. If this was done carelessly or before insufficient shrinkage had taken place, the highest parts of the relief decoration would be scratched and scarred, and such scars are often to be seen on finished pots.

Finally, the pot had to be finished. Some moulds allowed for a thick plain base at the bottom of the decoration, and the foot was turned out of this in just the same way as for any other pot thrown on a wheel. Other moulds made no allowance for a base, and a footring or pedestal had to be thrown separately and carefully luted into place on the bottom of the moulded portion. The fitting together was normally done with the pot mounted upside down on the wheel, so that the base could be centred correctly and any scars could be removed by turning the area of the join. The completed pot was then left to dry out thoroughly before being coated with gloss.

Before describing the preparation of the gloss and its application, it is appropriate to describe various other sorts of decoration used on both plain and moulded pots.

139 Fragment of Arretine pottery with the head of a figure defaced by scraping on withdrawal from the mould.

Barbotine decoration

Barbotine is the term used to describe decoration built up on the surface of a pot with very soft, almost liquid clay. The process is similar to that of piping icing onto a cake. The clay, in the form of a thick creamy liquid, was placed in a bag of skin or leather and squeezed out onto the pot through a hollow tube, probably a quill. The technique was very adaptable and could be used to great effect by a skilled operator. It was much used for building up scroll and leaf decoration on red gloss and other colour coated wares, and occasionally for figure scenes such as the famous hunt cups showing hare and hounds which

Col. Plate VI

140 Lion-head appliqué forming the spout of a mortarium made in central Gaul. Second century AD.

141 Bands of rouletting on a bowl made in a workshop in east Gaul.

141

were made in Gaul and Britain in the later second century. Barbotine decoration could also be applied or manipulated with the fingers to give an effect like overlapping scales or a rusticated surface.

Appliqué decoration

Appliqué is the term used to describe single figures or decorative details which were formed individually in separate moulds. These thin figures were then luted onto the surface of the pot. Handles, masks and decorative rosettes were made in this way and applied to Arretine vessels; appliqué lion masks were fixed as pouring masks on red gloss mortaria, and isolated appliqué figures were used to decorate North African red ware jugs and bowls. At one stage in the second century potters at Lezoux in central Gaul went through a phase of combining appliqué elements with barbotine decoration.

Rouletting and roller stamping

These names imply the same thing, but in practice they are used for two quite separate types of decoration. The term *rouletting* refers to the feathered surface decoration common on many types of pottery. It is often stated that the decoration was formed by running a toothed or grooved wheel over the surface of the pot; but a careful examination of the decoration shows that it could not have been made like this, for there is never any repetition of the pattern. The feathering effect was actually produced with a turning tool which was allowed to vibrate against the surface of the pot as it rotated on the wheel. When turning a pot it is easy to set up the sort of juddering vibrations which produce these marks, if the pot is fairly hard and the turning tool is held lightly; to avoid them, the tool must be sharp and must be held firmly. Vibrations of the same sort, between tool and workpiece, could occur when turning metal objects on a lathe, and the same tell tale feather marks are occasionally to be seen on the bases of turned bronze vessels.

Roller stamping is exactly what the name suggests. A wheel with decoration cut into its surface was rolled over the surface of the pot, leaving an impression of the same pattern repeated over and over again. The technique was common at all times, but replaced moulded decoration on the red ware bowls being made in northern Gaul in the fourth century AD.

Cut glass decoration

This technique involved cutting patterns into the surface of the pot to give an effect just like that of modern cut glass. The cuts are not always straight, and it seems probable that they were made with a graver rather than on a rotating wheel. The technique was popular in the red gloss ware workshops in Gaul for a brief period in the second century.

Stamping

Arretine, Pergamene and Gaulish red gloss wares were frequently stamped with the names of the maker or his workshop. Stamps were used as decoration for a brief period in the first century BC when Pergamene ware plates were stamped with palmettes in imitation of their Greek prototypes. In the fourth to sixth centuries AD, stamped figures and monograms were a common form of decoration on North African red ware plates and bowls.

142 (above) Roller-stamped pattern on a bowl from Trier. Fourth century AD. 143 (right) A stamped Chi-Rho monogram in the centre of a plate from Egypt.

The preparation of the red gloss

The composition of the red gloss surface on Arretine and other Roman pottery has baffled people for many years, for the technique died out at the end of the Roman period and was not rediscovered until this century. As might have been expected, the technique is incredibly simple.

The gloss is not simply a liquid form of the clay, like a slip; but is a suspension of fine particles derived from the clay. If an ordinary liquid clay is left to stand, the clay fraction will settle to the bottom leaving clear water above. But if a peptizing agent is added to the slip, a proportion of the smallest particles in the clay will remain in suspension and will not settle. It is this suspension which forms the basis of the gloss. The red colouring is due to the iron oxides, so only iron-bearing clay can be used to form a red gloss.

Adam Winter, a potter working at Mainz, has experimented in the preparation of suitable suspensions, and has found a number of ways in which they can be produced. Rain water can activate the clay: muddy rain running off the slopes of a clay pit was collected and left to settle, and a proportion of the finer particles remained in suspension. Alternatively a suspension can be prepared by mixing the clay with potash derived from pouring water over wood ashes, or by mixing with soda. Winter also discovered that a suitable gloss suspension can be extracted from some iron-bearing sand. All these methods, save possibly the one involving soda, would have been well within the ability of Roman potters.

While a suspension can be prepared from most clays, there is no guarantee that the results will give a good gloss. Winter noticed that if the suspension was glossy and shiny when dried out after application to the surface of the pot, then it will be glossy after firing. He noticed that puddles of clay in the bottom of a clay pit which dried and cracked but yet remained shiny were a sure indication that the clay could be used to make a good gloss. The glossy property has been investigated by Mavis Bimson at the British Museum Research laboratory. She has shown that of the three minerals which normally account for the smallest particles in a clay it is the mineral illite which gives the glossy surface. The other two minerals, kaolinite and montmorillonite, have a spiky structure, but illite has a flat, plate-like structure, so the molecules lie flat against one another giving an overall flat and glossy surface. To produce a satisfactory gloss it is essential to have a high proportion of illite in the particles in suspension.

Once a suitable suspension had been prepared it had to be thickened to a creamy consistency by evaporation; it was then ready for application. Greek pots were never coated all over, and the gloss seems to have been applied with a brush; Roman pots, on the other hand, were usually coated all over and the gloss was either poured over them, or they were dipped into it. The best vessels are remarkably free of signs of holding, but many thinly-coated pots have distinct finger marks around their bases where they have been incompletely covered. In the east mediterranean workshops an alternative method, that of double dipping, was used. The pot was held by the rim and dipped into the gloss so that one half of it was covered. The coating dried very quickly as the moisture was absorbed by the dry pot; the pot was picked up on the other side and dipped in again. To ensure complete coverage there was inevitably a line of overlap between the two dips, and since the coating was usually thin, this shows up as a

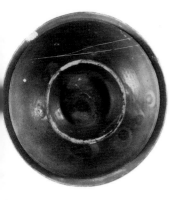

144 Finger marks on the base of a pot showing where it was held when being dipped in the slip.

thicker and darker band across the centre of the pot. Roman potters did not bother to coat the insides of enclosed vessels such as jugs, flagons and inkwells.

Kilns and firing

The remains of potters' kilns have been found in all parts of the Empire; they show that Roman potters used one basic type of kiln—the updraught kiln. In this the pots were stacked in a chamber directly over the fire, and the hot gases rose up from the fire, past the pots and out at the top of the kiln.

In practice kilns were normally dug into the ground, no doubt to prevent loss of heat and give greater support to the sides of the kiln. At the lowest level was the firing chamber which was stoked through an arched flue by a workman standing in a hollowed out stoking pit. The firing chamber was roofed by the floor of the stacking chamber directly above it; holes in the floor provided vents through which the hot gases could rise. The walls of the stacking chamber rose more or less vertically to ground level where they have invariably been broken off. One of the problems with Roman kilns is to know how they were covered; did they have a permanent superstructure in the shape of a dome with a central opening, or were they open at the top and merely given a temporary covering when being fired?

While the updraught principle was universal, the actual design and building of kilns varied immensely. Round or oval kilns were usual; they varied in diameter from two or three feet to up to seven or eight. They were mostly built of clay with the aid of tiles, stones and waste pots. There was great variety in the method of supporting the floor of the pot chamber; some rested on stilts, others on firebars and yet others on arches spanning the firing chamber. The wear and tear on a kiln during each firing was immense, and many kilns show signs of repair and relining. More elaborate kilns, built largely of bricks, were used for firing bricks and tiles. In the military tileworks at Holt in Flintshire and Holdeurn in Holland, a number of large kilns eighteen to twenty and more feet long were built around a common stoking pit. Those at Holt were rectangular, those at Holdeurn oval. No doubt such kilns could be used over and over again.

The same type of kiln was used for firing bricks and tiles and all types of pottery with the single exception of the red gloss wares. These seem to have been fired in a more sophisticated type of kiln as indicated by the debris from the workshops and the remains of the kilns themselves. The best discussion of red gloss kilns is that of M. R. Hull who found the remains of one kiln and much associated debris in his excavations at Colchester. Hull suggests that the kilns were built in such a way that the hot gases from the fire did not disperse freely amongst the pots in the stacking chamber, but were confined in clay pipes which effectively comprise a series of chimneys around the edge and through the middle of the chamber. The large clay disks which have often been mistaken for potters' wheels were fitted over the tops of the chimneys and provided a series of projecting flanges on which flat tiles and other roofing material could be laid. In this way the pots could be fired in a chamber which was free from gases from the fire and in which the weight of the roof was supported by the pipe-chimneys and not by the pots themselves. Hull's suggestions are amply confirmed by finds from other red gloss ware workshops.

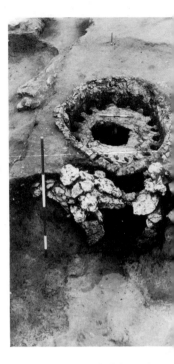

145 Overall view of a kiln with a large stoking hollow in the foreground. The firing chamber is oval and measures 5 ft 3 in. by 4 ft 3 in. Headington, Oxford; fourth century AD.

146

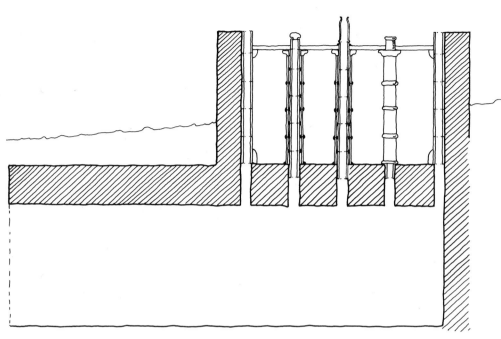

146 A possible reconstruction of the red gloss ware kiln found at Colchester. (after M. R. Hull)

Despite the evidence for elaborate kilns of this sort, there are still a number of problems. In the first place it does not appear to have been really necessary to keep the hot gases away from the surface of the pots; perfectly good red gloss wares could have been produced in an ordinary updraught kiln. Also, the pipes take up a considerable part of the space in the stacking chamber; the pots would have to be stacked around and amongst them and, since there was no door and the kiln had to be loaded through the roof, it is probable that the chimneys had to be rebuilt every time the kiln was loaded and unloaded. On the other hand the pipes provided a means of supporting the roof which otherwise must have rested on the pots themselves. Perhaps this advantage was greater than is realized.

Along with special kilns and firing conditions, red gloss pottery demanded special care in stacking. The evidence of failures, piles of pots which overheated and fused together in the kiln, shows that pots were normally stacked upside down. The reason for this is not always apparent; it seems to have been a part of the tradition of the workshops. Upside down stacking meant that a central support was required for the bottom piece in the pile for if it had to support the whole weight of a pile on its rim it would collapse. Various sorts of stacking rings have been found from plain wads put under plates to rings of clay supporting the insides of vessels. Tall piles of bowls were kept steady in the kiln by

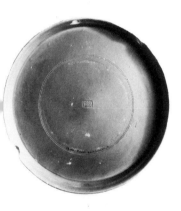

147 (left, above) A plate bearing the impression of the footring of the plate on which it was stacked in the kiln. In the centre is the stamp of the potter Annius Sextus. Diameter $6\frac{3}{4}$ in. **148** (left) A pottery ring used as a kiln support, and **149** (right) how plates were stacked with a pottery ring supporting the bottom plate.

pushing wedges of clay between them. These wedges sometimes have parts of the pattern from two different bowls impressed in their surfaces. The seemingly incredible fact about the red gloss pottery is that, despite the high shine achieved, the surface did not melt, and was not sticky at high temperatures. The clay wedges did not adhere to the pots, nor did pots adhere to one another when they happened to touch in the kiln.

Red gloss pots were fired with a normal oxidizing fire and without restriction of air to the firing chamber. The firing temperature of a number of pieces made in Gaul had been shown to fall in the range of 1050–1200°C.

This description of the making and firing of red gloss pottery is based mainly on evidence from Arretine and Gaulish workshops. From both technical and artistic points of view these workshops were the leaders in the industry, and derivative workshops are based on the same traditions. Inevitably there are differences between the products of the different workshops, and even within the same workshop the hardness of the pottery and the amount of shine on the gloss as well as its colour varied from time to time. From this technical point of view, some of the best pieces were produced in Neronian and early Flavian times in the workshops at La Graufesenque in southern Gaul.

Elsewhere, outside the major centres, derivative techniques and imitations have been examined in less detail so that, for instance, little is yet known about the method of production of the red surface of North African red slip ware, or of the later red colour-coat imitations common in north Gaul and Britain. Certainly, for the latter, the kilns were not specialized as the red gloss ones were, and the surface colour-coat itself is less well-prepared so that, while it is red, it lacks the shininess and adhesive qualities of the proper red gloss.

This general survey of the making of the best and most widespread type of Roman pottery inevitably covers many aspects common to the making of more types of pottery; there are a few other techniques still to be described.

Glazed pottery

Glazed pottery was not particularly common in the Roman period though the techniques were known throughout the Empire and at one time or another nearly every province had workshops producing it. The Roman techniques of glazing seem to have been discovered during the first century BC in Asia Minor or northern Syria, for it is from this area that the earliest and some of the best pieces come. Many of these pieces have moulded relief decoration and were made in exactly the same way as small Arretine vessels. The difference comes in the surface finish which was glazed a honey-brown inside and green outside; the green varies from a rich lime green to a pale colour, or when the surface has begun to disintegrate, to an opaque silvery surface.

Col. **Plate** VI below

Analysis of the glaze shows that it is a lead silicate glass with small quantities of colouring agents, copper in the form of cupric oxide for green and iron in the form of ferric oxide for brown. Experimental firings with glazes made up like this show that they melt readily at a moderate red heat of about 700°C. Roman lead glazes were restricted to green and brown, and it has been suggested that the sand which was the basic ingredient of the glaze contained qualities which prevented the forming of glazes of other colours.

Col. Plate VI below

The firing of glazed pottery poses some problems for once the glaze has melted, the pot will stick to whatever it is touching. For this reason it was normal to place the pots on stilts when in the kiln so that no more than three small points touched the glazed surface. The pot stuck to the stilt and had to be broken off it, but the resulting scars were small. As with red gloss wares glazed pots were frequently fired upside down, so the stilt marks show on the insides of cups and bowls. Also, the glaze was often applied too thickly so that when melted it ran over the surface to form a drip on the upside-down rim of the cup. Solidified drips of glaze are a common feature of glazed pots.

Nowadays it is normal to give a pot a preliminary, biscuit firing before glazing it, and it is usually assumed that the Romans did so too, though there seems to be no certain evidence for it. There is little to indicate the form of the glaze before firing; presumably it was applied as a liquid which could be painted on to the pot in such a way that one colour could be put on the inside and another on the outside. The actual firing seems to have taken place in a 'saggar' or muffle so that the glazed pot was totally enclosed and was protected from the kiln atmosphere. Fragments of the bases of pots which served as saggars have been found at Tarsus, but the best evidence comes from the military workshops at Holt where glazed pots, partly glazed stilts, fragments of saggars and other debris have been found. A tall clay stilt with three spikes at the top was luted into the base of a large bowl which served as a saggar; the glazed bowl was placed upside down on the stilt and a second large bowl was placed over the first so that the glazed bowl was totally enclosed. The evidence for the top cover is largely surmise, but without it the saggars could not be stacked on top of each other in the kiln.

The only alternative to lead glaze was an alkali silicate glaze. Glazes of this sort, producing a blue colour, were used on the eastern fringe of the Roman Empire from Parthian to Sassanian times, but they never gained popularity elsewhere.

Slips, colour-coats and paints

An effective sort of surface finish could be achieved with an ordinary clay slip which was simpler to prepare and to fire than the gloss and glaze surfaces. A slip is merely a liquid form of the clay used to make the pot. Roman slips were

150 Reconstruction drawing showing the method of firing glazed wares at Holt. (after Grimes)

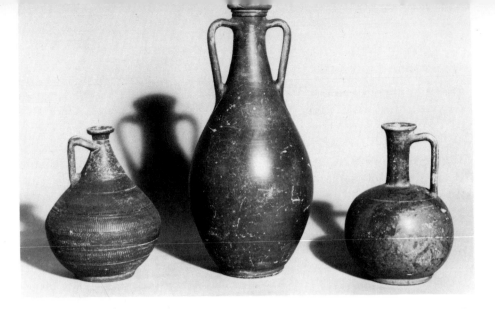

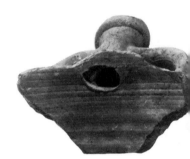

151 Bottles and a flagon from Cyprus. The narrow necks were all made separately and joined to the bodies before applying the slip.

normally coloured with iron compounds so that when fired they produced a deliberately coloured surface which, depending on the oxidizing or reducing atmosphere in the kiln, could vary from red and orange to brown and black. A slip coating could be made up of a different clay provided that adhesion between the slip and the pot was good, and that both had similar contraction rates. This was done successfully in Gaul in the first century AD and in Britain in the fourth century when white, iron-free slips were used to cover pink, iron-bearing clays.

Painted decoration was not common. When used, it took the form of a coloured slip painted onto a contrasting pot surface. Red-brown paints were used occasionally in the east Mediterranean in the first century and in Gaul and Britain in the third and fourth centuries to paint patterns on white ground pots. White paint was used for decorative details and mottoes on dark surfaced drinking beakers in Gaul and Britain in the third and fourth centuries.

Joining of necks and handles

Ordinary coarse pots were thrown in one piece and the extra work of adding pedestals and footrings was not normally necessary; but there was one class of pots where joining was necessary. These were the narrow-mouthed vessels like bottles and flagons. The size of the body of this sort of pot meant that the whole of the hand had to be inserted inside during the throwing of the lower part, and this enlarged the neck so much that it was then too wide to be closed up again without causing the clay to ripple and collapse. Thus, the necks were thrown separately, on a smaller scale, the insides being shaped merely with the fingers. When leather-hard, the neck and the body were joined with a simple butt joint, the two edges being luted together with wet clay and smoothed over on the outside. The insides of the joins were often very uneven and no trouble was taken to smooth them off.

Handles were also made separately and attached to the pot when it was leather hard. They are very seldom round in section, and cannot have been made by rolling. The normal practice nowadays is to pull handles out by hand, and Roman handles show every sign of having been made in this way. A lump of clay is pulled out between thumb and forefinger with an effect like pulling wire through a drawplate; the clay is kept wet and slippery and is squeezed as it is

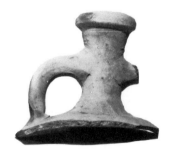

152, 153 Outside and inside views of the joining of a neck with two small handles to the wall of a bottle.

88

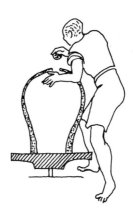
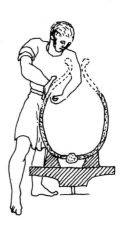

154 The making of a round-bellied amphora.

pulled so that eventually a long straight-sided handle is formed. The cross-section can be controlled to produce a flat or oval shape, and each one varies a little. Once pulled, the handle is left to dry for a while, and is then luted into place on the pot. Sometimes the sides of Roman pots were pierced and the end of the handles thrust through to make a better join.

Amphorae

Large round-bellied amphorae show signs of hand manipulation and of having been made on a wheel; also, they were quite definitely shaped at both the neck and the base, yet they do not appear to have been made in pieces. Adam Winter has shown how they could be made.

154 A large cylinder of clay was built up or thrown on a low level wheel or turntable. The upper half of this was then worked into the shape of the lower half of the amphora; the top was drawn in as tight as possible and the final hole was blocked with a clay stopper. The pot was then turned over and set up on the wheel again with the curving base mounted in a collar of clay. The upper part of the pot and the neck were then shaped and the handles put on. The shaping of the body of the amphora seems to have been done by a combination of throwing and manipulation, for both rotation marks and finger marks are clearly visible on the inside.

Regional differences

The Roman Empire embraced many different sorts of people and it is not surprising that there were considerable differences in the pottery from one region to another. In the first place cultural habits differed and this affected the shapes of vessels. Harald von Petrikovits has suggested that the shapes of drinking vessels reflect the posture of diners at table. Around the Mediterranean, people reclined to eat and drink so their cups are shaped like shallow open bowls. In the northern provinces people sat upright at table, so drinking goblets with tall vertical shapes and narrow mouths were used.

 Secondly, climatic conditions dictated different ways of life. Most vessels, even cooking pots, made in the northern provinces have flat bases suitable for standing on concrete floors or wooden tables. Around the Mediterranean many cooking pots have round bottoms more suitable for standing on the ground

than on a flat surface. No doubt many Mediterranean cookhouses had bare earth floors, or cooking was done out of doors.

A third difference seems to be due purely to tradition. Around the Mediterranean it was usual to fire pottery in an oxidizing atmosphere with an open fire, with the result that most pots are white, yellow, buff or red. In the northern provinces grey and black pots are far commoner than light coloured ones, and it is clear that they were deliberately fired in a reducing atmosphere. There is no doubt that it was easier to produce buff pots than grey ones, for an oxidizing fire is the normal open fire with plenty of draught. The persistence of the grey tradition in the north cannot be explained in any logical way; it appears to have been merely what the people were used to.

Experimental kilns

The problems of reduced firings and producing grey wares have been the object of a number of experiments in recent years. Some of the most successful have been performed by Geoffrey Bryant at Barton-on-Humber, Lincolnshire. Bryant has built and fired a total of six updraught kilns of Roman type. Not all have been satisfactory, but he has now established a reliable method of obtaining grey wares, and has learnt much about Roman kilns at the same time. His results may be described by reference to his fourth kiln—a successful one. This was a normal Roman-type updraught kiln with a single flue. It was three feet in diameter, and the walls of the stacking chamber were 2 feet 6 inches high; the top was left open. The advantage of the open top was apparent when stacking the

155 Geoffrey Bryant's experimental kilns 4 and 5 after firing.

pots in the kiln; the stacking could be done better and far more quickly in an open kiln than it could in one which was partially domed. Initially the kiln was fired without covering the top at all; gradually the pottery hardened, and when it was considered strong enough to be able to bear the weight, a domed roof of pre-fired plates of clay and tiles was built on top of it. The roof was finished off with a thick layer of turves and clay. All the while the fire burned without restriction and the atmosphere in the kiln was oxidizing and the pottery was buff. After nine and a half hours the temperature had risen to about 900°C and the firing had reached its peak. The kiln was stoked up for the last time and the flue and the vent in the roof were sealed. The result of closing the flue and the vent was that the final load of fuel burned with a very restricted supply of oxygen and the atmosphere in the kiln changed from oxidizing to reducing. Provided the air seal could be maintained this was sufficient to change the colour of the whole load of pots from buff to grey.

Bryant's kilns were burning about five cwt of timber to raise the temperature of the kiln to 900–1000°C. This is the sort of temperature at which many ordinary hard grey and buff wares were being fired though considerably lower temperatures gave sufficient fabrics; round-bellied Spanish amphorae, for instance, were fired at only 500–700°C.

Bibliography

Greek Techniques
Noble, J. V., *The Techniques of Painted Attic Pottery*, New York, 1965

Red gloss techniques
Bimson, M., 'The Technique of Greek Black and Terra Sigillata Red', in *Antiquaries Journal*, 36, 1956
Hull, M. R., *The Roman Potters' Kilns at Colchester*, London, 1963
Winter, A., 'Die Technik des griechischen Topfers in ihren Grundlagen', in *Technische Beitrage zur Archäologie*, I, 1959

Glazed pottery
Caley, E. R., 'Chemical Examination of Roman Glaze from Tarsus', in *American Journal of Archaeology*, 51, 1947
Grimes, W. F., 'The Works Depot of the XXth Legion at Holt', in *Y Cymmrodor*, 41, 1930

Kilns
Corder, P., 'The Structure of Romano British Pottery Kilns', in *Archaeological Journal*, 94, 1957

Modern experiments and analysis
Bryant, G. F., 'Experimental Romano British Kiln Firings', in A. Detsicas (ed.), *Current Research in Romano British Coarse Pottery*, London, 1973
Tite, M. S., 'The Determination of the Firing Temperature of Ancient Ceramics', in *Archaeometry*, 11, 1969

D. M. Bailey

7 Pottery Lamps

The need for artificial lighting in Roman times was largely met by torches, candles and lamps. Torches, made with or holding inflammable substances, were used mainly outdoors or on religious occasions, where their smokiness did not matter. Candles, of tallow or beeswax, were used, but more often in those parts of the Empire which did not cultivate the olive. Lamps employing olive oil as a fuel were used in vast numbers in all parts of the Empire, but especially where the oil was produced locally or where, as in Rome, its importation was a matter of course. Lanterns were merely wind-proof holders of lamps and not an alternative means of lighting.

Roman lamps are basically very simple objects, although the various features could be elaborated for functional or decorative reasons. A lamp has an oil-chamber to contain the fuel and a filling-hole to introduce the oil. It has a nozzle and a wick-hole to hold the wick, which was made of any soft, fibrous substance capable of feeding fuel to the flame by capillary action; linen was probably the most frequently used wick material. An increase in the lighting capabilities of a lamp could only be brought about by an increase in the number of nozzles. Very often the lamp was supplied with a handle, which was occasionally sur-mounted by a decorative feature, a device borrowed from bronze lamps. Little else was borrowed; clay lamps follow their own line of development and owe little to the shapes of metal lamps. However, hinged lamp-lids, to cover the filling-hole, were sometimes copied from bronze examples. The discus and the shoulder which together form the upper surface of the oil-chamber were often decorated to make the lamp more attractive. For the same reason lamps were frequently modelled in various plastic forms, in the shape of human heads, of animals and other subjects.

178

Lamps were made in a variety of materials, cast in bronze and lead, wrought in iron, beaten up in gold and silver, blown in glass and carved in stone. These are all techniques which are dealt with in other chapters in this book; they are not those of lamp-makers but of metal workers, gold- and silversmiths, glass-makers and stone carvers. Pottery lamps, however, were the products of specialist establishments, not necessarily very large, or of workshops which, while also making pots or terracotta figures, regarded lamps as one of their major lines. This chapter will discuss the manufacture of pottery lamps only.

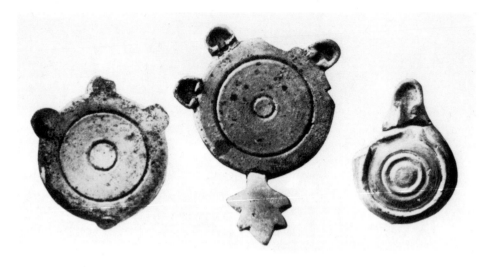

157 Clay archetypes from Pannonia. Second to third century AD.

Until late Roman times, Roman pottery lamps passed through a variety of forms and fabrics. From about the second century BC they were essentially mould-made products and the comparatively few wheel-made and hand-modelled examples can virtually be ignored. Wheel-made lamps represented a minor part of a pot-maker's repertoire, and potting techniques were used throughout; they are unlikely to be the products of a full-time lamp-maker. It is certain that most lamp moulds throughout the Empire were made of gypsum plaster, though few actual examples survive. Indications on the lamps themselves point to the use of plaster rather than clay for the moulds, for instance, raised globules caused by the broken air-bubbles which form when plaster is mixed and poured. The very scarcity of clay moulds in itself shows that some other substance was used, one which would tend to break down on burial except in very dry climates; it is significant that it is in Egypt and Tunisia that a number of plaster moulds have survived. In the following discussion it should be borne in mind that plaster was the material used for moulds, as the special characteristics of this substance, such as its tendency to harden very quickly, dictate some of the methods used in lamp production. However, moulds in other materials will also be mentioned.

To produce a new lamp the maker would normally need to construct an *archetype* which, when finished, would exhibit the shape and all the details, decorative and functional, of the proposed lamp, except that it would be solid, not hollow. From this archetype the lamp *mould* would be taken. Although wood or hardened plaster could conceivably have been carved to form such an object, surviving archetypes are of fired clay, and it is probable that most archetypes were of this material. The lamp shape was modelled in wet clay, the final shaping being done by carving when the clay was in a leather-hard condition. The body would thus be formed and with it the nozzle and handle (where the latter was wanted), and perhaps a decorative feature above the handle. The handle would not be pierced, nor would the filling or wick holes, although these holes were sometimes indicated by slight depressions. The base would be shaped at this stage, either with a slightly raised base, flat underneath, or with a base-ring.

This comprises a fully-formed archetype which, if fired, could be used to produce a mould for plain, undecorated and unsigned lamps. Indeed, such a mould would also be suitable for the production of solid, plain archetypes to be

158, 159 Two views of a basic clay archetype.

94

used as the bases for decorated forms; this would obviate the trouble of shaping each archetype from scratch. However, if the lamp-maker wished to produce decorated lamps, various additional processes would have to take place. The simplest decoration is the impressed pattern which is almost entirely confined to the shoulders of lamps; sunken designs on the discus are very few and far between. These impressed shoulder patterns were normally produced by poinçons, individual stamps of fired clay, carved wood or plaster, or metal, used to make a series of patterns, such as a row of ovules or a wreath of sunken leaves. This was done directly into the shoulders of the archetype while the clay was still in a soft enough condition to take the impressions; such patterns were not stamped into the lamps. In the same way, a poinçon with the maker's mark, initials or name, in reverse lettering, could be stamped into the base of the archetype though never into the lamps themselves. Impressed designs on lamps

160 Sunken patterns around the edge of an Italian lamp. About 75 AD.

161 The maker's name on the base of a lamp, made by impressing a name-stamp into the base of the archetype. An Italian lamp of the early second century AD.

162, 163 Cursive, handwritten names, inscribed in the archetype, appearing as moulded signatures on lamps from Cnidos. Early second century AD.

164 (above) Clay archetype with added details. Athenian, first century BC. **165** (below) A lamp-maker's clay poinçon from the military pottery at Holt, North Wales.

could also be produced by incising freehand into the archetype. This was often done with cursive signatures, although such signatures may occasionally have been written into the lamps after they had left the mould, rather than into the archetype. However, as far as one can tell this was rarely done.

To produce a mould-made lamp with patterns in relief, the archetype must also have the patterns in relief. It is impossible to impress patterns into a plaster mould, as by the time the mould is hard enough to remove it from the archetype —a very short time indeed—it is too hard to be stamped. Relief designs can be built up on the archetype by hand or perhaps carved directly by the craftsman. However, many of these patterns were mould-made and were then luted on to the archetype, in the same way as the reliefs are nowadays applied to Wedgwood Jasper Ware and to Doulton stoneware vases, and as relief decorations were applied to certain Hellenistic wheel-made lamps from Cnidus. The moulds which produced the appliqué patterns for the archetypes were often of plaster and occasionally of clay. They were made by using poincons or by moulding from any appropriate relief, sometimes from an already existing lamp which might be an imported one, or the product of a rival firm. The appearance of the same

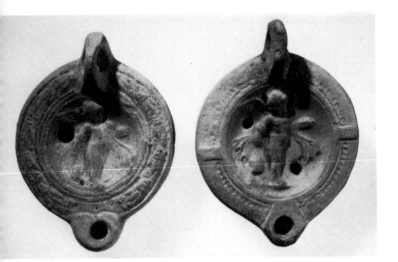

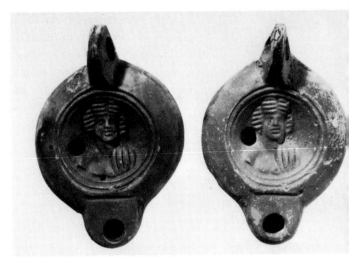

patterns on lamps by different makers (figs. 166 and 167) may argue itinerant poinçon-makers, or plagiarism, or simply harmonious relationships between workshops, with an exchange of tools. These open, one-piece moulds may perhaps be called poinçon-moulds (from their method of manufacture) or appliqué-moulds (from the purpose to which their products were put); their sole use was in the production of a decorated archetype.

In addition to the relief designs on the discus, raised patterns on the shoulders of lamps were also produced by poinçon-moulds from which appliqué motifs were taken and applied to the archetype. Complete shoulder patterns, such as a raised wreath or a row of vine tendrils, might be taken from one curved poinçon-mould, or a series of small designs could be moulded and applied individually in a row, as in the sunken shoulder panels of fifth century African red slipware lamps. Indeed, one obliging Tunisian lamp-maker used a coin of Theodosius II as a poinçon to produce the poinçon-mould from which he made the appliqué motifs which he cut to fit the sunken shoulder panels of his archetype. Inscriptions in relief, such as those found on *Firmalampen* (rather dull and utilitarian lamps made in Italy and the North-west Provinces from Flavian times until well into the third century AD) were also formed by applying the products of poinçon-moulds, in these cases moulds of the makers' names, to the bases of archetypes.

Mould manufacture

When the archetype was finished, complete with applied relief decoration, and perhaps signed, it was fired and was then ready for a *mould* to be taken. These were usually two-piece moulds consisting of an upper and a lower part, though some complex forms, especially plastic lamps, required three-piece moulds. Wet plaster was poured around the archetype up to the level of the intended join of the two halves of the lamp. In most Roman lamps this was at the widest points, at the edge of the shoulder. When the plaster had hardened, registration hollows (fig. 171) were cut into the upper surface of the edge of the mould or registration bosses were built up on it. Then, while the lower half of the archetype remained embedded in the lower half of the mould, more wet plaster was poured over the upper surface and into and over the registration hollows and bosses.

166 (above left) Tunisian and Cypriot lamps with identical discus reliefs. Second century AD.
167 (above) Tunisian lamps with identical discus reliefs, but by different lampmakers. Second century AD.

168 (above) An appliqué or poinçon mould from a Cnidian lamp. Early second century AD.
169 (below) Maker's name in relief on a North Italian *Firmalampe*. About 100 AD.

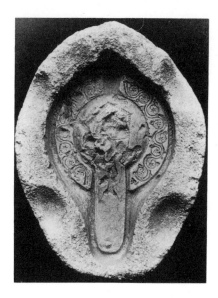

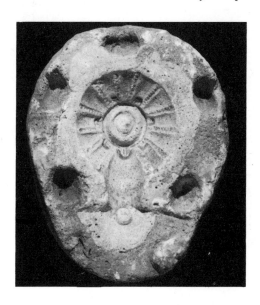

170 (right) Plaster mould for the upper half of an African red-slip ware lamp. Fifth century AD. **171** (far right) Plaster mould with registration bosses and hollows. Egyptian, first century BC.

175

Thus the upper half of the mould acquired a complementary set of bosses and hollows which ensured that the two halves of the mould were brought together accurately when lamps were being made. Occasionally, the outer edges of the moulds were marked instead, and these marks were lined up during the manufacturing process. In order that the archetype might be released easily, it would also have been necessary to oil or grease it before taking a mould, and also to oil the edges of the lower mould before pouring on the plaster of the upper mould. As many parallel moulds as the maker required would be taken as long as the archetype lasted undamaged; it could conceivably remain in a workshop for decades. The presence of parallel moulds—a necessity if a high level of production was to be maintained—is demonstrated by the differing positions of air-bubble globules on lamps which, at first sight, appear to be from the same mould.

172 Clay mould for the lower half of an Athenian lamp. Late first to second century AD.

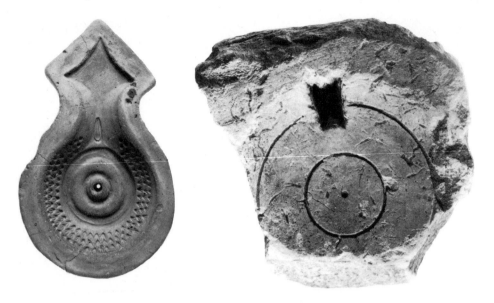

Moulds were also made in clay, a slab of wet clay being pressed over the archetype and levelled off at the point where the two lamp halves would join. When the clay had hardened sufficiently (but not to a stage where shrinkage of the clay due to water loss would have caused it to crack on the solid archetype) the registration hollows would have been cut—or bosses built up—and the other half of the mould made by pressing on a further slab of wet clay over the remaining exposed area of the archetype. When removed from the archetype, the clay mould was still soft and further decoration could be carried out on it either by manual incision or by stamping with poinçons, as in the case of late Hellenistic or early Roman lamps from Ephesus. When complete the clay mould would have to be fired before use. Moulds were also made by carving directly into soft limestone. This technique was used in Hellenistic Cyprus and also by some Jewish lamp-makers in Roman Palestine in the second half of the first century and the first third of the second century AD. The clear use of compass-drawn patterns in these moulds is apparent from many of the surviving lamps.

173

174

Casting from moulds

The mould, whether of plaster, fired clay or limestone, was now ready for use in the production of lamps. A thin sheet of wet clay was pressed firmly into one half of the mould, making sure that a sufficient quantity was pushed into the deep handle recess. The edges of the sheet were trimmed slightly proud of the edge of the mould. This action was repeated for the other part of the mould. The edges were moistened slightly and the two halves were brought together, the registration hollows and bosses ensuring that the pieces were positioned correctly. Indeed, the presence of these hollows and their complementary bosses (or of registration grooves) on practically all surviving moulds shows that the lamps were joined *within* the moulds and that the two parts of the lamp were not made separately and joined after removal from the mould. As the two halves of the mould were pressed together, most of the excess clay at the edges was forced inside the lamp forming a ridge of clay along the join and acting as an

175 Registration marks showing the correct way to assemble the two pieces of a mould from Ephesus. Sixth to seventh century AD.

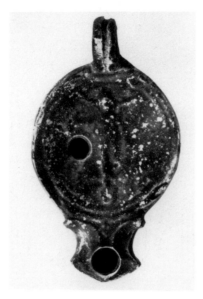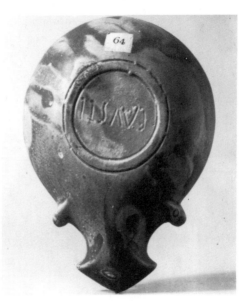

176 (right) Mould-made lamp with applied handle. Cologne, first century AD. **177** (far right) Fingermarks in the slip on the back of an Italian lamp. Early first century AD.

internal reinforcement. The lamp was removed from the mould when it had hardened sufficiently for it to be handled. With plaster moulds this stage was reached in a comparatively short time as plaster takes up water readily and much more easily than fired clay. After removal from the mould the lamp was left to dry until it was leather hard; then the web of clay on the outside of the join was pared away and any necessary touching up was carried out. The products of worn and blurred moulds might well need retouching; such moulds were themselves occasionally retouched so that the resultant lamps often differed markedly in detail from earlier products. Also at the leather-hard stage, the filling-hole and the wick-hole were pierced with hollow tubular tools and the hole in the handle was cut. Where a handle was required but had not been formed in the mould, as on many lamps of the early first century AD from the Rhine

176

frontier and on rather later lamps made in south Russia, it would be fashioned and applied at this stage. If the maker's name was not produced by the mould, it could be incised at this time; impressed inscriptions could only be formed in the mould as the unfired lamp would collapse under the pressure of a stamp.

When the lamp was completely dry a coating of slip was normally applied. This was usually done by dipping, submerging the lamp quickly and com-

177

pletely in the slip medium, as the finger-marks show. In most cases the slip was a thin solution of the clay of which the lamp was made, its iron-rich composition, together with the firing conditions, determining the final appearance of the completed lamp. In addition to producing an attractive surface coloration, the slip was applied to make the clay body less permeable to the oil used as fuel. With most Roman lamps, the thinly-applied or badly-applied slip would have had little such effect and much less, for example, than the almost non-porous sintered black glaze used in the interiors of many Greek lamps from the sixth century BC onwards (Greek black 'glaze' had much the same composition as the Roman slip but was more thickly applied). Unslipped or inadequately-slipped lamps absorb oil rapidly, until the whole fabric is permeated and the outer surface is glistening and sticky; this must have been accepted as inevitable by

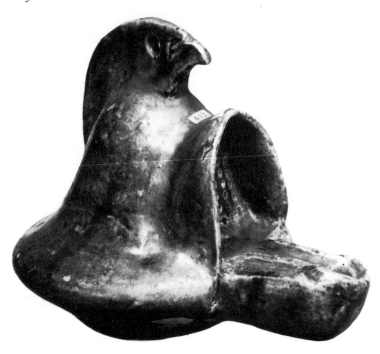

178 A helmet lamp with a vitreous green glaze. From Cologne, about 200 AD.

ancient users of pottery lamps. Other surfacing materials include vitreous glazes, probably employed at Corinth in the early years of the first century AD and at Memphis in Egypt a little later, and certainly used in Campania during the last third of the first century, perhaps in Central Italy in the second century, and at Cologne at the end of the second century, and doubtless in other parts of the Empire. A vitreous-glazed lamp, unlike most slipped lamps, was oil-tight, but its production normally involved two firings, a biscuit firing and a glaze or 'glost' firing. Some of the vitreous-glazed lamps from Pompeii and Herculaneum may well have been made overseas and imported in a normal slipped state, only to be glazed by another potter in Campania; certain green-glazed lamps with leaf-shaped handles and horse-head volutes are almost certainly Cnidian in origin, although the glaze has every appearance of being Campanian. On the whole, vitreous-glazed lamps were not common. Another surfacing technique occasionally employed in Britain and Germany was mica-dusting: this was purely decorative.

Normal Roman lamps, whether with a slipped surface or without, received only one firing. The kilns varied in constructional details, materials and size, according to local usage and the size and output of the establishment, but were basically the same updraught type of kiln as was used for pottery, and described in Chapter 6. The lamps were stacked in the kiln, one on top of the other, base on shoulder, as surviving wasters and kiln stacking-marks show. There was no need for stilts as, unlike objects coated with a vitreous glaze, the lamps did not stick to one another. Larger pieces of kiln furniture, supports and plates, were no doubt used to make the kiln loads more stable. Firing temperatures were probably between 800°C and 1000°C; there was undoubtedly a fair range of temperatures within the kiln during firing and this affected the appearance of individual lamps from the same kiln-load.

179 A kiln-stacking mark curving across the base of a lamp.

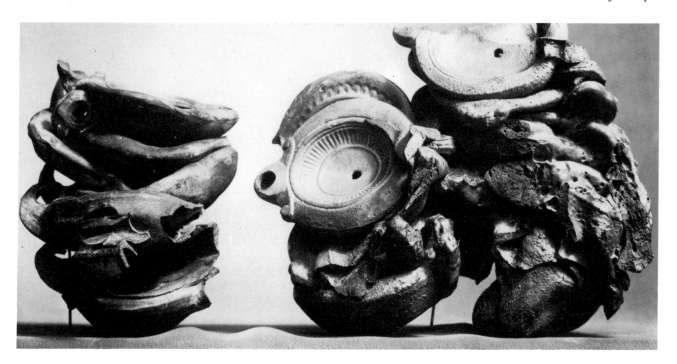

180 Wasters from Ephesus. Late first to early second century AD.

Distribution of lamps and lamp-makers

Details of the organization of workshops and of marketing are practically un-known, other than what can be inferred from the evidence of the lamps them-selves and from studies of the distribution of exported lamps. Local ateliers grew up wherever there was a demand, but lamps of finer workmanship or of unusual shape were always saleable in areas far from their places of manufacture. Indeed, local lamp-makers often used imported lamps as archetypes, from which they took moulds; the lamp industry in Cyprus in the first century AD was almost 181, 182 wholly dependent for its archetypes on imported Italian lamps. The products of the moulds made in this way were often, in their turn, used as archetypes. This continuing process frequently resulted in a tangled web of interrelated moulds and lamps of varying generations, the designs often retouched manually, both on lamp and in mould, the products becoming smaller and more blurred as they became more distant from the original imported archetype. Thus, Italian lamps were exported in the first century BC and in the first century AD, but more often to the west, to the north and to western North Africa; even in the second half of the second century Africa was still importing Italian lamps, although by this time large lamp workshops had been established and were producing lamps copied from Italian shapes. The North Italian *Firmalampen* factories exported to the North West Provinces from about AD 75, and their shapes and the names of some of the principal makers were plagiarized by local makers. Lamps signed Fortis are a case in point, but it is equally possible that some of the North Italian makers followed the flag, leaving Italy altogether to open new workshops where they felt it was a commercial proposition to do so. One North Italian workshop, that of Phoetaspus, appears to have had a branch in Egypt. The parent firm made *Firmalampen*, but the branch made other shapes; both signed

101

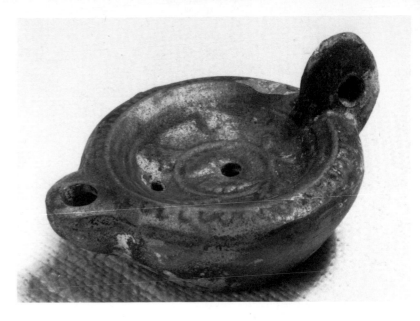

their products with closely similar relief letters. But again, it is possible that the Phoetaspus workshop moved from North Italy to Egypt; the chronological evidence is, at present, insufficient to prove this one way or another. A move in the opposite direction, from Egypt to North Italy is not likely, as the form of the signature is North Italian.

Exotic, well-made lamps, backed by a vigorous export consciousness, could find a market over wide areas of the Empire, a fact exemplified by the distribution of Central Italian lamps in the first century BC, of Cnidian products in the late first and early second centuries AD, of North Italian *Firmalampen* of the same date, of Tunisian red-slip lamps of the fourth and fifth centuries and, to a lesser extent, of Ephesian lamps in the sixth and seventh centuries.

It is difficult even to generalize on workshop organization, as few facts are known and changes of circumstances were inevitable in the hundreds of years of the Roman Empire. It seems likely that the smaller establishments were family affairs, probably employing no slave labour; the plethora of Central Italian lamp-makers of the second century AD who signed their products with the *tria nomina* were probably small family businesses of this kind. But among these and amongst the makers of similar lamps in Tunisia, were larger workshops with very high production in which slave labour was probably involved. One sign of the presence of slave or perhaps employed workers, as distinct from family labour, is probably to be inferred from the mould-marks found on many Italian lamps of the first century AD. These were produced by marking the mould, usually by incising a simple sign or letter, in order that its products could be recognized and distinguished from the products of parallel moulds made from the same archetype. Thus a check could be kept on the output of a particular mould and hence on a particular worker. These mould-marks are rare after the first half of the first century AD. The products of the Romanesis workshop at Cnidus exhibit the proprietor's name written in various hands. At first sight this seems to be a sort of checking system; however, the different varieties of the name were written into the archetypes and not into the lamps, which would seem to preclude a checking system as all moulds made from a particular archetype would have the same signature.

181 (left) An Italian lamp and 182 (above) a Cypriot copy, both of the second half of the first century AD.

183 A mould-mark on a signed Italian lamp. Mid first century AD.

To sum up, the procedures used by Roman makers to manufacture pottery lamps are fairly clear, despite the fact that very few workshops have been excavated properly, and many of the techniques employed can be inferred only from the lamps themselves and the properties of the materials used in their production. Some lamps would have required fairly complex methods in the production of their archetypes and subsequent moulds, but methods which were quite within the capabilities of craftsmen accustomed to handling clay, plaster and related materials.

Bibliography

Manufacturing techniques are discussed in:

Bailey, D., *Greek and Roman Pottery Lamps*, London, 1972

Bernhard, M. L., *Lampki Starozytne,* Warsaw, 1955

Broneer, O., *Corinth, Volume IV, Part II, Terracotta Lamps,* Harvard, 1930

Fremersdorf, F., *Römische Bildlampen,* Bonn, 1922

Perlzweig, J., *The Athenian Agora, Volume VII, Lamps of the Roman Period,* Princeton, 1961

Archetypes

Bailey, D., 'Lamps in the Victoria and Albert Museum', in *Opuscula Atheniensia,* 6 (1965)

Nicholls, R. V., 'Type, Group and Series: a Reconstruction of some Coroplastic Fundamentals, in *Annual of the British School at Athens,* 47 (1952)

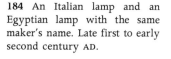

184 An Italian lamp and an Egyptian lamp with the same maker's name. Late first to early second century AD.

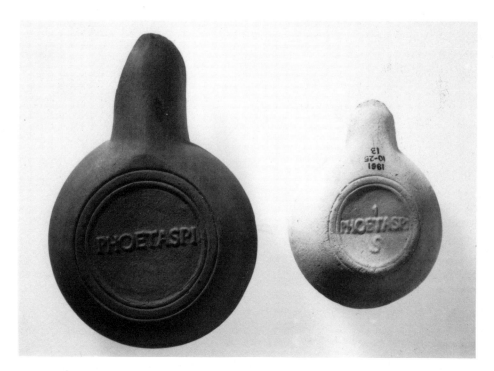

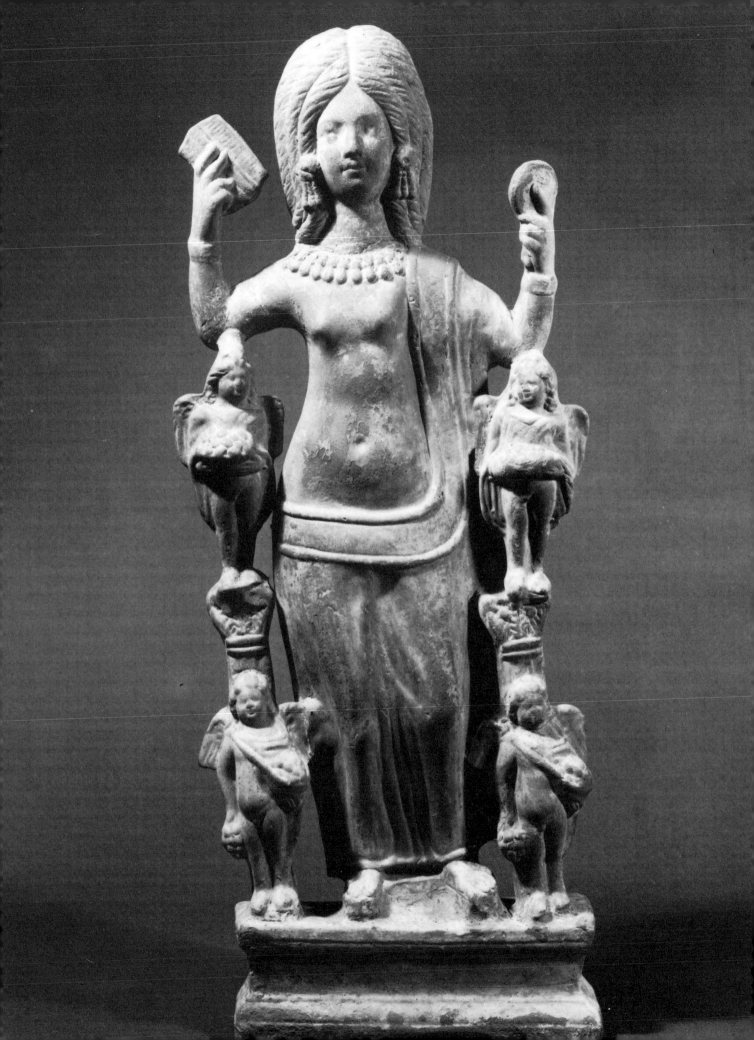

Reynold Higgins

8 Terracottas

It must be admitted that terracotta figurines did not have the same appeal in the Roman Empire as they had enjoyed in the Greek world throughout the seven centuries between the Archaic and Late Hellenistic period. The principal cause of the decline was evidently the growing cheapness of bronze; but a craft with such a history was bound to take a long time to die, and in fact it survived the first three centuries of our era.

In the eastern part of the Empire, with its Greek traditions, standards were still high in the first century AD but rapidly declined thereafter. In the Latin and Gallic west, lack of Hellenic tradition was compensated to a certain degree by a greater vitality. But the advent of official Christianity in the early fourth century put paid throughout the Empire to a craft too deeply rooted in paganism to survive.

The maker of terracottas was known in the Greek east as a *koroplathos* or *koroplastes*, whence the English term *coroplast*. In the Latin west he was called *plastes* or *fictor*. His craft was humble and was carried on in the courtyard of his house by the entire family with a few apprentices and perhaps a slave or two.

The earliest stages, the getting and refining of the clay, need no comment here, since they are exactly the same as for pottery. Sufficient to say that the clay must have many qualities: it must be plastic, to be workable; porous, so that moisture can easily evaporate from it; vitreous, to harden in the firing; and it must contain sufficient inert matter to hold up the shrinkage in drying and firing, which in a pure clay is of the order of 10 per cent. Consequently it was frequently necessary to mix different clays, or to add inert matter such as sand.

In general, the coroplast used the same sort of clay as the potter. In two areas of the Gallic west, however, the valleys of the Rhine and the Allier, they used
186 pipeclay, a secondary clay of great purity, comprising almost pure kaolin. This clay is not sufficiently plastic to be thrown on the wheel, but is quite capable of being moulded.

Manufacture

Archetypes. Roman terracottas were regularly moulded. For this process the first requisite is an archetype (sometimes known as a patrix), from which a number of moulds may be taken. An existing figurine of terracotta or some other material

185 A large composite terracotta figurine: Aphrodite with attendant Erotes bearing baskets of fruit. From Asia Minor, about 200 AD. Height 23 in.

would serve if it was of a very simple nature, but in general the archetype was modelled by hand, in clay. Sometimes, to save labour, the back was modelled with much less detail than the front. If the archetype was very simple, it was fired in the complete state, and was ready for use.

If, however, it was at all complicated, projections such as heads, arms, legs, or wings were cut off and fired separately, to be the basis for separate moulds. Such an archetype is illustrated in fig. 187.

Moulds. These were made of terracotta or plaster. To make a terracotta mould, the craftsman presses wet clay over the archetype, or section of archetype, until the required thickness, a half inch or so, is reached. When the enveloping clay has dried it is cut and removed in two sections. For a human figure the two sections will usually be for front and back; for an animal possibly for the two sides. Occasionally, if a female figure has an elaborate skirt, a third wedge-shaped part-mould may also be taken from the archetype, as seen in fig. 196. This is as near to piece-moulding as was reached in the pottery industry in antiquity. After removal, the moulds are touched up and fired and are ready for use.

186 (far left) White pipeclay figurine of Venus. Gallo-Roman, second century AD. Height 5½ in. 187 (left) Terracotta archetype for a mould. Attic, late fourth century BC. Height 6¼ in.

106

188, 189 (above) Terracotta mould for a female figure and a modern plaster impression taken from it. From Taranto, first century AD. Height 9½ in. 190, 191, 192 (below) Pipeclay mould for the body of a horse, and a modern cast taken from it. The legs and tail were made separately and added later. The outside of the mould was signed by the maker, Sacrillos. From St Pourcain sur Besbre, Allier, second century AD. Maximum length 6½ in.

Plaster moulds were made in exactly the same way as for lamps. They were easier to make, and more absorbent than terracotta, but had a very short life: after between fifty and a hundred pressings they were finished.

Moulding. The craftsman now takes a half-mould, dusts it with a little powdered chalk, and presses wet clay into it to the thickness of about one tenth of an inch. He then does the same to the corresponding half-mould. The edges of clay are scored and brushed with slip and the half-moulds are brought together, lined up on guide-lines which have been set out on their edges and securely tied.

Assembling. When the clay has dried out, the moulds are removed. Sometimes, after the necessary touching up, and the cutting of a vent in the back, the cast is complete. In more complicated pieces, various additions such as a hand, limbs, wreaths, etc. either moulded solid or hand-modelled, are attached with slip or slotted in. Occasionally the name of the maker or workshop-proprietor was inscribed on the back of the figurine.

Finally, the whole piece, or in some cases the front only, was covered with a slip of white clay as a basis for the decoration which was to be put on after firing.

Firing. The piece is now fired in a kiln up to a maximum temperature of 950°C.

193 (above) Plaster mould for a fish, with a modern plaster impression. Probably from South Italy, first century AD. Length $3\frac{1}{2}$ in. 194, 195 (below left) Front and back views of a terracotta figure of a boy. From Myrina, Asia Minor, early first century AD. Height $7\frac{1}{4}$ in. 196 (below) Terracotta figure of Aphrodite with separately made arms. Made at Myrina, early first century AD. Height $10\frac{3}{4}$ in.

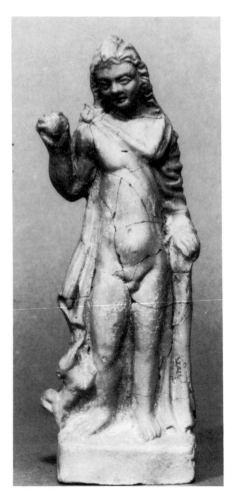

197 A top view of the composite terracotta seen on page 104, showing the crack along the line where the two halves of the main figure are joined.

Decoration

Col. Plate VII

Polychrome. After firing, a figurine was as a rule decorated with bright colours laid over the white clay slip which had been applied before firing. The colours, mostly natural products, were applied with a brush. To produce a kind of tempera paint, there must have been an organic binding medium, such as gum, albumen or honey, but such materials are very perishable, and none has yet been identified.

The composition of the colours is as follows:

Red is usually red ochre (also called haematite); or less commonly vermilion (also called cinnabar), a natural mercuric sulphide occurring in Asia Minor.

Pink is either a mixture of red ochre and chalk; or rose-madder, made from the root of the plant *Rubia tinctorium*, which has a slight purplish tinge.

Yellow is yellow ochre.

Blue is a substance known as Egyptian blue (or blue frit). It is made by heating a mixture of silica, malachite, chalk and natron. At first it was imported from Egypt, but later it was made in Italy—Vitruvius says at Puteoli (the modern Pozzuoli).

Green is malachite, a common copper ore.

Black is either soot or bitumen.

White is either chalk or gypsum.

Red gloss and vitreous glaze. Some terracottas were covered with a variety of the typical red gloss used on pottery; others were occasionally glazed with a yellow or green vitreous glaze. Glazed terracottas belong to the first centuries BC and AD.

Gilding. Roman terracottas were occasionally gilt, either completely (to imitate gilt bronzes) or partially. This practice was particularly common at Smyrna in the early years of our era. Gold leaf was applied either directly to the surface or over a layer of yellow or white underpainting. Whatever adhesive may have been used has long since perished and cannot be determined.

198 The god Bes, a red-slip coated terracotta figure from Alexandria. First to second century AD. Height 6¾ in.

Bibliography

Besques, S., *Figurines et Reliefs du Musée du Louvre*, III, Paris, 1972

Higgins, R. A., *Greek Terracottas*, London, 1967

Rouvier-Jeanlin, M., *Les figurines gallo-romaines en terre cuite au musée des antiquités nationales*, Paris, 1972

110

Jennifer Price

9 Glass

Glass had been made for at least 2500 years before Augustus became the first Roman emperor. Glass objects such as beads are known from about the middle of the third millennium BC, hollow vessels appeared in Mesopotamia a little before 1500 BC, and soon afterwards in Egypt as well. The glass industry in both areas almost died out after 1200 BC, but revived in Mesopotamia and North Syria in the ninth century, and in the next 500 years spread to Italy and perhaps also to Cyprus and Rhodes. The products from these centres were exported widely in the Mediterranean area, though one small group of jugs and alabastra, dating from the seventh to the fourth centuries, is only found in Italy, and a few cups of the later sixth or early fifth centuries occur only in graves at Hallstatt in Austria and at Santa Lucia de Tolmino to the north of Trieste. Pieces of glass in clay moulds found in the workshop of Phidias at Olympia show that glass was certainly being made in Greece in the middle of the fifth century.

There was a change in the centres of glass production during the Hellenistic period: from the late fourth century onwards there is no evidence of glass manufacture in Mesopotamia for two or three centuries, but Syria continued to be an important centre, and glassmaking was introduced into Alexandria soon after the foundation of the city in 332 BC and it rapidly became the dominant centre of production. In this period glass vessels became much more common than they had been in earlier times, and it is probable that workers from both Syria and Alexandria migrated to other regions whenever a sufficient demand arose—to Rhodes, perhaps to Greece and Pergamum in Asia Minor, and certainly to Italy.

Five main methods of making glass vessels and objects were available to the Roman glassworker. These were: applying molten glass to a pre-formed core; constructing vessels by arranging sections of glass rods around a pre-formed core; grinding from a block of glass; casting in open or closed moulds; and blowing. The first four were all used by the pre-Roman glassworkers; the last was invented only in the first century BC and formed the basis of the mass production which characterized the Roman industry.

Most of the vessels found before the Hellenistic period were made by the first of the methods mentioned above, but this method died out completely when the Roman glass industry developed. A core perhaps made of mud mixed with plant

199 The Portland Vase: a cobalt blue amphora cased with opaque white in which the design is cut cameo-fashion in relief. Late first century BC to first century AD.

200 (left) Hellenistic core-wound vessels decorated with marvered zig-zag patterns. **201** (below) Alabastron ground from a block of glass, with broken fragments showing how the inside was drilled out.

fragments was shaped and coated with ground limestone and fixed to a metal rod; this was either dipped into a crucible (or pot) of molten metal (glass), or threads of molten glass were trailed round the core to form the body and neck of the vessel. In addition to the background colour, trails of different coloured glass were often applied and manipulated to form zig-zag patterns on the body. The body was then reheated and marvered (rolled backwards and forwards across a flat surface to make it smooth), the rod and core were removed, and the rim and foot added. Vessels made by this method are found in Mesopotamia, North Syria and Egypt in contexts dating from about 1500 BC onwards.

Vessels made from sections of circular rods built up round a pre-formed core were first made in Mesopotamia. A small number of these vessels, dating from the fifteenth to the thirteenth centuries BC, have been found on sites in Mesopotamia and Iran. Sections of circular rods of different colours were arranged in patterns round a core and fused together. This early mosaic glass must be a distant ancestor of the mould-pressed and ground mosaic vessels made at Alexandria in the Hellenistic and early Imperial periods, but as yet very few vessels which indicate any intermediate stages are known.

When vessels and objects of glass were made by cutting away a solid block of glass the material was being treated in the same way as stone. In the Moh scale for determining the relative hardness of different minerals, glass has a hardness of about 6 and can be cut by harder minerals such as quartz and flint. (The scale is calibrated from 1 to 10 and in it specific minerals are numbered in order of hardness: 1: talc, 2: gypsum, 3: calcite, 4: fluorspar, 5: apatite, 6: felspar,

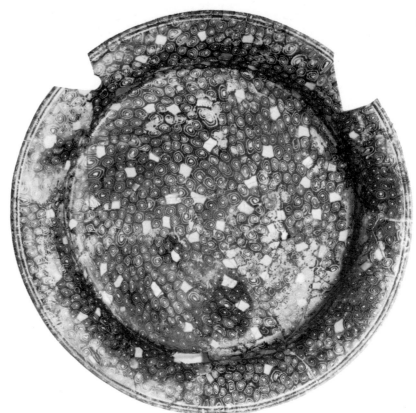

202 (right) Polychrome mosaic plate; fused in a mould, ground and polished. From Canosa, Apulia, late third century BC. Diameter 12 in.

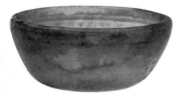

203 Monochrome Hellenistic bowl with two wheel-cut lines inside the rim.

202, 203

Col. Plate V

7: quartz, 8: topaz, 9: corundum, 10: diamond.) To make hollow vessels the inside of the block was ground out or drilled as shown in fig. 201. Vessels made in this way are not very common; more often the basic shape was cast, and the final form completed by cutting and grinding, as was the practice with the plain monochrome and mosaic polychrome vessels of the Hellenistic period.

Casting was not a method of manufacture often used for making the earliest glass vessels but became more common during the ninth to the fourth centuries BC, and was perhaps the most frequently used of the glassmaking techniques then known during the Hellenistic period, both in Syria and Alexandria. It had obvious advantages over the methods already described, as a comparatively wide range of forms could be produced, especially when combined with cutting and grinding. Bowls and jars and other open forms were produced in this way. The glass was either cast by the 'lost wax' method, the molten metal being poured into a mould after the wax had been melted, or small pieces of glass were put into the mould which was then reheated until the pieces inside fused into a solid mass. Alternatively the glass was poured into an open mould and worked into the required form; a plunger mould inside the main mould may have been used to define the inside of an open form. Moulds were also used to arrange pieces of polychrome cane in patterns, a second mould being placed inside to hold the fragments in position while the vessel was being fused. The glass vessels were finished by grinding inside and outside; sometimes the outside would be re-heated after grinding to create a shiny surface.

The invention of glass-blowing completely transformed the glass industry;

it was now possible to produce a wide variety of forms very much more cheaply than hitherto. For the first time glass was treated as an independent substance, with shapes of vessel outside the range of other materials such as stone, pottery, silver and bronze. The exact place and date of the discovery of glass-blowing is not known, but the evidence points to the Syrian coastal area in the middle of the first century BC; a blown flask has been found in a pre-Herodian cemetery at Ein Gedi in Israel, and recently fragments of blown glass, together with cast vessel fragments and glass waste, have been found in a cistern in Jerusalem which again dates from before the Herodian period. By the late first century AD blown glass had almost completely superseded the other methods of manufacture, at any rate for vessels.

Little is known about glass furnaces in antiquity; fragments of glass waste and glass rods were found with small pots and crucibles at the eighteenth Dynasty glassworking site at el Amarna in Egypt, and cuneiform tablets from the library of the Assyrian king Assurbanipal (668–626 BC) describe the building of a glass furnace as well as giving recipes for glass, but apart from these there is little evidence for furnace forms before the Roman period. However, the enclosed glass furnace must have been developed before the invention of glass-blowing because without this it would not have been possible to heat the glass in the pots sufficiently to allow it to be mouth-blown. Excavation has uncovered the ground plans of a few glass furnaces in the Roman empire, as at Cologne (see fig. 204) and Wilderspool in Lancashire, but there is only one contemporary illustration of a glass furnace. This is on a rather worn figured pottery lamp of a type dating from the mid to late first century AD which was found at Asseria in Dalmatia; it seems to indicate that there was an annealing chamber over the pot

205

204 Plan of the glass furnaces excavated at Eigelstein near Cologne showing successive rebuildings of the furnaces on the same site. Overall measurement about 16 feet.

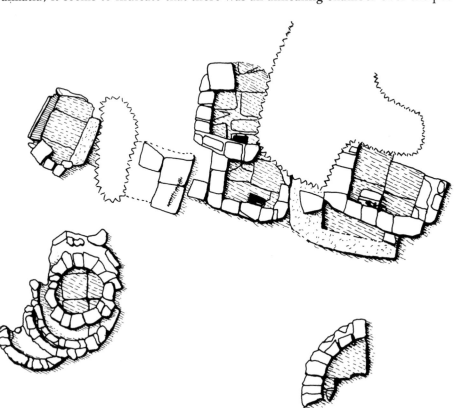

114

chamber. The annealing chamber was a heated area into which the vessels were placed after manufacture and allowed to cool very slowly by gradually moving them away from the hottest part of the chamber, until they could be taken out and stored. The controlled reduction of heat prevented the excessive strain produced by the surfaces of the vessel cooling more rapidly than the interior, and so prevented breakage. This furnace arrangement continued to be used until the Medieval and later periods, though sometimes the annealing oven was built on to the side of the furnace or existed as a separate structure in the glass-house.

The pots or crucibles were made of fireclay and shaped like open jars; some of these were big enough to hold quite large quantities of glass. The carinated pots from the third to the early fourth century glassworking site at Titelburg in Luxemburg were made of whitish, fine-grained refractory clay and measured 10–13 inches in diameter. A fragment from the base and lower body of a crucible found at Silchester had a basal diameter of about 7 inches and, assuming a height in proportion of 12 inches or more, would have held at least 33 lb. of glass. The fireclay pots must have been heated to a high temperature, probably in the furnace itself, before the raw materials for making the glass were put into them.

Roman glass furnaces were undoubtedly wood-fired. This practice was common everywhere until the destruction of the forests made it necessary to change to coal as an alternative fuel. In the late first century AD Plutarch referred to the suitability of tamarisk wood for this purpose, but when this was not available the glassmakers used whatever timber came readily to hand. Supplies of fuel must have been an important factor in determining the siting of glass-houses, as they were in later periods, and no doubt they caused many of the glassworkers to live a rather nomadic life, moving to find fresh supplies when the timber in any one area had been used up. Although many other factors were also involved, such as the large markets in the cities, or the existence of a particularly pure sand, it would have been less onerous to transport the raw materials to the source of fuel than vice versa. Charcoal may sometimes have been used as fuel as it produces a more intense heat than wood.

The composition of glass

The glass used during the Roman period was similar in its constituents to that made in most other periods of antiquity—namely a mixture of silica, soda and lime. The glass 'former' was sand and accounted for about 65–70 per cent of the total; to this was added soda (about 15 per cent), as a flux to make the mass more readily fusible, and lime (about 10 per cent), which acted as a stabilizer making the glass durable and improving the chemical resistance—a simple soda/silica glass would have been soluble in water. The remaining 5–10 per cent was made up of various impurities in the ingredients used. Almost any sand, washed and pre-heated to remove the extraneous matter, will serve for crude glassmaking, but the resulting metal might well be very discoloured. Pliny, writing in the first century AD, refers to sources of pure sand known to the glassmakers of his day: sand was used from the Belus River, near Ptolemais (Acre in northern Israel), from the Volternus River, on the seashore between Cumae and Liternum in Italy, and from Gaul and Spain. Strabo, writing at the end of the first century

205 A scene on the discus of a lamp from Asseria, Dalmatia, showing two glass workers at a glass furnace. First century AD.

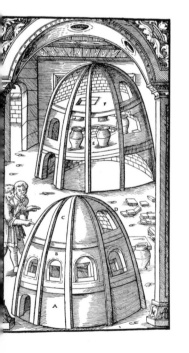

206 Glasshouse scene showing furnace and annealing chamber. A woodcut from Agricola's *De Re Metallica*, published in 1556.

BC, also mentions the glassmaking sand used by the workers at Sidon, and the sand in Egypt which the workers at Alexandria used. Besides these sources known from literature, the large deposits of pure sand near Cologne caused this city to become a very important glass manufacturing centre during the Roman period. Pliny also refers to Egyptian nitrum, a natural soda found plentifully in that country; there was probably a considerable trade in this commodity, but it is also likely that the ashes of certain sea plants were used as a source of soda. Lime is not clearly mentioned by any of the ancient writers, though perhaps Pliny is referring to this when he speaks of 'magnet stone' and shells. In any event limestone would have been readily available.

In the absence of any colouring agents the glass resulting from the soda/lime/ silica mixture was bluish green because of the iron present to some extent in all sand; this is the most common colour throughout the Roman period. However, the Roman glassmaker was aware that he could vary the colour of his product **Col. Plates V, XII** by adding specific metal oxides. For instance, the addition of copper would produce dark blue, dark green, ruby red or opaque red glass according to the furnace conditions; cobalt would make a rich deep blue glass; manganese was necessary for yellowish or purple glass, antimony for opaque yellow glass and iron for pale blue, bottle green, amber or black glass. In addition to the colouring agents, manganese and antimony were also used as decolorants throughout the Roman period. Antimony is a much more effective decolorant than manganese, so manganese was probably used only when antimony was not available, as appears to be the case in much of the glass found in the western provinces of the Roman empire. An almost colourless glass was also produced by careful selection of the raw materials.

Besides the ingredients already mentioned it was common practice in the Roman period, as it is now, to add to the batch a quantity (15–30 per cent is typical in modern glassmaking) of broken glass from malformed vessels, vessels broken accidentally in the glasshouse and glass taken from old pots. This material, known as cullet, lowered the temperature of fusion and was comparatively free from impurities as it had already been processed. Martial, writing in the first century AD, indicates that there was a flourishing trade in broken glass at least in Rome, when he referred to 'the tramping hawker from across the Tiber who exchanges sulphur matches for broken glass'. Excavations at glassworking sites have sometimes produced stocks of vessel fragments, and lumps of unworked glass-finds of this kind have occurred at Aquileia, Colchester, Cologne, Constanza, Wroxeter and elsewhere. Only when common bluish green glass was being made would cullet from many sources have been used. Manufacturers of colourless glass or glass of a specific colour would use cullet of the same composition, as any variation could spoil the quality of the glass produced; but the existence of this practice makes the study of the origins of the glass ingredients through scientific analysis very difficult indeed.

Glassfounding methods

Before being melted in the pot, the ingredients were heated together in an oven to burn off some of the impurities. This process, known as fritting, also lowered the temperature of fusion, and was common practice in glassmaking until the

207 Fragmentary blowing irons and a pair of shears—glass making equipment from Mérida, Spain.

205

207

208 Modern glassmaking: using a pontil rod to add a stem to a blown body on the end of the blowing iron.

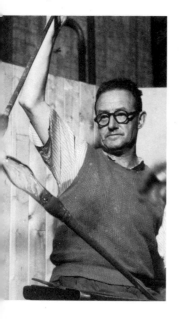

nineteenth century. The best of the frit was then broken up into small pieces and placed in the heated pot with the cullet for founding.

Roman glass founding cannot have differed greatly from the practices of the modern glasshouse. Essentially, a good pot metal depends on the heat of which the furnace is capable and the speed of the founding. If the ingredients are heated too slowly the resulting glass will be full of 'seeds', or small air bubbles which have become trapped in the mixture and are not able to rise to the surface. To avoid this, the furnace would have been heated to a high temperature before the materials were placed in the pot, and then heated further, before being reduced to the temperature needed to work the glass. During the manufacture of modern lead glass (which is worked at a lower temperature than soda/lime glass), the pots are heated to 1100°C before being placed in the furnace, and the glass is worked at 1250°C, which means that the temperature in the furnace outside the pots is about 1380°C; modern soda/lime glass is heated to around 1500°C. Since wood-fired furnaces were dependent on wind for the draught to produce these high temperatures it cannot always have been possible to work the glass furnaces, and many batches must have been spoiled. Bellows are known to have been used for industrial purposes even before the Roman period and most probably were employed to increase the draught to heat glass furnaces. Before the glass was used the impurities floating on the top of the metal would have been skimmed off with a long handled rake.

Very little is known about the tools of the Roman glassmaker. Rakes of some kind must have been employed, but there is no evidence for their existence at this early date. Long tubular iron rods—blowing irons—were essential for making blown vessels and one is illustrated in use on the lamp from Asseria. There is a collection of fragments of hollow iron rods from Mérida in Spain which are almost certainly blowing irons; some of these have the slightly thickened gathering end which is found on modern blowing irons. They were found with fragments of fourth century glass vessels and fragments of glassmaking waste left from the manufacture of open vessels, probably bowls. With this material was a pair of shears which may also have been used for glass manufacture. Apart from these examples there is no direct evidence for the existence of tools, but it seems likely that pontils or punty irons (long solid iron rods) were being used to hold half-completed vessels by the base while the rim, handle or applied decoration was being made; similar rods had been employed in the manufacture of the earlier core-made vessels, and they would have been easier to produce than the hollow blowing irons. Pontil marks are often clearly distinguishable on the base of glass vessels of the Roman period. From a study of the vessels themselves it is also clear that pucellas or pincers were used to produce raised knobs on the walls of the vessels. Marver blocks were also used; These were probably made of a smooth piece of fine-grained stone, though modern glassworkers use a flat surface of steel. The purpose of the marver block was to roll out and give shape to the 'gob' or *paraison*, and to cool the glass sufficiently so that it could be blown without distorting. At the Roman glassworking site at Wilderspool a limestone slab was found in front of each furnace, and these may have been used for marvering.

The workman used the blowing iron to gather glass from the pot in the

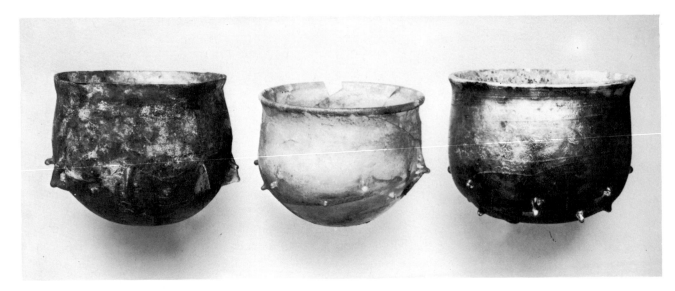

furnace; this iron had to be quite long, probably at least 4 feet, to prevent him from getting burned, but the upper length was governed by the height of the glassworker and by the size of the object being made. The gathering end of the iron was placed on the surface of the glass in the pot and twisted so that the molten metal collected on it. The iron with the glass attached was lifted out of the pot and still being turned in the hands was taken to the marver block and rolled backwards and forwards and then blown into, forming the body of the vessel. The whole process took very little time and for simple shapes nothing further was necessary except the formation of the base and the cracking off and finishing of the rim. For large vessels, the gather once marvered and blown could be returned to the furnace to gather more glass and the whole process

209 Cups with pinched decoration.

210

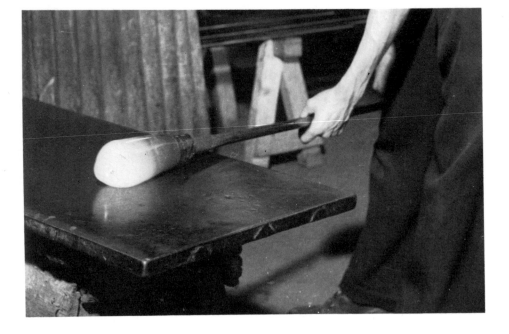

210 Modern glassmaking: marvering the glass by rolling it on a smooth surface.

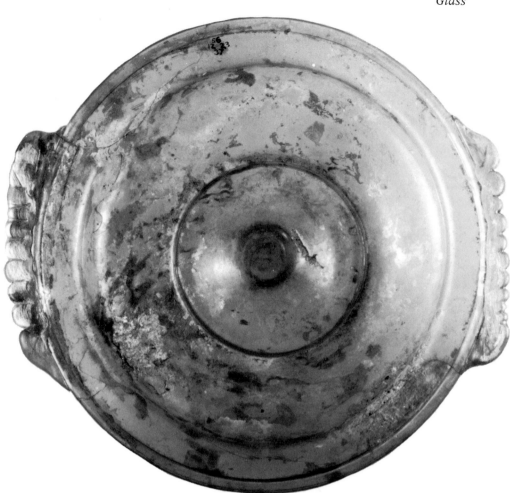

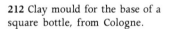

211 A large plate with a pontil mark on the base. The rim and pushed-in base are tubular. Diameter 8 in.

212 Clay mould for the base of a square bottle, from Cologne.

repeated. For more complex shapes, such as vessels with stems and feet and handles, more than one glassmaker was usually needed as it was essential to keep the blown body rotating while the extra glass for the stem and foot was gathered and added to the base and worked into shape.

Most of the glass of the Roman period was blown off-hand or into a mould made of either clay or wood; very few of these moulds have survived. There is a fragment from Cologne which may be from a mould for making the base of a square bottle or jar; it is made of terracotta, and has the negative impression of four concentric circles and a central dot, with right-angled bars at the corners. It is shown in fig. 212. The usual method of making these square vessels was to blow the body and base in a mould and then to finish the shoulder, neck and rim and attach the handle by manipulation. Sometimes, however, the bottle was free-blown (as seen in fig. 214) and the sides were then flattened on the marver block. One part of a two-part mould for making flasks shaped like a bunch of grapes was found at Macquenoise in Belgium, and some fragments of a clay mould which may have been used to make the first century cylindrical cups depicting scenes of chariot-racing have been found recently at Borgo in Corsica.

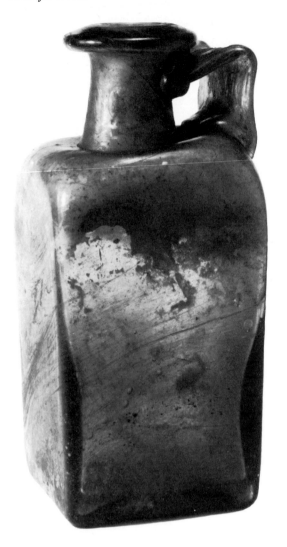

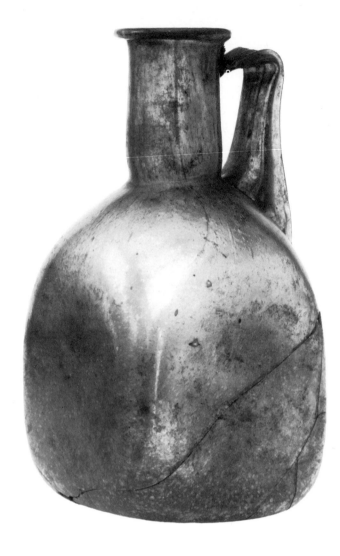

Apart from these finds, the evidence for mould-blown glass comes from the vessels themselves. A good deal of the patterned mould-blown glass belongs to the first century AD. In the second and third centuries only the square and hexagonal bottles, and certain cylindrical bottles with horizontal ridges in two bands on the body and the maker's name *Frontinus* in raised letters on the base, were regularly made in this way. In the fourth century vessels with honeycomb and other patterns were produced in some quantity.

Rims on vessels were finished in one of a number of ways: they could be simply cracked off, or ground smooth after cracking off; or cut off with shears and the edge heated in the furnace to form a fire-rounded rim. Sometimes the edge was bent over and down to form a tubular rim, or over and inwards and flattened on top, as was common on bottles.

Some bases were flat or simply concave; on others the lower body was constricted and the base pushed in to form an open ring; another version of this process produced a closed tubular base-ring. Other types of base included the

213 (left) Mould-blown square bottle and **214** (above) free-blown bottle squared by flattening the sides.

216

215 Some typical handles.

216 Mould-blown beaker with almond boss decoration. The vertical line cutting across the bosses reflects a join between two parts of the mould. Height 5½ in.

coil base, where a trail of glass was formed into a ring on the under side of the vessel; the pad base, where another blown gather was added to the base and cracked off, the edges being outsplayed to form the ring on which the vessel stood; and the true base-ring, which was made by applying a section of a cylinder to the under side of the body to form a stand.

Handles were always applied from a separate gather, and made of drawn glass.

Decoration

The decorative techniques used on Roman vessels fall into two groups—those created in the glasshouse while the glass was still hot, and those which required the glass to be completely cool and which need not have been worked in the same place or by the same people.

Blowing into decorated moulds has already been discussed; apart from the designs which were produced by blowing vessels in their final form in a mould, many patterns on Roman glass vessels are the result of blowing the vessel first

in a dipper mould in which the final design was produced in miniature and then expanded by free blowing.

Decoration was also produced by tooling the glass while hot—pincers were used to make raised knobs and ridges, and raised ridges were created by applying pressure to the surface of the glass. Indents in the sides of vessels were made by applying pressure with the tips of the pincers.

217

218

Trails and blobs of glass were often applied to vessels—these were either marvered flush with the surface of the body of the vessel or left standing proud. These additions could be in the same colour as the vessel itself, or in several different colours. An important group of vessels with 'snake thread' decoration were made in the second and third centuries in the Rhineland and the Eastern Mediterranean. Some of the fourth century glass vessels have applied glass decoration, in the form of blobs of different colours. In the first century AD trails and blobs of opaque white glass were marvered into the walls of brightly coloured vessels, as shown in fig. 217.

Col. Plate XII

There were two main methods of decorating glass vessels after they were cooled and otherwise finished; painting, and wheel cutting and engraving. Not many painted vessels survive. There is a small group of cups of the first century AD which typically has a design of birds and foliage in several colours on the body, and a flask from south Russia painted in the same way. There are

217 Small bowl with pinched vertical ribbing and marvered white trails. Diameter 4 in.

218 A slender unguent bottle with indented sides.

some painted lids from Cyprus and other regions of the Eastern Mediterranean, and a few cylindrical cups found in the north western provinces of the Empire and in Denmark in second and third century contexts which are painted with scenes from the arena.

Wheel cutting and engraving were used throughout the Roman period; simple wheel cut lines were very often used on cups and bowls. More complicated cutting included patterns of closely-set facet cuts over the body of the vessels: bowls and cups for the most part, though other objects, such as cast spoons, were also decorated in this way. Facet cutting came into prominence in the latter part of the first century AD, and continued to be used until at least the fourth century. Cameo cutting was used on vessels blown from blanks of two or more different coloured glasses; the outer skin, which was usually opaque white, was cut away to reveal the ground colour beneath, except for areas which were worked on a lapidary wheel to produce figured scenes in relief. The most famous of these cameo cut vessels is the Portland vase, but a number of other vessels and fragments in the technique exist. Other vessels in which the wheel was used extensively for both form and decoration include the 'cage cups'; these were made by cutting away a thick blank to produce an almost free-standing network of interlocking rings or figures, these being joined to the body of the vessel by small bridges. The Lycurgus cup shown in fig. 220 is the best

219 Facet-cut beaker from Barnwell, Cambridgeshire. Late first to early second century AD. Height 3½ in.

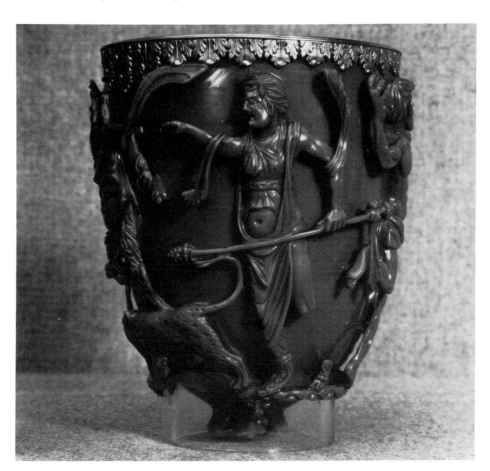

220 The Lycurgus cup with open-work figured frieze. Fourth century AD. Height 3½ in.

known of these cups, which more typically have a simple design of rings round the middle of the body, as shown in fig. 221, and sometimes an inscription below the rim. Freehand engraving with a flint burin was used to decorate a group of fourth century vessels, mainly segmental bowls, which depicted either hunting or mythological or Old and New Testament scenes. Often, a combination of facet and linear cutting was used, and sometimes the fine details of designs were picked out by engraving. With the exception of cameo-cut vessels, the use of cut decoration was mainly restricted to colourless vessels, which became common from the later first century AD onwards.

Besides being used to produce decoration, the wheel was also used to polish the surfaces of cast vessels. The inside surface of pillar-moulded bowls, and both surfaces of cast bowls and plates habitually show marks of lathe polishing. These vessels often occur in first century contexts but disappear almost completely in the late Roman empire.

Many other classes of glass objects were also made during the Roman period, and one of the most important of these is window glass. This first occurs in the first century AD, and was cast, probably in wooden moulds. The early window glass was ground smooth on one surface and left shiny on the other, and the thickness within a single piece varied considerably. Later, probably in the third century, cylinder blown window glass was made; this was gathered and blown in the same way as vessel glass, but swung on the end of the blowing iron to form an elongated cylinder, which was removed from the iron and opened out flat, and then cut up into pieces of suitable size.

Apart from the references already mentioned there is very little literary evidence for Roman glassmaking centres. From inscriptions it is clear that glass

221 A cage-cup from Termancia, Spain.

222 Enlarged detail of the engraving on the Wint Hill bowl. Fourth century AD.

223, 224 Cross-sections of some typical glass rims and bases.

was made in Rome and Puteoli in Italy. Funerary inscriptions mentioning individual workers exist from Athens, Lyons, Mauretania and Dalmatia; and the names of several first century AD glassworkers from Sidon are known from fragments of glass vessels which bear their names. Apart from these, Sentia Secunda of Aquileia is the only glassmaker to state the site of her glassworks. Glass bottles with the initials CCAA on their bases have been found in the Rhineland, and this may be an abbreviation of Colonia Claudia Ara Agrippinensis, the Roman name for Cologne; other groups of vessels with the name of the proprietor or manufacturer on the bases, which have a sufficiently tight-knit distribution pattern to indicate the approximate area in which the glasshouse was situated, include the Frontinus bottles (northern Gaul) and the AVG unguent bottles (southern Spain and Portugal). However, it seems extremely probable that the common vessels which are found in many parts of the Empire were manufactured in more than one place at the same time; it seems unlikely that commodities such as window glass would ever have been transported far, because the danger of breakage would have been too great. While there is no doubt that Sidon, Alexandria, Cologne, Rome and Aquileia were extremely important glassmaking centres throughout the Roman period and exported their products in great numbers for very considerable distances, it is also necessary to remember that except in the case of rare and luxury glass there may well have been a greater trade in glassworkers than in glass vessels; these men must have moved from place to place to meet local demand for the everyday glass vessels that would not have been worth importing. In this connection one might think of Benedict Biscop who, needing windows for his churches in Northumbria in the seventh century, imported glassmakers from Gaul to make them instead of shipping the glass across the North Sea.

Bibliography

Forbes, R. J., *Studies in Ancient Technology*, Volume V, second edition, Leiden, 1966

Harden, D. B., 'Glass and Glazes', in C. Singer et al., *A History of Technology*, Volume II, Oxford, 1956

Harden, D. B., 'Ancient Glass I, II, III: Pre-Roman, Roman, Post-Roman', *Archaeological Journal*, 125 (1968), 126 (1969), 128 (1971)

These articles contain very extensive glass bibliographies.

225 A pot with two holes in the side perhaps used as an equalizer for a double bellows operation. From Cranbrook, Kent, a site associated with iron extraction for the *classis Britannica*. Diameter 8¼ in.

Henry Cleere

10 Ironmaking

The distinction between the iron maker, who extracts the metal from its ores, and the iron worker or smith is for the most part a modern concept. Until the Middle Ages, smiths were capable both of smelting iron ores and of working the metal produced up into artefacts. However, during the Roman period there were certain areas, notably the Weald of Sussex and Kent, the province of Noricum, and (outside the Limes) southern Poland, where there were major industries producing semi-finished forged iron blooms that were exported for further working. It is justifiable therefore to give separate consideration in this work to the iron maker, since his craft represents a distinct technological discipline.

The technological background

Ironmaking is a smelting process, involving the separation of the metal in an ore from the chemical compound in which it occurs and from the non-metallic material (the gangue) in the ore. In the case of iron ores, the smelting involves a reduction process, since the primary or secondary iron compound in the ore is an oxide: the process of reduction involves the removal of the oxygen atoms from the oxide molecules to leave free metallic iron.

There are numerous iron compounds occurring in nature, oxides, carbonates, and sulphides being the most common. From the point of view of practical ironmaking, only oxides and carbonates are of economic interest; sulphide ores are difficult to reduce, and the presence of sulphur in the finished iron has a deleterious effect on the properties of the metal.

Iron carbonate can be broken down by heat to iron oxide, liberating carbon dioxide:

$$FeCO_3 \rightarrow FeO + CO_2$$

This is, in fact, a simplification of the processes involved, since, during heating in open hearths, the FeO formed becomes reoxidized by contact with the oxygen of the air to form Fe_2O_3.

It may be assumed, therefore, that the basic reduction operation, starting from any type of economically feasible ore, begins with ferrous oxide (Fe_2O_3). The atoms of iron and oxygen have a very strong affinity for one another, and considerable energy needs to be expended in the form of heat, combined with a

powerful reducing agent, in order to separate them. The reducing agent used is carbon, either in elemental form or as the incompletely oxidized gaseous compound carbon monoxide (CO). The latter attacks the iron oxide and removes an oxygen atom, forming the stable carbon dioxide (CO_2). Because of the strength of the bond between iron and oxygen atoms, the reduction process proceeds stepwise, the ratio of iron to oxygen atoms in the resulting oxide increasing with each step:

$$3Fe_2O_3 + CO \rightarrow 2Fe_3O_4 + CO_2$$
$$Fe_3O_4 + CO \rightarrow 3FeO + CO_2$$
$$FeO + CO \rightarrow Fe + CO_2$$

It has been clearly demonstrated by many studies that these three steps take place consecutively in increasingly hotter zones of the reduction furnace.

It should be emphasized that the process is one that requires a considerable amount of energy in the form of heat; exposure of iron oxide to cold carbon monoxide gas does not result in the production of iron. The reaction is therefore a strongly endothermic one.

It has been mentioned that carbon monoxide is an incompletely carburized oxide of carbon, ready to combine in a hot state with another oxygen atom. For smelting to be successful, the carbon monoxide must have only the oxygen atoms in the iron oxides available for combination; if there is any free oxygen available (in the form of air), the carbon monoxide will combine with this in preference to the oxygen in the core.

Iron ores do not, as has already been stated, consist entirely of iron compounds; the latter form only a variable proportion of the total make-up of the ore mineral. The remainder consists of non-metallic constituents, such as silica (SiO_2), alumina (Al_2O_3), and lime (CaO), known collectively as the gangue. It is essential that there should be physical separation of the gangue material from the reduced iron, otherwise the metal is disseminated throughout the mass of material remaining at the end of a smelt in the form of small particles, and separation is difficult or even impossible. This process of physical separation during the smelting is accomplished by the formation of a slag. A slag is essentially an artificial mineral, formed by the melting together of a number of gangue components to form a product that has a lower melting point than the metal itself. In modern ironmaking practice, this process is carried out by the use of added limestone (calcium oxide—CaO), which combines with the silica and alumina present, but not with the iron oxide, to produce a slag that melts at about $1200°C$. The added material in this case is known as a flux.

The use of limestone as a flux was not known in antiquity. Instead, a considerable proportion of the metal in the ore had to be sacrificed to enable the gangue to be melted and run out of the furnace separately. Early slags consist almost entirely of fayalite, the composition of which is $2FeO.SiO_2$. This means that for every molecule of silica in the ore, two molecules of ferric oxide have to be lost so as to produce a material that is fluid at a temperature of about $1200°C$ and can be run out of the furnace separately. This is possible because the melting point of pure iron is in the neighbourhood of $1635°C$, although the absorption by the iron of carbon has the effect of lowering its melting point. This is, in fact, the basis of the modern blast-furnace process, the product of which is pig iron

Right. The Oceanus dish and other pieces from the Mildenhall treasure, silverware of the fourth century AD. The figure decoration is thought to have been formed by a combination of casting and chasing. The large dish measures 2 feet across.

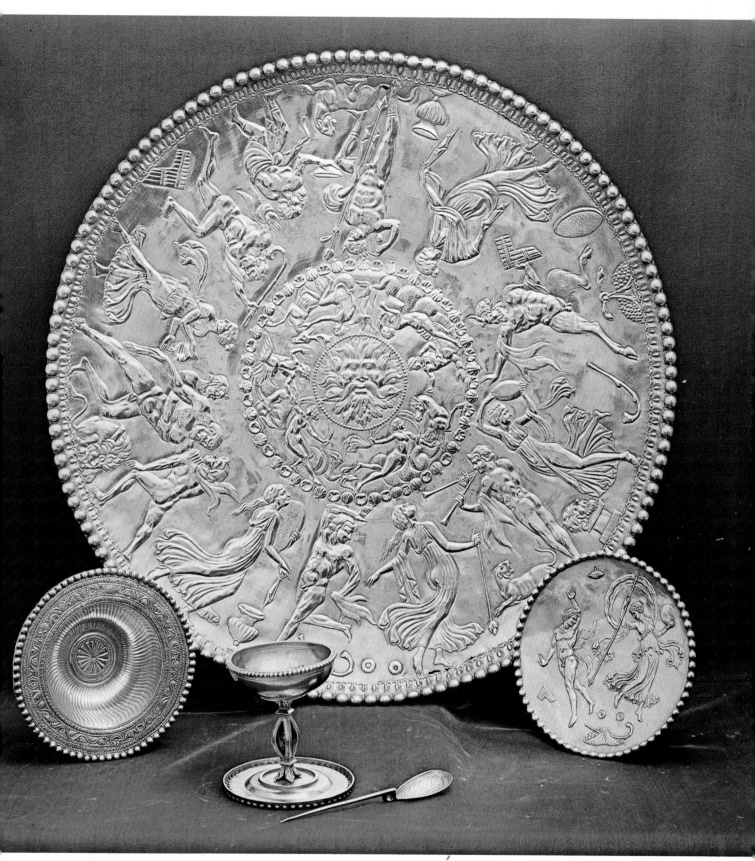

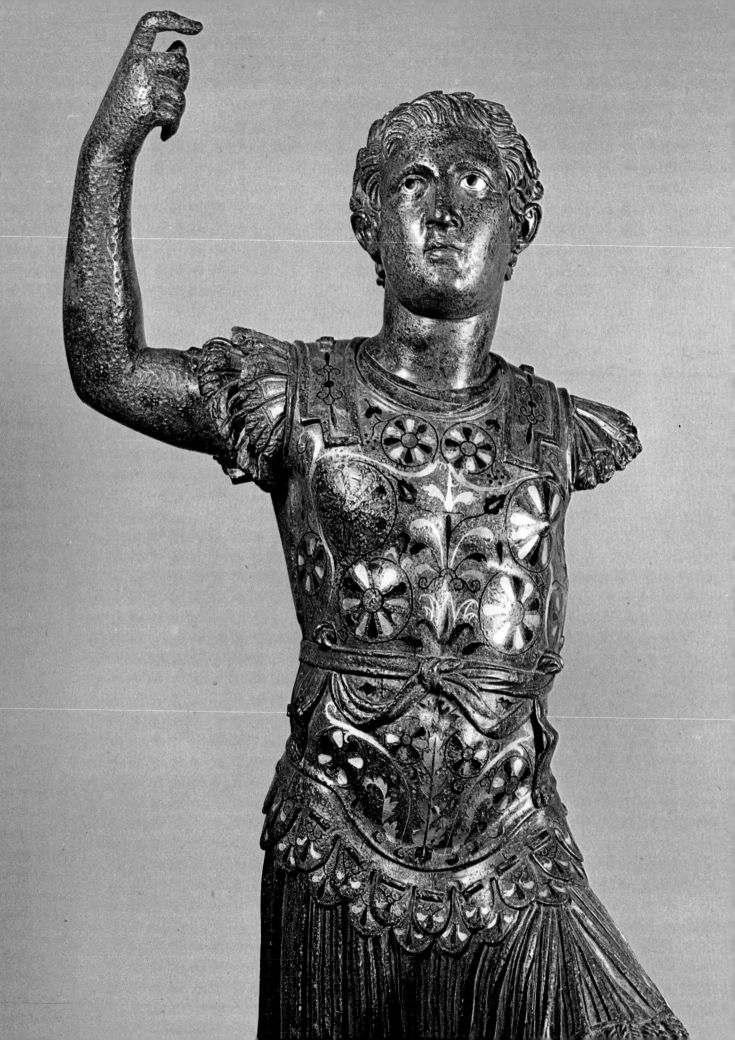

LEFT Bronze statuette of Nero, inlaid with silver and niello, cast in several pieces. The joint between the head and the body is visible around the neck of the cuirass. The left arm is missing because its joint failed. Found near Coddenham, Suffolk; about one third life size.

RIGHT Cast bronze head of a mule with inlaid eyes. From the head of a *fulcrum*, the metal bracket reinforcing the end of a couch. First century AD. Height $3\frac{1}{2}$ inches.

RIGHT Enamelled bronze brooches and a stud. On the smaller pieces the colours are separated by bronze divisions; on the larger piece the divisions are limited to concentric rings, and the colours, green and blue, and orange and yellow, are set side by side. The stud is decorated with bands of millefiore enamel. From Britain and Gaul, second and third centuries AD; slightly reduced.

ABOVE Denarius of Julius Caesar with edge cracks probably caused by cold striking. Enlarged 2½ times.

LEFT AND BELOW Gold jewellery. Earrings, one with plasma and blue glass beads; first to third centuries AD. Fingerrings, a Hellenistic Hercules knot and later Roman pieces. The nicolo intaglio shows Sol riding a quadriga; the fretwork is *opus interrasile*, the gems garnet, sapphire and plasma.

RIGHT Jug with preformed ribs and a marbled pillar-moulded bowl, from a first century AD burial at Radnage, Bucks. Slightly reduced.

IV

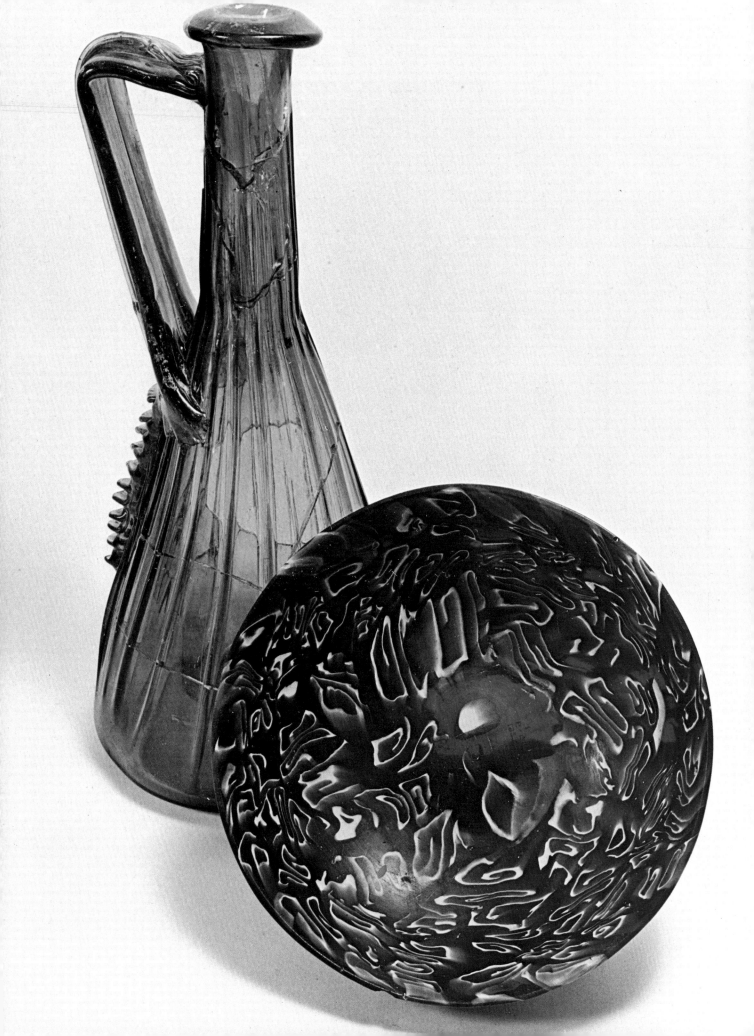

LEFT Small pots with decorated and coloured surfaces. Gaulish samian ware with 'cut glass' decoration; beaker with white paint over a dark brown slip, partly faded to orange due to uneven firing; self-coloured pot with barbotine 'thorns' and rust coloured paint on the rim; cup with orange slip over barbotine spots; pot with dark brown slip thinning to orange over the decoration and on the lip where it has been applied unevenly. First to fourth centuries AD, heights: 3–4 inches.

LEFT Glazed cups with moulded and barbotine decoration. The middle piece shows stilt marks inside and a dark solidified lump of glaze on the rim. First century AD, heights 3–3½ inches.

RIGHT Terracotta figure of a pagan mother goddess. Pale pink clay painted red on the throne, blue on the drapery and pink on the flesh. Attic, about AD 300; signed by the maker, Leonteus. About actual size.

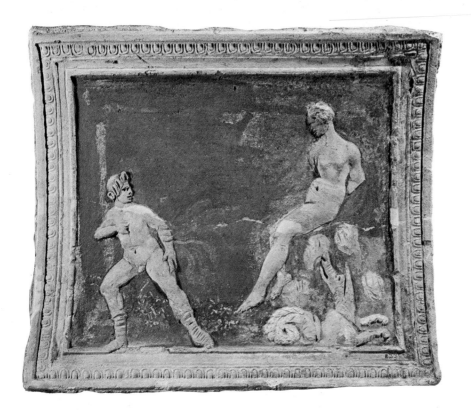

LEFT Concave stucco panel, from the ceiling of a vaulted tomb. Perseus and Andromeda in relief against a red background. From Pozzuoli, first century BC to first century AD. 19 inches wide.

LEFT Painted plaster ceiling, reconstructed from fragments. Yellow birds and leopard heads and green and white flowers painted in panels on a red background. From Verulamium; second century AD. Dimensions: 6 feet 6 inches by 6 feet 9 inches.

RIGHT Garden scene with birds amidst flowers and fruit trees. Part of a painting on the walls of the villa of Livia at Prima Porta. Augustan period. Height: about 8 feet.

ABOVE Part of a wall mosaic in the house of Neptune and Amphitrite at Herculaneum. Hunting scenes and floral patterns set against a blue background. The borders are edged with shells. First century AD.

BELOW Floor mosaic with a black and white panel showing a seahorse set in the polychrome Dolphin mosaic at Fishbourne. Dated to the mid-second century AD by fragments of samian pottery used as tesserae. About 5½ feet wide.

RIGHT The head of Autumn from the Seasons pavement at Cirencester. Tesserae of naturally coloured stones and red glass. Modern restoration in the top right corner. Second century AD. Height 26 inches.

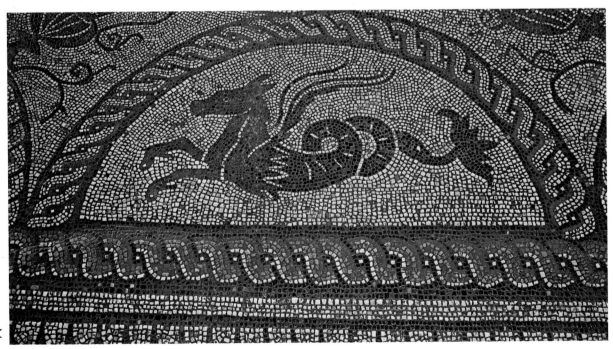

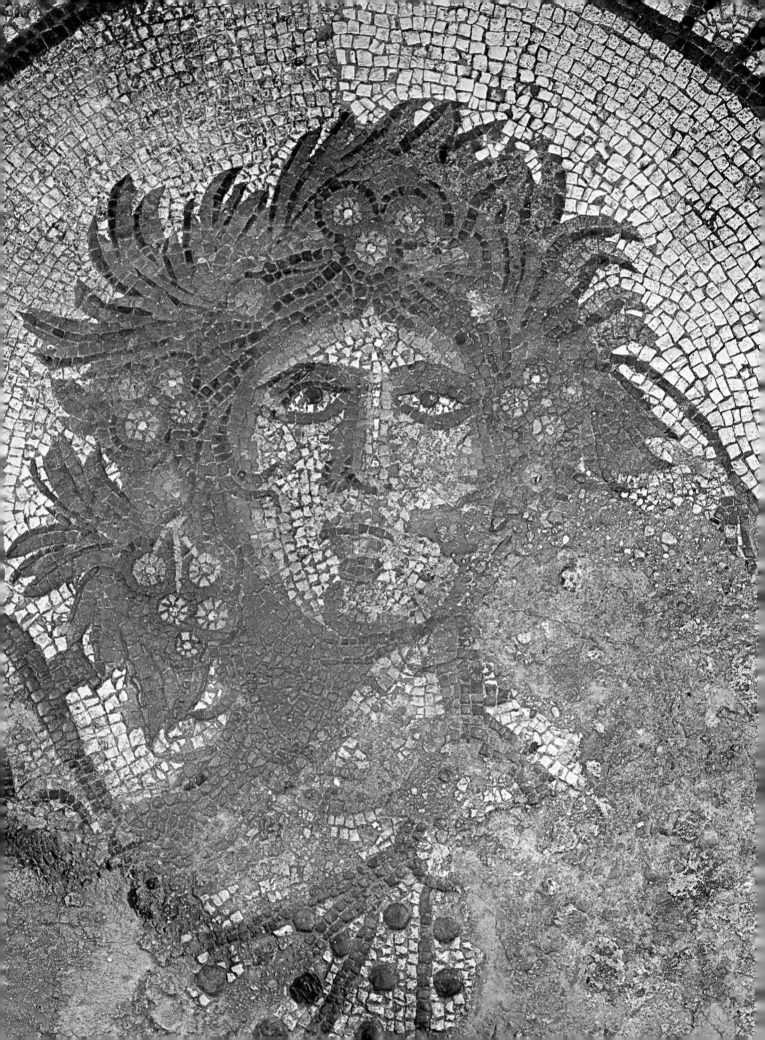

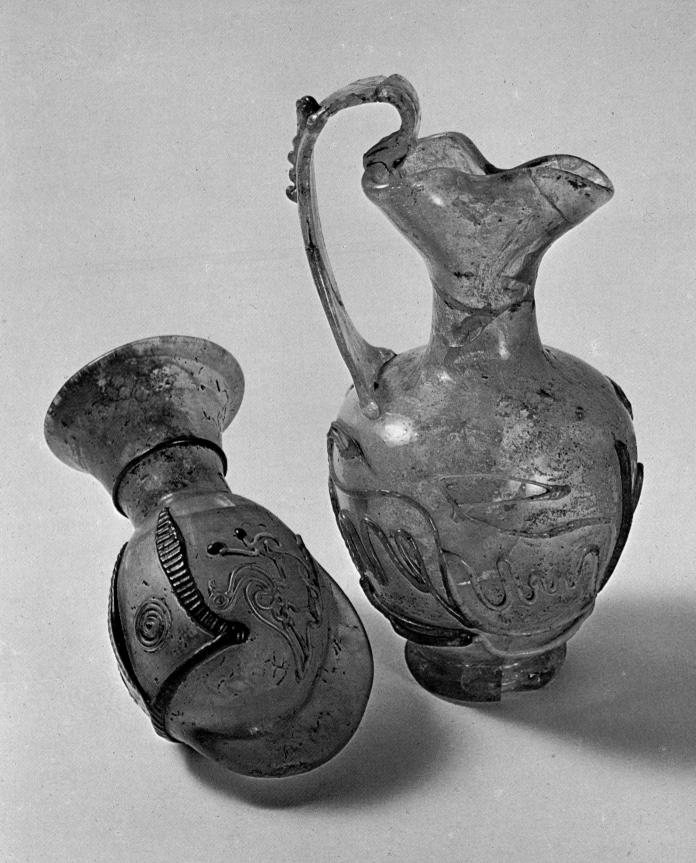

or cast iron, with a melting point of about 1300°C. However, although cast iron was occasionally produced in antiquity by accident in Europe and the Near East, as at the Roman site of Wilderspool, near Warrington, it was not until the Middle Ages that the technique of handling and further working this material was properly understood in Europe (although it was being produced regularly in China from the fifth century BC).

It will be seen from the above, therefore, that there are certain basic requirements for successful smelting of iron ores:

1 A reducing agent
2 A source of heat
3 A reduction chamber that is adequately sealed, so as to prevent atmospheric oxidation of the reducing agent.

Raw materials for iron making and their treatment

Iron Ores. These, as described in the previous section, consist of oxides or carbonates. The most common oxide ores are magnetite (Fe_3O_4), haematite (Fe_2O_3), and limonite ($Fe_2O_3.H_2O$), whilst the carbonate ores are generally grouped as siderites or spathic ores. The occurrence of magnetite ores is not widespread, and they do not appear to have been used to any great extent in antiquity. Haematite in its specular or kidney forms is more common; in Britain there were deposits in Cumberland and at Llanhari in South Wales, both of which were probably being worked in the Roman period.

The most common iron ores used by the Roman iron makers were the limonitic and carbonate ores, in their many forms. These are very widespread in Britain, occurring in the Weald, the Forest of Dean, and along the Jurassic ridge stretching from Lincolnshire down to Oxfordshire. They are also easily reducible, requiring the minimum amount of heat and reductant for successful smelting.

Roman mining for iron ore appears to have been almost exclusively opencast, although there is an example of an underground drift mine from the site at Lydney. Iron ores are so widespread and easy to win that there seems to have been little need for the elaborate underground mining techniques developed by the Romans in Greece, Spain, and elsewhere for the winning of gold, silver, copper, and lead ores.

At the Erzberg in Noricum the iron ore was quarried away from exposures on the mountainside. In the Weald ore mining was a pitting technique: the ore bodies appear to have been revealed in the banks of the many small streams that cut through the soft Wealden clays. Once an exposure was discovered, this would be followed into the bank, the overburden being discarded, until it petered out. Trial shafts appear to have been dug in the vicinity and, where these revealed the presence of another lens of good-quality ore, the shaft was widened out into a pit. A ramp was left running up from the pit bottom, up which trolleys or sledges may have been hauled or manhandled; the typical Roman ore pit in the Weald has a keyhole shape, the straight portion representing the ramp and exit.

It was possible to feed the limonitic and carbonate ores directly into the furnace. However, this imposed an additional burden on the furnace; in the case of the limonitic ores, heat was needed to drive out the water of combination from the ore as well as perform the reduction operation, and for the carbonates it was

Left. Snake-thread glasses. A jug with blue and yellow trails and a dropper flask shaped and decorated like a helmeted head with a bird eating cherries on the side of the helmet. From the Rhineland, third century AD. Slightly enlarged.

needed to drive off the excess CO_2. Both ores also tend to be somewhat wet in character and so heat is also needed to dry them. For all these purposes, the heat needed is not great—about 500–600°C—and the presence of excess oxygen in the atmosphere had no effect on the process. To reduce the load on the smelting furnace in terms of blowing rate and size, therefore, it became common practice to roast these ores in open furnaces, using wood as a fuel.

Most ironmaking sites have areas of hard-burnt clay, often circular in shape, surrounded by considerable ash and fine particles of ore that have been changed in colour as a result of heating, and these are generally interpreted as the bases of ore-roasting heaps. The Bardown Roman site has produced two examples of a specially built roasting furnace. This consists of a trench in the ground, about 10 feet long by 15 inches broad, open at one of the narrow ends and lined with stones, coated with prepared clay. It has been suggested that the furnaces were filled with a mixture of broken ore and wood or charcoal, and were then fired. The fire would burn slowly through the furnace charge, carrying out the operations described above. When the fuel had all been consumed, the roasted ore would have been raked out at the open end, sieved to remove any charcoal or ash and to separate out the finer ore particles, and then stocked for smelting in the reduction furnace at a later date. It seems likely that in fact operations at Roman ironmaking establishments were seasonal, the entire work effort being devoted for a lengthy period to a single process step. Thus, all the workers would be engaged on ore mining and roasting until such time as an adequate stock of roasted and sized ore had been amassed for the subsequent smelting phase of the cycle.

An experiment was carried out with a reconstruction of one of the Bardown roasting furnaces. It was found that adequately roasted ore was obtained by leaving the fully charged furnace to burn through overnight. An experiment was also made using bellows (or in this instance an electric blower) to speed up the process by introducing greater heat, since some broken flagon necks had been found at Bardown in association with one of the furnaces, and these were interpreted as having been used as supports for wooden bellows nozzles. The process was certainly speeded up, but it was found that the degree of roasting was very uneven: some ore lumps were partially reduced whilst others were roasted only on the outside. It would appear therefore that the secret lay in the proper construction of the alternate layers of ore and fuel in the furnace.

The mechanical treatment of the ores is somewhat conjectural. The ore nodules from the Wadhurst Clay in the Weald, for example, vary in size from about 2 inches to 10 inches cube. The smaller nodules could have been charged direct to a smelting furnace, but the larger ones were too massive to be reduced properly. There must therefore have been a measure of crushing before roasting, probably using stone or metal hammers (although it should be noted that the effect of heat on this ore is to cause it to fragment, owing to the expansion of the entrapped moisture). The size degradation of the ores resulting from roasting must have necessitated a sieving or screening process, so as to eliminate the finer particles of ore, which would have tended to clog the smelting furnace. There is ample evidence of this practice from a number of Roman iron-making sites, where layers of fine roasted-ore particles are common on the refuse heaps.

Fuel. The other basic raw material for ironmaking is fuel, in this case as a source of reducing agent as well as of heat. Green wood was used in all probability for the roasting operation, since it would have been capable of supplying the degree of heat needed for this process. However, it would not be suitable for the smelting process, where greater temperatures are required and where the presence of other volatile constituents in the wood would be undesirable and would detract from the efficiency of the process.

Mineral coal was certainly known to the Romans, and it has been found on a number of ironmaking sites, such as Corbridge and Wilderspool. It is generally assumed that this was used only for smithing and not for smelting, but there is no reason why it should not have been used. It has a high calorific value and the presence of sulphur, which makes it unsuitable for use without prior coking in the modern blast furnace, would not have been markedly deleterious, having regard to the relatively low temperatures involved. However, there is as yet no direct evidence of its use for smelting.

Peat was a common fuel in antiquity. As a smelting fuel it was less effective than charcoal, but it seems to have taken its place in areas where wood was scarce, such as Shetland, where peat is believed to have been used at the Wiltrow site. The use of peat as a smelting fuel in some early artefacts has been deduced from the nitrides found in the resulting metal, but this theory has not yet received general acceptance.

The fuel *par excellence* for ironmaking in antiquity was charcoal. The method of charcoal manufacture has not changed greatly in the past four millennia (although the retort method, in which a number of by-products can be collected, has largely superseded the older heap method in the more developed countries); the process is fully described in the literature and will not be dealt with here.

Charcoal is an excellent fuel for ironmaking, since it is carbon in a very pure form, without the impurities such as sulphur and volatiles that make coal unsuitable in modern blast furnace practice. It was used exclusively as a fuel for ironmaking until Abraham Darby's first successful experiments with coke at Coalbrookdale in 1709. Indeed, there are still charcoal-based blast furnaces in operation today in Australia, Brazil, and elsewhere.

With the introduction of the blast furnace, with its relatively tall stack, the selection of timbers for charking became critical: it was necessary to select the slower-growing hardwoods such as oak and hornbeam, since charcoals made from softer woods such as birch and conifers would not have the strength to support a furnace charge weighing many tons.

However, with the small furnaces in use in antiquity, mechanical strength was not a significant factor, and examination of woods from Wealden Roman sites has shown a wide variety of woods being used. Oak predominates, as might be expected in an area where the mature cover was oak forest, but other trees such as hornbeam, beech, birch, hazel, hawthorn, alder, etc. were also being used as a source of charcoal.

There is evidence that there was some size grading of the charcoal as well as of the ore. The deep layers of discarded fine ore particles in the refuse dumps of Roman ironmaking sites are paralleled by equivalent dumps of fine charcoal, rejected because it too might block up the air passages in the furnace charge.

Furnace construction materials. The final raw material that needs consideration is that of the furnace itself. It has been mentioned that the furnace needs to be airtight, so as to prevent the access of undesirable air into the interior. The best material for this purpose is undoubtedly clay, which can be made impermeable and is also capable of withstanding high temperatures.

However, the constructional materials for furnaces vary: in clay areas, such as the Weald, the furnaces are usually constructed entirely of clay, built round a former of some kind such as a section of tree trunk or a framework of withies, to give them rigidity while the clay is drying out. In the Highland zone, however, the basic structure may be of stone, as at Rudh'an Dunain on Skye, but coated on the inside (and sometimes on the outside) with a sealing layer of clay.

These clay linings, whether on a stone or a clay base, had to be prepared with great care; there is evidence from Holbeanwood, Sussex, Ashwicken, Norfolk and elsewhere of very careful drying out of furnace linings, followed by meticulous filling of any resulting shrinkage cracks and a second gradual raising of the internal temperature. Only when the lining was completely consolidated and coherent was it safe to begin smelting.

The clay appears to have been carefully puddled and kneaded before use, and there are indications that a grog filler, probably made from the debris of dismantled furnaces, was used to reduce shrinkage on the furnaces at Holbeanwood.

In addition to the clay used for the furnace superstructure and lining, clay was also used to fill the front aperture of the furnace, through which the blast was introduced and slag was tapped. Again, this was well puddled clay, probably in wedge-shaped pieces some 10 inches long and 4–5 inches square in section at their larger end. A number of these wedges, often still bearing the finger marks of the man who moulded them, have been found on Roman sites, such as Bardown and Beauport Park in the Weald. They are usually very well fired and on some the ends are impregnated with slag.

Furnace types

I have recently attempted a classification of early iron-smelting or bloomery furnaces, in an attempt to impose some order on the bewildering number of furnace types that have been described in the literature.

Most standard works describe the most primitive type of iron furnace as the 'bowl' furnace. However, I am of the opinion that furnaces of this type could not have been used for the successful production of iron, and that the so-called bowl furnaces are for the most part the bases of shaft furnaces, the superstructures of which have been destroyed and scattered.

Broadly speaking, early iron-smelting furnaces can be classified as follows:

Group A: Non-slag-tapping furnaces

> Diagnostic features *a* No provision for tapping of molten slag
> *b* Hearth below ground level
> *c* Blown by forced draught (bellows)

> *Sub-group 1* No superstructure ('bowl' furnace)

> *Sub-group 2* Superstructure: cylinder or truncated cone

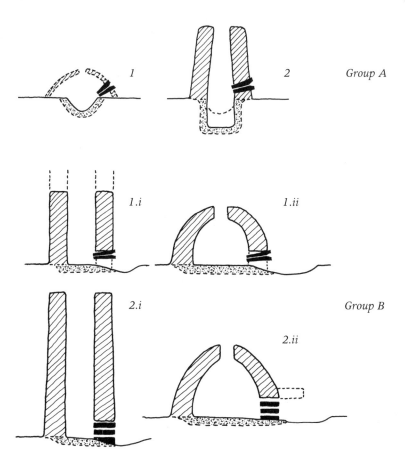

226 A scheme of classification of early bloomery furnaces.

Group B: Slag-tapping furnaces

Diagnostic features *a* Provision for tapping molten slag
 b Hearth level with surrounding ground surface
 c Superstructure

Sub-group 1.i Blown with forced draught
 Cylindrical superstructure

Sub-group 1.ii Blown with forced draught
 Conical or hemispherical superstructure

Sub-group 2.i Blown with natural draught
 Cylindrical superstructure

Sub-group 2.ii Blown with natural draught
 Conical or hemispherical superstructure

Schematic sections of representatives of each of these types are shown in fig. 226.

For all practical purposes, *Group A* was not represented in Britain during the Roman period; those furnaces that have been described as bowl furnaces are in every case either the bases of shaft furnaces of *Group B.1* or were forging hearths.

Group A.2 represents a tradition that travelled across Europe from Hungary, Czechoslovakia, and Poland through northern Germany into Schleswig-Holstein during the Early Iron Age and may have been brought to Britain by the Anglo-Saxon invaders of the fifth century AD.

It also seems to be fairly clear that there were no furnaces in use in Britain of the natural-draught type (*Group B.2*); the distribution of these furnaces seems to have been limited to mountainous areas such as the Jura and the Alps. Throughout the whole Roman period in Britain, only furnaces of *Group B.1* were used. The excavator has retracted his original interpretation of the Ashwicken furnaces as having been blown with natural draughts, following extensive trials on a laboratory facsimile.

The bulk of the furnaces known from Britain come from the Weald. The corpus of furnaces prepared by Penniman contains a number of items which can only dubiously be described as smelting furnaces, and recent excavations have brought a number of new furnace complexes to light in the Weald, at Crawley, Holbeanwood, Minepit Wood, and Pippingford Park. The Crawley and Holbeanwood furnaces, which date from the second and third centuries AD, are all of *Group B.1.i*, whilst those from Minepit Wood and Pippingford Park are of *Group B.1.ii*. The dates of the last-named two sites are somewhat in dispute: carbon-14 determinations have given late Roman period dates, but the associated pottery in both cases is clearly early first century. It is interesting that radiocarbon dates on charcoal from Holbeanwood are also strongly in conflict with pottery evidence.

Most of the other furnaces known from Britain are of *Group B.1.i*—for example, those from Ashwicken and Stamford. It would appear that the domed furnace was an Early Iron Age type, as used outside the Limes in Germany during the Roman period, and that it was superseded in Britain by the cylindrical shaft type. The Roman origin of the latter is perhaps best illustrated by the Holbeanwood furnaces, which were clearly operated by units of the *classis Britannica*, as shown by the numerous finds of stamped tiles at the main Bardown settlement.

Operation of furnaces

The method of operating these furnaces has been studied by the present author and others, using facsimiles of Roman furnaces, and full details of the procedures involved may be obtained from the published reports on these trials. In the present study, only a summary description will be given of the process sequence.

After having been dried out and carefully sealed with fresh clay, the furnace was preheated by burning green wood, probably for at least half a day, so as to ensure even heating gradients through the thickness of the shaft walls. The front orifice was then stopped up with the wedges of clay referred to in an earlier section, a hollow cone of baked clay (known as a *tuyere*) being inserted at the top of the arch.

At this point, charcoal would be fed to the furnace and blast would be applied through bellows inserted into the tuyere. In this way, the temperature in the combustion zone immediately above the tuyere would rise to $1300°C$ and above. Once this temperature had been attained, small additions of ore and charcoal, probably no more than 2 lb. at a time, would be put into the top of the shaft as the

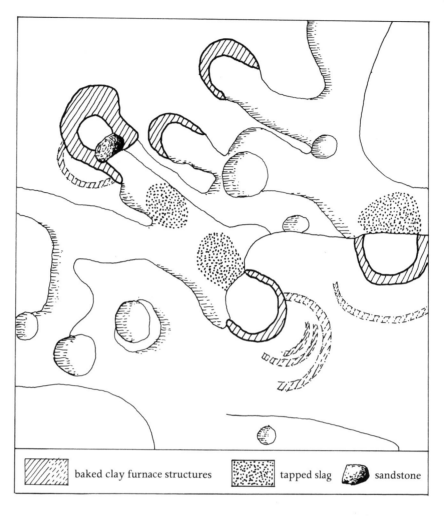

baked clay furnace structures tapped slag sandstone

227 (above) Holbeanwood furnace 4, showing the lower part of the shaft with the front of the arch formed by a block of sandstone. The scale is in inches. **228** (right) Plan of the excavations at Holbeanwood, Sussex, showing furnaces with evidence of successive rebuilds. Patches of tapped slag were found in front of several of them.

stock level at the top of the furnace dropped, as a result of combustion of the charcoal below. Experiments have shown that a 1:1 ore/charcoal ratio would have been adequate to achieve successful reduction.

Reduction proceeds as the ore lumps descend in the furnace shaft, being exposed to increasing temperatures and greater concentrations of hot reducing gas. Small globules of metallic iron are formed and gradually coalesce, collecting in the form of a spongy mass of iron at the base of the furnace.

At the same time, part of the iron oxide (FeO) formed during the reduction process combines with the silica of the ore as fayalite and descends more rapidly in a molten state to the hearth of the furnace. The material that first reaches the relatively cool area below the tuyere level tends to solidify, as does that in contact with the inner walls of the furnace. The solid material at the base, known as the 'furnace bottom', is raked out at the end of the smelt, and these large cakes of slag are common finds on refuse heaps associated with ironmaking settlements.

The slag formed later in the process, however, is hotter and remains fluid. It can be allowed to run out of the furnace from time to time, solidifying as it comes into contact with the air.

135

There is some doubt as to how the slag was tapped from the furnace. Earlier workers suggested that the seal in the front arch, made of clay wedges, was removed from time to time, allowing the slag to gush out. However, practical attempts to do this have not proved very successful: it is not easy to break down the clay seal and, because this cannot be done with the bellows still in operation, there is a serious danger of the furnace going cold and the whole process being disrupted.

The fortuitous use of a turf as the bottom layer of the front arch seal with the facsimile of one of the Holbeanwood furnaces suggested that in fact only the bottom part of the arch was blocked, and that temporarily. Once the temperature of molten slag was attained in this zone, the filling would be removed and the slag would be allowed to run out continuously during the operation. The need to raise the bellows above this slowly moving stream of red-hot material may explain the small post holes to be found to one side of the furnace arches on the Holbeanwood furnaces.

Whatever the slag-tapping procedure, the formation of metallic iron and its slow build-up continues. The process comes to an end when the bloom that has been built up spans the whole of the inside of the furnace to a depth of, say 4 inches. The factor determining the ultimate size of the bloom is the ability to remove it with tongs, either from the top of the shaft or through the furnace arch, without causing serious damage to the superstructure. Unlike the furnaces of *Group A.2*, so common in the Holy Cross Mountains in Poland, where the whole furnace structure was removed to reach the bloom, weighing some 300–400 lb., the Roman shaft furnaces in Britain were re-used many times. Some of the Holbeanwood furnaces shows signs of several relines and may have been used twenty or thirty times before they finally disintegrated. The average bloom weight from these furnaces was probably 20–40 lb.

Once the process was completed and the bloom had been withdrawn, any loosely adhering slag would be raked out, together with the furnace bottom, and hot repairs would be made to the linings of the furnace, where the adherent slag had broken away, tearing with it some of the clay base. Both the Ashwicken and the Holbeanwood furnaces showed evidence of such patching.

It is likely that another smelting operation would begin immediately, so as not to lose the heat stored in the walls of the furnace. The front arch would be reblocked, a new tuyere would be inserted, and charcoal and ore charging would begin again.

In the meantime, the raw spongy bloom would be subjected to a series of alternate heating and hammering processes. It would be necessary to heat the bloom, which consisted of a spongy mass of iron, its interstices filled with slag, to a temperature of some 1100°C, a temperature at which the slag would be semi-molten and the iron weldable. The repeated heating and hammering would have the effect of expelling the entrapped slag, which would solidify around the hearth in characteristic tiny platelets, and of consolidating the iron into a solid block of metal.

A typical worked bloom, from Cranbrook in Kent, is shown in fig. 229. It weighed about 2 lb., and so was probably one of several made from the product of a single smelting operation. This bloom has been studied using modern

metallographic techniques, and the section shown in fig. 230 shows remanent slag inclusions as dark streaks. This internal structure is very characteristic of bloomery iron. These were the semi-finished products sold by the iron makers for further working up by smiths into iron artefacts, as described in the next chapter.

The structure of the bloom was metallurgically very inhomogeneous. The earliest reduced metal, as it passed through the lower sections of the shaft at temperatures in excess of 1200 °C, become alloyed with carbon by contact with the hot charcoal, and was in fact converted into steel. However, the process was a slow one: in my own experiments, it took some 8 hours to produce about 20 lb. of metal. As a result, this earlier reduced iron was in turn decarburized (i.e. the carbon that it had alloyed with was burnt out of it) by the hot oxygen in the air blast, and this resulted in the formation of a very pure iron indeed. Since, however, the process was a finite one, it was inevitable that the metal formed from the later additions of ore would still retain a considerable amount of alloyed carbon. The result, after hammering up the raw bloom, was a block of metal that was mostly of pure iron but which included patches inside it of markedly harder and stronger metal.

There is a possibility that this phenomenon was recognized by the Roman ironworkers, and that they may have knocked off the top of the raw bloom, consisting as it did of steel, for use on the cutting edges of tools and weapons. There are certainly examples of implements with steel cutting edges welded on, such as a chisel from Chesterholm. However, there may have been a separate steel-making process (see below).

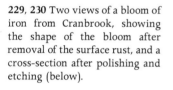

229, **230** Two views of a bloom of iron from Cranbrook, showing the shape of the bloom after removal of the surface rust, and a cross-section after polishing and etching (below).

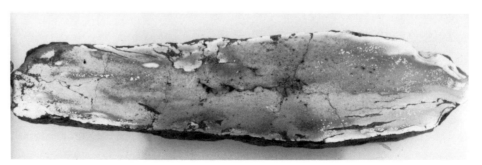

The clay nozzles or tuyeres used to channel the blast into the heart of the furnace are common finds on Roman sites. Most of these are simple cone- or trumpet-shaped nozzles, usually slagged on their narrower end, where they would have been in contact with the molten slag inside the furnace.

There is also a double-aperture type, known only from the Weald. This would have been a little more effective in spreading the turbulence created by a single bellows round the small combustion zone of a 10–14 inch internal diameter furnace and thereby creating generally hotter conditions.

These tuyeres were used to protect the nozzles (in all probability of wood) of the bellows used by the Roman ironmakers. Unfortunately, no examples of these are known; ethnographic parallels suggest the use of animal skins or drum-type bellows, perhaps used in pairs alternately, so as to maintain a steady draught, and either hand or foot operated.

A curious pot from the Cranbrook site, associated with the iron industry of the *classis Britannica*, may have acted as an equalizer for a double-bellows operation. It has been postulated that two bellows were luted into two of the side apertures, with simple flap valves of leather on the inside. An exit nozzle would be fixed to the third aperture, this nozzle being in turn led into the clay nozzle or tuyere in the furnace wall. The top of the pot would be sealed with leather. So far, no other examples of pots of this kind have been found on Roman ironmaking sites.

225

Production of steel

Pure iron is a relatively soft ductile material, of little use for cutting tools or weapons. In order to impart greater hardness and strength to it, iron must be alloyed with very small amounts of carbon (about one per cent) to form steel.

It is possible, as mentioned above, that the last-reduced portion of the bloom, which was highly carburized, may have been detached and tested, perhaps using some simple hammering criterion, for subsequent use for cutting edges or complete tools. However, there is no direct evidence of this practice.

In Noricum, a natural steel was formed by the smelting of an ore rich in manganese, as a result of which *ferrum noricum* became famous throughout the Roman world. A process for the direct production of steel in the bloomery furnace was in use in Bohemia, involving the addition of an extra compartment in the base of the furnace, into which the reduced iron, carburized during its passage down the shaft, was collected in an area that was protected from the decarburizing effect of the air blast. The size of the industry in this area, and the large number of Roman trade goods found there, suggests that steel from the east may have been a major object of trade.

Another important source of steel was India. There are numerous references in classical literature to the superior qualities of 'Seric iron', later known as 'Wootz steel', and produced largely in the Hyderabad region of India. This material was produced by packing small pieces of bloomery iron in sealed clay crucibles, together with carbonaceous material such as chopped straw. These crucibles were then heated for long periods in a charcoal fire, the effect being for the carbon from the straw to diffuse slowly and evenly throughout the mass of iron fragments, and then for the whole mass to melt and form a homogeneous

231 Double tuyeres reconstructed from fragments found at the bloomery site at Bardown, Ticehurst, Sussex. Width about 5 in.

lump of steel. At the end of the process, the crucibles were broken open, revealing a small ingot ready for further processing.

There is no evidence of the use of this technique in Roman Britain, although there are indications that it may have been in use elsewhere in the Empire. However, a strange structure from Colsterworth, Lincs., described erroneously by the excavator as a 'blast furnace', may be a crucible or carburizing furnace. It was a clay box with large openings front and back and holes 4 inches in diameter in the middle of each side. There were a number of small holes, made with the fingers, in the roof, and these were closed with small sherds of second century pottery. It is suggested that this may have been filled with charcoal and fragments of iron and then ignited. Careful control of the access of air could have produced relatively even carburization of the iron and thereby the production of steel.

Another method of steel production—or of imparting the qualities of steel to artefacts—was that of case-hardening. However, this was more properly the smith's responsibility and will not be dealt with in this chapter.

The organization of Roman ironmaking

On the micro-scale, the organization of Roman ironmaking shows two distinct types of site: the single and multi-furnace sites.

Good examples of the single-furnace site are those at Minepit Wood and Pippingford Park, both early Wealden sites with furnaces of *Group B.1.ii.* These were small-scale operations, with modest outputs from single furnaces over relatively short periods. Ore roasting, charcoal burning, smelting, and smithing were all carried out within a small compass, and work may even have been seasonal. Neither site shows much evidence of permanent occupation, although Pippingford may have been associated with a larger Roman settlement at Garden Hill, Hartfield.

Multi-furnace sites are illustrated by Ashwicken and Bardown. At Ashwicken, five shaft furnaces were found grouped around a central core of compacted sand at the base of what was almost certainly a worked-out ore pit. It is interesting that this pit was subsequently backfilled with smelting slag and other industrial debris, suggesting at least three phases of operation during the second and third centuries. The smelting site at Holbeanwood, where twelve furnaces have been found in two groups of six, was an outlying working site associated with the large Bardown settlement, which covered some four hectares during the period between the mid-second and late-third centuries AD. Iron smelting was originally carried on at the main settlement but, as ore and timber supplies near at hand were used up, a series of satellite sites were set up on the ore-bearing strata, all a mile or so from the main settlement and connected to it by slag-metalled roads. Occupation continued at the main site but industrial activity was removed to the satellite sites (of which at least five have been identified), where no traces of permanent habitation have been found.

At Holbeanwood and Ashwicken the whole process sequence (mining, charcoal burning, smelting, and forging) appears to have been carried out in the surrounding area, as testified by the waste materials found on the considerable refuse heaps.

On the macro-level, there is now clear evidence of at least three types of ironmaking enterprise in the province during the Roman period. Direct imperial control, through the *classis Britannica*, was exercised over the iron industry of the eastern Weald, in the hinterland above Hastings. It is possible also that this major iron-producing enterprise moved some time in the late third century AD; certainly none of the *classis Britannica* sites shows any evidence of occupation much later than about AD 250, and the recent excavations at Dover show that there was no continuity between the headquarters of the fleet and the later Saxon Shore fort. It is not inconceivable that the 'public sector' industry moved to the Forest of Dean, where there was certainly considerable activity in the third and fourth centuries AD, and where there is an important inscription from Lydney Park referring to an officer of the fleet.

There was also a major 'private sector' industry in the western part of the Weald, along the lines of the roads linking the prosperous and thickly populated South Downs with the major commercial centre at Londinium. It is not unlikely that there may have been a comparable industry based on private enterprise on the Jurassic ridge in Northamptonshire, although recent iron-ore mining has destroyed most of the traces of this industry.

Finally, there was the small-scale industrial settlement, with one or two furnaces, serving a small town or even a villa establishment. There are many examples of this type of enterprise, scattered throughout the province.

Bibliography

General

Coghlan, H. H., *Prehistoric and Early Iron in the Old World*, Pitt Rivers Museum, Oxford, 1956

Davies, O., *Roman Mines in Europe*, Oxford, 1935

Tylecote, R. F., *Metallurgy in Archaeology*, London, 1962

Regional

Pleiner, R., *Die Eisenverhüttung in der 'Germania Magna' zur römischen Kaiserzeit*, 1964

Straker, E., *Wealden Iron*, London, 1931

Weiershausen, P. *Vorgeschichtliche Eisenverhütten Deutschlands*, Leipzig, 1939

Ironmaking sites in Britain

Cleere, H. F., 'Bardown and Holbeanwood', in *Sussex Archaeological Society, Occasional Papers*, 1, 1970

Cleere, H. F., 'Wealden Sites', in *Archaeological Journal*, 131, 1975

Money, J. H., 'Minepit Wood', *Bulletin of the Historical Metallurgy Group*, 8, 1974

Smith, I. F., 'Stamford', ibid., 4, 1970

Tebbutt, C. F., Cleere, H. F., 'Pippingford Park', in *Sussex Archaeological Collections*, 111, 1973

Tylecote, R. F., Owles, E., 'Ashwicken', in *Norfolk Archaeology*, 32, 1960

Furnace types

Cleere, H. F., *Antiquaries Journal*, 52, 1972

Penniman, T. K., Allen, I. M., Wootton, A., *Sibrium*, 4, 1958–9

Smelting experiments

Cleere, H. F., *Britannia*, 2, 1971

Straube, H., Tarmann, B., Plöckinger, E., *Kärntner Museumsschriften*, 25, 1964

Tylecote, R. F., Austin, J. N., Wraith, A. E., *Journal of the Iron and Steel Institute*, 209, 1971

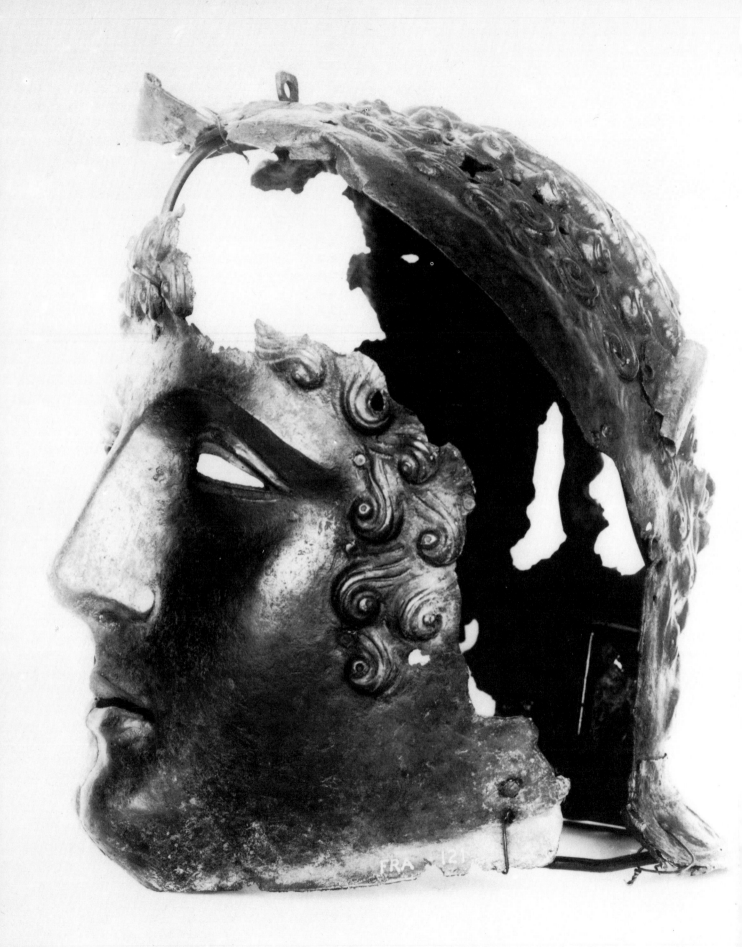

W. H. Manning

11 Blacksmithing

The Roman smith, like his predecessors and successors for many centuries, used wrought iron formed in a smelting furnace. Some smiths, particularly those working in remote areas, may have smelted their own metal from local ores, but they were probably a minority; the average Roman smith will have obtained most of his iron from specialist smelters, although scrap metal must always have been an important source, unfortunately for the archaeologist.

The working of wrought iron imposes its own tools and techniques on the smith, and these differ fundamentally from those of a craftsman casting a molten metal. The blacksmith's technique is forging—hammering the malleable red-hot metal into shape; joins being dependent on the fact that when two pieces of white-hot iron are hammered together they will fuse or weld to form a firm and permanent union. Other methods of working are used, but they are secondary, and almost all of the blacksmith's tools have to be adapted for red-hot metal.

We see the blacksmith in a number of contemporary reliefs, usually standing or sitting at his anvil with his hammer and tongs, the tools with which he is always associated. A few scenes are more informative and show not only the smith and his basic tools but also his assistant and the hearth itself. The smith is dressed with remarkable uniformity in a short, sleeveless tunic which passes over one shoulder, but leaves the other shoulder and arm completely free.

The hearth was a vital part of the smith's equipment, in constant use to heat the metal as it was worked. In most cases it will have been raised on a platform of stone or brick, and hearths of this type are shown in various classical scenes, such as that from the Catacomb of Domatilla, or in a relief from Aquileia. Both hearths are basically the same; they stand on a platform with the fire itself covered by a hood which is elaborated into a regular pediment in the Aquileia scene. In the graffito from the Catacombs, the assistant stands with the bellows, which are of the modern double-handled type, behind the furnace where he is protected from the heat and glare of the fire by the back of the hood. In the Aquileia relief, the draught is introduced from the side and the assistant is protected by a special screen through which the nozzle of the bellows projects. Here two pairs of bellows appear to be in use to give the effect of double-action bellows and maintain a continuous draught. No doubt under some circumstances the smith will have used a simple bowl furnace, and a few such furnaces are

233, 234, 237

232 Iron parade helmet with face mask from Newstead.

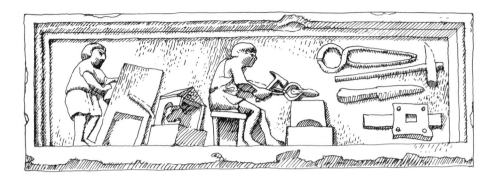

known which were certainly smithing rather than smelting furnaces; but in most cases these will have been used for heating the blooms when they were prepared and consolidated by hammering, and they are, therefore, not smith's furnaces in the normal sense. Unfortunately, the evidence for raised hearths, if it survives at all, will consist only of the brick or masonry base and its purpose may not be obvious. The fuel used will almost invariably have been charcoal. Coal was available in some limited areas, particularly west and north Britain, but in the hearth it may fuse into an unwieldy lump which would be a grave disadvantage for the smith who needs to be able to move his fuel around the work to gain the maximum heat at the critical point. There is no reason to suppose that in the areas where coal was available charcoal was not equally easily obtained. No doubt coal was used experimentally from time to time, but there is no evidence to suggest that it gained even a limited general acceptance by black-smiths. The fire itself was, and is, managed by three tools: the poker, rarely needed with charcoal; the rake, which has a blade set at right angles to the stem; and the shovel (fig. 235 from Newstead), almost invariably with a long twisted handle. Such tools have changed scarcely at all since the Roman period.

All reliefs showing the anvil show it as a roughly squared block of iron, less than a foot high, which splays slightly towards the top; it is set in, or on, a block of wood to raise it to a convenient working height. This is the form seen from Hadrian's Wall to Pompeii, and it is known from excavations over as wide an area, and as far east as Roumania. Sometimes it has a slight stem, which could be set in the anvil block, or it may have the base slightly hollowed, producing the effect of four small legs, as in the Aquileia relief, and an example from Pompeii; but these are minor variations. As with all tools which either strike the metal or on which it is struck, the edges are rounded to prevent them cutting

233 (left) Relief on a smith's gravestone, Aquileia. On the right, the tools of his trade and one of his products, a lock. Width 3 ft. 11 in.

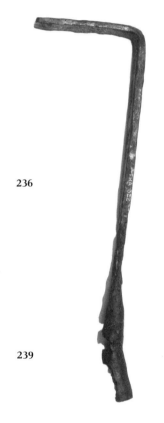

236

239

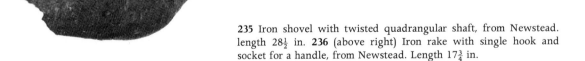

235 Iron shovel with twisted quadrangular shaft, from Newstead. length $28\frac{1}{2}$ in. **236** (above right) Iron rake with single hook and socket for a handle, from Newstead. Length $17\frac{3}{4}$ in.

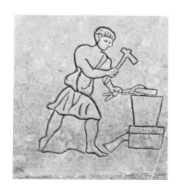

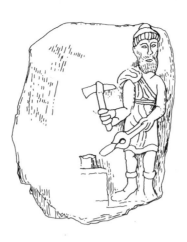

238 The Corbridge smith god, an appliqué on a large grey pot showing a bearded smith working at his anvil. Height about $5\frac{1}{2}$ in.

234 (left) and **237** Scenes from the catacomb of Domatilla; on one side an assistant works the bellows at the back of the hearth (left), on the other the smith works at his anvil (above).

239 An anvil from Pompeii.

into the work. A few anvils have a cylindrical hole running through from the top to emerge on the sloping side, a detail which appears in the anvil of the Corbridge smith god. This was basically to allow a hole to be punched through metal resting on the anvil, for if this was not done over a hole the face of the anvil would be damaged by the punch, the punch ruined and the work only partly pierced. Such holes are invariably round, a fact which shows that they are not 'hardy holes' as has sometimes been claimed. The modern anvil has two holes in its face, one round for punching, the other square to hold the tangs of hardy tools, which are set in the anvil and used by resting the metal on them and striking this with the hammer, instead of the other way round. Their advantage is, of course, that they do not require the third hand which is needed if the hammer, tool and work all have to be held. The tangs of such tools are invariably square to prevent their turning under the blows of the hammer and ruining the work. The beaked anvil, which is the modern type, with a flat working face (wedge) and a long 'beak', used when working on curved pieces such as collars or horse shoes, is known in the Roman period, but is extremely rare. Examples come from Silchester and Heidenburg in Germany; they are small by present standards and have a long stem which fitted into the anvil block instead of the massive integral stand of the modern anvil. Their great advantage, apart from providing the beak, is that they are lighter for their size than the block anvil; the Silchester anvil, for example, weighs only 20 lb. as against over 50 lb. for a fairly small block anvil.

The other basic tools of the blacksmith are tongs and hammers, neither of which have changed greatly since the Roman period. Tongs had appeared in Greece by the sixth century BC and were in general use long before the main period of Roman expansion. The functional parts of tongs are, of course, the

240, 241 Top and side views of a beaked anvil from Silchester. Length 13 in.

242

244

243

245

jaws; the long handles merely serve to keep the smith's hands clear of the fire and hot metal. The blacksmith has the inestimable advantage over most other craftsmen of being able to make his own tools, and nowhere is the result of this seen more clearly than in the variety of jaws found on tongs. The commonest form has an outward bow which ends in parallel gripping faces, giving the jaws a pear-like appearance. Others have plain flat jaws without a bow. These are types which could be used in general work, but more specialized forms existed. The gripping faces might rise at right-angles from the end of the bowed jaws with the tip of one of the faces turned over the other to give an L-shape, a device to stop the work flying out of the jaws as it was struck. Another type, known from actual examples and sculpture, has a U-sectioned gripping face on the lower jaw into which the upper face slots; jaws like this would be needed if a narrow rod was being held and hammered, any other form might allow it to slide out at the side. Smaller tongs, which could be held with one hand are also known although they are less common. They can only have been used with cold metal, or with very small pieces of hot iron, if the smith's hand was not to be burnt. The jaw forms are very similar to those of the larger tongs.

The basic roughing-out of the work and most of the finishing was done with a hammer, and the Roman smith had a full kit of hammers, ranging from the two-handed sledge, or striking, hammer, down to the delicate tools needed for shaping the mechanism of a lock. The sledge hammer has not changed since the Roman period, but a fundamental change has taken place in the smaller hand-hammers. The modern smith most frequently uses a ball-pene hammer, which has a flat face at one end and a ball-like one at the other. This form was not known in antiquity, and instead the smith used cross-pene hammers of various weights and sizes. In this type the flat face is balanced by a blunt 'chisel' edge set at right angles to the line of the handle; in use the effect will have been much the same as a ball-pene. The cross-pene type was very common; of thirteen hand hammers found in two hoards at Silchester, all but one were of this type. Other forms are known, but they need not concern us here, although it may be noted that the 'set' hammer, which does not strike the metal directly but is placed on it and struck with a sledge hammer, was known. The handle is set asymmetrically, and serves only to steady the hammer.

246

247

242–247 Iron tongs of various types and sizes, from London and elsewhere.

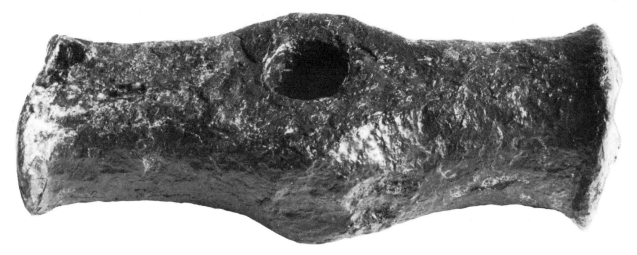

248 Sledge hammer from Silchester. Length 8½ in.

249 Hand hammers from Silchester. Lengths 6¼ in and 7 in.

250 A bloom of iron from Newstead. About half actual size.

The raw material of the smith took the form either of blooms of newly smelted iron or of scrap. As the bloom comes from the furnace it is covered and intermixed with slag which is expelled by repeatedly heating and hammering it. Prepared blooms are rare finds, for obvious reasons; a small group is known from Newstead in southern Scotland, and a single example (fig. 229) from Cranbrook, Kent. In weight they varied between 2 and 20 lb. Scrap must have been an important source of material, but it must be remembered that all the evidence suggests that iron was a relatively cheap metal in the Roman period, and the inconvenience of handling small pieces was often too great to justify their re-use. Hence, of course, the fact that so many pieces survive on Roman sites. Large hoards of iron work occur throughout the western provinces, especially in Gaul, Germany and Britain, and are often identified as scrap intended for re-use, but there are good reasons for supposing that the majority were votive offerings concealed for religious rather than economic reasons.

But whether scrap or new iron, the process of working was the same. The metal was heated in the hearth and then carried with tongs to the anvil where it was hammered into the rough shape. If the piece was large two men might work on it, one to hold the tongs, the other to strike it with the sledge hammer; both are skilled operations, for the iron is moved and turned as it begins to take shape, and the hammer blows must always fall in the right place, with the right force, or the work will be spoiled. If the piece was smaller the smith could work alone, either using smaller tongs or by using a clip, in the form of an oval

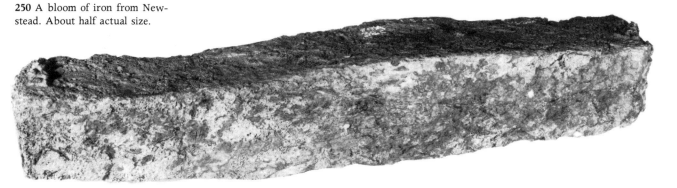

147

or a figure-of-eight loop, to hold the handles of the tongs firmly together and allow him to hold them in one hand. As soon as the metal begins to cool it ceases to be malleable and must be reheated in the fire. A simple object might be made from one piece of metal, but in most cases the final object was composed of several pieces welded together. In some artefacts the weld lines can be clearly seen, but more commonly they are only visible on radiographs.

The method of working iron imposes its own limitations on the design of the artefact. The ornamentation which is so easily produced on cast metals by adding it to the model or cutting it into the mould, involves excessively difficult and time consuming work for the blacksmiths, and for this reason is usually avoided. Sockets for such tools as chisels were formed by hammering out flanges and then folding them over on a mandrel or the beak of the anvil and welding along the join, although if the metal is thick there is no real need to weld the edges, and this was often left undone. The blade of a large tool, such as a plough coulter, was attached to the stem by a cleft weld; a chisel edge was formed on the stem and welded into a V-shaped cleft cut into the top of the blade. The commonest form of weld, however, is the scarf weld, where the ends of the two pieces to be joined are hammered out to thin them and then welded together, the weld often being visible as a diagonal line running across the object. In some cases it is clear that the edges of tools were made of a separate piece of metal welded on, and it is tempting to see in this evidence for the intentional use of 'steeled' material. But the whole question of the use of steel in the Roman period is a vexed one which requires many more analyses before any real conclusion can be reached, and it must be remembered that many of these tools were made in a way which required an additional piece to be welded on. In a few cases it is clear that the edge was of steel, as in a chisel from Chesterholm which has been metallurgically examined.

The controlled production of steel has been discussed in the previous chapter, but it must be emphasized that there is no evidence for widespread, regular, intentional production of steel in the Roman Empire and the value laid on the natural steel of Noricum and on the Indian (Seric) iron, which was in reality a steel, tends to confirm its rarity. But there is another method of producing steel which must have been employed by the Roman smiths, albeit perhaps with no very clear understanding of what they were doing. Wrought iron is a very pure form of the metal, containing less than 0.5 per cent carbon; to turn it into steel the carbon content has to be raised to about 1.5 per cent. As has been explained this can be done by heating iron with charcoal (an almost pure form of carbon) when a certain amount of carbon will alloy with the surface layers of the iron. These conditions occur in the smith's hearth, but the iron is usually in it for too short a time for more than a thin skin of steel to form. This process is known as 'case-hardening', or carburization, or cementation. When a piece of case-hardened iron is worked it will be repeatedly heated and hammered out, folded over, and hammered again, until the smith has obtained a suitably homogeneous metal. In the process, of course, he has produced a 'layer-cake' of iron with thin bands of steel running through it—a structure which combines the resilience of iron with the hardness of steel. How far this process was understood in the Roman period is uncertain. To get the full advantages of steel it must be 'quenched'

251 X-radiograph of an iron woolcomb from Ixworth, Suffolk, showing that the teeth were made separately and welded into the handle.

by raising it to white heat and then plunging it into water. This treatment radically alters the crystalline structure of the steel making it very hard, but also very brittle; too brittle for normal use. It has, therefore, to be modified or 'tempered' to soften it somewhat. This is done by reheating, and the final hardness depends on the temperature reached during the reheating; the higher the temperature, the softer the metal. The smith is able to judge the temperature of the metal by the colour changes it undergoes as the heat increases. How widely this process was consciously applied in the Roman period is not known, and only a programme of metallographic research will provide the answer, but the probability is that many smiths had at least an empirical knowledge of tempering, and this is confirmed by the appearance, at least by the end of the second century AD, of 'pattern-welded' weapons. Pattern-welding is a process whereby the layering effect of folding and welding case-hardened iron is intentionally used and further increased by twisting case-hardened rods and welding them together to produce a mixture of steel and iron, which, when etched, reveals a striking pattern; hence the name. The complexity of layering which could be produced becomes apparent if it is remembered that a single piece of case-hardened iron if cut and folded fifteen times would give over twenty thousand layers of iron and steel! The pattern is only an attractive and distinctive side effect, useful no doubt in showing the quality of the blade, but not in itself important, and the main concern of the smith and his patron was with the strength and resilience of the metal produced in this way. It was a process ideally suited for weapons, where the cost was likely to be a secondary consideration. Swords made in this way come from both inside the Empire, at South Shields, for example, and from Denmark, in the Nydam Hoard, both of early third century date. The weapon was further enhanced if a strip of pure steel was welded to the edge where its hardness would have the maximum effect.

The fact that iron kept at red heat in a furnace packed with charcoal will become case-hardened means that certain massive pieces, such as anvils and the beams which served as the lintels of hypocaust furnaces were abnormally hard. They were made by welding blooms of iron together, and had to be kept in the furnace for many hours in order to maintain the large welding surface at the required temperature of $c. 1000°–1200°C$, during which time all the surfaces inevitably became thoroughly carburized. The process was graphically shown by the discovery of an unfinished furnace beam at Corbridge, Northumberland still standing in the simple hearth in which it was being made. At the time of its abandonment it weighed 340 lb. and contained 20 blooms—each the product of a single smelting. The hardness of these steeled beams was a great advantage when they were in use, but effectively prevented their being cut up for reuse once they were scrapped, simply because they were as hard if not harder than the tools available. Few things show more clearly that iron was not a valuable metal in the Roman period.

There does not seem to be any difference between the tools of the military and civilian smiths and, throughout the western Empire at least, tools appear to have been largely standardized. The anvil, tongs and hammer are the most obvious examples; but there were many other specialized tools, and discussion of a few will reveal their range. One of the faults of the block anvil is the absence

of a beak on which hollow and rounded pieces can be worked This was overcome to some extent by the use of the hand mandrel, a slightly tapering or cigar-shaped bar of iron, one end of which was held while the other rested on the anvil. In modern practice metal is cut with sets or chisels, the difference between the two being that the chisel is held in the hand and struck with a hand-hammer, while the set is held with a handle (which may be no more than a wire twisted around it) and struck with a sledge hammer. Both are found in forms suitable for cutting hot and cold metal. In the Roman period it seems likely that the chisel was used relatively rarely. In Britain, for example, a number of possible examples come from London and sites on Hadrian's Wall, but it is difficult to distinguish a smith's chisel from a mason's chisel and they are equally likely to have belonged to the latter craft. It is noticeable that these chisels are absent from sites such as Silchester where dressed masonry was not common, although other smith's tools, including sets, occur there in some numbers. A rare form of chisel has a wedge-shaped blade with an iron handle set at right angles to it, giving it the appearance of a small axe. The set is essentially a shorter, stronger version of the chisel; the most characteristic form has a pronounced waist. Unlike the modern sets the Roman examples do not have a groove for the handle.

Holes were made with punches, which are usually round or square in section, and enlarged with drifts, which although similar in general appearance to a punch are usually shorter and stouter, often with their head slightly narrower than the stem to allow them to be driven right through the metal. Rivetting was used in this period for joining sheet metal, particularly when the metal was so thin that the force necessary in welding would have distorted it. The head of the rivet is usually carefully formed, but the tail is merely flattened, and there is no indication that a rivet-snap was ever used. Occasionally one finds rivets used in unexpected places; a most notable example being a grid-iron from Silchester (see fig. 256) which is entirely rivetted together, a laborious process with no obvious advantages over welding, except perhaps that of neatness. Punching through thick metal was avoided wherever possible; and in an axe or hammer, for example, the tool was formed about the eye. It must always be remembered

252 Hand mandrels from Silchester. Scale in inches.

255

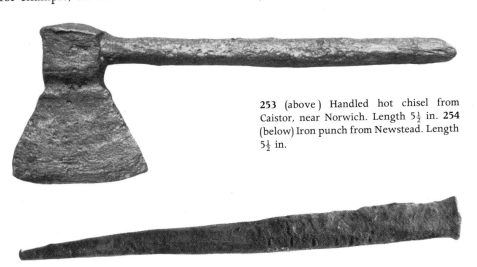

253 (above) Handled hot chisel from Caistor, near Norwich. Length 5½ in. 254 (below) Iron punch from Newstead. Length 5½ in.

255 Iron punches and drifts from Silchester. Scale in inches.

256 A gridiron from Silchester. Approx. 18 in. square.

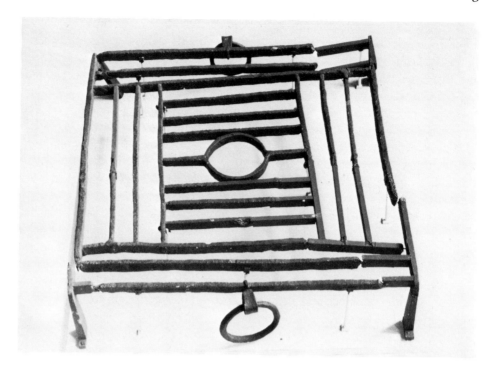

257 (above) Flat file from Newstead. Length 8 in. **258** (below) Files from Silchester.

that the Roman blacksmith did not have total control over the carbon content of his material and therefore could not always guarantee that his punch was made of harder steel than the metal it was intended to pierce.

Roman saws were quite unsuitable for cutting iron, and all work which today would be done with a hacksaw was then cut with chisels or sets. Files, on the other hand, were widely used. They exist in several forms; flat files, often with teeth on both faces; square files; and the rare knife file, which has teeth on both sides of the blade. Most were general purpose tools used for finishing metalwork, not only iron, but the knife file is more specialized and correspondingly rarer. At the base of the blade near the handle, there is a deep nick used for 'setting' the teeth of saws by twisting them; the file itself would then be used for sharpening the teeth. All these files will have been made by smiths, perhaps specialists, in much the same way as they were in the remoter parts of Europe and America as late as the nineteenth century: the iron blank was prepared, strapped to a block of lead, and the grooves cut individually with a chisel struck with a heavy hand hammer.

Specialist equipment developed for making a particular type of artefact is rare among the tools of the Roman blacksmith, but it was found necessary for the production of nails. These were needed in very large quantities, but to forge and 'head' each one by conventional means would be excessively time consuming and so the nail-heading tool was developed, and remained in use until the advent of machine-made nails in recent times. A nail-heading tool is a bar, expanded at one or both ends where it is pierced by a square or round, tapering hole. A rod which could be conveniently handled, with the cross-section of the intended nail, was prepared and one end forged into a point; the length of metal required for the nail plus an allowance for forming the head was

then cut off, and, while still red-hot, dropped into the nail-heading tool with the narrow end of the tapering hole upwards. Simple though this sounds great skill was required to ensure that the nail stem tapered correctly so that it fitted into the hole with just enough metal projecting above to form the head. The tool was then rested over the anvil hole and the head of the nail forged. As the metal cooled it contracted and the nail could be removed by turning the tool over and tapping it on the edge of the anvil. In skilled hands, nails could be produced with great rapidity by this method.

It is probable that we do not yet know the full range of Roman smiths' tools. Recently evidence has come to light showing that swages (grooved tools used in shaping rods and the like) were in use at the end of the Iron Age in south-eastern England, and although none are known from Roman Britain it is improbable that they passed entirely out of use. Similarly fullers (chisel-like tools with blunt, rounded noses used for expanding the metal and forming shoulders) are almost unknown in Roman Britain, and although the cross-pene of a hammer might serve for some of the functions it can scarcely have replaced them entirely. As more work is done both on excavations and in museum collections many of these gaps will undoubtedly be filled.

Elaborate pieces such as the face masks of parade helmets were probably made by hammering sheet iron into moulds although until some moulds are found proof of this is lacking. Quite certainly use was made of the fact that iron expands when it is heated, and circular bands such as the tyres of cart wheels were shrunk on by using this property.

The degree of specialization among the smiths of the Roman world is uncertain. The vast majority were working in small towns, or villages, or on great estates, and they must of necessity have been masters of all work. But many such skilled and experienced craftsmen would have been capable of fine and elaborate work if the opportunity arose. In the larger towns the market will have been great enough to support specialist craftsmen; men such as the smith of Aquileia whose memorial shows not only the workshop but a selection of his tools, tongs, hammer and a file, together with the product, a lock. Here there can be little doubt that we see a lock-smith, in whose work the file was as important as the more obvious smith's tools. There are also groups of tools, mainly edged-tools, chisels and knives, usually from large cities such as London, which are stamped with the maker's name, and here again one supposes that they are the products of specialists.

Military work probably fell into two classes. The general repairs and maintenance, as well as the production of day-to-day requirements and structural ironwork (including nails, to judge from the vast hoard found in the legionary fortress at Inchtuthil, Perthshire), were done by soldier craftsmen. Most expendable weapons, spear heads, artillery bolts and arrow-heads, will also have been made on the spot, but the better equipment, including swords and armour, probably came from specialized centres. The fine inlay on legionary dagger scabbards such as is shown in fig. 260, from Usk, Monmouthshire, for example, is the work of specialists, and the production of face masks as in fig. 232 from Newstead, whether in iron or bronze, will have been far beyond the skill of the legionary smith. In the later Empire we know that there were central armament

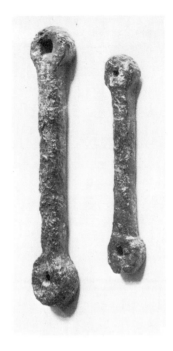

259 Nail-heading tools from Silchester.

260 The pattern of inlay on the scabbard of a legionary dagger from Usk, Monmouthshire.

233

works, many of them specialized in their products, and the system may have had its origin in an earlier period.

The competence and skill of the Roman smith is seen in his products. They may not have produced such obvious show pieces as the great screens of the Middle Ages (although how many of these would be known if we had to rely entirely on archaeological evidence?), but there are details, such as the Newstead face masks and helmet or, in a different way, the reef knots on the English cauldron chains which suggest that when the opportunity came there were blacksmiths who could rise to the occasion.

261 Decorative knot in the centre of a loop-in-loop iron cauldron chain from Appleford, Berks. Fourth century AD.

Bibliography

General
Coghlan, H. H., *Notes on Prehistoric and Early Iron in the Old World*, Oxford, 1956
Singer, C., et al., *A History of Technology I*, Oxford, 1954
Tylecote, R. F., *Metallurgy in Archaeology*, London, 1962

Iron tools
Goodman, W. L., *The History of Woodworking Tools*, London, 1964
Mercer, H. C., *Ancient Carpenter's Tools*, London, 1960
Smith, H. R. B., *Blacksmiths' and Farriers' Tools at Shelburne Museum*, 1966

Roman site finds
Bushe-Fox, J. P., *Excavations at Richborough, IV*, London, 1949
Cleere, H., 'Roman Domestic Ironwork from Brading', *Bulletin of the Institute of Archeology, London*, I, 1959
Curle, J., *A Roman Frontier Post: The Fort of Newstead*, Glasgow, 1911
Frere, S. S., *Verulamium Excavations, I*, London, 1972
Jacobi, L., *Das Romerkastell Saalburg*, Homburg v. d. Höhe, 1897
Manning, W. H., 'A Hoard of Romano British Ironwork from Brampton', *Transactions of the Cumberland and Westmorland Antiquarian Society*, 66, 1966
Neville, R. C., 'The Great Chesterford Hoard', *Archaeological Journal*, 13, 1856
Piggott, S., 'Three Metal-work hoards from Southern Scotland', *Proceedings of the Society of Antiquaries of Scotland*, 87, 1953
Pitt-Rivers, A. H. L., *Excavations in Cranborne Chase*, I–V, London, 1897–1905.

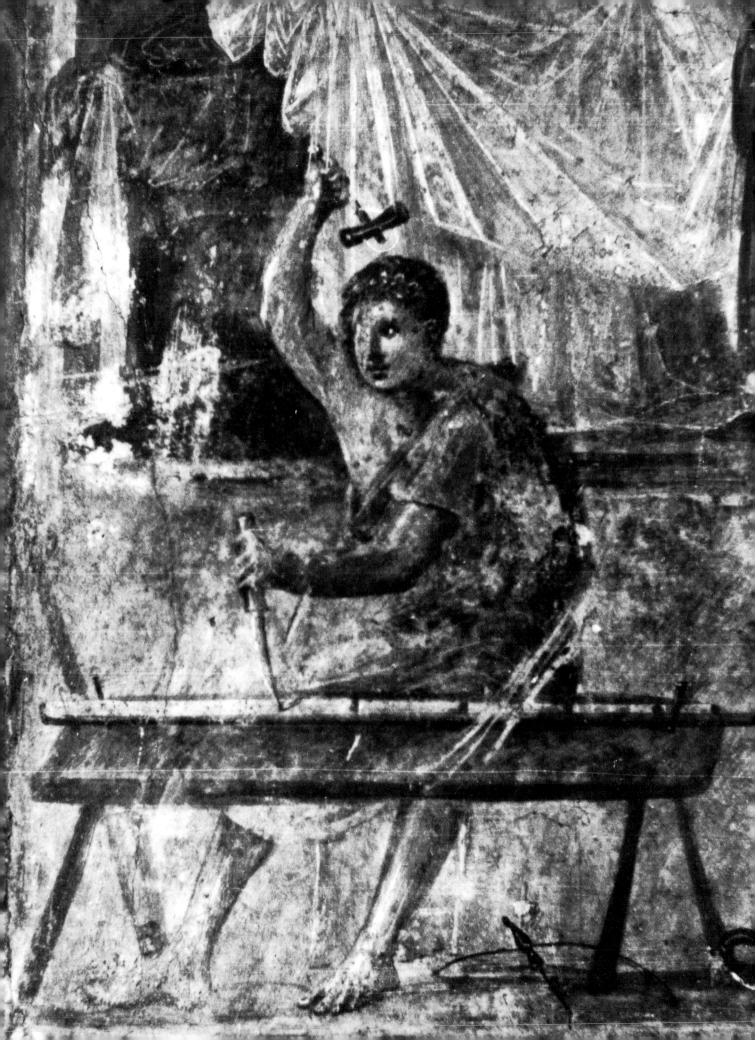

Joan Liversidge

12 Woodwork

Carpentry was invented by Daedalus, says Pliny, and with it the saw, the axe, plumb-line, gimlet and glue. The square, the plummet and the lathe, however, he attributes to Theodorus of Samos. In this quotation we have literary evidence for some of the tools required for one of the skills essential to any civilization, that of the wood-worker. The evidence for woodworking in the Roman Empire includes many tools, illustrations of men at work from wall-paintings and reliefs, inscriptions, and a few additional literary allusions, backed up by work surviving from earlier times which suggests considerable inherited knowledge from Egypt and the Hellenistic world.

Pliny gives some information about suitable trees for the carpenter, and to his list can be added items from the fourth century BC author Theophrastus. We learn most about the preferences of the furniture-maker. Beech is easily workable although brittle and soft. It was used for chairs, tables, and chests, and for 'elastic bed-steads'. Beech could also be cut into thin layers for veneers. Theophrastus adds carts and ships to the list of its uses and recommends trees grown in mountainous country as the best. Several varieties of oak, holly, lime and fir were also used and cypress, particularly for chests. Maple was prized for beds and tables, willow for couch-frames, juniper for tables, and yew for the decoration of chests and footstools. Ebony was used for veneers.

In the first century BC there arose in Rome what Pliny (XIII.96) calls the table-mania for tables made of attractively veined dark honey-coloured citron wood found in Mauretania and north-west Africa. The same author saw one which Cicero had bought for half a million *sesterces* and prices continued to rise to well over a million. Tables over three feet wide are recorded. By the end of the first century AD supplies of citron wood were exhausted.

The elm is particularly commended by Theophrastus for expensive doors with elm-wood hinges because it did not warp. The wood was easy to cut when green but difficult when dry. Therefore the doors were put together from new wood and then left for a year or two to season thoroughly. Other specialized uses include oak for roof shingles and wheel-axles, maple for yokes, and fir for writing tablets. Builders used sweet-chestnut for roof timbers. When about to split, Theophrastus tells us, it made such a loud crack people could rush out of the baths in time. Pine, palm, cedar and cypress were also recommended for building.

262 A wall painting showing Daedalus at work cutting mortices with a hammer and chisel; a bow drill lies on the floor. From the House of the Vettii, Pompeii.

155

Shipwrights used elm for strength, and oak, beech and cedar, with fir for lightness. Pine was also prized for masts, yard-arms and oars; and praised for its capacity to absorb glue. Some woods, such as oak and cypress, are commended for resistance to decay, others such as lime were easiest to work, or resistant to wood-worm or other pests. For the handles of tools, olive, elm and ash were favoured and traces of ash have been found in the sockets of chisels in a hoard of scrap iron from Brampton, Cumberland.

With such an appreciation of the need to search out suitable timber, forests were one of the Empire's chief assets. Apart from local needs for building materials and fire-wood, supplies were moved by the members of the guild of *dendrophoroi*, usually by water. A relief from Bordeaux shows four of them with a tree-trunk. The forests of Gaul and Germany were famous, and firs from the Vosges and Jura, oaks from the Ardennes, and pine, maple and birch from various localities all found their way to Italy. Corsica was another source of oak. Egypt was short of trees, but further east Asia Minor and Syria were better provided, and the cedars of Lebanon remained popular.

Diocletian's Edict of prices of AD 301 gives the cost of large timbers which were no doubt intended for building or shipping. Measurements are given in cubits which were probably equal to 18 inches. Maximum prices for pine vary from 5,000 denarii for 12 yards of timber 12 inches square to 50,000 denarii for 25 yards of timber 18 inches square. Oak and ash cost 250 denarii for 7 yards of timber 9 inches square, and a newly discovered fragment of the Edict from Aphrodisias adds beech of the same length, and shorter lengths of cypress and sappinus to the list. The last line of the new fragment of the Edict begins the list of payments due to the workers starting with those trimming the oak, the hardest wood, for which there was presumably the highest rate of pay. Further on Diocletian's Edict lays down regulations for the price of a load of wood brought by wagon, camel, ass or donkey.

Roman tombstones frequently depict implements used for setting out work and for measurements by carpenters. The freedman Caius from Bordeaux holds a rule in one hand and an axe-adze in the other, and elsewhere squares, circles and levels are illustrated, and also the dividers used to draw circles or geometric designs or to transfer measurements to the material. Bronze or iron dividers survive not infrequently with other tools easily recognizable by modern carpenters. Hoards of ironwork have been found at a number of sites and from them come axes with flat butts and graceful, slightly curved blades, and spoon-shaped adzes. These were used for the preparatory work. Sometimes two implements are combined, one on either side of the handle. The Bordeaux relief shows an axe-adze; there is an adze-hammer from Great Chesterford, Essex, and similar combined axe-hammers are also known.

Saws

Saw blades occur not infrequently and show several developments compared with earlier tools. The Romans appreciated the value of setting the teeth so that they projected right and left alternately. Pliny notes this as a device for preventing the saw getting clogged when working with green wood. This method of setting allowed the hand-saw to be used with a straight handle, and the blade could be

263

270

263 Tombstone of the carpenter Caius from Bordeaux.

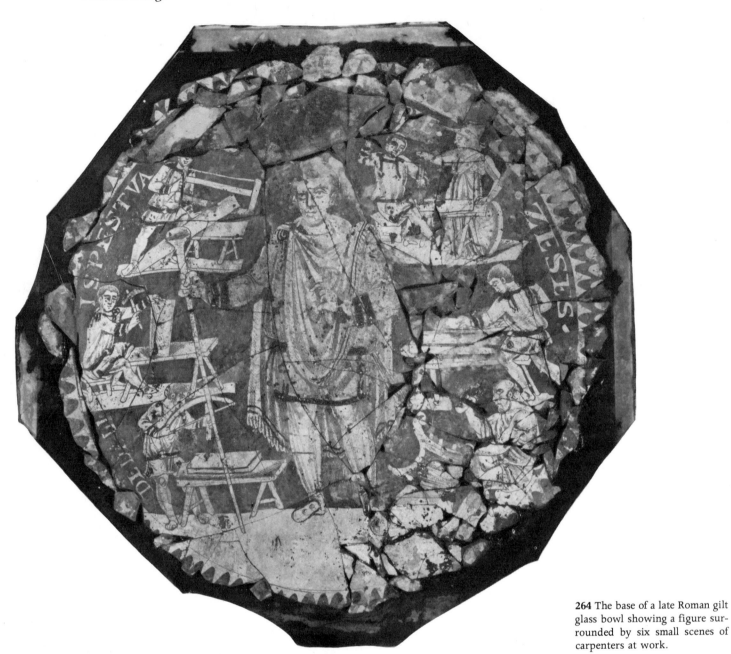

264 The base of a late Roman gilt glass bowl showing a figure surrounded by six small scenes of carpenters at work.

pushed rather than pulled and so be less inclined to buckle. Frame-saws in which the blade was held at both ends are found in varying sizes. The simplest form consists of a blade 30 inches long fitted into the end of a piece of wood bent into a semi-circle and fastened with crude spikes. A bow-saw of this type from the Faiyum is now in the museum at University College, London, and it has been suggested that the Romans brought the tool to Egypt from Greece.

More often the saw blade is held between wooden uprights connected either by a cross-bar above and below, as with the large two-man ripping-saws, or else the blade appears below a cross-bar. Above the bar the uprights are linked

158

by a cord well-damped and tied to each end. This would shrink as it dried and help to keep the saw taut. In some cases, to avoid untying and damping the cord, a toggle-stick was provided to take up the slack. A frame-saw of this type used by one man appears as a detail on a gilt glass from the Roman catacombs. Others are known from an altar dedicated to Minerva by a guild of workmen, now in the Capitoline Museum, and a relief of craftsmen carving a three-legged table in the Antiquarium Comunale. Wall-paintings from Pompeii and Herculaneum show two men using the larger types of the same tool as a double saw. Fragments of bow or frame-saw blades have been found at British sites including Verulamium and Great Chesterford, and several survive in a hoard of ironwork from Heiden-burg bei Kreimbach, now in the Historisches Museum der Pfalz, Speyer. The teeth are not always set and the back of the blade and the edge are parallel, unlike the hand-saw blades which tend to be triangular. A fine example of the latter survives at Verulamium.

Planes

The earliest known planes come from Pompeii. Pliny was obviously familiar with them and notes how the plane could cut continuous shavings from fir planks instead of the chips removed by other tools. An example in beechwood survives from the fort at Saalburg, with the cutting-iron set at an angle of 50° protruding through the sole, and wedged in position. A relief from the fort shows a workman using such a tool. Other planes have an iron sole to give greater accuracy and durability, sometimes, like the examples from Verulamium and Silchester, held to the wooden frame by four iron rivets. In Germany two central side plates were added connected by three cross-rivets, one of them securing the wedge which held the cutting iron in place. The finest example found comes from early

265 Marble relief showing carpenters at work making a table.

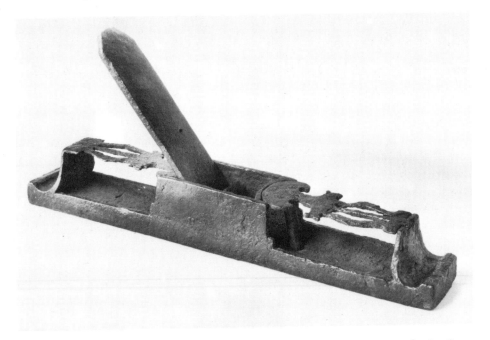

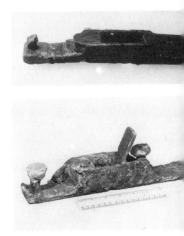

266 (left) An iron plane from Cologne. First century AD. 267 (below) A beechwood jack plane from the Roman fort at Saalburg. 268 (bottom) An iron plane from Silchester.

first century Cologne and has in front a curved piece concave towards the front of the plane. The spaces below the fretted pieces were filled in with wood, with slots cut in to form grips for the worker's hand. The Vatican gilt-glass shows planing in progress. A number of plane-irons have also been found in Britain, Germany and France, and they are evidence for tools of varying size and purpose. Panelled cupboard doors of the type portrayed on the relief showing a shoemaker from Ostia or the Simpelveld sarcophagus in Leyden Museum, or panels actually found at Herculaneum, give us some ideas of the finished article. Experts believe that part of a third or fourth century door from the Faiyum, now in Bristol City Museum, needed for its manufacture not only smoothing and jack planes, but also a variety of moulding, plough rabbet and shoulder planes.

Drills, chisels and gouges

The favourite boring tool was the bow-drill which is first recorded in Egypt. One is depicted on the glass in fig. 264, but the artist has mistakenly shown the workman holding the drill-stock in the middle instead of by the nave at the top. Spoon-bits set in wooden handles were probably used as augers. The chisel has a remote ancestry. Made of materials in current use, it develops from neolithic flint or stone through bronze and iron tanged and socketed varieties. Paring chisels with handles made in one piece with the blade have been found at Verulamium. Others in the Silchester collection in Reading Museum are accompanied by socketed morticing chisels varying from 3 to 5 inches wide. Daedalus in a Pompeian wall-painting from the House of the Vettii is using a tanged mortice chisel with a long wooden handle as he makes the wooden cow for Pasiphae, and one with a shorter blade appears as one of the details of the gilt-glass in fig. 264. Other tanged and socketed chisels have been found in London and with the iron-work hoards from Great Chesterford and Worlington. Gouges of varying sizes also occur.

262

269 A panelled wooden door from the Faiyum, Egypt. Third or fourth century AD. **270** (below) Carpenters' tools from Great Chesterford, Essex. From left to right: an adze-hammer, a small hammer and an axe, two socketted gouges, and two socketted chisels; below, two saw blades.

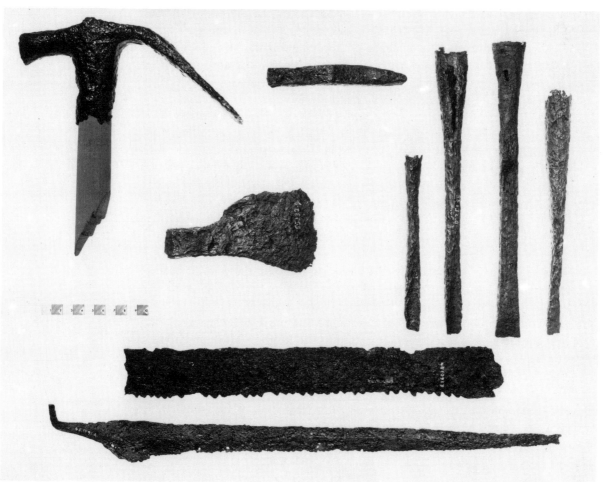

Joan Liversidge

Lathes

When the lathe was invented is uncertain, but a date in the second millennium
BC is generally suggested. Once the use of the potter's wheel was discovered the
idea of a device for turning wooden objects may soon have followed. The oldest
turned object known is a bowl from an Etruscan tomb of *c.* 700 BC at Corneto, and
some form of lathe would be necessary for the mouldings decorating the wood
or metal legs of Greek and Roman furniture. Besides the remark of Pliny already
quoted, literary evidence includes a reference in *Theages*, a work sometimes
ascribed to Plato, in which carpenters are described as the people 'who saw and
bore and plane and turn'. No ancient illustration of the lathe survives, but from
the Mediterranean it spread north probably in pre-Roman times. In Britain shale
armlets were fashionable and several Iron Age workshops are known near the
shale deposits in Kimmeridge Bay, Dorset. Debris surviving includes the small
disks cut out from the armlets and these have holes where they fitted on to the
pegs or spindle of the lathe. In Roman times the industry also made furniture,
using the lathe for small round table-tops and couch-legs. Wood could be bent
into shape when necessary for objects such as the *klismos*, a favourite Greek
and Roman chair. Pieces were fixed together with wooden tenons and dowels
of various shapes, metal nails and glue. Pliny remarking on the importance of
glue, notes that some woods, notably hard oak, will not take it, and goes on to
list the best materials to use for veneers, among them maple, box, holly, palm
and poplar. Fine work was smoothed with skate or shark skin, and wax or oil
of cedar or juniper was rubbed in during the finishing process.

The development of the plane probably led to the invention of the carpenter's
bench. Some work could be done placed on a block of wood or on planks laid
across trestles as illustrated by scenes in the Vatican gold-glass. When two
men used the large frame-saw one might stand on a plank beside the wood being
sawn with the other man on the ground. The cobbler on a relief from Rheims
who may be a maker of wooden shoes, sits astride a small bench with a last fixed
in front of him and this method could be used when making small objects.
When the plane was used however, there must be room to lay the material flat
and a means of holding it in position. The painting depicting Daedalus in the
House of the Vettii shows a bench with pegs securing a piece of wood being
worked with hammer and chisel, with a bow-drill lying on the ground near it.
Remains of actual equipment discovered at the Saalburg include planks with
mortices for legs and a number of small iron bench stops. A number of tools
found in a bucket represent the only evidence for the carpenter's tool-bag.
A model reconstruction of a carpenter's shop in the Reading Museum shows a
carpenter at work with his tools on the wall and shelves nearby.

The status of the carpenter varied but usually he was a freedman or slave.
Mention has already been made of the *dendrophoroi* or timber dealers. At Ostia
they had an important *collegium* and surviving fragments of its membership
lists give the names of at least six well-to-do freedmen. Originally known as
lignarii, the guild got its name from the part it played in providing and parading
the pine tree required annually for the festival of the *Magna Mater* each spring.

The craftsmen we know most about probably worked on their own or with

262

272 (right) The hub (section) and
a sketch of the wooden wheel
from Newstead, with a one-piece
ash rim bound with an iron tyre.
Diameter 3 ft.

162

271 Tombstone of the carpenter P. Beitenos Hermes.

the help of one or two assistants or apprentices in shops with living quarters above or behind. A carpenters' quarter is known in Rome and most work was done to order. Caius at Bordeaux is not the only carpenter known to us by name or appearance. A stone fragment from Cologne mentions one called Titus Gesatius. P. Beitenos Hermes, a couch-maker from the Greek islands, had a plane, dividers and a set square on his tombstone now in the Louvre. Another tombstone in the Archaeological Museum, Turin, shows the wagon maker A. Minucius, bowling along an eight-spoked wheel. Many reliefs depict the craftsmanship of men like him as do the actual wheels sometimes recovered from damp sites. One from Newstead, Scotland, with a rim of ash, willow spokes and an elm hub shows a careful choice of materials. Diocletian's Edict lists freight and sleeping wagons and also individual items such as axles, spokes and wheel hubs, turned and unturned, and a variety of two-wheeled carriages and four-wheeled wagons with names frequently of Gallic origin is known from numerous sources. A guild of *cisani* (wagon makers) existed at Ostia and others are known from Praeneste.

From Astakos in Bithynia we know of the freedman Maximus, a wood-working house-builder of unrivalled skill. He is a reminder of all the woodwork needed in Roman houses for roofs, floors, balconies, stairs and partitions, even when masonry or brick rather than timber or wattle and daub were available for the walls. When masonry was used, scaffolding might be necessary and temporary casing for concrete beams and vaulting. Seats, balustrades, stages and other platforms, and masts for awnings were needed in theatres and amphitheatres. Greek temple accounts remind us of the number of workers needed for large building projects. Seven wood-carvers, twenty-two carpenters, sawyers, joiners, and a lathe operator were employed in the final stages of the construction of the Erechtheion in 408–407 BC, some no doubt only temporary visitors to Athens.

For such work a knowledge of carpentry must often have been combined with other skills although a wood-worker does not normally work in metal or stone. In Rome *c.* AD 130 one of the leaders of the Roman collegium of wood-workers was P. Cornelius Thallus, the son of an architect. The inscription on his coffin found at Arles tells us that Q. Candidus Benignus was a member of the local collegium of builders and carpenters. He possessed great skill and was a student of building theory. A modest man, great craftsmen called him 'master'. A specialist in waterworks and road-building, he was sweet-tempered, gentle, studious and a good host. The reference to waterworks has given rise to the suggestion that Candidus Benignus may have designed the large flour-mill at Barbégal with its rows of water mills at eight different levels. Skill in carpentry would be needed to design the mill-wheels and other wooden fittings.

For ship-building, organization on a much larger scale must often have been necessary to saw and join planks and make oars and masts. The guild of the *fabri navales* at Portus had over 350 names on its list at the end of the second century, mostly freedmen but including some army or navy veterans. They probably made merchantmen, and perhaps also barges, ferries, and other small craft for local use. The veterans would be putting their skills acquired in the forces to good use. Another such guild existed at Ostia and is known to have

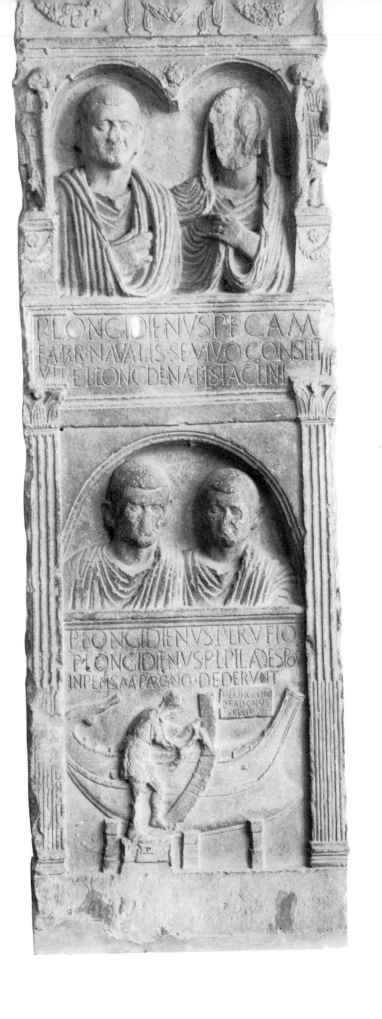

273 Tombstone of P. Longidienus Camillus showing a craftsman at work on a boat.

had a guildhall and probably also maintained a large temple. Diocletian's Edict differentiates between shipwrights working on river vessels, who were paid 50 denarii, and on sea-going ships who received 60 denarii daily. The latter command the highest wages for a wood-worker.

273 The best picture of a *faber navalis* at work comes from a tombstone at Ravenna put up in the late second or early third century. Above are busts in a niche and an inscription giving the name P. Longidienus Camillus and his trade. Below he is seen at work beside a ship, holding a piece of timber which he is carefully shaping into a graceful curve with an adze. Beside him is the inscribed comment, 'P. Longidienus pushes on with his work'. The ship is firmly supported on blocks and the craftsman stands on a substantial object with a lock. Can this be his tool chest? And why is he working beside what appears to be a finished piece of work?

Ancient ships were constructed in one of two ways. Either a skeleton with keel and ribs (frames) was set up and planks fastened to it. Or the skeleton was omitted and a shell of planks, each pinned to its neighbour, was fashioned. In northern Europe the planks overlapped and were rivetted together, producing the clinker-built ships of the Vikings and others. In the eastern Mediterranean the planks were set edge to edge (carvel-built) and secured with dowels. The Romans were believed to use the skeleton keel method, but a fresh examination of the above-mentioned tombstone by Lionel Casson seems to qualify this theory. Remains of wrecked merchantmen discovered by underwater archaeology did indeed show a skeleton of keel and frames but combined with edge-joined planks. These planks were fixed together with great care and skill, with tenon and mortice joints and held by a dowel to prevent them working loose. On sea-going ships in particular the joints almost adjoin. It seems that elements of both types of ship-building were present; which did the *faber navalis* use when he set out to construct a new ship?

Longidienus' ship appears so well made that it seems its planking was already complete. The piece of wood he is shaping is surely a frame to insert in his completed shell, and the tops of other frames already in position are visible in the photograph. Such a method called for great skill and precision from the shipwright and the result was a hull of remarkable strength. On one fragment of planking brought out of the Mediterranean is the line scored across the inside of the hull which indicated to the craftsman where a frame was to go. Remains of boats recovered from the river Thames at London were also carvel-built, solid flat-bottomed sailing barges of oak which may represent the Celtic traditions mentioned by Caesar when describing the ships of the Veneti.

Bibliography

Burford, A., *Craftsmen in Greek and Roman Society*, London, 1972
Goodman, W., *A History of Woodworking Tools*, London, 1964
Pliny, *Natural History*, books 7, 13 and 16.
Singer, C., *et al.*, *A History of Technology*, II, Oxford, 1956
Theophrastus, *On Plants*

J. P. Wild

13 Textiles

The mere fact that most inhabitants of the Roman Empire wore clothes ensured that the textile industry played an exceptionally important role in the Roman economic system. Under the heading 'textile industry' a surprising number of varied activities and processes can be listed, reflecting the wide spectrum of Roman society which contributed in some respect to textile production. A grandmother spinning wool in her homestead in the Cheviots is as significant a figure as the weaver of silk damasks in Syrian Berytus.

Ancient textile fabrics and the methods used to produce them are badly documented. Roman writers supply little direct information, since textiles were a facet of everyday life which demanded no comment. Surprisingly, poets often tell us more than prose writers; for spinning and weaving regularly feature in the best-loved Greek myths, and some Roman poets had a passion for scholarly description. Surviving textiles and textile implements from archaeological contexts are much more helpful. The present account, therefore, is based primarily on archaeological sources, supplemented by the literary record and information extrapolated from modern primitive practice.

The textile technology of the Roman Empire was by no means uniform—that was perhaps the secret of its vigour. The traditions of the pre-Roman and Roman-Iron-Age woollen industry were dominant in the west while in the east the heritage of Greek and Oriental craftsmanship in a wide variety of fine fabrics remained strong. This chapter is largely concerned with the western provinces. It takes the reader stage by stage through the processes of textile manufacture from the sheep's back to the finished cloth.

Fibres and their preparation

Wool. From the time of the earliest agricultural communities in western Europe the sheep was the major source of textile fibre. We have learnt a great deal in recent years about the character of early sheep from the research of M. L. Ryder into surviving ancient wools and sheepskin.

Two breeds are detectable in the Roman provinces: a small goat-like animal with a brown fleece resembling the modern Soay sheep of St Kilda, and an improved breed with a finer, normally white, fleece which was developed by selective breeding from the Soay-type. The Soay has a kempy fleece and wool-

274 Detail of a wall painting showing a vertical two beam loom. From the Hypogeum of the Aurelii, Rome.

fibres which are generalized as medium-fine. The improved breed lost most of the kemp; its fibres ranged from a generalized medium-fine to true fine wool. This was probably the Tarentine or 'jacketed' sheep mentioned by Roman writers.

The latest research has shown that short-wool sheep, such as are found in England in the Middle Ages, had already begun to develop from medium-wool in Roman times, possibly within, but certainly outside, the northern frontiers of the Empire. Wool trade across the Roman frontiers now begins to make sense.

It is difficult to plot the distribution of flocks in the Roman provinces. For Britain, finds of iron woolcombs point to sheep raising on and around the Breckland Heath of East Anglia, a major wool-producing district in the Middle Ages. The Romano-British peasant of the Fenland probably kept sheep, too. In fact virtually anyone with land would have kept a 'backyard' sheep or two, if only for milk. In the fourth century, according to the *Notitia Dignitatum*, an official handbook, a wool-weaving workshop was sited at 'Venta'. The best candidate among the places named *Venta* is still Winchester. For the continent there is documentary evidence of sheep-ranching in Flanders by the Atrebates, the Nervii and their neighbours. There were wool-weaving workshops at Trier, Reims and Tournai.

Sheep were shorn in the early summer with the aid of iron shears almost identical to the type in use nowadays. Only the fine wool clip was washed, just before or after shearing. Wool was often dyed 'in the fleece', a process to be described later.

Long-stapled wool was sometimes combed to remove the unwanted short fibres and impurities. Flat iron combs with long teeth are found throughout the western provinces and were probably used for this purpose. We hear in Italy of professional woolcombers, *lanarii pectinarii*. Carding with handcards was not invented until the Middle Ages, so wool which was not combed probably had foreign bodies teased out by hand.

Flax and Hemp. The vegetable fibres, flax and hemp, are more difficult to grow and convert into fabrics than wool, and they cannot match wool's amazing versatility. But flax may have been an earlier source of textile fibre than wool in Europe and the Mediterranean region. Both flax and hemp were spun and woven in the Roman Empire, especially in the eastern provinces.

Flax was more important for woven textiles than hemp. The methods of growing and harvesting both plants and preparing their fibres for spinning were broadly similar. In the absence of sufficient information about hemp culture in the western provinces, flax will be our main concern below.

There is no lack of linen textiles in Roman Britain and the continental provinces, but little direct evidence for where flax was grown. A glass rubber for smoothing linen cloth was found on a Roman site at South Shields. In the continental provinces the Morini and Caleti of Pas-de-Calais and Le Havre are known to have been linen producers, the founders of the celebrated Flemish flax industry. Their output may have been supplemented by growers in the Rhône Valley. There is no sign in the Roman period of more than one strain of cultivated flax.

Methods of harvesting and production have changed little since antiquity.

The tall flax stalks were harvested in high summer, just before they became ripe. They were pulled up by hand, root and all. Pliny the Elder tells us of the processes which followed. First, the flax was bundled up and the bundles weighted down in stagnant or slow-flowing water for about three weeks. During the *retting*, as this process is called, bacteria loosen the unwanted bark from the workable bast fibres within. After drying the flax was *broken*, pounded on a flat stone with a wooden mallet, and then *scutched*, bent over a narrow object and beaten with a flat wooden blade. These actions loosened the fibres completely from the bark and core. In the final operation, *hackling*, the flax fibres were drawn through the long iron teeth of a wooden combing-board (*aena*) to get rid of the last remnants of woody material.

Hemp is a tougher raw material than flax; but where hemp fibres are still prepared by hand today, the tools and techniques which Pliny described in connection with flax can still be seen.

Silk and Cotton. For the ancient trader textiles must have been one of the easiest of all commodities to handle. In the Roman world textiles of every style and quality moved freely along the trade routes inside and far outside the frontiers. In less happy times only luxury textiles travelled. Silk was always popular, whatever the economic climate.

Cultivated silk from the mulberry silk-worm was raised only in China until the sixth century AD. Chinese silk fabrics, yarn and possibly even the cocoons were imported into the Roman Empire in ever increasing quantities. Wild silk was imported mainly from India, but the Aegean island of Cos was famous for a local variety. Its output must have been small, but its silk probably travelled into Hallstatt Europe. There is confusion in the ancient sources on how exactly the silk was obtained from the cocoon on Cos. Cultivated silk can be reeled off the cocoons, but the wild silk moth usually bites its way out of its cocoon and reduces the silk fibre to short lengths which have to be spun.

Isolated finds of cotton in late-Roman contexts in Europe must represent a chance distribution of the material. In two of the four known instances, orientals brought the cotton with them as personal effects.

The Romans experimented with a considerable range of natural fibres, few of which were more than curiosities; they include rabbit hair, goat hair, *pinna*, mallow and asbestos.

Spinning

Spinning has a specially significant position in the conversion of fibres into fabrics. For one thing, it absorbs a disproportionate amount of labour. Moreover, it is manual dexterity rather than sophisticated implements that determines the quality of the product. There is little difference between the quality of the best ancient hand-spun yarn and that achieved by modern mechanical methods.

In antiquity spinning was a cottage industry, one of the most familiar and essential chores of the housewife or her servant girls. Their implements were the distaff and the handspindle.

The simplest form of distaff was a short forked stick, the prongs of which supported the mass of fibres to be spun. It was held in the left hand. The spindle

was a narrow rod of bone or wood, up to 8 inches in length, which had a symmetrical thickening near the lower end to wedge the spindle whorl. The latter, a disk with a hole, lent impetus to the spindle while rotating. Distaffs and spindles of more precious materials are found, but the vast majority were certainly of wood.

The Romans practised 'suspended spindle spinning', the most advanced technique in antiquity. The actual operation of spinning consisted of two basic steps: drawing out the fibres and twisting them. First of all, the distaff with the fibres which had been fastened to it was grasped in the left hand. The spinster, seizing a few fibres from the mass on the distaff between the wetted forefinger and thumb of the right hand, simultaneously twisted them together and drew them gently downwards.

When she had drawn out and twisted in this manner a short length of thread, she tied it to the top of the spindle. (Roman spindles did not have a hook to aid this operation.) Then, taking the tip of the spindle between the forefinger and the ball of her thumb, she gave it a vigorous twist to set it in motion, and then let go. The thread with the free-rotating spindle on the end of it thus hung straight down from the mass of fibres on the distaff. With the fingers of her right hand she then continued to draw out a controlled number of fibres from the distaff, which were twisted by the action of the spindle into a thread. At the same time the weight of the spindle stretched the thread as it was being formed and made it finer.

The simultaneous drawing and twisting continued without a break until the spindle reached the floor and stopped. At this point the spinster had to halt, pick up the spindle and, using it as a bobbin, wind up the spun thread. She made the thread fast on top of the spindle again, gave the latter a twist and continued the operation as before. When the spindle was full of yarn, she broke off the thread and rewound it into a ball.

A final point about the mechanics of spinning is worth making. The direction in which a spinster rotated her spindle, clockwise or anticlockwise, was determined by local convention which was only broken for specific technical reasons. In the northern Roman provinces as a rule yarns were spun clockwise. (Yarns spun clockwise are referred to for clarity as Z-spun yarns, the centre stroke of the letter corresponding to the direction of the spin.) In the eastern provinces, however, an anticlockwise spin-direction was the norm, except for yarns in fine wool cloth from a group of workshops in Syria. In the north west, wool cloth was sometimes given particular stability by being woven from Z-spun yarn in one thread-system, S-spun in the other.

Looms

Woven textiles and the mechanical devices on which they were produced in Roman times are closely related topics. Discussion on the one cannot eschew reference to the other. For the sake of clarity the question of looms will be considered first, followed by an examination of some surviving textiles and their weaves. Logically, however, the textiles should come first, since they are a good source of evidence on types of loom.

Direct evidence on Roman looms is scanty; they were of wood and none

275 Wooden spindles complete with whorls. From the Faiyum, Egypt. The longer one measures 13 in.

276 The Z and S-spin convention.

277 A typical warp-weighted loom.

survive. But the literary sources are relatively informative. There are a few representations of looms in ancient art, and modern survivals of primitive looms shed useful light on structure and modes of working.

The basic loom of classical antiquity was the *warp-weighted vertical loom*, which is still used today in outlying parts of Scandinavia. The two main uprights (each over 6 feet long) (fig. 277,a) were linked across the top by a cloth-beam (b), to which the warp was attached. From each upright at about breast height there projected a short bracket (c), the end of which was usually forked to support one end of the heddle-rod (d). The brackets were set in holes in the uprights and so could be adjusted for height. The heddle-rod itself was usually of wood, but may sometimes have been a stout reed, lighter than a wooden pole.

Lower down the frame a fixed shed-rod (e) spanned the gap between the uprights. The latter were made to lean against a roof-beam or wall at a slight angle. All the 'odd-numbered' warp-threads (A) (or even-numbered as the case may be) hung perpendicularly behind, but free of, the fixed shed-rod (e). Groups of them were fastened to each loom weight. The leashes (that is, adjacent loops made out of a single length of string) bound each of these odd-numbered warp-threads individually to the heddle-rod (d) which lay in the angle between the brackets and the uprights. The even-numbered warp-threads (B) on the other hand were tied to a corresponding, but separate, row of loom-weights and hung over the front of the shed-rod (e) parallel to the tilted uprights. Each leash therefore passed from the heddle-rod (d) to its appropriate odd-numbered rear warp-thread between a pair of even-numbered warp-threads.

In this position the so-called 'natural' shed (X) was open. To change it, the heddle-rod (d) was placed in the forks of its brackets and the back row of warp-threads was thus drawn to the front of the even-numbered. This created the 'artificial' shed (Y). Two spacing-cords (f), one for each system, were stitched in and out of the warp-threads to hold them apart correctly. By passing a hank of weft through the shed and then changing it plain cloth could be woven on a loom of this type. Twill required two more heddle-rods and a different leash-arrangement.

The warp was anchored to the cloth-beam (b) by means of a starting-border, woven in a preliminary operation on a band-loom. The starting-border is characteristic of cloth woven on the warp-weighted loom.

After the weft-thread had been inserted into the shed, the weaver pushed it into position against the existing web of cloth with a variety of small implements. A bone or antler weaving-comb was used in the Iron Age, replaced in the Roman period either by an improved version in wood or by the weaving-sword (*spatha*). The latter, shaped like a large paper-knife, was pushed up or down within the shed. A bone pin-beater (*radius*) could be used in conjunction with the comb or sword to free knots: it resembled a cigar, pointed at both ends. Roman weavers did not use a shuttle, but threw the weft as a ball, hank or 'dolly'.

The warp-weighted loom, dominant at first in the Roman Empire, eventually faced competition from the two-beam loom which was more convenient for weaving many types of cloth. But it survived throughout the Roman period wherever unusually large webs of cloth were woven, for example among the the linen-weavers of Egypt.

278
279

278 (far left) Iron Age weaving combs of bone from Radley, Berkshire. Length 5½ in. **279** (left) A wooden weaving comb from Roman Egypt. Length 11 in. **280** (far left) A typical British Iron Age loomweight and (left) a pyramidal Roman loomweight from the villa at Mungersdorf near Cologne. Half size.

The two-beam loom held its warp under tension between two cloth-beams, an upper and a lower. It was often used for tapestry-weaving and in this guise it is represented occasionally in Roman art. Its uprights stood vertical, each on some form of 'foot', and the whole loom was probably a better piece of carpentry than the warp-weighted loom. Because of the tension on the warp, only a comparatively narrow shed could be opened. The type seems to have been known in Iron-Age Scandinavia, and Roman writers refer to it regularly.

The third main type of Roman loom is surrounded by controversy. It was the horizontal loom, developed by weavers in the eastern provinces or in the Persian Empire, who experimented with increasingly complex weaves in the third and fourth centuries. The earliest textile which I know from a dated context which appears by reason of the complicated nature of its shed arrangement to have required multiple heddle-rods or a draw-string device (and hence a horizontal loom) is a silk damask from Trier. It is dated to AD 395 and bears a weaver's mark in Latin.

If Walter Endrei's attractive suggestion is correct, the Syrian or Persian weavers adopted the horizontal loom from the nomads of the Steppes and refined it for their own use. In Roman times it is unlikely to have been found outside the workshops of specialists, particularly silk-weavers.

274

281 A 2-over-2 twill from Caerwent.

A number of small *band-looms* for braid-weaving and tablet-weaving may be presumed for the Roman period. The small perforated square or triangular tablets for producing decorated or corded bands and borders are not uncommon finds on Roman sites, and tablet-woven borders are attested, too, among the extant textiles. Narrow bands could also be woven with the aid of a rigid heddle or heddle-frame. These were made of bone and bronze, and probably also of wood, and could accommodate a small number of threads. The odd-numbered threads were tethered in a central hole, the even-numbered were free to slide in a slot. The shed was changed simply by moving the frame up and down across the work.

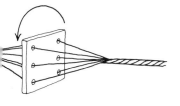

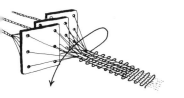

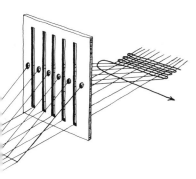

Above: **282, 283** The use of tablets to weave braid. Below: **284** The use of a rigid heddle or heddle-frame in weaving narrow bands.

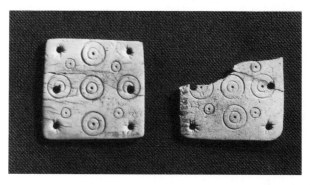

285 (left) A heddle-frame made of bone strips fastened with bronze bindings. One strip is now missing; originally there were six holes and five slots accommodating a total of eleven threads. From South Shields. $1\frac{3}{4}$ in. by 3 in. **286** (above) Six-hole bone tablets for tablet weaving, from Alchester, Oxfordshire. $1\frac{1}{2}$ in. square.

Textiles

Surprise is often expressed by the layman that *any* Roman textiles survive at all. But in Roman Britain and the Rhineland over two hundred cloth fragments have been discovered, and the total increases every year. While few can be assigned to a specific garment or article of soft furnishing, they give a good conspectus of Roman weaves and fabrics in the provinces.

There are two principal conditions which favour the survival of textiles in the northern provinces. They are, firstly, anaerobic conditions with constant moisture, and, secondly, protection or replacement of the textile by the corrosion products of certain metals. Ideal anaerobic conditions prevail in marshy ground undisturbed since antiquity. The peat-burials of Denmark illustrate this best, but on a smaller scale the marshy terrain outside the Roman fortress on the Kästrich at Mainz has facilitated the survival of great quantities of woollen rags. Corrosion products necessarily preserve smaller amounts of fabric, but pieces of linen bags or purse linings are often found in association with hoards of bronze coins.

In plain weave, the weft passes over one warp thread and under the next, as described in the discussion of the warp-weighted loom above. In 2-over-2 twill the weft passes over 2 warp threads and under 2, but the passage of weft moves one warp thread to left or right after each weft throw. In 2-over-1 twill, the

weft passes over 2 warp threads and under 1—or vice versa as shown in fig. 287.

Plain weave is well represented in all places at all times. Roman linen was almost exclusively plain-woven. The gypsum burials from Dorchester, York and Trier, for example, preserve fragments and impressions of many qualities of household linen used for wrapping the dead. There is plain-woven wool cloth from the Walbrook in London, decorated with simple tapestry bands inserted as weft during weaving.

Twill of the 2-over-2 variety was used for matting at a very early date but it is not found as a textile weave until the Bronze Age, and then only once. However, it became extremely popular in Iron-Age and Roman Europe; for it imparted stability and compactness to wool cloth. It is rarely found in any other fibre.

Twill was more difficult for the weaver than plain weave, but even more complex were chevron twills in which the direction of the weave changed either in the weft or warp direction. Both were known in the Iron Age, but it is not until the Roman period that the combined form, diamond twill, caught on.

The cloth finds from Mainz include all types of twill, ranging from fairly coarse plain twills to fine diamond twill. The earliest datable Roman diamond twill is from Colchester, perhaps part of a mattress cover, burnt during the Boudiccan revolt of AD 60. An important new group of wool textiles from Chesterholm near Hadrian's Wall also contains twill. It is probably of late first or early second century date.

287 A 2-over-1 twill from Corbridge.

288 (far left) Fragment of a 2-over-2 twill weave with weft chevron pattern, from Saltburn, Yorkshire. Actual size. **289** (left) Fragment of woollen cloth, a 2-over-2 plain twill weave, from Chesterholm near Hadrian's wall. **290** (right) A 2-over-2 diamond twill from Mainz.

Northern Europe was famous in the Roman world for its check-patterned cloth (*scutulata*). A fragment of weft-chevron check cloth from Falkirk exemplifies this technique, but more spectacular is the complete blue check cloak of Roman-Iron-Age date from Thorsberg in Schleswig-Holstein.

Twill of 2-over-1 style features less frequently than 2-over-2 twill among Roman textile finds in the north-western provinces. It was less suited to the warp-weighted loom, and may not be native to western Europe. It is essentially a pattern weave; for if warp and weft are in contrasting colours, the cloth, too, will have a different colour on each face.

In the third and fourth centuries silk weavers in Asia Minor began experiments on the basis of 2-over-1 and 2-over-2 twill to produce more complicated weaves. Ultimately, true damasks emerged from their work. A small fragment of check silk in 3-over-1 twill was found in the Holborough barrow in Kent. It was probably an import from Syria.

Non-woven fabrics deserve a brief mention, but their production-methods are too diverse to be discussed in the present chapter. The warp-plaiting technique called *sprang*, produced on a frame, was used for bags and openwork hairnets—and in North Africa for matting. It occurs throughout the Roman Empire. Knitting with two needles as we know it is found surprisingly rarely in Roman times, but finds of bronze needles in the western provinces and knitted fabrics in the eastern provinces show that at least it was known.

Dyeing and finishing

So far we have examined three separate areas of skilled craftsmanship—the primary fibre production, spinning and weaving. Strictly speaking, fibre production and some aspects of fibre preparation were a branch of Roman agriculture, but spinning and weaving were of course independent textile crafts. Certain specialists, such as the woolcombers, had a part to play, too, but they did not affect the broad outline of the organization of textile manufacture.

Two further crafts round off the picture, dyeing and finishing (fulling). Technically, dyeing should have been considered immediately after fibre production, since ancient dyemen treated unspun fibre more often than yarn or woven cloth; but it is more convenient for us to consider it along with fulling. Both crafts required more expensive and permanent plant than any other branch of the textile industry.

The Gauls were accomplished dyers according to Pliny the Elder. His account is amply confirmed by the Iron-Age cloth fragments from the Hallstatt saltmines, in which the colours are well-preserved. The western provincial craftsmen inherited this technical tradition, but introduced new and improved plant.

An ancient dyeworks contained a series of stone-built boilers, each supporting a copper vat in which the fibre or cloth was dyed and the dyestuff itself prepared from its raw materials. Pompeii, Herculaneum and Ostia have some fine examples of such workshops.

The methods and chemistry of Roman dyeing are still obscure. We know that a purple dye from the shellfish *Murex brandaris* was highly regarded, but other sources, such as the whelk *Purpura haemostoma* and the lichen *Archil*

yielded a substitute purple. Vegetable dyes, however, such as madder and woad were more readily available and easier to apply.

Many dyes would not 'take' without a mordant. The fibre had to be treated with alum or iron salts before the dyestuff proper would adhere. Manipulation of the mordant could affect the shade of the finished colour. Wool was commonly dyed; linen much more rarely.

The professional fuller had two main functions, to finish cloth in loom-state and to launder soiled garments.

The first stage in the fulling of wool cloth was to tread it out in a tub of water in a solution of fuller's earth or decayed urine. This released the residual grease and dirt. It is commonly supposed that the treading also caused the cloth to shrink, one of the aims of later mechanical fulling or 'tucking', but Walter Endrei has recently suggested that this was *not* one of the main aims in Roman times.

Another cloth-finishing technique was raising and cropping the nap. The fabric, draped over an horizontal beam, was worked over with an *aena*, a spiked board held in the hand. The nap thus raised was trimmed with a pair of long iron cropping shears. Sometimes yarn was specially spun and woven to facilitate the raising of nap: such soft-finished cloth was called *vestis pexa*.

Wool cloth was sometimes bleached with sulphur in the fuller's workshop, as wall-paintings in a Pompeian *fullonica* demonstrate. Linen cloth was probably bleached, too, and polished with a glass linen-smoother. Before the customer or weaver received his goods back, they were pressed in a screw-turned clothes-press.

In many parts of the Roman world a fullery is distinguishable by the tanks

291 (left) A fuller treading cloth; 292 (above) cropping the nap; reliefs on a tombstone from Sens, Yonne.

291

292

293

and basins which take up much of the floor-space. Much of the plant, however, might equally well be of wood, with or without a lead-sheet lining, and perhaps for this reason no fulleries on the Italian pattern have been recognized yet in the western provinces, although there is epigraphic evidence for them.

Textile tradition and achievement

Most crafts practised in the Roman provinces either had a metropolitan origin or were strongly influenced by metropolitan trends. However, the reverse seems to be true of the textile crafts. The textile traditions of north-west Europe and of the Greek-speaking East were quite distinct, and Roman textile technology included them both. Italy appears to have had few technical advances in the field of textile production to its credit. Improved finishing plant may be one. As a result, the diversity of textile manufacture in the western and eastern provinces persisted throughout the Roman period and beyond.

Bibliography

Forbes, R. J., *Studies in Ancient Technology* IV, Leiden, 1956

Henshall, A. S., 'Textiles and weaving appliances in prehistoric Britain', *Proceedings of the Prehistoric Society*, 16, 1950

Hoffmann, M., *The Warp-Weighted Loom*, Oslo, 1964

Jones, A. H. M., 'The Cloth Industry under the Roman Empire', *Economic History Review*, 13, 1960–61

La Baume, W., *Die Entwicklung des Textilhandwerks in Alteuropa*, Bonn, 1955

Ryder, M. L., 'The History of Sheep Breeds in Britain', *Agricultural History Review*, 12, 1964

Ryder, M. L., Stephenson, S. K., *Wool Growth*, London, 1968

Singer, C., et al., *A History of Technology* I–II, Oxford, 1944–56

Wild, J. P., *Textile Manufacture in the Northern Roman Provinces*, Cambridge, 1970

Wipszycka, E., *L'Industrie Textile dans l'Egypte Romaine*, Warsaw, 1965

293 Iron cropping shears from Great Chesterford, Essex. Length 4 ft 3 in.

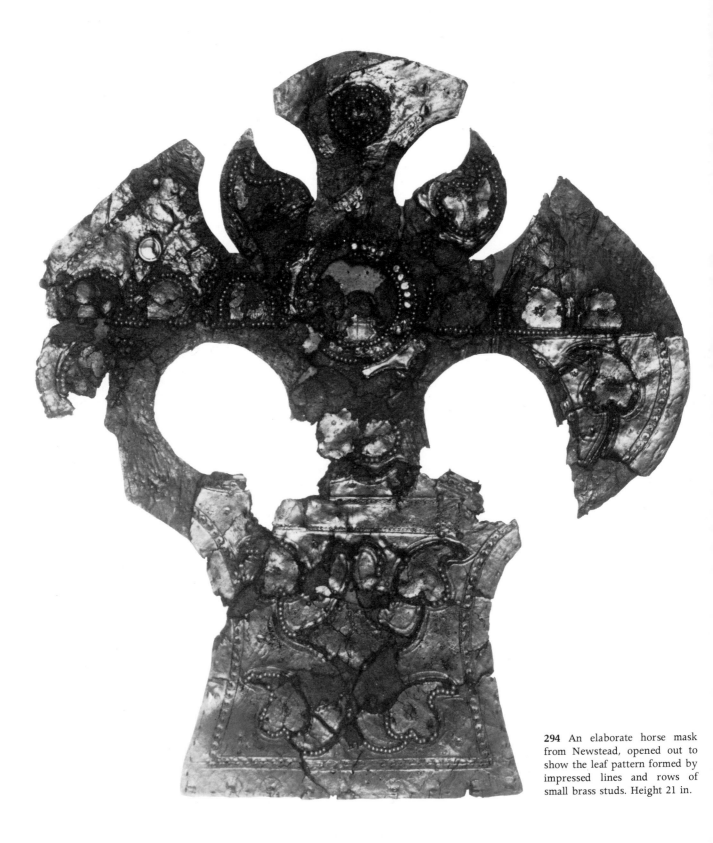

294 An elaborate horse mask from Newstead, opened out to show the leaf pattern formed by impressed lines and rows of small brass studs. Height 21 in.

J. W. Waterer

14 Leatherwork

Although relatively scanty, fragmented and widely scattered, there is, never-theless, sufficient evidence to justify the assertion that the Romans, at the height of their civilization and Empire, were highly skilled in the arts of making leather of excellent quality and of converting it into a wide variety of objects of everyday use in many of which craftsmanship of a high order is manifest. In fact it seems probable that they were the most sophisticated users of leather in the western world up to their time. Wherever their empire extended there is massive evidence that leather was a prime necessity of life.

Raw animal skin, usually 'cured' to some extent, has been used by man from the time of his emergence as a hunter for many purposes some of which still survive, such as the moulded containers (*tandu*) of the Hausa people and others, and parchment the use of which is still widespread. But these are not the 'leather' with which this article is exclusively concerned. Leather is a manufactured product; it can be made from the skin of any animal but it is made by the skill of man and is essentially different from raw skin. This is established by three basic factors: raw skin when dry is normally hard and horny because the collagen is tightly compacted; but it can be readily softened with water in which condition it rapidly becomes a prey to putrefaction promoted by bacteria; or it can be dissolved in hot water to make glue or size. Leather is made from the marvellous fibrous structure known as the *derma* or *corium*, the middle layer of the skin, the fibre bundles being separated, protected by chemical substances and lubricated with oil, fat or grease, so that the finished product can, if required, be made as soft as velvet, can be wetted and dried without harm, and is im-putrescible. This transformation is achieved by a series of processes broadly known as 'tanning' but of which there is a wide choice according to the particular characteristics required in the finished product.

Bacteria develop rapidly in freshly flayed hides (of the large animals) and skins (of the smaller beasts); consequently they must be protected against irreparable damage until they reach the tanyard (which may be far distant). The ancient methods were sun drying, dry salting or wet salting. The processes preliminary to actual 'tanning' are washing, liming to induce a condition receptive to the tanning liquors and to facilitate removal of wool, and de-hairing. There are three ancient, basic methods by which raw skin can be converted into

leather: firstly, vegetable tanning employing the 'tannin' present, in varying degree, in all vegetable matter such as wood, bark, leaves and fruits; secondly, chamoising (now usually called oil 'tanning') in which fish or marine animal oils are oxygenated and form a protective film around the fibres; and thirdly, tawing (now usually called 'mineral tannage') which results from immersion in a solution of alum and salt. Of all these processes there are now many varieties. Of the three basic methods there is evidence that the Romans used the first and third but, so far, no evidence of use of the oil process although it was probably employed in combination with tawing, for example in the dressing of leather for sails as described by Caesar. The conversion of the raw skin into leather is followed by a selection from a variety of processes known collectively as 'finishing'; these are intended to render the 'rough tanned' hides and skins suitable for particular purposes. Appearance is governed by colouring and finish whilst other processes affect the actual character of the leather. Colouring is achieved by 'staining' which involves colouring the surface, 'dyeing' which involves immersion or 'painting' which nowadays signifies pigmented nitro-cellulose applied by spray but in the past denoted a mixture of dye and pigment which provided an opaque surface to mask surface blemishes. The leather could be given a smooth or grained finish, or a bright or dull one. It could be made firm by rolling or hammering, or soft by folding and rolling backwards and forwards on a cork-covered board; or it could be made tough yet pliable by impregnating it with 'dubbin', a mixture of cod-oil and tallow. This latter process is called 'currying' and consists in working the grease into wet leather with 'slickers' of stone, glass or metal.

Practically no colour has survived long burial or immersion; whatever its colour originally, most ancient leather is now black or more rarely dull brown, resulting from chemical action.

It is impossible to say how far Roman knowledge and practice extended in the direction indicated. The total amount of leather objects, or parts of them, so far exhumed from Roman civil and military sites must be considerable, but only a very small part of it has been scientifically explained; so far as I am aware the leather in regular use appears to have been limited to the hides of bovine animals and perhaps deer, and to the skins of goats, or more rarely sheep, vegetable tanned and, to judge from its condition after nearly two thousand years, of excellent quality. Some attempts have been made both to identify the pelt more definitely and to determine more precisely the nature of the tanning agents. But, through long ages of burial or immersion, the evidence has vanished as also has any indication of the nature of colouring, surface finish or 'stuffing' (grease or oil) used in the subsidiary process of dressing. Yet in numberless cases the material remains indubitably leather, often hard and brittle yet amenable to modern conservation processes. In general the bovine leathers were used for soles of footwear, harness and parts of military equipment, and the thinner goatskin for clothing, tents, bags and other containers.

It is, perhaps, curious that no kind of chamoised (oil dressed) leather has yet been identified. The basic process is supposed to have arisen from the attempts of early man, or his predecessors, to soften dry, horny pelts by rubbing into them grease, fat and brain substance from slaughtered animals. Brain substance

in particular, because of the phosphorus content, would have produced an elementary 'tannage'. It is not so strange that no specific evidence remains of the use of tawed (alumed) leather for, unlike tanned or chamoised leathers, it will not withstand water and therefore is unlikely to survive immersion or prolonged burial. The evidence here is philological. The word for alumed leather was *aluta* and one of its uses was for sails, but in this case its somewhat fragile character would have been overcome by combining the essential feature of chamoising with tawing.

Decoration by cutting

It is characteristic of good quality, well dressed leather that, if cut with a sharp knife, the resultant 'cut' or 'raw' edge will not fray in use—at least not for a very long period. In this respect leather in Roman times must have been superior to any other flexible material then available, and hemming was not essential. 'Cutting' can consist in producing a piece of leather of given size and shape, from either a whole hide or skin or a large piece left over from other work; this is normally done with the leather laid flat on a wooden surface, using a template. Cutting can also be employed for removing unwanted leather as in the openwork shoe called a *caliga* and calls for great skill; one false cut would completely ruin the whole piece of leather. Slitting (a single cut) in its simplest form is often found in the simple, one-piece shoe called a *carbatina* in which horizontal slits around the upper edge permitted a leather lace to be taken from side to side over the instep. In the example illustrated from Newstead it is not quite certain whether the scallops were deliberately cut or result from the pull of the lace in long use—probably the former because in its simplest form the *carbatina* is a single piece of leather wrapped around the foot and secured by a single lace around the top edge, whereas this example has been shaped to the foot, being

300, 301

295 (above) The 'pattern' for a one-piece shoe. **296** (right) A one-piece *carbatina* from Newstead.

181

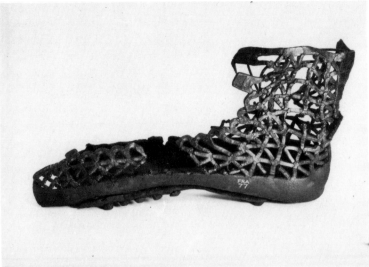

seamed up the heel (in the vast majority of cases this is the only stitching found in Roman footwear) and has a very sophisticated latchet in addition to the instep lace. For ages it has been the custom of leather craftsmen to use a special edge-tool to remove the sharp right angle formed by a knife-cut through thickish leather. This is a most delicate operation and yet in the example illustrated every one of the many knife-cuts has been so rounded off. One important feature here is the remains of the lace with its carefully cut 'spear point' (left side) and another is the purely decorative pair of simulated knots reminiscent of net work that appear in several places, such as the toe just left of centre, and which are particularly prominent in fig. 301. It must have called for great skill to carve this miniature ornament in addition to the intricacies of the 'network' design.

Another extraordinary fact is that all Roman footwear—even the daintiest women's shoes—were built up on the same clumsy type of sole that, with a system of straps, served as a military sandal, made of an average of three layers of thick leather joined together with iron hob-nails, although one or two examples are known in which the layers are laced together with rawhide. The Romans seem not to have been concerned with the crudeness of these soles; the hobnails were often worked into patterns, many uncouth but some very attractive and at least one representing a bound prisoner of war who was thus figuratively trodden underfoot. In the case of a sandal the ends of the straps, or in the case of a shoe the lower margin of the upper, were inserted between two layers of the sole, being secured by the iron nails which had either hemi-spherical heads or slightly conical ones. I have found no evidence for the spiked nails depicted in some old drawings. There is an unusually advanced form of Roman shoe with a double latchet fastening from the Walbrook, London. Apart from its hobnailed 'sandwich' sole, it might have been made in the nineteenth century.

Finally, there is a method of piercing holes through leather, either with a special knife or with hollow iron punches, to produce intricate lace-like patterns for which I know of no precedent prior to Roman times, although the ancient Egyptians turned soft leather into a flexible network by means of fine slits. The

297, 298 Halfboots from Newstead—the functional military type and fancy cut-out version. **299** (below) The patterns of iron hob-nails on the soles of shoes from Valkenburg.

300

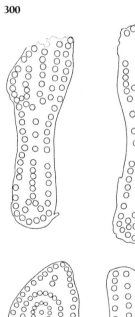

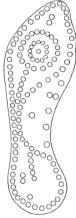

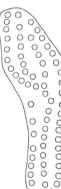

300 (above) An openwork sandal with simulated knots and a spear-point lace. From London, second century AD. **301** (right) Part of an openwork sandal with simulated knots. Many of the edges have been edge-tooled.

302 A latchet shoe from the Walbrook, London.

183

most remarkable Roman example so far met with is a small fragment of thin leather (probably goatskin) recently recovered from a London ditch, the square holes in which are one millimetre square; they were almost certainly punched although no leather punch so small is made today. Some of the larger pierced designs appear to have been cut with a narrow-bladed knife because the edges are quite sharp whereas a hollow punch, which outwardly tapers upward, pushes the top edges of the hole it makes downwards, leaving them slightly rounded, and also tends to leave the bottom edges somewhat ragged. The extreme accuracy with which this pierced work—whether cut or punched—is done is truly astonishing, as can be seen in the accompanying illustrations. So far as I am aware, no tools—knives or punches—which could have been used for this work, have been identified, although one or two narrow knives found at Newstead are possible types.

Another kind of piercing has been observed on a few objects, one of which was found in the original layer of fine silt which had accumulated in the bottom of the Roman ship recovered from the Thames at Blackfriars, London, in 1962; although it is almost certainly of Roman origin there is no proof that it was actually in the ship at the time it was wrecked. Its general character and the nautical device suggest that it may have been the front of a wallet in which, perhaps, the ship's papers were carried. This fragment unfortunately lacks much that might have helped to solve the problems it raises. The holes along the edges and those parallel to them are quite clearly stitch holes associated with assembly of the component parts or with some kind of lining; they are slightly oval (indicating the kind of awl used) and here and there can be seen the shallow

303 (below) A shoe from the Walbrook, London with an astonishingly regular arrangement of small openwork triangles. Such work gives the impression of having been stamped out in a single operation as with a modern composite press-knife, yet the triangles have the sharp edges that indicate knife-cuts. Length 10½ in. **304** (right) Fragment of thin goatskin from London with tiny punched holes. Almost full size **305** (right, below) A decorative dolphin indicated by small slits in leather found in the bottom of a ship in the Thames at Blackfriars, London. Height 7½ in.

305

184

grooves made by the thread which, as usual, has completely perished. But the tiny slits, one and a half millimetres long, evenly placed, which together form the greater part of the delineation of a dolphin, are quite different. The possibility of their once having carried an appliqué—a decorative device frequently found in Roman leather work—has been considered, but there is no sign of stitching. The little slits are in themselves too inconspicuous to provide a satisfactory ornament and they are too small to carry leather lacing of which other signs would have been found had it been used. A possibility is that a coloured braid or a twist of wool was threaded through them. The object is now black as is all leather recovered from waterlogged deposits, but it may once have been coloured; the material is vegetable-tanned goat or sheep skin.

Indented ornamental marks of permanent character can be made on the surface of leather with a variety of tools, such as iron stamps on the surface of which a design has been cut in relief; this can be an isolated motif or one from which a border can be made by repetition. Such tools can be used cold on damped leather or heated on dry in which case the degree of heat employed will govern the extent to which the leather is darkened at the point of contact. In addition, a variety of tools (usually of brass) is used to impress lines, single or multiple, fine or coarse. All these marks can be traced in Roman work, but I know of no extant examples of the marking tools themselves; perhaps they exist but have not yet been recognized. The fact that the Romans employed these methods of decoration is evident from a small number of surviving objects including a horse mask from Newstead and a shoe from the Walbrook, London on which a line of stamped ornaments is combined with a pinked upper edge.

294

In mediaeval times much beautiful decorative work was done with a fine, sharp incising tool which was allowed just to cut through the thin grain surface of the leather which, as it set, opened up slightly. This technique was much used in Italy in conjunction with gilding and coloured glazes and although no examples are known, one wonders if the fine incising had its origin in Roman craftsmanship.

Colouring

Such colouring as the Romans may have applied to leather would have been derived from the natural dyestuffs, vegetable or animal including purple from murex. But although a Roman shoe excavated at Southfleet many years ago was said to be purple, it is certainly not so now and, as previously stated, it is unlikely that any form of colouring would have survived centuries of burial.

Stitching

Stitching is basically a way of joining together the component parts of an object and was so employed in Egypt some 3700 years ago. The practice, which involves the use of a needle and either a sinew or thread, developed from the primitive practice of threading narrow laces of leather or untanned skin through a series of slots. Stitching can be very decorative even when its purpose is purely utilitarian. Sometimes, of course, its purpose is entirely decorative, but the nearest the Romans seem to have got to the purely aesthetic use of stitching is the decorative elaboration of the stitching by which an appliqué pattern (possibly coloured) was attached to an object. There are many examples of utilitarian stitching, efficient and strong but not particularly beautiful, to be seen in the surviving fragments of clothing, military tents, bags, shield-covers and saddles. Of these perhaps the tents are the most remarkable, largely owing to the meticulous studies of remaining fragments by McIntyre and Richmond and by Dr Groenman-van Waateringe who have left us with very little that we do not know about these extraordinary structures. They were made in various sizes, from that of the rank and file (*papilio*) which was 10 feet square, and that of a centurion which was about 20 feet square, to those large enough to be furnished with tables and couches, for the use of officers and the commander. The various types are depicted on Trajan's column. All were made of leather and were so designed that they could be rolled up for transportation. Richmond found that the leather used for tents was calfskin which is normally a close-textured, fairly thin leather of considerable strength. The Romans were well aware that any animal skin will readily stretch from side to side but far less from neck to tail, and so the individual panels for the roof, approximately 2 feet by 18 inches, with the stretch running *across* the narrower dimension, were placed with this short side horizontal to prevent the roof from sagging to any great extent. Generally the panels overlapped like roof tiles, various kinds of seam being used, and the edges where they touched the ground or formed an entrance were either hemmed or bound. At parts where there was any particular strain the panels were reinforced with an additional thickness of leather. The guy ropes were fastened to strongly-made leather loops often of twisted strips like a rope, which were attached to patches of suitable size and shape (sometimes two thicknesses

186

306 A reconstruction of the Newstead horse mask illustrated on page 178.

307 The upper side of a shoe sole in which the customary hobnails are replaced by rawhide lacing. The upper was attached by sewing through the holes around the edge. The roughness of the lacing would have been covered by an insole. From London.

308 Decorative patches further enhanced by decorative stitching on part of a saddle found at Valkenburg. First century AD.
309 (right) Reconstruction of a leather tent from Valkenburg. First century AD.

320

of leather) which were strongly sewn to the main fabric. It is manifest that the tents were kept in good order, for many panels display rents mended by neatly-sewn patches. Of the six different methods of stitching recorded, the most interesting is that employed in some cases for joining the roof panels where the simple overlap joint was not sufficiently waterproof. This consisted in joining the two panels placed face to face with a simple basting stitch, turning them face downward, pressing flat the two selvedges and then covering them with a narrow strip of leather felled at both sides; the felling stitch is one that goes only half way through the material to which the strip is to be attached, so that no stitching is visible on the front. To do this neatly requires considerable skill. By this means the tendency of the seam to open up slightly under tension would be prevented and the join rendered waterproof. It seems probable that leather used for such a purpose would have been kept in good condition and rendered highly water-resistant by the regular application of oil or grease, but if, in fact, any such treatment has survived prolonged burial it has not, so far, been discovered and the probability is that no scientific search has yet been made for it.

Very little information is available about leather clothing; for the most part only scraps have been discovered. Many have thought that the tunics worn by soldiers depicted on Trajan's column were of leather, citing the chevroned bottom border as a distinctive feature of leatherwork; but recent examination of the original plaster casts in Rome has revealed that they were undoubtedly of mail, though it remains likely that the garment worn under the mail was of leather. The almost skin-tight breeches have folds that appear to indicate leather rather than fabric, while the short cloak that hangs from the shoulders of some men was almost certainly of leather—made water resistant with oil or grease. Of civilian clothing we know hardly anything; even though many fragments, some with stitch holes, have been found it has not been possible to reconstruct the sort of garments from which they came. There is only one nearly complete 'garment'; it is a brief pair of leather trunks such as is being worn by the girl athlete depicted on a fourth century mosaic at Piazza Armerina, Sicily. The trunks were found in a second century well in London; they are an outstanding example of leather craftsmanship. In the first place the edges,

310 Leather trunks, part of a bikini. Found in a well in London, second century AD.

311 Leather shield cover moulded to the shape of the shield boss. From Vindonissa.

instead of being simply cut are beautifully hemmed using a 'fell' stitch that is invisible on the front as it penetrates from the back, through only half the thickness of the leather. Secondly, the laces by which the garment is tied each side are all doubled and have an extra strong anchorage to the body of the garment where it would be placed under strain. But in spite of these precautions, one pair of laces had broken away and this was, no doubt, the reason why it was thrown down the well and thus preserved for posterity.

Moulding

One of the most interesting characteristics of leather is its facility for being moulded into intricate shapes which can be preserved indefinitely under normal conditions. This property, which was discovered in prehistoric times, arises from its fibrous structure. Perhaps the commonest examples are provided by the leather sheaths for knives, daggers and swords, which go back at least to late Neolithic times and were common from the Iron Age onwards. They are usually 'set' in shape by the moulding process, and the Romans may have been the first to apply the process of moulding to larger and more ambitious shapes. In *De bello Gallico* Caesar records that the 10th Legion was attacked by the Nervii with such suddenness that they had no time to remove the *tegumenta* from their shields. This passage was meaningless until, at Vindonissa, there were discovered the remains of loose leather covers for protecting the elaborately ornamented and highly-prized shields. These covers were provided with a circular hole for the umbo over which was sewn a separate piece of leather

188

moulded to its exact shape, indicative of the craftsman's attitude of mind toward leather work.

The original method of moulding and setting leather into a given shape is simple and has been in continuous use ever since it was perfected. The term by which it was known from the fourteenth century at least, *cuir bouilli*, has for many implied some esoteric process, a closely guarded trade secret, but in fact it consisted in nothing more mysterious than soaking vegetable tanned leather in cold water until saturated, then laying it aside until the surplus water had oozed out leaving the leather in a highly plastic condition. It could then be worked by hand, over formers or in moulds, into almost any conceivable shape in which it would 'set' if dried in a moderately warm temperature. The greater the heat the harder it set until eventually it became brittle. The process was employed for making containers of many kinds, armour, sconces, funeral effigies, ornamental panels and objects intended to hold liquids, such as bottles, flasks, buckets, pitchers and tankards which were lined with pitch or natural resin.

Saddles and harness

Representations of saddled and harnessed Roman horses are not rare but the saddles, of which there appear to have been three kinds, have aroused little interest until recently—probably because so little was known about them. A number of saddled horses, with and without riders, appear on Trajan's column (erected AD 113); most seem to be equipped with what appears to be an unusually elaborate, much elongated saddle-cloth or shabrack. This object, which rests

312 A scene from Trajan's column showing horses 'saddled' with shabracks. A leather tent is to be seen in the walled enclosure on the right.

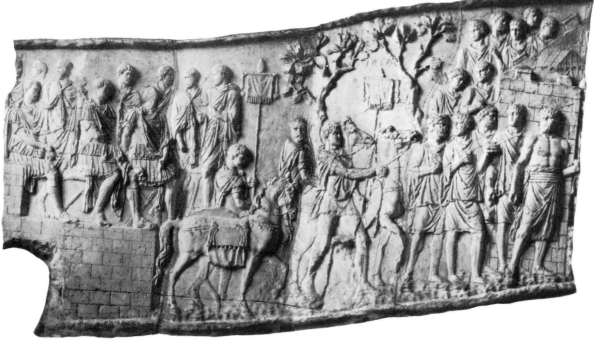

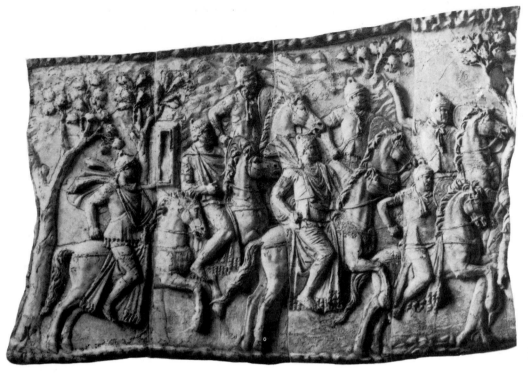

313 Horses 'saddled' with shabracks, a scene from Trajan's column in Rome. Erected in 113 AD.

directly on the animal's back, hangs, partly in folds which indicate its flexible character, down each side to below the level of the horse's belly; in most cases a second layer of material overlies the first but descends to only about half its length. This strange object is, in fact, a primitive 'saddle'. Although no parts have yet been found, or at least recognized, they were almost certainly of leather and of double thickness if certain fretted bronze plates (*opus interrasile*) have been correctly interpreted as weights inserted between the layers to prevent the long flaps flying outwards too freely. It is also possible that there was either an interlining or a stuffing, perhaps of hair, to cushion the seat slightly. The edges appear to carry a binding which usually has a decorative character. In several examples an oval shield is shown hanging between the two flaps, no doubt supported by straps; in another case the shorter flap seems to have been converted into a kind of wallet into which miscellaneous objects have been stuffed. How this 'saddle' was secured to the horse's body is not known; if there was a girth it is hidden by the flaps.

From the days of bare-back riding a constant aim was to devise a sure seat so that the rider was better able to control his steed. The first attempt originally was the horse-cloth or shabrack (perhaps an animal skin) of which the object described above was merely a rather elaborate variant. The next development was the conversion of the 'cloth' into a pad, perhaps secured by some kind of girth; this was marginally better. In due course stuffed ridges or rolls were formed in the pad, the precursors of the 'pommel' and 'cantle' of later saddles. These afforded some support to the rider where it was needed, each side of the crotch, and when the stirrup was invented (not by the Romans) effective control

of the horse was in sight. In time stuffed ridges in a pad became the wooden 'walls' of the medieval saddle; they afforded not only a sure seat but protection for a vulnerable part of the body.

The Romans did not advance beyond the stage of stuffed ridges in a species of shabrack of which a clear representation is provided by a seventeenth century drawing of a sculpture that was on the column of Theodosius erected in Constantinople in AD 379–395, but no longer exists. Other possible examples occur on tombstone sculptures in the Rhineland.

The third, more elaborate kind of Roman saddle was, prior to recent discoveries, an enigma, imperfectly known from a few sculptures and from a first century pottery lamp in the Guildhall Museum, London; it is not depicted on Trajan's column. For the partial elucidation of its true character we are indebted to Dr Groenman-van Waateringe's discoveries at the mid-first century fort at Valkenburg. The distinguishing but incomprehensible feature of this kind of saddle as it appeared in all the known representations was what seemed to be a conical erection at each end which appeared to be a rather crude equivalent of the 'cantle' and 'pommel' of later saddles. It is now known that these erections in fact comprise two *pairs*, fore and aft, of 'horns' formed of leather-covered semi-cylindrical bronze shapes which were perhaps originally filled with wood. These bronze 'horns' were attached to the leather shabrack in some manner still unknown. Bronze 'horns' were found at Newstead but have only now been recognized for what they are. In a general way this form of saddle resembles the type first mentioned in that it is basically a leather shabrack with side flaps of

314

314 A horse with a horned saddle, on a gravestone from Trier.

normal length for a pony, probably consisting of two layers of hide, perhaps with an interlining or padding between them, with the four vertical 'horns', approximately 8 inches high, one at each of the four outer 'corners'. In the latter respect it is unique; nothing in the least resembling it is known either before or after Roman times. I am inclined to the view that it is not a riding saddle for which purpose it is eminently unsuitable; it is virtually unmountable except from a stirrup which was not invented before the fifth century AD or from a mounting block which would have been impracticable on active service, and the 'horns' are so placed that they afford no support for a rider. It is more like a primitive form of pack-saddle on which bulky baggage such as rolled-up leather tents and bundles of *pila* could be carried. For such purposes each *contubernium* of eight men and also each centurion was allocated one pony or mule with its attendant.

A reason why this saddle does not appear on Trajan's column may be that its subject matter is almost entirely concerned with strenuous fighting and defence constructions and, although one or two horse-drawn carts are shown, there is no baggage train in which one would expect to see a sumpter. Dr Groenman-van Waateringe was fortunate in finding, at Valkenburg, both bronze horns and large leather parts of these saddles, thus she was able to provide the first 'reconstruction'. But some uncertainties remain: for example, although no vestiges were found, Dr Groenman-van Waateringe has suggested that the bronze horns were secured to some kind of wooden frame. But although at first this seemed possible, study and experiments have revealed so many problems that I now doubt whether it was so. The alternative seems to be that the horns were sewn to the shabrack by their leather covering but even here a problem arises from the fact that two of a set of four horns have a flat vertical extension at a right angle to the base, the purpose of which is so obscure that in my own tentative 'reconstruction' of the general appearance of the saddle, they have been omitted. Some saddles seem to have been ornamented with *appliqués* fastened with decorative stitching.

315 Two reconstructions of the horned saddle by Dr Groenman-van Waateringe and the author.

Roman harness was very simple, comprising an elementary bridle, reins and usually combined breast-strap and breeching with the necessary supports. But at Newstead was found the remains of something more elaborate and perhaps ceremonial; it was not recognized at the time of discovery and has since been called a 'chanfron' (the frontlet of horse armour which, in mediaeval times was sometimes made of *cuir bouilli*) but being made of two layers of thin leather it is too frail to be effective as armour; it is probably part of a decorative mask. There is no sign of stitching but it carries ornamentation of great interest, consisting of 'incised' lines (done with a blunt tool), and leaves, small brass nails and larger studs secured with washers. It was said to be 'characteristic of provincial Roman art'.

294, 306

Finally evidence of an interesting example of the decorative use of leather combined with utility, is provided by a small fragment from the second century Mithraic Temple in London. This bears part of a design—probably a border—in gold leaf. It is probably the remains of a leather curtain, perhaps used to screen the entrance to a secluded apartment.

Bibliography

Cichorius, C., *Die Reliefs der Traianssäule*, Berlin, 1896–1900

Curle, J., *A Roman Frontier Post and its People: The Fort of Newstead*, Glasgow, 1911

Gansser-Burckhardt, A., *Das Leder and seine Verarbeitung in römischen Legions-lager Vindonissa*, Basle, 1942

Groenman-van Waateringe, W., *Romeins lederwerk uit Valkenburg*, Groningen, 1967

McIntyre, J., and Richmond, I. A., 'Tents of the Roman Army and Leather from Birdoswald', *Transactions of the Cumberland and Westmorland Antiquarian Society*, 34, 1934

Waterer, J. W., *Leather Craftsmanship*, London, 1968

Webster, G., *The Imperial Roman Army*, London, 1969

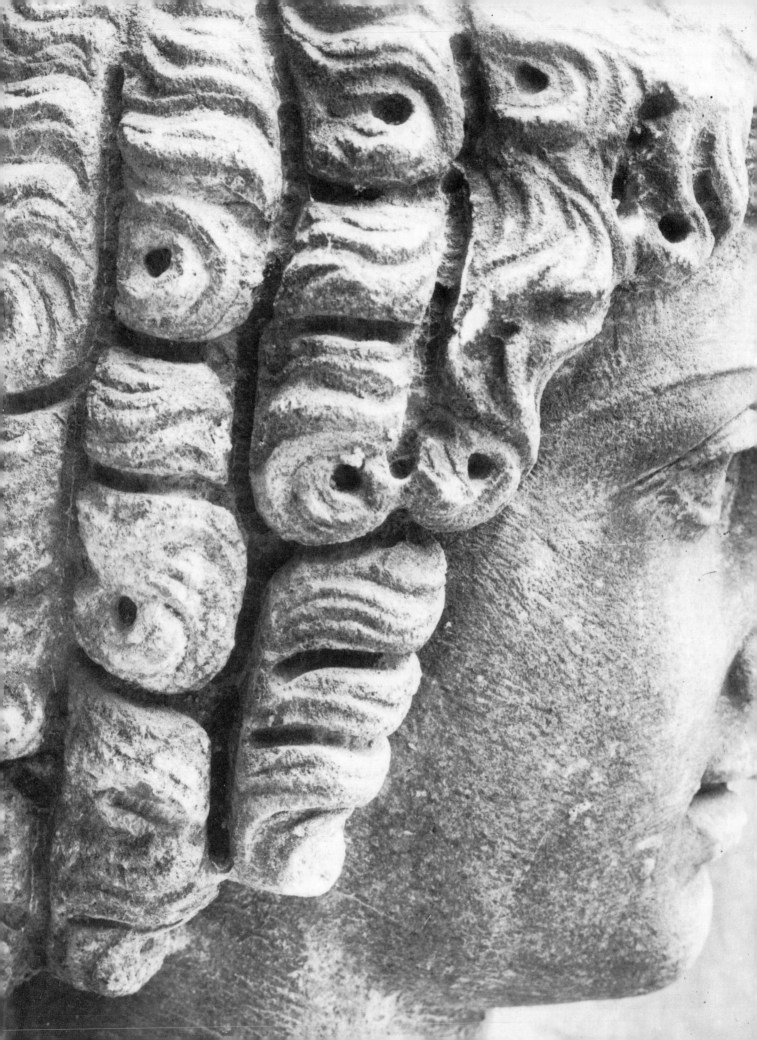

Donald Strong and Amanda Claridge

15 Marble Sculpture

There was no sharp distinction in Roman times between the artist and the craftsman. The word *marmorarius*, therefore, covers not only the sculptor but also the mason and stone-worker and even the man who cut inscriptions in marble. The word *sculptor*, though it occurs in literature and in inscriptions, is rare until the late Empire.

The ancient *marmorarii* were organized in workshops (*officinae*) and were generally slaves, freedmen or free *peregrini*, especially from the Hellenistic world. Comparatively few won reputations as individual artists, although it was clearly possible to have a distinguished career and some of the most successful sculptors moved freely about the Empire. We have, for example, the epitaph of a certain Zenon who was born at Aphrodisias and died and was buried in Rome, and one Novius Blesamus, who is said in his epitaph to have decorated the whole world with statues. A number of successful 'families' are known; for example, that of Polykles and his sons Timarchides and Timokles and their sons working in Athens, Delos and elsewhere in the second century BC, or the family from Tyre associated with the Rhodian School in the same period, one of whom may have forged the Piombino Apollo. A very interesting sculptor's career is that of C. Avianius Evander, who was a freedman of one M. Aemilius and directed an *officina* on behalf of his patron in Athens. Cicero got to know him in Athens and in 51 BC bought sculpture from him. His career thereafter was somewhat checkered. He went with Antony to work in Alexandria soon after 36 BC, and as a prisoner of war in 30 BC was taken to Rome where he is known to have carried out important work, including the restoration of old masterpieces.

We have very little information from ancient written sources about the craft of the sculptor. What we know has to be deduced from the sculptures themselves and from comparisons with modern practice. It is generally assumed, and rightly, that the methods and the tools used in the direct carving of hard stones have not changed significantly since ancient times. The Romans, who had no indigenous tradition of marble carving, learnt their technique from the Greeks; indeed it is certain that a very high proportion of those who carved marble sculptures in the Roman Empire were of Greek origin. The earliest works of marble sculpture to arrive in Rome came from Magna Graecia and mainland Greece, and by the second century BC Greek marble sculptors, using funda-

316 Running and vertical drill-work in the hair and the marks of a rasp finish on the face, on a head from a relief representing a Province in Rome.

195

mentally the same methods that had been employed for centuries, were established in the city.

The raw material for marble sculpture was quarried in many parts of the Empire and was traded throughout the Roman world. The word for a quarry is *metallum lapicidina*. Under the Republic marble quarries were usually exploited by private contractors, but in the Empire most of them came under Imperial control. The evidence for saying that some important quarries, for example the Pentelic quarries near Athens, stayed in private hands is very slight. The quarries at Luna (Carrara) in northern Italy were controlled by the nearby colony at the beginning of the Empire. The fact that the most important quarries everywhere were owned and worked by the State from the Julio-Claudian period onwards is shown by the inscriptions on marble blocks shipped to Rome and found in 1867 on the site of the old Emporium. These slabs also tell us a little about the various officials involved in the administration.

The three chief white statuary marbles used in the Roman period were Parian, Pentelic and Luna (Carrara). Parian, which comes from the north-eastern zone of the Island of Paros, is a brilliant translucent white with a large crystalline structure. Pentelic, from near Athens, is a fine-grained stone, comparatively easy to work, which acquires a lovely yellow-gold patina with age. Luna marble, fine-grained like Pentelic, from the Apuan Alps near Luni, was certainly the most widely used in Italy from the late first century BC for architecture and sculpture, though it was not exported on a large scale. A fourth marble, Proconnesian from the island of Marmara, was much used in earlier workshops and is found all over the Empire; this is another large grained marble of two qualities: the variety of a uniform sky-bluish tint for statuary, and for the sarcophagi for which it was very popular from the first century AD onwards, a variety with regular parallel veining of a darker blue. There is quite a range of quality and colouring found in most quarries: at Luna Michaelangelo preferred the beds at Serravezza and some of the best stone still comes from the valley of Ravaccione, where the massive blocks employed in the column of Trajan were quarried. If possible, to cut transport costs, the marble was transported by sea; a recently discovered shipwreck in the Bay of St Tropez had a cargo of partly-worked column drums and other architectural members from Luna intended for some massive temple in southern Gaul. Wrecks with similar loads have been explored in many parts of the Mediterranean.

The methods used in the quarries, as in the workshops, have remained very conservative. The method of obtaining a block of marble was laborious and involved first isolating it by cutting narrow trenches round the sides with picks and then splitting it free from the bed with wedges. The use of saws for the purpose did not come into the Carrara quarries until 1895 and throughout antiquity the saw seems to have been used only for slicing marble veneers. Because of the enormous expense of transport as much preliminary work as possible was done on the marble at the quarry. Statues were cut into rough form and shipped for completion; monolithic columns were cut into standard sizes and sarcophagi blocked out with standard forms of decoration to be completed by the agents of the suppliers. A shipment of unfinished sculptures from the Proconnesian quarries was discovered recently in a wreck in the Black Sea; in

addition to half-finished sarcophagi and ionic capitals, it included a blocked-out colossal statue of a Roman emperor wearing military uniform and a portrait bust, datable to the late first century AD.

The chief tools of the sculptor were the punch, the point, the claw chisel (usually with five teeth) and the flat or bull-nosed chisel (*scalprum*)—used with an iron hammer or a wooden mallet (*malleus*). The tools were of iron or a low-grade steel. The preliminary work of setting out the basic position of the figure in the block was carried out with the punches and heavier points, followed by more precise modelling with the claw chisel, which also smoothed the surface to be worked next with flat chisels whose more delicate cutting edges would have been quickly damaged by working directly on to the punched or pointed surface. The penultimate surface modelling before rasping was achieved with progressively finer flat chisels. Detail in the hair and eyes and textural effects

(Left, top to bottom) **317** An unfinished bust from Aquileia. The head has only been roughed out with a punch while the draped bust has reached the flat chisel stage. The neck has been left thick to give support until a later stage in the work. **318** A punch from Aphrodisias and points from Pompeii and Foret de Compiegne, Oise. **319** A modern claw chisel and one from Foret de Compiegne, Oise. **320** Claw chisel marks and some flat chisel marks on the back of a statue in the Vatican.

321 (below) Flat chisels from Pompeii and Compiegne, Oise. **322** (right) Bull-nosed and flat chisel work and running drill channels on the drapery of an unfinished statue of a barbarian prisoner from Rome.

323 (left) Detail of the eye of an Antonine portrait head with characteristic thin lower lid and relatively heavy upper one. The engraving of the pupil and iris, a practice which became general in the early second century, was done with the edge of the chisel, sometimes aided by a drill. **324** (above) A broad mason's chisel from Pompeii and a flat chisel from Foret de Compiegne, Oise.

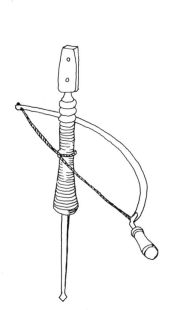

325 (above) A bow-drill. The drill is of iron with a wooden handle and comes from Egypt. The bow is a reconstruction. **326** (right) Vertical drill work giving a honeycomb effect to the hair of a Flavian lady in Venice.

326

316

328

327

were then achieved with the flat chisel used as an engraving tool—working with the corner of the chisel edge against the stone—and with fine points. The drill, rotated either by a bow or by an assistant with a strap, invariably with a solid iron chisel tip, was used at all stages of the work, though in the earlier periods great efforts went into removing all traces of its use. Used at right angles to the stone, it could speed up the work of clearing away large areas of stone at weak points, such as between the legs, and the depths of heavy folds in drapery. A series of vertical drilled holes were made to the required depth and the intervening stone knocked away. A particular feature of its use in drapery and on reliefs was deep undercutting to give added definition. When held at an angle so that the drill head moves along the surface of the stone as well as cutting into it, so as to produce a continuous channel, it is called the 'running-drill', though the tool used is the same simple drill. Once again its advantage was its speed, for it was a rapid means of undercutting, requiring no further working. Where a smooth finish was called for the sculptor could move straight on to the rasp or abrasives. The decorative qualities that could be achieved with the running drill became increasingly popular in the second century AD, especially when combined with a high polish on skin or flat surfaces in a search for dramatic effect.

An engraved slab from the catacombs of S. Helena outside Rome shows a sarcophagus manufacturer at work drilling detail into one of the lion's heads on a fluted sarcophagus; he is using a drill rotated by straps held by an assistant, bracing the tool with a rod held in his left hand.

327 The sculptor Eutropos and his son at work with a drill; a scene from the father's tomb which the son made.

328 Detail of Antonine drill and chisel work in hair. The small connecting struts left spanning the drill channels are a feature that seems to have been introduced at this period.

Although in the Hellenistic world a perfectly smooth and delicately modelled surface had been produced using only a fine flat chisel, rasps and fine abrasives were usually employed to bring out the special qualities of the marble. A rasp finish was generally favoured for the drapery and some Athenian workshops also used it as the final skin surface. Fine sands from Naxos and Thebes, pumices from Egypt and Crete, and emery from Naxos and Cyprus enhanced the translucency of the marble surface and gave a realistic skin-like finish. The extremely high polish on many Roman works may have been produced by the equivalent of the modern 'mason's putty'—powdered oxide of tin or oxide of zinc.

Skill in carving complicated subjects from a single piece of stone was especially admired; it was claimed, for example, that the Laocoon was carved from one piece of marble. But, on the whole, the Roman sculptor was quite prepared

329 (above) A possible form of iron rasp. **330** (right) A rasp finish showing on the lower drapery of a togate statue of Titus in the Vatican.

201

where necessary to make projecting parts of his sculpture out of separate pieces and to join them to the main piece, either because he had not a sufficiently large block of marble to start with, or to save himself the extra work involved in cutting the whole from a single block. Because early adhesives were poor, based as they were on resins and waxes, sculptors preferred to use socket and tenon joints of stone and/or metal dowels with lead or mortar to give extra strength. Where two plane surfaces were to be joined they were both very carefully worked to give a close fit, at least on the outer edges, and dowel holes were worked in both to take a rod of bronze or iron. Where small details such as the tips of noses, edges of drapery and toes had to be added with a fine straight joint, the central zone of each surface was slightly roughened with a point, claw or rasp, and a glue made from resin thickened with limestone powder applied. In the Roman period the fashion of combining white with coloured marble made skilful piecing together important; sometimes two white marbles were combined using a higher quality for the head and arms as, for example, on the Augustus from the Via Labicana in the Museo delle Terme. The prevailing practice of re-using old statues for new dedications by giving them new heads and other details gave some Roman sculptors a reputation for particularly skilful work of this kind. Repairs were constantly needed on old statues. One of the best-known examples of ancient repair is the Hadrianic Discobolos from Castelporziano in the Museo delle Terme, where a deep cutting was made into the base to accommodate a restored foot and leg.

331 (above) Shallow socket with projecting iron dowel for the attachment of the left forearm of a statue of a woman from Velleia. 332 (below) Four *puntelli* on the leg and cloak of an unfinished statue of a barbarian prisoner. 333 (bottom) A modern sculptor's pointing instrument.

In the Hellenistic period, largely as a result of Roman taste, there was an increasing demand for sculpture in everyday contexts; the most persistent demand was for copies of Classical masterpieces. The Kings of Pergamon seem to have been the first to commission them in the second century BC, and what may be called free versions of the Athena Parthenos and other fifth-century works have been found in Pergamon itself. It seems that more accurate methods of copying did not come into use until about 100 BC. As today, the practice apparently was to make a plaster model of the original and to transfer points marked on it to the block of stone to be used for the copy—the so-called 'pointing-off' process. There is, however, no written account of pointing methods in Roman times. Leonardo da Vinci's method, described in his notebooks, involved constructing a 'case' round the model and fixing a series of pegs to touch the surface at certain set points. 'Pointing' as a modern process is carried out by a 'pointing machine'—or better, a 'pointing instrument', since the process is not mechanical—which consists of an inverted 'T' with moveable sockets into which adjustable arms are fitted. In the same way as Leonardo's case, certain set points are fixed by adjusting the arms of the instrument to touch points on the model. However these basic points were achieved, they were then transferred to the copy block by setting up the same instrument on it and marking the positions, while the rods indicated the depth at which the points lay. Holes were drilled to the required depth and the surplus stone removed accordingly. Once the general position of the figure within the stone had been achieved further fixed points (*puntelli*) were marked and from these secondary measurements could be made with compasses. These took the form of dome-shaped protruberances with a small depression in the centre to take the point of the compasses. Particularly good

334 The head of an ephebe in Bekhen stone, closely reproducing the effect of the colour and appearance of an original bronze statue.

335 Struts and a tree stump support strengthening the legs and parts of the drapery on this statue of M. Holconius Rufus from Pompeii.

examples of these *puntelli* survive on the unfinished statue of a barbarian prisoner found in a workshop on the Campus Martius.

A few of the plaster 'models' from which ancient copies were made have survived. The storeroom found at Baiae in 1954 contained pieces of plaster casts —drapery, hands, feet and parts of heads including the famous Aristogeiton from the Tyrannicide Group—which were presumably intended for copying. It has been suggested that the inventor of 'pointing' was Pasiteles, a south-Italian Greek of the first century BC with a reputation among Roman patrons as a versatile artist; but there is no evidence to confirm this. He was the founder of a 'school' of sculpture, and is said to have always worked from a clay or plaster model.

The pointing process can be very accurate if many points are taken, and it has been argued from the differing Roman copies of a common original that in antiquity fewer points were taken than in modern times. But it is difficult, after comparing a number of copies, to question the high accuracy that it was possible to achieve where a faithful model was available. Variations were more likely to have occurred as a result of an incomplete or badly made cast of the original than as a result of technical shortcomings. Copyists were often proud of their work and signed their products (e.g. the Athena Parthenos in the Museo delle Terme).

Most of the copies were marble versions of originals in bronze and the best early examples show extreme skill in simulating the characteristics of bronze techniques, for example the fine chisel work in the hair and the sharp and precise detail of the eye and mouth. The copyist of such bronze works was, however, often forced to introduce new and unsightly features such as struts to support free hanging arms and outspread fingers, and the tree-trunk or a similar feature to strengthen the supporting leg.

The Romans inherited the Greek view that marble sculpture must be painted. Garden sculptures are shown in this way in the wall paintings of Pompeii. Sculptures which survive with traces of their original painting intact reveal that it could range from being purely decorative, according to certain established conventions, to being strongly naturalistic with subtle colouring of the various details of the face as in portraiture. When the Augustus from Prima Porta was discovered in 1863, scholars were astonished to see its vivid colouring of reddish-browns, yellows, pinks and blues. These colours appear to have dominated the palette of the painter of marble sculptures throughout the early Empire and are still found as a basic scheme in mithraic reliefs of the third century AD. In portraiture, reddish-brown was used for the eyebrows, eyelashes, the corners of the mouth and nostrils and for the irises, with the pupil filled in in black. Reddish-brown traces in the hair of many portraits may or may not be the remains of an underlay for gilding. It seems that Roman sarcophagi were richly gilded, especially on the drapery and hair, while the flesh parts were usually left white. The predominant impression of a sarcophagus with marine subjects would probably have been blue and gold. The practice of gilding bronze statues of emperors and their families may have had its equivalent in marble versions. Coloured stones and glass were also used for inlaying details such as eyes and actual ornaments.

The Roman taste for polychromy is clear from the ever-increasing popularity of coloured marbles which were first introduced to Rome in the first century BC, and began to be used for statuary from the time of Augustus. We are told that certain stones were appropriate to specific subjects, for example, statues of the Nile and Egyptian deities such as Isis were normally executed in *bigio morato*, a black marble from Capo Tenaro; satyrs were often done in *rosso antico*, a red marble also from southern Greece; and the variegated marbles and alabasters were used particularly to reproduce the rich colours of oriental drapery and to simulate chased metal. Normally the coloured marble was used for drapery, while the head, arms and other flesh parts were carried out in white marble. Red porphyry from Egypt which came into vogue under Trajan, probably because of its similarity in colour to the Imperial purple, was used in the later Empire to carve complete figures of Roman emperors. The coloured marbles are usually of a very compact structure and require a high surface finish to bring out the best in them, but Roman methods of working the very hard stones, in particular the granites and the porphyries, and especially the methods by which they achieved the fine finish on them, are not fully understood. The range of coloured stones available to the Roman craftsman at the height of the Empire was considerable. Pavonazzetto was a white and blue-violet mottled marble from Synnada near present-day Afyon in Turkey, and was one of the first marbles introduced to Rome, where it was called *Dokimion* or Phrygian marble and was mainly used for veneering slabs, ornamental basins and table legs, although it was also used as a statuary marble, as for example in the statues of barbarian prisoners in the Museo Nazionale, Naples. Cipollino, of a light green colour with waves and veins of a darker green, from Karystos in the south-east of Euboea, was certainly known in Rome by the time of Julius Caesar, and although its schistic constituents limit its use mainly to columns and slabs, it

was occasionally used for figured sculpture, for example the crocodile from the Canopus at Hadrian's Villa. Giallo antico, varying in colour from a creamy white to gold and orange and even an almost blood red, was quarried in the hills around Chemtou, ancient Simitthu, in Tunisia, and because of its extremely fine and compact texture was greatly used in very thin slabs as a veneer marble. Its use in sculpture seems to have been restricted to forming one of the elements in a draped portrait bust of various marble veneers. And there were many more such coloured marbles.

A much discussed problem concerns the treatment of the flesh parts of marble figures. Certainly from the Hellenistic period onwards some figures were given not only a fine surface polish with abrasives but, it seems, a further wax coating; the precise nature of this finish and the methods of achieving it remain uncertain. In our Roman sources we read of an encaustic wax process known as *ganosis* applied in the periodic 'redecoration' of the face of the Jupiter Capitolinus, and similar to the treatment given to the surface of frescoes. The word is also applied by modern scholars to describe the treatment of the surface with wax and oil designed to preserve marble sculptures exhibited in the open air and to impart a realistic flesh-like tone to the otherwise startling white of freshly carved marbles. Recent analysis of a Greek fourth century head with remains of such a treatment showed that the wax applied was not beeswax but a natural wax of uncertain origin with a high paraffin content. Further experiments such as this will have to be carried out before the exact nature of the process is clear.

This is not the place to discuss the technical characteristics of sculptural 'styles' in different parts and at different periods of the Roman Empire. It is, however, important to say that a major stylistic change may sometimes appear as little more than a technical change, although the reasons underlying the changes may be much more complex and far-reaching. Purely technical elements must be carefully considered if the wider issues are to be understood: different techniques co-existing in different workshops, the existence of regional techniques and so on. As examples we might take the widely different treatment of late Republican portrait heads which have led scholars to make technical groupings within broader stylistic groups. As an example of regional differences, the obvious case is the use of the drill in ornamental detail, which was particularly favoured by the marble workers of Asia Minor and from there influenced the whole of the Empire. Fashion among patrons is perhaps the best explanation of the fact that at some points, for example in the Antonine period, a highly polished surface finish was desired on the flesh parts of portrait and other sculptures to contrast with the 'colouristic' use of the drill to perforate and darken the mass of hair, but we should not underestimate the sculptor's own taste and preferences in the use of his tools. His affection for the use of the drill, which is both rapid and very effective in its results, is such that it often seems to have dictated the work. The deep 'honeycombs' of Flavian ladies' hairstyles are dominated by vertical drill holes; the ornament of sarcophagi from Asiatic workshops is controlled by the use of the drill; a linear use of the drill, held presumably as a running drill, to give shape and form to locks of hair and contours of figures, was common in the later second and third centuries AD.

The interchange of ideas between various workshops in the Empire was

326

205

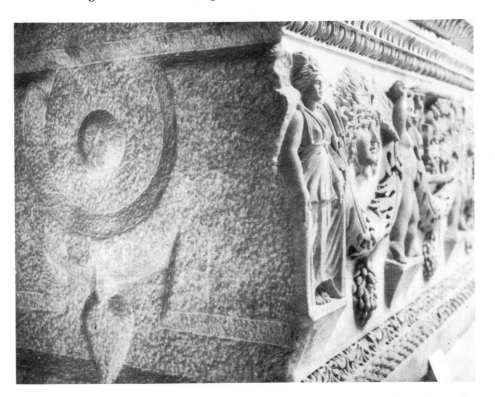

336 A garland sarcophagus. The unfinished short side shows the state in which the sarcophagus was transported from the quarry workshop.

effected in a number of ways. The sculptors themselves, like those from the 'school' of Aphrodisias, travelled widely and had an Empire-wide reputation. *Marmorarii* from Bithynia worked in many places; one from Nicomedia is recorded at Leptis Magna where the Severan building programme produced a cosmopolitan influx of craftsmen, including some from Athens. In the second and third centuries a highly organized trade in marble sarcophagi was established from Greek centres, especially from Athens and the cities of Asia Minor. We have already seen that blocked out versions of standard decorative forms were prepared at the quarry and shipped abroad. The Athenian workshops, turning out fine quality Pentelic sarcophagi with figured sculptural relief, exported their work in an unfinished state, leaving their agents in particular provincial towns to arrange the completion of the relief work and of the portraits. These agents would have been trained in the Athenian workshops. A sarcophagus exported to Arles has two of its sides completely carved while the other two remain in low relief and roughly finished; it must be supposed that the sarcophagus arrived from Athens with all four sides in the same unfinished state and that the local *officina* finished only two of them to satisfy local requirements. The sarcophagus trade was clearly organized with great efficiency and one finds that the Attic workshops had a monopoly in some provinces while their Asiatic rivals controlled the markets elsewhere.

It is often said that standards of technique underwent a serious decline in the late Empire. This is often true of what may be called work in the classical tradition and it can be seen particularly in the later Roman copies of Greek masterpieces. For example, in a third century copy of the Athena after Myron in Hamburg, there is no longer the precise attention to detail nor the same attempt to achieve

206

by subtle carving the texture and finish of the original bronze. The surface is dead and the drill work very obvious. Similar technical details can be seen in the major works of sculpture during the same period. It would, however, be wrong to argue that the decline of the Classical tradition was due to a failure of craftsmanship brought about by economic and other factors. If there is an element of truth in this, it is only the negative side of a more artistic revolution that seems to have been taking place. Indeed, right until the final collapse of the Western Empire one is constantly reminded that highly skilled craftsmen in stone and marble still plied their trade in Rome and were still capable of producing work of high quality.

337 Compasses, 338 a plumb bob and 339 proportional dividers from Pompeii.

Bibliography

Modern manuals
Miller, A., *Stone and Marble Carving*, London, 1948
Rich, J. C., *The Materials and Methods of Sculpture*, New York, 1947

Ancient techniques of carving and copying
Adam, S., *The Technique of Greek Sculpture*, London, 1966
Bluemel, C., *Greek Sculptors at Work*, second edition, London, 1969
Harrison, E. B., *The Athenian Agora, Vol XII, Portrait Sculpture*, Princeton, 1953
Lippold, G., *Kopien und Umbildingen griechischer Statuen*, Munich, 1923
Muthman, F., *Statuenstützen und decoratives Beiwerk an griechischen und römischen Bildwerken*, Heidelberg, 1951
Richter, G. M. A., 'How were the Roman copies of Greek portraits made?', in *Römische Mitteilungen*, 69, 1962
Richter, G. M. A., 'Plaster Casts', in *American Journal of Archaeology*, 74, 1970

Quarrying
Ward Perkins, J. B., 'Quarrying in Antiquity', *Proceedings of the British Academy*, 57, 1971

Marbles
Gnoli, R., *Marmora Romana*, Rome, 1971
Enciclopedia dell'arte antica, 'Marmora'

Painting and Waxing
Langlotz, E., 'Beobachtungen über die Antike Ganosis', in *Archäologischer Anzeiger*, 1968
Reuterswärd, P., *Studien zur Polychromie der Plastik*, Stockholm, 1960

Roger Ling

16 Stuccowork

The term 'stucco' is applied to various aspects of plaster and plastering, often in a vague and inconsistent way. Confusion arises from the adoption of two somewhat contradictory meanings. On the one hand it can have a functional sense, referring generally to plaster-work employed for architectural surfacing and decoration (and particularly, now, to the protective coating applied to the exterior of a building); on the other hand it can have a chemical sense, distinguishing the plaster based on lime (calcium oxide) from the plaster based on calcined gypsum (the modern plaster of Paris, a hemihydrate of calcium sulphate).

By and large the plaster used by the Romans for architectural work was lime-plaster, which set slowly and produced a hard, durable surface; while that employed for moulding and casting was the quick-setting gypsum-plaster, which produced sharp impressions but tended to be friable and to disintegrate in damp conditions. But the distinction is not complete. Lime-plaster seems occasionally to have been employed for plaster statuary, for instance the portrait-busts from the late second century AD tomb of the Valerii beneath St Peter's in Rome; while gypsum-plaster may well have continued to be used now and then for architectural work in the relatively dry atmosphere of Egypt, where it had been the regular material in use before the Greek conquest of 332 BC. Furthermore, gypsum or plaster of Paris seems frequently to have been added to lime-plaster in Greece and Italy, to judge from the writings of Vitruvius and Pliny. The former warns against its being mixed in cornices, the latter writes that it is 'very pleasing in whitewash, architectural figure-work and cornices'.

The best definition for our purposes might then be 'a hard slow-setting plaster based on lime and *normally* employed for architectural work'. The most common function which this material performed was, of course, to provide the plain coating of walls, vaults, columns and similar surfaces, which was applied partly for protective reasons and partly to enhance the appearance of the building, both internally and externally. More often than not, such a coating would be prepared with a view to painting, as described in the following chapter. But as a refinement on plain surfacing, the plaster might be worked in imitation of architectural features, such as ashlar masonry, projecting cornices, the fluting of columns, and even the leaf-carving of Corinthian capitals. The most adventurous role of stucco, however, was in the creation of an art-form comparable with

340 A soldier chopping lime, a detail of a scene on Trajan's column dedicated in Rome in 113 AD.

341 Stuccoed column capital at Herculaneum. Before 79 AD.

342 Stucco fluting on a brick-faced column, in the House of the Gem at Herculaneum.

mural painting or mosaic: that is, the covering of architectural surfaces, especially interior surfaces, and notably vaults, with systems of ornamental and figured reliefs. This is stucco decoration *par excellence*. It seems to have been evolved in Italy during the first century BC (if we leave aside the apparently unrelated tradition in certain eastern provinces) and to have been transmitted to the other European provinces and Africa during the first and second centuries AD, though never there attaining the general currency or technical standards of the Italian work, particularly that of the Rome area and the cities of Campania.

Before we examine the literary and material evidence for the techniques of the Roman stucco-worker, it is well to understand the chemical processes involved in the formation of lime-plaster. Lime itself does not occur naturally and has to be obtained by the calcination of one of the calcium carbonates (calcite and its massive varieties limestone, marble and chalk). When roasted, these give off carbon dioxide, being thus converted into quicklime (calcium oxide). The reaction can be expressed in the chemical formula:

$$CaCO_3 + heat \rightarrow CaO + CO_2$$

The new material has lost nothing in volume, but weighs barely half as much as the original calcium carbonate, and may easily be broken up. If it were now treated with just sufficient water, it would give off considerable heat before crumbling to a white power (slaked lime or hydrate of lime).

$$CaO + H_2O \rightarrow Ca(OH)_2 + heat$$

But treatment with more water produces the thick suspension of this powder in water which is mixed with some form of grit to create the mortar and plaster used by builders. In drying it takes back carbon dioxide from the air and reverts to what it was at the beginning of the cycle: calcium carbonate.

$$Ca(OH)_2 + CO_2 \rightarrow CaCO_3 + H_2O$$

The chemical processes are naturally more complicated if one takes into account the impurities contained in the natural limestone or other mineral from which the lime is burnt. But the foregoing account gives the essence of the story.

Let us first look at the ingredients of Roman lime-plaster, beginning with the lime. For this, the right kind of stone had to be chosen; and the ancients had clearly learnt by empirical means which sorts were best. Vitruvius writes, 'Care must be taken to burn lime from white stone or from *silex* [translation uncertain]; that obtained from dense and harder stone will be useful in structural work, that from vesicular stone in plaster-work.' Pliny agrees with this, except that he condemns the use of *silex* for either purpose. He adds that quarried stone is better than that collected on river banks, and commends the stone used for querns, because of its somewhat oily nature.

The ancients were also aware of the desirability of thorough slaking of the lime. Vitruvius again: 'The right course is to take lumps of the best lime and slake them long before they are needed, so that any lump which has not been sufficiently burnt in the kiln will be forced in the course of the long slaking to lose its heat and be burned to an even consistency. For when it is used fresh, without being thoroughly slaked, it contains particles of crude lime and so, when applied, produces blisters. These particles complete their slaking in the plaster, dissolving and destroying its polished surface.' Old Roman building

343 Stuccoed vault in Fondo Caiazzo, Pozzuoli. The decorative scheme radiates around a central medallion. Late first or early second century AD.

laws, referred to by Pliny, had evidently prohibited the use of lime which had been run less than three years previously. To test the thoroughness of the slaking, Vitruvius recommends taking an axe (*ascia*) and chopping the lime in its pit much as one chops wood. 'If the axe comes against lumps, the lime is not tempered; and when the iron blade emerges dry and clean, it shows that the lime is weak and thirsty; but when the lime is rich and properly slaked, it sticks round the tool like glue, thus confirming that the tempering is complete.' This testing process may be the very stage illustrated in a relief from Trajan's column, where a soldier is shown working some material in a square tank with a form of axe or mattock.

340

The other main ingredient in wall-plaster is the material or materials used to give it body, like sand and marble-dust. The sand again had to be chosen with care. Whilst recommending fresh quarry-sand for concrete, Vitruvius warns against its use in plaster, lest its richness cause cracks to appear in the drying. 'River-sand, however, on account of its leanness . . . acquires firmness in the plaster when worked over with floats.' The various types of marble-dust are also considered. 'Marble varies in type from region to region. In some places it

is found in lumps with shining grains like salt, and this type when crushed and ground is useful in plaster-work. In places where supplies are lacking, the marble chippings . . . which marble-cutters throw down in the course of their work are crushed and ground, then sifted and used in plaster. Elsewhere, for example on the borders between Magnesia and Ephesus, there are places where it is dug ready for use, without the need of grinding or sifting; it is as fine as any that has been crushed and sifted by hand.'

These types of marble need not all have been marble in the modern sense. Indeed, analyses indicate that several different minerals might have been involved: in addition to true marble-dust, modern researchers have identified, or claim to have identified, calcite, calcspar and alabaster-dust (like gypsum, a form of calcium sulphate). The substance or substances mixed with the lime would obviously differ from one area to another, depending upon the availability of materials. Thus the stucco of volcanic regions, especially that of Puteoli (Pozzuoli), the great Campanian port, contains distinctive brownish-purple grains of volcanic sand; while at Pompeii, where the volcanic sand was also used, another important ingredient was calcite crystals, which could have been obtained from veins in the limestone of the nearby Sorrentine peninsula.

A few minor ingredients, added for particular and limited purposes, may also be mentioned. Crushed tile is recommended by both Vitruvius and Pliny for use in damp localities, specifically in the undercoating, and has indeed been identified in surviving remains, for instance at Pompeii and in a Republican villa at Salapia in the south-east of Italy. Whitening pigments might on occasions have been mixed in the surface layer: Pliny claims that an Egyptian mineral called 'paraetonium' was 'the richest of all the whites and the most tenacious for plaster on account of its smoothness'. It is possible, finally, that other materials may have been employed to retard the setting of the stucco. Although we hear nothing of the exotic substances used in more recent centuries, Pliny tells us that a fifth-century BC Greek artist, Panaenus, had incorporated milk and saffron in the plaster of the temple of Athena at Elis, and no doubt Roman artists and craftsmen knew similar tricks of the trade.

The proportions in which the main ingredients were mixed would naturally be another variable factor. Chemical analyses are unhelpful in that they do not distinguish between the calcium carbonate formed from the hardening lime and that added in the form of calcite or marble-dust; nor can they reveal whether other chemicals identified are present as impurities in the lime or have been added deliberately. There are also clear differences between the composition of the upper layers and undercoats of a plastered surface. For the former a typical recipe might have been the two parts of calcspar and one of lime used by Venturini Papari in his experiments to reproduce Roman stucco; while the undercoats may well have been composed according to the same general formula as that given by the ancient writers (and still used today) for bonding-mortar. If this was made with quarry-sand, the sand and the lime should be mixed in the ratio of three (Vitruvius) or four (Pliny) to one; if with sea-sand or river-sand, in the ratio of two or three to one.

But how did the stuccoist carry out his craft? For plain surfacing designed to carry painted decoration we have a long exposition written by Vitruvius.

Starting with the vault, which was surfaced with reeds attached to a wooden framework, he prescribes first a rendering coat, then a layer of sand (i.e. sand-mortar), then a surfacing of 'creta' (stucco containing clay or chalk?) or marble (stucco containing marble-dust). After the vault was polished, cornices were to be applied below it. These should be light and delicate, should be made of marble-stucco, and should not carry relief ornamentation in smoky rooms where the whiteness of the material would show the soot and demand frequent wiping. He continues, 'When the cornices have been completed, the walls should be given a very rough rendering coat, and then, when this is virtually dry, be overspread with layers of sand-mortar, adjusted horizontally to the rule and line, vertically to the plumb-bob, and at the corners to the set-square. . . . As the mortar dries, a second coat should be applied, and then a third. The firmer the foundation provided by the sand-mortar, the more solid and durable will be the plaster. When in addition to the rendering coat not less than three layers of sand have been laid on, then the mixture for the layers of powdered marble must be prepared. It is worked till it no longer sticks to the shovel (*rutrum*) and the iron blade can be drawn clean from the mixing-tank. After a thick layer has been applied and has begun to dry, a second layer of medium thickness should be spread; and when this in turn has been worked over and well rubbed, a finer coat should be applied. In this way the walls will be consolidated with three layers of sand and the same number of marble, and will remain free from cracks and other flaws. Moreover, if the consolidation is reinforced by working over with floats and the surface is smoothed till it has the lustre of marble, the walls will have a resplendent effect when the colours are applied and polished.'

The striking detail in this passage is the number of layers prescribed for the walls. Pliny (or his source) is scarcely less demanding—he recommends five layers, three of sand-mortar and two of marble-stucco. That both writers were being rather idealistic is shown by the archaeological evidence. True, the 'House of Livia' and the house in the grounds of the Villa Farnesina in Rome, both decorated in the early Augustan period, about the time that Vitruvius was writing his treatise, have provided examples of the six-layer technique, with the three undercoats composed of lime, sand and *pozzolana*, and the three upper coats of lime, sand and either marble-dust (the Farnesina house) or alabaster-dust (the House of Livia). But these were well-to-do establishments, perhaps Imperial residences. In the majority of buildings the standard of work fell more or less short of the Vitruvian ideal. At Salapia (third or second century BC), plaster fragments show only two coarser backing layers and two finer superficial layers; in the 'Aula Isiaca' on the Roman Palatine (late first century BC) four backing layers and one surface layer have been distinguished; while at Pompeii and Herculaneum, though a multi-layer technique is found in certain cases, especially in the better-quality work of the Republican period, the more normal procedure required only two or three layers, the lower one or two consisting of lime and sand, and the surface of lime and calcite. Indeed, Vitruvius himself admits the frequent disparity between theory and practice, for he specifically warns of the faults which may ensue 'when only one coat of sand and one of ground marble is applied'.

The main tools used in preparing a plain stucco surface were two in number,

both still used today. For applying the material to the wall there was an iron trowel (*trulla*) similar to the modern pointing-trowel, with a flat pointed blade attached, often by a strongly offset neck, to a short straight handle. This tool is carved on a number of funerary reliefs of masons and plasterers, while surviving examples, some retaining their wooden handle grips, are preserved in several museums. The other tool, used for spreading the plaster and smoothing the surface, was the float (*liaculum*), a flat square or oblong plate equipped with a handle in the middle of the back face. Several stone versions are known from Greek contexts, notably a whole set from Aegina, dating to the sixth century BC, and Hellenistic examples from Delos and Samothrace. Many of these, especially the ones from Delos and Samothrace, would, however, have been too heavy for use on walls and were probably intended for levelling and consolidating floors of plaster or *opus signinum*. The same will have applied to the iron float of Roman date found at Verulamium (St Albans). Wall-plasterers no doubt tended to use lighter floats of wood which have generally perished; the only extant example known to me was retrieved from a well outside the Saalburg Roman fort in Germany. Fortunately, however, we have two artistic representations of craftsmen at work with floats. One is a Pompeian painting which shows a plasterer standing on a low table, with vessels full of materials beside him, and using both hands to polish a wall in the background. The other is a relief from Agedincum (Sens) in Gaul in which a plasterer smoothing a wall with his left hand is followed by a painter applying colour before the surface dries.

344 A plasterer using a float; a scene recorded on a Pompeian wall painting which no longer survives.

345 Decorators at work: on the right a plasterer, on the left a painter. Part of a stone relief from Sens, Yonne.

If Vitruvius and Pliny give us some information on how smooth stucco surfaces were prepared, they have little or nothing to say on work in relief. Here we are dependent almost entirely on archaeological evidence.

Architectural details like drafted masonry, column-fluting and impost-mouldings could have been produced in a fairly mechanical manner. Drafted masonry, for instance, was achieved either by first preparing a smooth surface in the normal manner, then incising a pattern of block-work upon this surface, and finally applying a further layer, smoothed in the same way and carefully squared at the edges, within each block; or alternatively by modelling the block-work in the undercoat before the fine surface layer was spread evenly over both the blocks and their margins. For column-fluting, if this was not merely incised in the surface, the craftsman must have hollowed out the channels and sharpened the arrises by hand and trowel, before polishing them with some type of specially-shaped float. Cornices could have been carried out in analogous fashion: one of the floats from Aegina has a concave surface clearly designed to fit the profile of a stucco moulding. But, where strong projection was involved (and this happened frequently with cornices, despite Vitruvius's strictures), some form of armature or core was necessary. This was often provided, in the case of a cornice, by iron pegs or nails hammered or mortared into the wall or by a projecting course of brick; while in the case of vertical members, such as semi-columns or colonnettes, it could be built up in brick, terracotta tubes, or some such material as wood bound with twine. In all strongly projecting parts not only the surface plaster but also the underlying layers would have been worked in relief. The heavy stucco ceiling-coffers which were fashionable in late-Republican Italy were fully modelled in a thick preliminary mortar coating, nails again being used as a key, while the surface plaster was spread evenly over frame and field alike.

Architectural enrichments required closer treatment, though again much of the work would have been fairly mechanical. Repeating ornaments like the egg-and-dart, or even patterns of miniature figures, like the lyre, swan, dolphin and cupid ornaments which often decorated cornices during the last years of Pompeii, could have been produced by pressing stamps of wood or terracotta in the damp plaster. Some of the detail of Corinthian capitals might perhaps have been produced in the same way, but here most of the work, particularly deep-cut and overhanging elements, was clearly carried out by hand in the manner of the reliefs considered below.

This brings us to the more purely decorative type of stucco-relief work, the work which moves into the realm of art: the all-over decoration, incorporating figures and plant ornaments, often of great delicacy and accomplishment, applied to walls and vaults. Here the initial stages differed little from those involved in preparing a flat surface for painting, though the number of layers, whether on vault or walls, never exceeded three. But preparing a surface was obviously just the beginning of the stuccoist's work. His next step was to divide the area into a system of panels or fields by applying strips of relief. On walls, especially those of the last years of Pompeii and later, these strips were worked in the form of architectural members, for instance slender columns carrying light entablatures. On vaults, the treatment was far more flexible. The frames

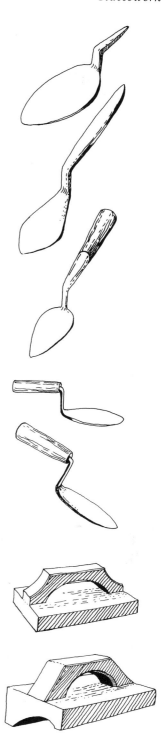

346 Plasterer's trowels from the Roman fort at Saalburg and plasterers' floats, one flat, one shaped to fit a moulding, from the sixth/fifth century BC sanctuary of Aphaea at Aegina.

215

varied considerably in width and complexity, while the designs which they created ranged through almost the whole gamut of possibilities, beginning with grids of squares which might be merged to form oblongs, larger squares, and L- or T-shaped compartments (which might in turn be filled with subsidiary shapes such as lozenges and medallions), then proceeding to systems of concentric square borders, all-over curvilinear patterns, and elaborate interlocking designs constructed round a central medallion. Whatever the design, it was carefully mapped out in advance with the aid of incised guide-lines, drawn where necessary with compasses, rule or set-square. In some decorations, particularly earlier ones, like those of the House of the Cryptoportico at Pompeii, the guide-lines for the main frames were drawn on the undercoating and the mouldings applied before the surface plaster; but later, as these mouldings became shallower, all the frames, along with their preliminary drawings, were executed upon the finished surface. In either case few mouldings were complete till they had been decorated with stamped enrichments, pressed either into the moulding itself or into the surface-coating spread over it. The detail of a vault in Fondo Caiazzo at Pozzuoli shows good examples of the technique of these enrichments, the upper series of eggs clearly having been impressed in sets of three, and the lower series in pairs.

The fields were now ready for the final stage in the process: the application of the reliefs. In the case of strongly projecting motifs, like the athletics prizes modelled on the upper wall in the baths at Cales in Campania (*c.* 90–70 BC), the plaster might be built up round a core of broken bricks or suchlike; but in most decorations the reliefs were delicate enough to be worked with a single application of fine stucco. Where the background was to be left plain, the stucco was

347 (left) Decorative scheme of a stuccoed vault in the Baths of Sosandra at Baiae. Probably first or second century AD. Approximate dimensions 24 ft 4 in. by 26 ft. **348** (above) Decorative scheme of a stuccoed vault in the Stabian Baths at Pompeii. Before 79 AD.

349

350

349 (above) Detail of vault decoration showing the guide lines for the main frames on the backing mortar and for the inner frames on the surviving fragments of surface plaster. From the House of the Cryptoportico, Pompeii; 50–75 AD. 350 (right) Cupids and a dragonfly, a detail of a vault in Fondo Caiazzo, Pozzuoli, showing mouldings applied to the final stucco surface and stamped enrichments. Late first to early second century AD.

351 Detail of the Meleager frieze showing Pegasus. The stucco relief has fallen away leaving a tidemark and exposing the roughened surface. The wings are merely painted on the background. 62–79 AD.

normally applied in a damp mass while the surface was itself damp, and was then modelled by hand and tools *in situ*. In many cases a preliminary sketch was first incised in the plaster, but was often modified or disregarded when the actual modelling took place. If for any reasons the surface had already dried, or if large-scale figures or high relief were involved, the plaster was scratched and gouged to give the reliefs greater purchase.

The latter procedure was customary when, as often happened, the background was coloured. A close examination of the Meleager frieze from Pompeii and especially of those parts where the stucco reliefs have fallen away reveals that the surface was first painted, then (presumably, although the traces are unclear) the outlines of the figures were drawn in, and finally areas were scratched away within the outlines. Probably to save time, the stuccoist roughened only the ground beneath the central parts of the figures, and one can see where the stucco encroached on the painted surface, leaving a tide-mark beyond the edge of the gouged-out area. Details in low relief were applied with a thin plaster wash or blue paint.

In neither plain nor coloured decorations is there any firm evidence for the use of moulds or stamps in the manufacture of these reliefs. The suggestion, advanced by some writers, that figures and ornaments could occasionally have been shaped in moulds before being applied to the wall or vault is unconvincing, since this would have been a slow and clumsy technique even when the relief was high. In any case most stuccoes are too delicate to have been fashioned separately. The use of stamps pressed into the damp plaster on the actual vault or wall surface is a more plausible procedure. It is certainly possible that recurring motifs like rosettes or small animals could have been produced

217

352 A pair of stucco caryatids which are almost identical in form. From the wall of a tomb outside Rome, 50–0 BC.

354 (right) Cupid with a lyre, a stucco relief supplemented by incision in the background. From a tomb at Pozzuoli, first or second century AD.

Col. Plate VIII

353 Floral ornament showing marks of indenting tools, a detail from the Farnesina stuccoes. About 20 BC.

by this means, while there are one or two examples of larger figures being repeated in nearly identical form which may point the same way (for instance, the pairs of caryatids on slabs from Rome, now in Copenhagen). Nonetheless the resemblances, even between series of simple ornaments in the same decoration, are never strong enough to provide conclusive proof of the intervention of stamps; nor are there any of the tell-tale surface marks which one would expect. In any case, even if stamps were used to obtain the main shapes, much of the detail was certainly modelled by hand and tool afterwards.

The marks of this modelling are one of the more characteristic features of stucco-relief work; they impart a freshness and spontaneity which stands in sharp contrast to the more formal style of the well-known relief plaques in terracotta. On the one hand we have the fingerprints of the craftsman as he pushed the plaster into position; on the other, we have the abundant impressions of the tools with which he gave it shape and executed the inner detail. Particularly striking are the rapid incisions employed to produce the folds of flesh, the crinkles of petals, the feathers of wings, and so forth. These, with their bold linear shadows, often give the effect of pen-and-paper sketches. That the plaster of the ground, as well as that of the relief, normally remained damp during this work (that is, of course, in the case of all-white decorations) is clearly indicated by the way in which some of the tooling was carried on to the field surface. Fine details, for instance further wings or billowing drapery, are sometimes drawn in this way; while the outline of a figure is generally scored with an incising tool, both to make the figure stand out, and perhaps also to ensure the adhesion of the relief at the edges.

This brings us to the question of tools; can we identify the implements with which the stucco was modelled? Here, since no stucco-modeller's house or depot has been certainly identified, and there is no funerary relief carved in honour of such a craftsman, our evidence is confined to the stuccoes themselves, which suggest the use of various forms of spatula for shaping and indenting, of knives for cutting, and of a sharp instrument like a burin for incising—much the same tools, presumably, as were employed by modellers in clay. Many of them may have been of wood and have perished, but there must be others of bone or bronze which have survived without being recognized. They may lurk, for instance, among the multitudinous knives and spatulae ascribed to surgeons: all such instruments would probably have been made by a normal smith and sold on the open market, where they would be accessible to people of every craft and profession. It is perhaps safest not to attempt any specific identifications, but as an instructive parallel one may cite two spatulae identical to a type of probe used by ancient doctors which were found at St Médard-des-Prés (western France) among the apparatus of a painter. Otherwise, the only tool worth mentioning is a bronze instrument with an upcurving blade, of which there are examples in Cambridge and Aphrodisias. As the one in Aphrodisias was found in a sculptor's workshop, one may guess that it was employed in the making of clay models; in which case it would be a plausible candidate for the tool-kit of the stucco-worker too.

Whether the backgrounds were coloured or not, the reliefs were left almost without exception in their natural white state. Colours were not applied before the third century AD, when stucco tended to be used more frequently for large-scale sculpture, often in very high relief or in the round. But the gilding of reliefs, or their painting in imitation of gilding, occurred occasionally from the first century AD onwards, notably in Nero's two Roman palaces, the Domus Transitoria and the Domus Aurea, where it supplemented the rich effect of decorations which already combined miniature stuccoes with painted arabesques and inset glass beads. In a couple of cases (a villa at Stabiae, and the tomb of the Valerii in the Vatican) the same technique was employed with the apparent intention of giving large-scale figures, whether in relief or in the round, the semblance of bronze or gilded statues.

We may conclude with a few words about the organization of work on a stucco decoration. Here a valuable piece of information is provided by a graffito in the fourth-century Platonia beneath the church of San Sebastiano outside Rome. Evidently inscribed by the stucco-workers who decorated the room, this graffito reads, 'Musicus with his workmen Ursus, Fortunio, Maximus, Eusebius': a firm of five men, therefore—possibly a freedman and four slaves, although the names are not conclusive. We may conjecture that firms like this were responsible for most commercial work. That several hands might be engaged in one decoration is shown by the differing styles of the stuccoes of the Underground Basilica near Porta Maggiore in Rome, where a basic pattern seems to have been interpreted according to their individual taste and competence by a number of craftsmen, sometimes with notable freedom, as in the vaults of the side aisles. In the realm of higher art, the stuccoes of the Farnesina house in Rome again show the work of different hands, but one hand (that of a master) predominates. This artist may

355 A bronze implement, perhaps a modeller's tool. Length 8 in.

have been himself responsible for the designs, or he may have been executing those of another man, as Raphael's pupils carried out their master's designs. At the same time, like Giovanni da Udine, he may have been a painter as well as a stucco-worker; the links in theme and style between the stuccoes and paintings of the house are certainly strong enough to suggest that the same artists could have had a hand in both.

These are all matters which merit further research. In particular, we have one valuable weapon for determining how work on some of the better-preserved decorations was allocated—the craftsmen's fingerprints, recorded in the actual material which he modelled. Such traces, infinitely more decisive than stylistic judgements, could, if studied by someone with sufficient expertise and adequate resources, tell us a good deal about the number of men involved and the way in which they were deployed.

Bibliography

Augusti, S., 'La tecnica dell'antica pittura parietale pompeiana', in *Pompeiana. Raccolta di studi per il secondo centenario degli scavi di Pompei*, Naples, 1950

Bankart, G. P., *The Art of the Plasterer*, London, 1908

Blümner, H., *Technologie und Terminologie der Gewerbe und Künste bei Griechen und Römern*, Leipzig, 1875–87

Borrelli Vlad, L., and others, 'Il restauro dell'Aula Isiaca', in *Bollettino dell'Istituto Centrale del Restauro*, 1967

Cagiano de Azevedo, M., 'Affresco', in *Enciclopedia dell'arte antica*, i, 1958

Cagiano de Azevedo, M., 'Stucco', in *Encyclopedia of World Art*, xiii, 1967

Klinkert, W., 'Bemerkungen zur Technik der pompejanischen Wanddekoration', in *Mitteilungen des Deutschen Archäologischen Instituts. Römische Abteilung*, lxiv, 1957

Pliny, *Natural History* xxxv, 36; xxxvi, 174 ff., 183

Ronczewski, K., *Gewölbeschmuck im römischen Altertum*, Berlin, 1903

Venturini Papari, T., *L'arte degli stucchi al tempo di Augusto*, Rome, 1901

Vitruvius, *On Architecture* ii, 4, 2–3; ii, 5, 1; vii, 2 ff.; vii, 6

Wadsworth, E. L., 'Stucco reliefs of the first and second centuries still extant in Rome', in *Memoirs of the American Academy in Rome*, iv, 1924

For a comparison of Greek plaster-work see the following:

Martin, R., *Manuel d'architecture grecque* i. *Matériaux et techniques*, Paris, 1965

Orlandos, A., *Les matériaux de construction et la technique architecturale des anciens Grecs*, Paris, 1966–8

Pamela Pratt

17 Wall Painting

Col. Plates VIII, IX

Wall paintings were extensively used by the Romans to decorate all types of building. The form of the painting and the standard of workmanship were dictated by the nature and importance of the building and the wealth of the patron who commissioned the work. Paintings were designed not only to be appropriate to the functions of the room but also to enhance the architecture of the building.

Designs changed as fashions changed, but basically the techniques of plastering and painting remained much the same. A large part of our knowledge of these techniques is based on the account given by Vitruvius and to a lesser extent on that given by Pliny. Most of the information is substantiated by modern scientific examination of paint and plaster samples. However, there are some mysteries, discrepancies and deviations from the techniques described. Many of these discrepancies could have been caused by the lack of certain materials and of highly skilled and experienced craftsmen in different regions of the Empire.

Apart from the wall support a wall painting is made up of two main parts: the stucco plaster ground and the paint layer. The choice of materials used in both parts and their preparation was known to be most important. In his introduction to the description of how materials should be used in building, Vitruvius makes it quite clear that the general principles for choosing materials for use in different operations are important for stability and durability, 'so that when they are familiar those who think of building may not make mistakes but get supplies fit for use'. He is no less specific when he comes to discuss the choice and preparation of materials used in stucco plaster (as described in Chapter 16) and the pigments used for painting. Both he and Pliny suggested that for durability a stucco plaster should be composed of a rough cast layer containing a coarse filler, followed by at least three coats of a fairly coarse lime and sand mixture. These were covered by finer layers of lime and marble powder, as described more fully in the previous chapter. Vitruvius states that 'When the walls have been made solid with three coats of sand and also of marble, they will not be subject to cracks or any other faults.' These instructions were not always followed and some plaster grounds are composed of only two or three layers.

Normally lime plaster sets by the evaporation of water and by carbonation, the free carbon dioxide in the atmosphere reacting with calcium hydroxide to

356 Part of the large figured frieze from the Villa dei Misteri, Pompeii.

form crystals of calcium carbonate. However, there are some limestones which contain alumina and silica in the form of hydrated aluminium silicate which, if calcined and slaked, set by carbonation and the rehydration of the aluminium silicate. These form very strong plasters of low porosity which have the advantage of setting in damp conditions or even under water. Limes of this type are known as hydraulic or semi-hydraulic depending on the percentage of alumina and silica present. Hydraulic limes come from lias limestones and chalk marl and the semi-hydraulic limes from grey chalk, siliceous limestones and argillaceous limestone. They appear to have been used in the construction of buildings in damp regions.

The Romans also discovered that by adding different types of filler material to non-hydraulic limes they could give them hydraulic properties and thus increase their usage. Perhaps the best known of these materials is pozzolana, a naturally occurring volcanic earth which was discovered by the Romans in the area of the Bay of Naples; it takes its name from the town of Pozzuoli. Pozzolana contains decomposable silicates, and when it was ground and added to slaked lime it combined with the lime to give a hydraulic plaster. Other volcanic ash material from other areas was also used. Materials such as powdered tile, brick and potsherds, prepared from clay which has a high silica content, were also found to give semi-hydralic properties, hence the inclusion of ceramic materials in coarse plaster layers in areas where natural pozzolanic material does not occur. Vitruvius in fact recommends that plaster prepared for use in damp places, like ground-floor rooms, should contain material of this sort: 'To the height of about three feet from the pavement rough-cast made of powdered earthenware instead of sand, is to be laid on so that this part of the plaster may not suffer from damp.' It is therefore not surprising that very often the plaster used as a ground for Romano-British wall painting is found, on examination, to contain a fairly high percentage of powdered ceramic material.

357 Section through a fragment of plaster from Herculaneum showing the fine plaster layers and the rough plaster. The filler in both layers is clearly visible. About twice actual size.

Pigments

The pigments used in Roman wall painting were obtained from mineral, vegetable and animal sources. The mineral pigments included the earth colours such as the ochres which were easily obtainable, occurring as they do in sedimentary rock deposits which are widespread in Europe and Asia. Other mineral pigments derived from the heavy metals occur only as isolated deposits, and so were less easy to obtain and therefore an expensive commodity in wall painting. They were classified by Pliny as the 'brilliant' pigments and under that title he mentions cinnabar (vermilion), armenium (azurite) and malachite. These, and perhaps others, had to be purchased by the patron who commissioned the wall painting as an extra over and above the cost of the painting. To overcome the scarcity and expense of these pigments, substitutes were found or made chemically.

Vegetable dyes such as indigo were also used. This was another expensive material classified as a brilliant pigment by Pliny and often other materials such as woad were used as substitutes. Most dyes were mixed with a highly absorbent material such as chalk which was then ground for use as pigment. Tyrian purple, a dye obtained from a species of sea mollusc, was also used in this way, according to Pliny, but its great expense must have made its use in wall painting rare.

Red pigments

Vermilion or cinnabar (mercuric sulphide) was obtained from the naturally occurring mineral cinnabar, by which name it was also known in antiquity. Pliny refers to it as 'minium' but this has led to confusion in the past, as the name was also used for red lead, a pigment of similar colour. According to Vitruvius the pigment was prepared by heating and washing the ore to remove waste and to make it friable. It was then ground for use.

Red lead or 'minium' was manufactured by heating litharge or white lead to form lead tetroxide (Pb_3O_4) which was then pulverized to form, as Pliny puts it, 'a minium of second rate quality'.

Haematite or red ochre is one of the naturally occurring earth pigments. It is composed mostly of oxides of iron, either in the anhydrous or hydrated form. The colour varies from the maroon of the anhydrous form to reds and yellows of the hydrated form. These pigments only needed grinding before use, but if finer pigment was required, it was produced by washing and further grinding.

Realgar is the natural orange-red sulphide of arsenic. It is mentioned in connection with painting by both Pliny and Vitruvius but there is still very little evidence that it was used in wall painting.

Blue pigments

Egyptian blue, blue frit or Pompeian blue was a blue pigment artificially prepared from copper, silica and calcium. It was commonly used in Roman wall painting. According to Vitruvius silica in the form of sand was mixed with flowers of soda and copper, all of which were finely ground. The mixture was then made into a paste with water, put to dry, then placed in earthenware pots and fired. The different components fused together to form a crystalline compound, bright blue in colour. It was coarsely ground for use, as finer grinding caused it to lose colour.

Natural ultramarine comes from the semi-precious stone, lapis lazuli. There seems to be some doubt that it was used as a pigment in Roman wall painting.

Azurite was obtained from the naturally occurring mineral of the same name, basic copper carbonate, which was washed and coarsely ground to give a deep blue colour.

Indigo, a blue vegetable colouring material derived from different plants of the genus *Indigofera*, probably of Indian origin, was used to dye chalk or kaolin and other absorbent earths to produce a material that could then be used as a pigment for wall painting.

Woad was obtained from the woad plant *Isatis tinctoria*, which is native to southern Europe. It was more readily available and very similar to indigo, and was used, prepared in the same way, as a substitute.

Purple

Tyrian purple was used primarily as a dye but was also adapted to make a pigment. It was obtained from several types of sea mollusc, notably *Murex brandaris* and *Purpura haemostoma* which were to be found on the shores of the Mediterranean and Europe. The dye is made from a white molluscan secretion which becomes coloured on exposure to strong light. The colour varies from a deep crimson to purple. The pigment was made by dyeing white earth material. Pliny describes how the colour deteriorated if a batch of dye was used more than

once. Both Pliny and Vitruvius tell us that the pigment dried very quickly unless mixed with a medium, and for this purpose Vitruvius suggests honey and Pliny egg. The best purple was said to come from Tyre.

Among vegetable purples one recorded by Vitruvius was made from mixing the dyes madder and hysginium. Madder was a pink-red dye obtained from the root of *Rubia tinctorium*. Hysginium is said to have been made from a parasite of the oak bush, *Quercus coccifera*, which is a native of North Africa and Spain. The mixture of dyes was then used to dye chalk which was ground and used as a pigment. Vitruvius suggested that the juice of whortleberries (bilberries), when mixed with milk, also made a good purple.

Burnt 'cinnabar' was a dull purple pigment made from heating a yellow ochre and then quenching it with vinegar. Other ochres containing ferric oxide also produced a purple colour when heated.

Green pigments

Terre verte or green earth is a pigment commonly found on Roman wall paintings. Col. Plate IX
It is a naturally-occurring earth pigment made up of two main minerals, glanconite and celadonite, and contains iron, magnesium, aluminium and potassium hydrosilicates. The colour varies from yellow-green to greenish-grey.

Malachite occurs naturally as the mineral, basic copper carbonate. Vitruvius mentions that it was mined in Macedonia. It was a very expensive pigment and Pliny mentions that *terre verte* could be used as a substitute.

Verdigris, a basic copper acetate, was manufactured, according to Vitruvius, by placing copper plates covered with vinegar in an enclosed vessel.

Yellow pigments

Yellow ochre is a natural earth pigment composed of a mixture of clay and silica, coloured by the presence of different hydrated forms of iron oxide, mainly limonite; it varies in hue according to the composition. There were many different ochres recorded by Pliny and Vitruvius, each with different names given according to the region where the ochre was mined or its characteristics: Attic slime, Scyric ochre, marbled ochre, clear ochre, etc. Attic ochre was said by Vitruvius to be the best for wall painting; Pliny calls it the most expensive.

Orpiment is the natural yellow sulphide of arsenic and is chemically very similar to realgar (see red pigments). Pliny tells us that it came from Syria and was easily broken up to form a pigment. According to Vitruvius it was also mined in Pontus.

Brown pigments

Sinopis is a red-brown ochre easily obtainable and much used in wall painting.

Brown umber is very similar in composition to the ochres, but contains manganese dioxide as well as hydrous ferric oxide. It was easily obtainable and was prepared for use by the system of reduction to a powder used for most of the other naturally-occurring pigments.

White

Lime white was prepared by calcining marble or oyster shells and grinding and slaking for use.

Lead white was prepared artificially by soaking wood chips in vinegar and placing them with lead in an enclosed vessel. This was not a very stable pigment as it tended to darken, so lime white was more commonly used.

Black

The black commonly used in wall painting was made from carbon. The carbon was obtained by burning materials such as resin, brushwood, pine-chips and the dregs of wine. For use the carbon was ground and mixed with size.

Preparation for painting

When the plaster was mixed with the appropriate filler it was applied to the wall surface, working from the top to the bottom. Each coat was allowed to dry a little before the next was put on. Usually the thickness of the different plaster layers decreased as the plaster became finer.

If a wall was particularly large scaffolding was erected to allow the plaster to be applied in horizontal sections. After the completion of a section the scaffolding was moved down to enable work to be continued on the one underneath. If the plaster in the upper section was allowed to dry out before the next was applied it was more difficult to mask the joints between the sections, and they are visible when paintings, constructed in this way, are examined in a raking light. Vertical joins are rarely found except where a wall is more than sixteen or twenty feet long.

The Istituto Centrale dell Restauro in Rome, in a recent article on their research into the techniques of Roman wall painting, gave the paintings in the Imperial Villa, Pompeii, as examples of work executed on a plaster with both horizontal and vertical joins. In the same article the Istituto report that they found that there are usually two or three horizontal plaster sections, about six feet in height, on walls not more than sixteen feet long. This gives us some indication of the surface area a Roman plasterer could cover at one time.

When all the layers of plaster had been applied the surface was prepared for painting. In the case of poorer-quality paintings the plaster was left rough. In the case of better-quality paintings, however, the fine plaster layer underwent rigorous smoothing and polishing, probably with a stone burnisher or marble roller. Vitruvius explains why: 'After they are rendered solid by the use of plasterer's tools and polished to the whiteness of marble they will show a glittering splendour when the colours are laid on with the last coat.' The report by the Istituto Centrale suggests that kaolin or bole (natural ferruginous aluminium silicate) was incorporated in the fine plaster layer to enable it to take a high degree of polish. This they have deduced from a reappraisal of the chapters of Vitruvius dealing with stucco and wall painting, and by examining samples.

Techniques of painting

Background colour was laid on to the rough or polished plaster surface, while it was still fresh and damp, using water as the vehicle for the pigments. This method of painting on to freshly laid lime plaster has become known as true fresco. Paintings executed in this way are very durable, since the pigments

358 A fragment of wall plaster showing a rough surface finish.

359 A fragment of wall plaster with a smoothed but not polished surface.

227

become bound to the plaster as the calcium carbonate crystals form. Vitruvius comments that 'when the colours are carefully laid upon the wet plaster they do not fail but are permanently durable'.

Designs for the paintings were sometimes planned and worked out on the rough plaster layers to fit in with the architectural scheme of a room. Simple guide-lines for basic designs were incised with a graver while complicated areas were painted in more detail using a pigment such as red or yellow ochre. Plastering was then completed, and the guide-lines redrawn. Detail was painted on to the coloured background when the plaster was either damp or dry.

The recent research carried out by the Istituto Centrale suggests that in important paintings the background was polished again after the main colours had been applied, and before the plaster had dried out or the detail added. In areas which were to receive overpainting the polishing was done with greater pressure. Plaster which is many layers thick retains moisture for a considerable time and polishing it would have caused this moisture, containing calcium hydroxide, to come to the surface. This concentration of calcium hydroxide on the surface then enabled the painter to overpaint in true fresco using pure pigments or pigments mixed with bole or kaolin to aid adhesion.

It is thought that some paintings were given another polishing after the detail was added, which would account for the lack of sharpness of line and the absence of brush marks. This is in contrast to other paintings where the detail is 'impasto' in appearance, as in the sample of Herculaneum plaster photographed in a raking light and shown here.

Architectural detail, isolated figures and simple designs could all be painted in this way. More complex scenes, however, needed more attention. If the plaster dried out too much the fresco technique could not always be used. To avoid this problem, in areas where complex scenes were to be painted, the coloured background and fine plaster were removed and a new fine plaster applied. The painter then had more time to finish the work in true fresco.

The Istituto Centrale suggest that the paintings in the Villa dei Misteri, Pompeii were executed entirely in true fresco on an already coloured and polished background. Obviously the success of the technique depended on the speed and artistic ability of the craftsman and such expertise must have been rare. In less important paintings, simpler methods were used.

356

The tempera technique allowed details to be added to the coloured plaster background after the plaster had dried. Pigment was mixed with a water-miscible medium such as egg, honey or size, which bound the particles together to form a paint. This was diluted with water and used directly on the dry wall.

Some of the pigments used in wall painting were recorded by Pliny as unsuitable for use on a wet plaster ground. The colours he mentions are purple (unspecified), indigo, blue (unspecified) and orpiment, so presumably these colours were always used with a medium.

Both Pliny and Vitruvius tell us that carbon black was ground with size for use as a pigment, and this was probably because its greasy nature made it difficult to use without a binder of some kind. This did not, however, preclude its use on wet plaster. Black was recommended by Vitruvius for use in winter apartments where paintings done with light colours would have been damaged

360 A fragment of wall plaster from Herculaneum showing details of the painting.

by smoke: 'In these rooms, immediately above the dado, panels of black are to be worked up and finished with strips of yellow ochre or vermilion intervening.' He also recommended that vermilion should be used '. . . in enclosed apartments'. This was because a high light level caused the vermilion to darken. Vitruvius also suggested that walls painted with this pigment should be further protected by applying wax and oil to the paint surface: 'After the finishing of the wall is dry, let him apply with a strong brush Punic wax melted in the fire and mixed with oil.' The wax was heated and applied to the wall using an iron vessel containing charcoal. It was then allowed to solidify and was worked over with a waxed cord and finished with a linen cloth.

There has, in the past, been considerable controversy and discussion about the techniques that were used for Pompeian paintings. The report by the Istituto Centrale, Rome, on the examination of Roman wall-painting technique provides much evidence to support the theory that true fresco was extensively used. Another earlier suggestion, made by Selim Augusti after examining samples of plaster from Pompeii, was that a calcium soap and wax solution was used both in the preparation of the plaster and the application of the pigment. Other earlier theories include the suggestion that pigment was first mixed with wax which was then applied molten, allowed to solidify and made to sink into the plaster by heating the surface of the wall with an iron vessel containing charcoal. This method which we now know as 'encaustic' was certainly used by the Greeks and the Romans for painting on wood, but there is no documentary evidence to support the theory that it was used for wall painting. It is possible that methods and materials used in the early restoration of the Pompeian paintings has made analysis more difficult and the results misleading.

The use of wall paintings for the decoration of buildings was widespread before the Roman period and the techniques used by Roman painters were based on the methods used by craftsmen of those earlier periods. However, as knowledge of chemical behaviour grew, so techniques were adapted and refined until a very high level of craftsmanship and skill was attained.

There are still a number of gaps in our knowledge of the many adaptations and deviations from the basic techniques that were used, and some controversies still have to be resolved. An intensive programme of scientific examination and analysis of samples of paintings of different periods and from widely differing sites is needed before a more detailed assessment can be made.

Bibliography

Augusti, S., *La technique de la peinture pompeienne*, Naples, 1957

Davey, N., *A History of Building Materials*, London, 1961

Frere, S. S., 'Excavations at Verulamium: second interim report', in *Antiquaries Journal*, 37, 1957

Gettens, R. J., and Stout, G. L., *Painting Materials*, New York, 1942.

Mora, P., 'Proposte sulla tecnica della pittura murale romana', in *Bollettino dell'Istituto Centrale dell'Restauro*, 1967

Pliny, *Natural History*, books 33–5

Vitruvius, *On Architecture*, books 2 and 7

230

Frank Sear

18 Wall and Vault Mosaics

361 (left) Mosaic-lined niche from a fountain at Baiae, about 100 AD. Height 44 in.

The technique of using small pieces of stone, glass, terracotta, shells and a variety of other brightly-coloured materials as a wall incrustation is a very old one. A well-known early example comes from Erech (Uruk) in Mesopotamia. The row of half-columns is studded with small terracotta cones, painted red or black or left in the brownish colour of the terracotta. They were then driven into the wall while it was still wet to form chevron, zig-zag and lozenge patterns. The Erech 'mosaic' dates to the third millennium BC, and shows how readily, from the earliest times, bright, hard materials were used to produce a lively and durable inlay on walls.

It is often thought that wall incrustations of the kind found at Erech were isolated phenomena, and that mosaic was confined almost exclusively to floors until the time of Constantine. But to judge by the wall and vault mosaics at Pompeii and Nero's Golden House which use cut-glass tesserae to produce highly complex ornamental and figurative designs, the art was by no means in its infancy even in the first century AD. Evidently the origins of wall mosaics go back further. It will be helpful to outline these earlier stages in order fully to understand the techniques employed in later mosaics.

Until about the middle of the first century AD wall mosaics were employed, almost without exception, to decorate fountains and 'nymphaea'. A nymphaeum is literally a grotto or cave inhabited by the nymphs or muses, but later the word came to refer to artificial as well as natural grottoes. These nymphaea usually contained a fountain or spring. They were much valued by the Romans as shady, cool retreats in hot weather and found a place in almost every wealthy man's villa.

The earliest of these nymphaea were natural grottoes, but they were soon embellished with troughs, spouts and shells. The discovery, in 1946, of a number of third century BC terracotta models of fountains in a prehistoric cave near Locri, Calabria gives us a good idea what these early grottoes looked like. The model illustrated shows a grotto with shells and deposits of moss left by the damp. It was probably partly natural and partly cut from the rock.

The big country villas of the first century BC with terraces, supported on rows of concrete barrel-vaults, often incorporated several nymphaea in their undercrofting. A typical nymphaeum of this kind contained an apse, sometimes cut

362 Terracotta model of a grotto from Locri. Height 18¼ in.

231

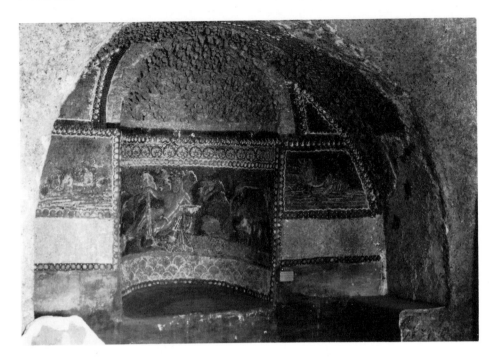

363 (left) Nymphaeum at Anzio, lined with pumice and mosaic. Mid first century AD.

364 The undercroft of a late Republican villa at San Vittorino.

from the living rock, which represented the place where the water sprang, and the concrete walls were covered with shells and volcanic pumice to give the appearance of a natural grotto. An example of such a nymphaeum incorporated into the platform of a villa can be seen in the terracing of a late Republican villa at San Vittorino near Tivoli.

Often stucco and small uncut chips of marble were used to supplement the shells and pumice. These additional materials gave designers fuller scope to produce more ambitious wall and vault decorations, many of which are reminiscent of contemporary fresco or relief stucco work. The elaborate coffering on the vault of the nymphaeum in the so-called 'Villa of Cicero' at Formia gives us some idea of the virtuosity of these artists. The vault is studded with chips of marble, pumice and shells of all shapes and sizes. The areas between the coffers are inlaid with oyster shells on a ground of marble chips, and the coffers themselves are outlined with a double row of small oval shells and a row of small round shells. Inside the coffers is a variety of circles, half-circles and lozenges. In the centre of each coffer is a petalled flower or an oval in reversed mussel shells. The precision and regularity of the work is remarkable. It is this already highly disciplined use of materials that seems to foreshadow the developed mosaics of a century later.

One or two features of the shell decoration in the 'Villa of Cicero' nymphaeum are closely analogous to the cut-glass mosaic work of a century later. For example the nave vaulting of the nymphaeum is supported by four columns whose necking grooves and echinus are indicated by rows of shells, and whose shafts are decorated with panels outlined in shells. A niched fountain covered in mosaic was found in the garden of the Casa delle Colonne a Mosaico at Pompeii, which dates to the mid-first century AD. In front of it stood four mosaic columns supporting a covered pavilion. The columns were removed to the National

367

365 Plan of the coffering on the vault of the nymphaeum in the villa of Cicero at Formia and **366** (below) detail of the coffering.

Museum at Naples where they are at present on display. The Doric capitals outlined in shells serve to remind us that the introduction of glass mosaic was only a stage in the evolution of a technique which dates back to Republican times.

Let us now follow more closely the stages by which pumice and shell decoration like that in the 'Villa of Cicero' were translated into the glass mosaic seen at Pompeii. During the first century BC marble chips were used to supplement the range of materials available to the 'shell mosaicist', but so far no coloured materials had been used. In one or two cases the plaster into which the marble chips and shells were pressed was painted in bright shades of blue, red, yellow and green. However, in a true polychrome mosaic the colour should be supplied by the tesserae rather than the background plaster, and the tesserae used hitherto, the marble chips and the shells, were white. The earliest known examples of coloured tesserae on a wall or vault appear in the mid-first century BC on the vault of a Republican cryptoporticus under Hadrian's Villa at Tivoli, and in the so-called 'Villa of Horace' at Sant'Antonio, Tivoli. Shells and marble chips are used in both, as in the 'Villa of Cicero' nymphaeum, but also, in an attempt to add colour, small pellets of 'blue frit' or 'Egyptian blue' were used.

Egyptian blue is a blue pigment ($CaCuSi_4O_{10}$) made by heating together silica, a copper compound (usually malachite), calcium carbonate and natron. It is made as a paste, and then fired at a temperature of 850°C. The coloured compound is formed by the heating. It is then rolled into pellets $\frac{1}{4}-\frac{1}{2}$ inch long. Jars of these pellets were found in a recently discovered wreck of a Roman ship found in Mellieha Bay, Malta. They were no doubt bound for Rome where they were to be ground up and used as a blue pigment. That these pellets were incorporated into wall 'mosaic' schemes as early as the first century BC is a curious but undoubted fact. Indeed, long after glass tesserae were used in wall mosaics these blue pellets remained in constant use where an even, powder-blue background was required. Most Pompeian fountains use Egyptian blue in preference to blue glass, and they turn up as late as the reign of Hadrian, and as far away as Leptis Magna in North Africa.

In late Augustan and Tiberian buildings glass was slowly incorporated into wall and vault 'mosaics'. At first the glass used was pieces of broken glass vessels, glass disks and twisted glass rods. A nymphaeum in the Casa dell'Ancora Nera at Pompeii has glass disks in the upper part of its pilasters and uses marble chips and Egyptian blue tesserae extensively elsewhere. Pieces of glass, Egyptian blue and shells were also found in the late Augustan or early Tiberian grottoes at Capri. Finally, by the time of Tiberius cut glass tesserae were used along with Egyptian blue, twisted glass rods, broken glass and pumice to decorate grottoes.

One of the earliest surviving buildings to use glass tesserae is the Columbarium of Pomponius Hylas at Rome, which appears to date to about the time of Tiberius. Over its entrance is a niche containing a mosaic plaque. The niche has an apse and is covered with a small barrel vault incrusted in pumice with a cornice of shells running underneath. There are traces of coloured glass tesserae on the walls, and the floor of the niche is covered in marble. The plaque itself is capped by a row of whelk shells and outlined in cockles and twisted glass rods. Inside is an inscription in mosaic, and below are two heraldic confronting griffins. The use of glass tesserae is limited, most of the decoration being in pumice,

367 Mosaic-covered column from the Casa delle Colonne, Pompeii.

368 (above right) Mosaic panel from the columbarium of Pomponius Hylas outside Rome. **369** (right) Details from a fountain in the Casa de Gran Ducca, Pompeii: twisted glass rods and shells used as edging for mosaic panels; pumice and shells and the impressions where other shells and twisted glass rods have fallen away (far right).

shells, twisted glass rods, white stone tesserae and Egyptian blue. The only coloured glass used is green, yellow and blue.

It appears from this and contemporary buildings that cut glass tesserae became part of the stock-in-trade of wall mosaicists at about the time of Tiberius. The adoption of broken glass and glass disks in Augustan and early Tiberian buildings no doubt facilitated the transition. That glass should have been introduced is no surprise, as it was the ideal substance to catch the light and sparkle against the waters of the fountains it normally adorned. It was also more commonly available by the end of the first century BC as a result of the establishment of glass factories in Italy under Augustus.

The plaque in the Columbarium of Pomponius Hylas is one of the first examples of a true mosaic on a wall. It still has most of the features of its antecedents: the pumice, the twisted glass rods, the shells and the Egyptian blue, but the use of cut glass tesserae means that it is indisputably a mosaic. We have seen how wall mosaic evolved, and it is clear that this evolution has little to do with contemporary floor mosaics. Perhaps this is not surprising in view of the very considerable differences between wall and floor mosaics. Today we use the word 'mosaic' to signify wall and floor mosaics alike, and it may be the very terminology we use that has caused the misapprehension that wall mosaics were rare in Roman times and only appeared at the time of Constantine as a development from floor mosaics. The Romans did not think so. Floor mosaicists and wall mosaicists were given different names. The technique of floor mosaic was called 'tesselatum', and that of wall or vault mosaics 'opus musivum'. There was a sharp distinction in the minds of the Romans between floor mosaics and the art of decorating nymphaea (or 'musaea' as they were often called) with a range of materials which finally included cut glass tesserae. Perhaps they found difficulty in finding a name for the latter and solved the problem by giving it a general title, derived from the type of building with which it was associated from the earliest times. Hence their term 'opus musivum'.

We have seen that wall mosaics evolved independently of floor mosaics, and that the Romans made a distinction between the two. How then can we tell if a fragment of mosaic has come from a floor or a wall? In one or two cases it is clear enough. If, for example, the fragment has a pronounced curve or corner it must come from a wall or vault. Sometimes a fragment is on a heating tube and once belonged to the lining of the hot or warm room of a bath. The presence of shells or pumice is a sure indication that the fragment came from a wall or vault. But there are more fundamental distinctions. Let us compare representative examples of the two techniques. For our wall or vault mosaic let us take the octagonal medallion in the centre of the barrel-vaulted nymphaeum in Nero's Golden House, and for our floor mosaic the Seasons pavement at Chedworth.

370, 390

Observe first of all the greater care taken in laying and smoothing the floor mosaic. A floor mosaic has to be walked on, and thus is basically functional in a way that a wall or vault mosaic is not. If one or two tesserae of a floor mosaic are loose or unevenly laid whole areas of the mosaic will break up very rapidly under the constant tread of feet. This can be seen only too readily on an archaeological site where the mosaics are not constantly repaired and maintained. In a wall mosaic there is no need to lay the tesserae perfectly flat or even close together. Indeed it is often an advantage if the faces of individual tesserae are laid somewhat obliquely so that they can catch the light and shimmer. The evidence seems to be that in wall and vault mosaics the tesserae were fixed none too firmly in their plaster beds to judge by the number of cases where the only evidence of the existence of a mosaic is the honeycomb of holes from which the tesserae have long since fallen.

Another striking difference is the vivid colours of a wall or vault mosaic compared with those of floor mosaics. Wall mosaics were largely composed of glass tesserae, and an almost infinite range of bright colours can be achieved in glass. Floor mosaics were on the whole made up of coloured stone and marble

370 The central octagon in the vault of the nymphaeum of Polyphemus in Nero's Golden House, a glass mosaic panel set in a plain pumice background.

tesserae. This does not mean that floor mosaics never contain glass. Many do, especially bright green and bright blue, colours which could not be obtained in stone, and in North African floor mosaics glass of practically every colour is used. As a rule, however, one can say that wall mosaics tend to be composed largely of glass tesserae except where the colour required can be obtained more cheaply or easily in stone. Thus a typical wall mosaic will use glass for all colours with the possible exception of white, black, pink, ochre and brown, which were often in stone. Floor mosaics tend to be entirely in stone except for bright blue and bright green, and small amounts of any other bright colour which is needed for special effect.

Having established some of the main differences between floor and vault mosaics, let us examine how a wall or vault mosaic was laid. The procedure was probably similar to that used in floor mosaics. That is to say that a cartoon of the total design was sketched on to the penultimate layer of plaster. If the design was a figured one the master craftsman would perhaps start work on a figure or perhaps just the head and leave the background to his assistants. He would lay the final layer of plaster over a small portion of the cartoon and begin laying the tesserae. He would have to be careful to lay only as much plaster as he could cover before it dried. In some wall and vault mosaics there is evidence that a more detailed outline of the final design was painted on to the final layer of

plaster while it was still wet and before the coloured tesserae were inserted. In the medallion in the vault of Nero's Golden House and in the mosaic in the vault of tomb 'M' underneath St Peter's traces of paint can be seen in the holes where the tesserae have fallen out. The colours used did not necessarily correspond to those of the tesserae, and there is no doubt that they were only intended as a guide rather than a complete polychrome 'painting' of the mosaic that was to cover them. For example a wash of greyish blue is found under grey tesserae, ochre under lime and pale yellow under deep yellow.

370

The tesserae themselves are normally just over $\frac{1}{4}$ inch square, although they are often bigger if they are high up in a vault. The glass used in the first century AD tended to be of a more even texture and colour, and the tesserae more sharply cut than in the late Empire. By the third century the glass is often bubbly and cracked, and the tesserae lose their regular squared shape. In the vaults on either side of the 'natatio' in the Baths of Diocletian the edges of the tesserae vary from $\frac{1}{4}$ to 1 inch in length, and their shapes are so irregular in many cases as to suggest that they were hammered off the block rather than cut. More primary colours are used in the earlier period; by the second and third centuries pinks, purples and orange appear more frequently. Little use is made of gold tesserae before Constantine, although a few were found in Nero's Golden House, and occasional examples turn up in Britain, Germany, France and Switzerland. Mica and other minerals are sometimes found in wall mosaic, and, as has been said, Egyptian blue was commonly used until at least the second century AD.

There are very few well-attested examples of wall mosaic in England. Glass tesserae, some with gold leaf, were found in the Roman villa at Southwick, Sussex, and these may imply the existence of a wall mosaic. A more secure piece of evidence for wall mosaic turned up in the Roman villa at East Malling, Kent, where a fragment measuring $8\frac{1}{2} \times 7$ inches was found. The fragment has a pronounced curve which implies that it came from a wall. The pattern is a pelta with white tesserae in limestone and brown and yellow tesserae in clay paste. The baths of a Roman villa at Wingham in Kent had a plunge whose walls were lined with black and white tesserae. Apart from these and a few other scanty traces we have no idea how much wall and vault mosaics featured in the decoration of buildings in Roman Britain, although we may suspect that they never enjoyed the same vogue as they did in Rome and the North African provinces.

In Rome and central Italy wall and vault mosaics, especially the latter, grew in popularity during the second and third centuries AD. The curves, niches, domes and exedras of the new concrete architecture required rich surface treatment. Flat surfaces such as walls and the backs of niches could be lavishly veneered in marble, but intricately curving apses, vaults and domes demanded a more flexible inlay. Painting was sometimes used, but mosaic offered the same flexibility combined with a more lively surface effect and richer polychromy. The second century Baths of the Seven Sages at Ostia contain an exedra decorated with mosaic which gives some impression of this rich surface treatment. The mosaic is no longer confined to a medallion set into a pumice ground as in Nero's Golden House, but spreads freely over the half-dome, lunette and down the soffit of the arch. The patterns are familiar from wall painting—the scrolls, tendrils, flowers and fish—but the effect is one of greater clarity and opulence.

371 Scrolls and foliage patterns on the underside of an arch in the Baths of the Seven Sages at Ostia. About 120–140 AD.

By the time of Constantine the number of wall and vault mosaicists employed throughout the Empire must have been very great. The large areas of mosaic on the dome of the so-called 'Temple of Minerva Medica' at Rome, on the vaults of the Baths of Diocletian, and in the domed vestibule of Diocletian's Palace at Split in Yugoslavia alone gives us some impression of the activity of wall and vault mosaicists at the end of the third century AD. There can be little doubt that they belonged to recognized guilds, and that they had their own separate pay structures like painters, sculptors and floor mosaicists. The fourth century Edict of Diocletian fixes the wages of a *musearius* at 50–60 sesterces a day. The Codex Theodosianus draws the distinction between *tessellarii* (floor mosaicists) and *musivarii* (wall and vault mosaicists), and the latter were actually paid more. Perhaps the additional pay took into account the danger of working high up on a vault. Such dangers existed, as in the case of a young workman of twenty-five who is recorded as having fallen to his death while putting up a vault mosaic (C.I.L., IX, 6281). One must assume that craftsmen from these same guilds were responsible for the Christian mosaics that adorned the churches of Constantine a generation later. The early Christian mosaics in Rome and Ravenna, which used the same types of glass tesserae and many of the techniques we have discussed, reveal that their creators were not so much originating a new tradition, but infusing fresh spirit into an old one.

Bibliography

Becatti, G., *Scavi di Ostia, IV, Mosaici e pavimenti marmorei,* Rome, 1961

Bovini, G., 'Origini e tecnica del mosaico parietale paleo-cristiano', in *Felix Ravenna,* 3, 1954

Caley, E. R., 'Analysis of glass tesserae', in *Isis,* 38, 1948

Cecchelli, C., 'Origini del mosaico parietale cristiano', in *Architettura e Arti decorative,* 2, 1922

Frost, H., *The Mortar Wreck in Mellieha Bay,* London, 1969

Joly, D., 'Quelques aspects de la mosaïque parietale au Ier siècle de notre ère', in H. Stern, G. Picard, *La Mosaïque Gréco Romaine,* Paris, 1965

Lavagne, H., 'Le Nymphée au Polyphème de la Domus Aurea', in *Mélanges d'archéologie et d'histoire,* 82, 1970

Leclercq, H., 'Mosaïque' (early Christian Mosaics), in F. Cabrol, H. Leclercq, *Dictionnaire d'Archéologie et de Liturgie,* Paris, 1935

Lucas, A., and Harris, J. R., *Ancient Egyptian Materials and Industries,* Fourth edition, London, 1962

Lugli, G., 'Nymphaea sive musaea', in *Atti del IV Congresso di Studi Romani,* 1938

Neuerburg, N., *L'Architettura delle Fontane e dei Ninfei nell'Italia antica,* Naples, 1965

Pirie, E., 'A fragment of wall mosaic from East Malling', in *Archaeologia Cantiana,* 71, 1957

Sear, F., *Roman Wall and Vault Mosaics,* forthcoming from the German Archaeological Institute, Rome, 1976

Stern, H., 'Origins et débuts de la mosaique murale', in *Etudes d'Archéologie classique,* 2, 1959

Svennung, J., *Compositiones Lucenses* (Opus Musivum), Leipzig, 1941

240

David S. Neal

19 Floor Mosaics

The first mosaic floors were made of natural pebbles. A mosaic of this sort found at Gordion in Asia Minor has a simple geometric pattern, and dates from the eighth or seventh centuries BC. By the fourth century the art of the pebble mosaic was flourishing in Greece; good examples have been found at Pella and Olynthus where light-coloured pebbles are used for the design and darker ones for the background. Figures were surrounded with strips of lead or terracotta to make their outlines more distinct.

Mosaics incorporating natural pebbles and cut stone tesserae have been found at Morgantina, Sicily; they are dated 275–215 BC. This phase marks the transition from pebble mosaics to mosaics made entirely of cut stone tesserae. In the Hellenistic world of the second and first centuries BC it was fashionable to copy paintings in mosaic. Panels of highly detailed and intricate mosaic work were 375 used as centrepieces, *emblema*, in floors of otherwise simple design. The size of the tesserae used in the *emblema* was minute, of the order of a small fraction of an inch (1–4 mm.), and the work was referred to as wormlike, *opus vermiculatum*. These detailed panels were probably prefabricated and mounted on slabs of stone or tile so that they could be exported ready-made and set into floors made locally.

In Republican and early Imperial Italy there were many varieties of floor made up of stones set in concrete: there were plain or coloured concrete floors with a few tesserae set in to give a sense of pattern; there were floors set with shaped pieces of coloured marble, *opus sectile*; and there were all-over mosaic Col. **Plate X** below floors. At this early date, plain black and white mosaics predominate, the figures and decoration being set out in black against a white background. The typical multi-coloured Roman mosaic is a development from the Hellenistic and early Imperial practices.

Tesserae were normally made of stone, though terracotta and glass were also used. Stone tesserae were usually made from rocks indigenous to the area where the mosaic was to be laid; though in Italy, where it was common practice to import large quantities of foreign stone and marble and where it was possible for a mosaicist to obtain a supply of chippings and off-cuts from masons' yards, stone from farther afield was often used. In Britain the use of imported stone was rare; but a mosaic from Eccles in Kent has tesserae of white limestone possibly

372 Detail of a pebble mosaic from Pella. Early third century BC.

241

373 Floral patterns on a pebble mosaic from Sicyon. Mid fourth century BC.

originating in continental Europe. Other desirable stones were transported considerable distances: Purbeck marble and Kimmeridge shale from Dorset were used in mosaics in Gloucestershire and stone from the Forest of Dean in mosaics as far east as Oxfordshire.

The availability of different coloured rock from quarries and outcrops was very wide, but it was rarely possible in Britain to find a true red from a natural source. To overcome this problem stones were scorched to obtain a range of tones of reddish hue; more commonly, however, red tesserae were made from terracotta.

Terracotta tesserae came from several sources, the most common being old roofing and building tiles; sometimes they were purpose-made as at the Roman brickworks at Wykehurst Farm, Cranleigh, Surrey, and in the case of the blue terracotta tesserae in the pavement from Carisbrooke, Isle of Wight. Tiles provided a limited range of colours, red and yellow from the outside and blue, grey and black from the over-fired dark core. The pavements from Combley, Isle of Wight and Gadebridge, Herts were constructed mainly of tesserae of this sort. At Combley the black tesserae had not been fully trimmed with the result that the red surfaces of the tile were partly visible; at Gadebridge the terracotta tesserae included red, yellow, pink and two tones of grey and only the outline of the perspective box design was of stone. The subtle shades of pink and grey that could be achieved with terracotta suggests that the clays were specially blended and fired to make them. It is probable that large parts of other pavements were also made of terracotta tesserae, but that the materials have not been adequately recorded.

In the second century AD fragments of samian pottery were a useful source of red. The fabric was much finer than broken tile, and was a better material for figured work. Identification of the makers of fragments of samian used as

Col. Plate XI

374 A fragmentary mosaic made up largely of terracotta tesserae of different colours. From Combley, Isle of Wight. Width about 10 ft 6 in.

tesserae in mosaics at High Wycombe and Fishbourne has made it possible to establish a date, a *terminus post quem*, for the construction of the pavements.

In Britain glass tesserae were mainly prepared from broken vessels although elsewhere they were often purpose-made and sometimes predominate over other materials. They have been found on only six Romano-British mosaics where they were used to highlight special features. Blue was used in the feathers of the peacock train on the Leicester mosaic, red in flowers garlanding the head of Spring on the Seasons mosaic from Cirencester, and green to represent vine leaves on the Bacchus pavement from Verulamium. Green is also used to give a speckled effect to the back of a hare on a pavement from Cirencester and on the Venus pavement from Bignor. Tesserae of glass paste were commonly used in Gaul and Italy, but have only been identified in one mosaic in Britain: the pavement from Roxby in north Lincolnshire. Here yellow paste was used in a small bird. Eight gilt-glass tesserae, perhaps imported from Italy, have been found at Southwick in Sussex.

The preparation and cutting of tesserae in the Roman period are largely matters for speculation. There are iron objects which are believed to have been portable anvils; originally they would have been set into blocks of wood and could have been used in chipping tesserae to shape. However, pincers are commonly used today and would also have been ideal in Roman times. There is evidence from Norden Farm, Corfe Castle, in Dorset, to suggest that the tesserae were being prepared in buildings close to the quarry from which the stone came. This is a first century site, and it is possible that the tesserae were destined for mosaics at Fishbourne. Elsewhere heaps of tesserae have been found in buildings as, for example, at Water Newton, Rudston and Gadebridge, but these were not necessarily prepared on the site and may merely indicate a supply of stones used for repairs.

Preparation of foundations

Vitruvius gives instructions for the preparation of a proper foundation for a pavement: having constructed a firm base, either of broken stones or, for an upper floor, of timber, lay a layer of stones no smaller than fill the hand; over this lay a 9 inch layer of broken stones mixed with mortar, and over this a 6 inch layer of crushed tile and mortar; only then can the pavement be laid on top.

The essence of these instructions is that the floor must be solid, and it is for this reason that each layer had to be beaten down thoroughly before the next one could be laid on top of it. In practice the best mosaics were laid on a well-prepared foundation of several layers of rubble and mortar as described. Vitruvius warns especially against laying a floor across the top of another wall, for it will surely crack across the buried feature as it settles; this sort of failure was not unusual where pavements were built over hypocausts.

376
377

The guide lines for the basic patterns were ruled or scored, or sometimes painted on the surface of the top layer of the foundation. The tesserae were then laid on to a thin bed of mortar spread out over the guide-lines. This method of working is not so illogical as it first appears. It would not have been possible to lay a mosaic in a matter of hours, and so it would have been impractical to plot out the design in the final bedding since this had to be soft to hold the tesserae,

375 A mosaic from Zliten with an *emblema*, a panel made up with minute tesserae set in a marble tray.

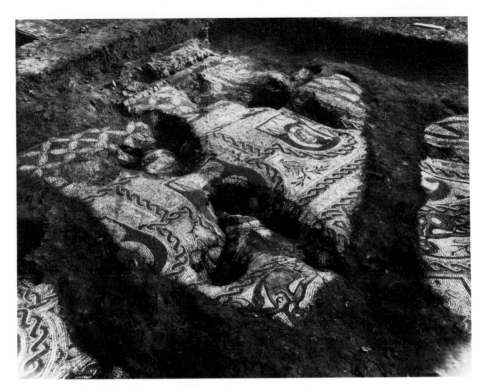

376 Mosaic at Brantingham on Humberside, Yorkshire, found collapsed into the underlying hypocaust.

and therefore had to be put down a little at a time as required. The number of guide-lines necessary for a mosaicist would have been minimal, only the basic framework of the design being outlined. It would not have been necessary to outline more as the mosaicist was a highly professional craftsman capable of laying mosaic, particularly repetitive designs, without recourse to a pattern. At Rudston, Yorkshire, and at Francolise in Italy, guide lines were scored into the wet mortar; at Cirencester, Gloucester and at Utica in Tunisia red paint was used. Red paint also appears to have been used to make guide lines beneath a fourth century BC pebble mosaic at Pella. Setting out with painted guide lines was perhaps more convenient than with scored ones since it could be done on hard mortar, whereas scoring had to be done while the mortar was still soft.

Setting mosaic

There are three methods of laying mosaic: the direct, the indirect and the reverse methods. The direct method involves setting the tesserae individually into the bedding mortar. With the indirect method the tesserae are first bedded in sand, then strong paper or cloth is glued to their upper surface. Once the glue has set, the design can be removed from the sand and eventually reset into bedding mortar. All that is then required, once the bedding mortar has dried, is for the glued backing to be dissolved with hot water. The reverse method is somewhat similar to the indirect method, but instead of the surface of the tesserae being laid face up, each piece is glued face down on to a coloured cartoon which is also of paper or cloth. After the section has been finally relaid and the cartoon washed off, the picture will be the reverse to that which was showing in the workshop.

377 Guide lines inscribed in the wet mortar beneath a pavement at Rudston, Yorkshire.

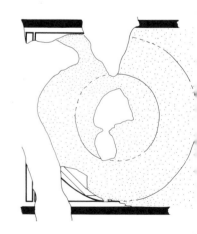

It is difficult to detect the use of the indirect and reverse methods in ancient mosaics, but it is probable that they were used fairly frequently for they had a number of advantages. The main one was that the work of assembling the mosaic could have been begun before the floor on which it was to be laid was ready. Another advantage was that at slack times standard motifs and repetitive patterns such as strips of guilloche could be prefabricated and kept in stock until required.

A number of mosaics in Britain include errors or abnormalities in their designs which suggest that the reverse method was used in their construction and that the patterns were not assembled in the correct way. At Brantingham on Humberside an intersecting pattern in a panel of mosaic on the edge of a large floor is interrupted in the middle, and there is a gap between the two halves of the design; it looks as though this panel was prefabricated in two sections and that one of the sections was inadvertently laid the wrong way round. On the Lion and Stag mosaic from Verulamium the central group of the two animals was placed asymmetrically in its panel with the result that the tail of the lion had to be cut short. This error could have been caused by inadequate guide lines, but it is more likely to have occurred if this part of the mosaic was prefabricated and the design was made a little too large. The guilloche forming the intersecting box border around the Cirencester Hare mosaic may also have been prefabricated. Instead of the guilloche flowing from top left to bottom right, it ran the other way, from top right to bottom left, and this is inconsistent with the guilloche bordering the same mosaic. Such an error could occur in the workshop when lengths of guilloche were laid without allowance for reversal. At Rudston, when the Venus mosaic was lifted, it was noticed that the mortar beneath the figured portions such as the leopard and the shield was a different

378, 379 A break in the pattern of a border on the Brantingham mosaic.

380 Central panel of the lion and stag mosaic at Verulamium showing the border cutting off the lion's tail.

colour and texture from that used elsewhere in the pavement. It is probable that these motifs were set in position first and the infilling background tesserae added afterwards.

The laying of mosaic was carried out by teams of workmen probably consisting of master craftsmen assisted by apprentices. The more artistic representations would have been set by the craftsmen and the backgrounds and repetitive patterns laid by the apprentices who would also have laid the plain borders and carried out the final grouting. This involved filling the interstices between the tesserae with a fine tile mortar and polishing the tesserae with abrasive stones and fine sand.

Evidence for master and pupil at work has been noted on a number of mosaics. On the Dolphin mosaic from Verulamium, triangular registration tesserae were sometimes placed on either side of the central 'eye' in the bands of guilloche. The purpose of these registration tesserae, which are a feature not observed elsewhere, appears to have been to obtain an even angle in the bands of guilloche. This seems to be an example of a mosaic where the master craftsman was teaching his pupil; in order to maintain quality, the craftsman carried out preliminary registration and then allowed his pupil to continue.

381 The hare mosaic from Cirencester.

382 (left) A painting of the dolphin mosaic at Verulamium.

383 The registration tesserae in the guilloche border of the dolphin mosaic.

The inferiority in the workmanship of the wind personifications compared with the bust of Christ on the Hinton St Mary pavement has been attributed to a less-experienced mosaicist, perhaps a pupil. More obvious is the contrasting workmanship of many of the Corinian school pavements on which the surrounding meander and panel borders are inferior to the mosaic itself.

Repairs

A number of pavements in Britain show evidence of major repairs. The Hunting Dog pavement from Dyer Street, Cirencester, is of two contrasting styles, and half the pavement appears to have been relaid. The original work, probably datable to the second century, includes brilliantly executed heads of sea-gods, a head of Medusa and a panel containing a sea panther. The remainder of the pavement, however, differs in style to such an extent that the design is un-balanced. No attempt, apart from a poor representation of a sea leopard, has been made to reproduce the original work, and instead of filling the panels opposite the sea-gods with similar figures, one was filled with a guilloche 'mat' and the other with a flower. A close inspection of the central panel with hunting dogs reveals that these too have been executed during later repairs. The scene

384 The hunting dogs mosaic at Cirencester, copied from an old lithograph.

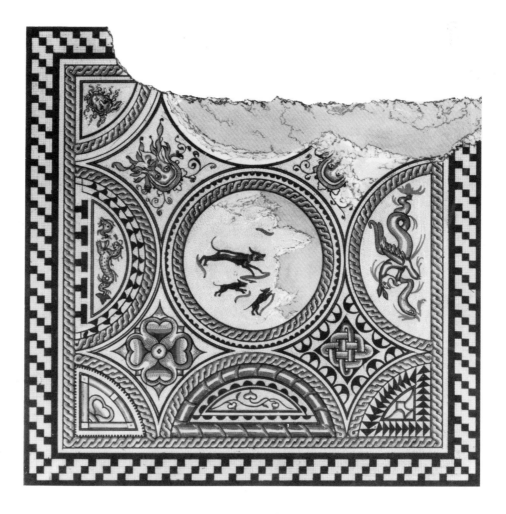

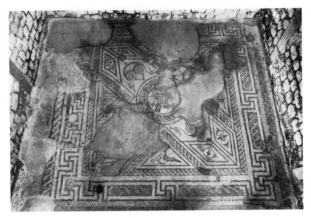

387 (right) Scenes from the story of Dido and Aeneas on a mosaic from Low Ham, Somerset.

385 The saltire mosaic in the baths at the villa at Chedworth, Gloucestershire.

originally illustrated on this panel is unknown; however, since most of the decoration of the original panel was of marine subjects, it is likely that the central design will have been on the same theme. Extensive relaying such as this probably followed the collapse of the pavement into a hypocaust.

Another pavement also situated over a hypocaust and showing evidence of extensive relaying is the displayed 'saltire' mosaic at Chedworth. Less than half of the original work survives. The repairs to this pavement would appear to have been by a mosaicist from the Corinian school. He has matched the designs tolerably well, but has rounded off the angles of the lozenge patterns. Similar workmanship also occurs on a mosaic at Silchester, which is almost certainly by the same mosaicist.

Evidence of extensive repairs of this sort should be compared with examples of the abandonment of perfectly good panels of mosaic. At Cirencester there are three cases of one mosaic being laid on top of another one. Admittedly, in each case there had been structural alterations to the buildings and the old floors would not have been an exact fit in the new rooms; but there seems to have been no attempt to remove the old floors, or even to continue to use them in cut down form in the new rooms.

Minor repairs were sometimes made with patches of *opus signinum*, mortar mixed with chips of crushed tile, as around the head of Autumn on the Seasons pavement at Cirencester.

Pattern books

The choice of a mosaic was probably decided after looking through a pattern or copy-book—a procedure rather similar to choosing a wallpaper. These pattern books would have featured a selection of designs as well as a range of individual motifs and decorative details.

The copying of patterns in this way leads to similarities between the mosaics made by any one group of mosaicists and, for this reason, it is now possible to attribute many mosaics to particular workshops. Imported patterns show up when they are not typical of their region, or perhaps when they have not been suitably adapted; a notable example is the pavement from Low Ham, Somerset, which illustrates the Vergilian story of Dido and Aeneas. The figures on this pavement are arranged so that they are visible from the outside edge of the floor.

386 A fourth-century mosaic overlying a second century mosaic in a house in Insula XIV at Cirencester.

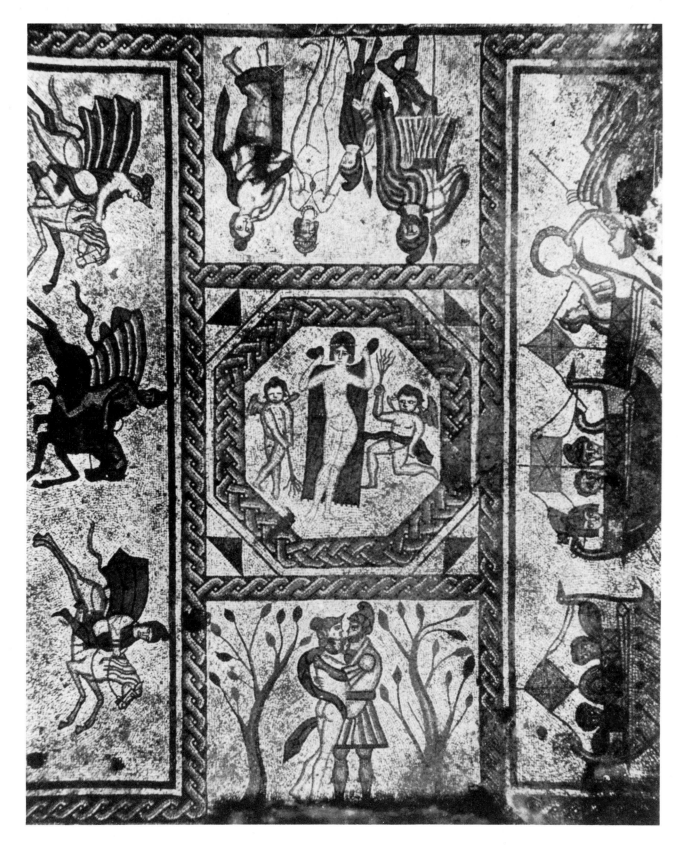

Professor Jocelyn Toynbee has shown that this sort of arrangement would be suitable for a villa in North Africa where the centre of the room might be surrounded by an ambulatory from which the figures could be seen, but that it was hardly suitable for a villa in Britain where no such arrangement existed.

The use of pattern books also meant that traditional patterns tended to be retained and repeated. This is particularly noticeable in Britain where a number of fourth century pavements repeat the patterns that were common two centuries before. A typical example is the fourth century Bacchus mosaic from Verulamium. Although badly damaged, the design can be restored completely; it shows meander and lozenge patterns usually associated with the first and second centuries.

Workshops

In recent years much work has been done on identifying the products of different workshops. In Britain David Smith has identified four particular schools or *officinae* which were at work during the fourth century. The workshops, he suggests, were based at Dorchester (*Durnovaria*) in Dorset, Cirencester (*Corinium*) in Gloucestershire, Water Newton (*Durobrivae*) in Huntingdonshire and the fourth school possibly at Brough on Humber (*Petuaria*). These schools each had a favourite range of motifs and even designs; for example, the Corinian school

388 The design of the Bacchus mosaic at Verulamium restored by the author from the surviving fragments. The central square measures 15 ft 2 in.

389, 390 The Seasons pavement in the main room of the villa at Chedworth, with a detail showing Cupid dressed for summer. Fourth century AD.

was famous for representations of Orpheus and the Durnovarian school for water scenes.

The Corinian school was the largest of the British workshops, and was responsible for laying over forty known mosaics in the area around Cirencester. These mosaics are spread throughout Gloucestershire, and occur also at Halstock, Dorset, at Wigginton, Stonesfield and North Leigh, Oxfordshire, and possibly also at London.

Within any one group of mosaics there is considerable variation in the quality of the work. The masterpieces of the Corinian school are the Orpheus pavements at Woodchester and at Barton Farm, Cirencester, the Bacchus pavement from Stonesfield and the Seasons pavement from Chedworth. But at Chedworth there is another pavement with a saltire pattern which is also a product of the Corinian school. It is clearly apparent that this saltire pavement is inferior in workmanship to the Seasons pavement. The tesserae are larger and they are made of different materials; the background tesserae are grey rather than white as on the Seasons pavement. It seems possible that the saltire pavement could be the product of an offshoot of the Corinian school, but it is more likely that it is a later product of the main workshop, for it is noticeable that the best pavements were the earliest ones. These can be seen as the work of the mosaicist who was the founder of the school; after he died or moved away, his patterns were repeated for a time, but the quality of workmanship declines.

385

390

The collapse of the Roman Empire brought an end to all mosaic production in Britain and in the north-western provinces; the schools of mosaicists were dispersed and the techniques were lost. Elsewhere, in the Byzantine Empire, the techniques continued to be used to produce mosaics illustrated by designs which were now predominantly Christian.

Bibliography

General works
L'Orange, H. P., and Nordhagen, P. J., *Mosaics*, London, 1966
Levi, D., 'Mosaico', in *Enciclopedia dell'arte antica*, Rome, 1963
Toynbee, J. M. C., *Some Notes on Artists in the Roman World*, Brussels, 1951
Vitruvius, *On Architecture*, Book 7

Hellenistic techniques
Phillips, K. M., 'Subject and Technique in Hellenistic-Roman Mosaics', in *Art Bulletin*, 42, 1960

Romano-British mosaics
Smith, D. J., 'Three fourth-century schools of mosaic in Roman Britain', in H. Stern, G. Picard, *La Mosaïque Gréco Romaine*, Paris, 1965
Smith, D. J., 'The Mosaic Pavements', in A. L. F. Rivet (ed.) *The Roman Villa in Britain*, London, 1969

Bibliography of Romano-British mosaics
Rainey, A., *Mosaics in Roman Britain*, Newton Abbot, 1973

Acknowledgements

The preparation of this book has involved many people besides ourselves. We are particularly grateful to friends and colleagues for much advice on technical matters and for making material and illustrations so freely available. We would like especially to thank: Mr H. Hodges; Miss O. Godwin; Messrs P. Clayton, G. Cuzner and B. Holden; Professor S. S. Frere, Mr R. Goodburn and Herr A. Mutz; Miss D. Charlesworth, Mrs M. U. Jones and the staff of the Ancient Monuments Laboratory; Mr D. F. Allen, A. H. Baldwin and Sons, Dr A. Barb, Messrs S. Bendall, R. Carson, J. Casey, Dr J. P. C. Kent, Mr R. Pell, Dr R. Rose, Mr W. Thomas, Dr R. Tylecote and Mr P. Wagstaff; Mr G. Bryant; Mr A. Levy and Mrs V. Sussman; Mr G. C. Boon, the Glass Manufacturers' Federation, Dr D. B. Harden, Dr M. G. Jarrett, Mme Morrachini-Mazel, Messrs K. S. Painter, R. H. Price, and G. Rogers; His Grace the Duke of Wellington; Dr W. Groenman-van Waateringe; Mr R. W. Adams; Mr A. D. MacWhirr, Professor C. M. Robertson and Dr I. M. Stead.

The drawings are mostly the work of Michael Woods and we thank him for his patience and skill in interpreting our rough sketches. Finally we would like especially to thank Tony and Leslie Birks-Hay who have designed this book so successfully. They have given our work an extra dimension.

Location of objects

The present location of most of the objects illustrated is indicated either in the text or caption or by the source of the photograph. The remaining objects are either in private possession, or have been excavated so recently that they have not yet found a permanent home, or are listed among the following:

Antiquarium Comunale, Rome: 265
British Museum: colour plates I–V, VII, VIII; 7, 14, 134, 135
Guildhall Museum, London: 303
Istanbul Archaeological Museum: 336
Musée du Louvre: 271
Museo Arquelogico Nacional, Madrid: 223
Museo ex-Lateranese, Vatican: 320, 322, 334
Museo Nazionale, Parma: 331
Museo delle Terme, Rome: colour plate IX; 352
Palazzo dei Conservatori, Rome: 316
Reading Museum: 240, 241, 248, 249, 252, 255, 256, 258, 259, 268
Staatliche Museen, Berlin: 19

Sources of Illustrations

We gratefully acknowledge the use of photographs and drawings from the following sources:

Alphabet & Image: 269
Archaologisch Instituut der Rijksuniversiteit, Utrecht: 170
Ashmolean Museum: colour plates III and VI; 20, 22, 26, 27, 31, 32, 36, 37, 50, 54, 55, 58, 125, 128–131, 133, 136–144, 147, 148, 151–153, 185, 197, 224, 261, 278, 279, 285, 288, 356
H. Atkinson: 155
Donald Barlin: 301
Bibliotheca Apostolica Vaticana: 264
Mavis Bimson: 59
Trustees of the British Museum: colour plate I, 1, 9–13, 15–18, 25, 28, 29, 40, 52, 56, 60, 62, 64–67, 70–74, 156, 160–164, 166–169, 172, 173, 176–181, 183, 184, 186, 188, 189, 193–196, 198–203, 209, 211, 213–215, 219–222
David Brown: 7, 14
M. Chuzeville: 271
Cirencester Excavation Committee: 381, 386
Cuming Museum, London: 307
Durham University: 289
Deutsches Archäologisches Institut, Rome: 370
Fitzwilliam Museum, Cambridge: 361
Fotofast Bologna: 273
Fototeca Unione: 274
Glass Manufacturers' Federation: 206, 208, 210
W. L. Goodman: 262
Guildhall Museum, London: 302, 304, 305, 310
Heidelberg University: 187
Hunterian Museum, Glasgow: 39
G. Holden: 4, 5, 6
Michael Holford Picture Library: colour plates II–V and VII–XII
Trevor Hurst: 303
Inspectorate of Ancient Monuments, London: 46, 48
Landesmuseum, Trier: 314
Musée des Antiquites Nationales, St Germain-en-Laye: 190–192
Musée d'Aquitaine, Bordeaux: 263
Museum of Archaeology and Ethnology, Cambridge: 270, 293
Museum of Classical Archaeology, Cambridge: 355
Museum of Leathercraft, London: 300
National Monuments Record, London: 385, 389, 390
National Museum of Antiquities, Scotland: 232, 235, 236, 250, 254, 257, 294, 296–298, 306
National Museum of Wales, Cardiff: 165
D. S. Neal: 44, 45, 47, 49
Norwich Castle Museum: 253
Ny Carlsberg Glyptotek: 352
Oxfordshire Archaeological Unit: 145
A. Pacitto: 376, 379
Petrie Collection, University College, London: 171
Zev Radovan: 174
E. Ramsden: 373
Reading Museum: 268
Rheinisches Bildarchiv, Cologne: 43
Rheinisches Landesmuseum, Bonn: 266
Richmond Archives, Ashmolean Library: 372
Saalburg Museum: 267
E. Schulz: 33–35
Shrewsbury Museum: 41
Soprintendenza alle Antichita, Calabria: 362
Soprintendenza alle Antichita, Napoli 342, 350
Staatsbibliothek Berlin: 19
Thames and Hudson: colour plate I
University of Newcastle upon Tyne: 238, 275, 284, 287
Verulamium Museum: 380
Victoria and Albert Museum: 182
R. L. Wilkins: 23

A number of illustrations have been copied or adapted from published works:

Abramic, M., in *Bonner Jahrbucher* 1959: 205
Adam, S., *The techniques of Greek Sculpture*, 1966: 329
Blümner, H., *Technologie und Terminologie der Gewerbe und Künste bei Greichen und Römern*, ii, 1879: 344
Bruno, S., *Les petits amours de la maison des Vetti*: 53
Buckman, J., Newmarch, C. H., *Remains of Roman Art in Cirencester*, 1850: 384
Casson, S., *The technique of early Greek sculpture*, 1933: 319
Cichorius, C., *Die Reliefs der Trajanssäule*, 1900: 312, 313, 340
Curle, J., *The Fort of Newstead*, 1911: 272
Fremersdorf, F., in *Kölner Jahrbuch* 1965/6: 204, 212
Furtwangler, A., *Aegina, Das Heiligtum der Aphaia*, 1906: 346
Gansser-Burckhardt, A., *Das Leder im römischen Legionslager Vindonissa*, 1942: 311
Grimes, W. F., *The works depot of the XXth legion at Holt*, 1930: 150
Groenman-van Waateringe, W., *Romeins lederwerk uit Valkenburg*, 1967: 299, 308, 309, 315
Higgins, R. A., *Greek and Roman Jewellery*, 1961: 57, 61, 63, 68, 69
Hull, M. R., *The Roman Potters' Kilns at Colchester*, 1963: 146
Iványi, D., *Die Pannonischen Lampen*, 1935: 157
Jacobi, L., *Das Romerkastell Saalburg*, 1897: 346
Julliot, G., *Inscriptions et Monuments du Musée gallo-romain de Sens*, 1898: 291, 292, 345
Miltner, F., *Forschungen in Ephesos*, IV, 1937: 175
Morin Jean, M., *La verrerie en Gaule sous l'empire romain*, 1913: 218, 223, 224
O'Riordain, S. P., in *Proceedings of the Royal Irish Academy*, 1942: 51
Oswald, F., Pryce, T. D., *An introduction to the study of Terra Sigillata*, 1920: 132
Richter, G. M. A., *Ancient Italy*, 1955: 333
Thompson, H. A., Wycherley, R. E., *The Agora of Athens*, 1972: 24
Wild, J. P., *Textile Manufacture in the Northern Roman Provinces*, 1970: 277, 281–283.
Winter, A., in *Technische Beiträge zur Archäologie*, 1959: 126, 127, 154

All other illustrations are from the respective authors' own photographs and drawings.

Index